• INVENTING BERGSON •

• I N V E N T I N G •

B E R G S O N

CULTURAL POLITICS AND THE

• PARISIAN AVANT-GARDE •

Mark Antliff

PRINCETON UNIVERSITY PRESS • PRINCETON, NEW JERSEY

Library of Congress Cataloging-in-Publication Data
Antliff, Mark, 1957–
Inventing Bergson : cultural politics and the
Parisian avant-garde / Mark Antliff.
p. cm.
Includes bibliographical references and index.
ISBN 0-691-03202-5
1. Bergson, Henri, 1859–1941—Influence.
2. France—Intellectual life—20th century.
3. France—Politics and government—1870–1940.
4. Art, Modern—20th century—France. I. Title.
B2430.B43A58 1992
944.081'3—dc20 92-13264 CIP

This book has been composed in Linotron Trump Medieval and Gill Sans

An earlier version of part of this book appeared as
"Bergson and Cubism: A Reassessment," *Art Journal,*
special issue on "Revising Cubism," 47 (Winter 1988), 341–49.

C O N T E N T S

COLOR PLATES

1. Albert Gleizes, *Woman with Phlox*, 1910. Oil on canvas, 81.6 × 100.2 cm. Museum of Fine Arts, Houston, gift of the Ester Florence Whinery Goodrich Foundation.

2. Albert Gleizes, *Bridges of Paris*, 1912. Oil on canvas, 58.3 × 71.7 cm. Museum moderner Kunst, Vienna.

3. J. D. Fergusson, *Blue Beads, Paris*, 1910. Oil on board, 50.2 × 45.7 cm. Tate Gallery, London.

4. J. D. Fergusson, *Rhythm*, 1911. Oil on canvas, 162.8 × 115.5 cm. University of Stirling, Scotland. Reproduced with the permission of the Perth and Kinross District Council, Fergusson Gallery.

5. Henri Le Fauconnier, *Village in the Mountains*, 1911–1912. Oil on canvas, 39 ⅜ × 31 ¹¹/₁₆″. Museum of Art, Rhode Island School of Design. Membership Dues. Photography by Cathy Carver.

6. Albert Gleizes, *The City and the River (La Ville et le fleuve)*, 1913. Oil on canvas, 31 ½ × 25″. R. Stanley and Ursula Johnson Family Collection, Chicago.

7. Carlo Carrà, *Funeral of the Anarchist Galli*, 1911. Oil on canvas, 6′6 ¼″ × 8′6″. Collection, The Museum of Modern Art, New York. Acquired through the Lillie P. Bliss Bequest.

8. Gino Severini, *Sea = Dancer*, 1914. Oil on canvas, 105 × 80 cm. Peggy Guggenheim Collection, Venice. Photograph © 1991 The Solomon R. Guggenheim Foundation.

BLACK-AND-WHITE ILLUSTRATIONS

OVER THE YEARS since I first became interested in Bergson, a number of people have generously aided me in developing this project. I am grateful for all the help and stimulation I received from my advisor, Robert L. Herbert, whose approach to the social history of art deeply affected my own. A course with Richard Shiff at Yale in the fall of 1985 led me not only to rethink Bergson's impact on the French avant-garde, but to reconsider European modernism as a whole, a task greatly facilitated by the inspirational example of Shiff's own writing. Similarly, Linda Henderson's scholarship and intellectual generosity played a significant role in shaping the book's parameters. Together with my former advisor Vojtech Jirat-Wasiutynski, Herbert, Shiff, and Henderson offered advice and resources throughout the period leading to the book's completion. In addition, Walter Cahn offered timely advice on numerous occasions.

This book began as a doctoral dissertation at Yale University. My study at Yale was facilitated by a generous grant from the Social Sciences and Humanities Research Council of Canada, and the sweat from the collective brows of my family. As a Mary Davis Predoctoral Fellow for 1988–1990, I was able to spend a year researching the project in Europe before finishing the dissertation in Washington at the Center for Advanced Study in the Visual Arts (CASVA). In Paris, Henri Gouhier and Jean Guitton gave me the authorization to consult the Bergson archive at the Bibliothèque Jacques Doucet, and François Chapon and his staff assisted my study there. My research on the Rhythmists in Scotland was greatly aided by Robin Anderson, Jim Hastie and Roger Bilcliffe of the J. D. Fergusson Art Foundation. I am also grateful to my friend Mary Minty for aiding my research and travel in England. Following my return to the United States CASVA provided me with a wonderful environment in which to write and exchange ideas, and thanks go to the staff of the Center for making that possible. My subsequent development of the thesis into a book was aided by a post-doctoral fellowship from the Social Sciences and Humanities Research Council of Canada. I would like to thank Elizabeth Powers and Tim-

othy Wardell of Princeton University Press for all their help in seeing this book to completion.

I would also like to thank a number of friends who, in various ways, have helped over the years. For their friendship and advice during my years at Yale I would like to thank Mathew Affron, Eric Cohen, Elisabeth Fraser, Joseph Inguanti, Nancy Minty, and Chris Reed. More recently Tracy Cooper, Marc Gotlieb, Patricia Mathews, Sarah Schroth, and Claire Sherman have played a similar role. My gratitude goes to my companion Patricia Leighten, whose comradely advice greatly aided the writing process and whose groundbreaking work, like that of Bob Herbert, offered me an example of how the study of politics and art could be profitably combined.

My advisor Bob Herbert deserves a special note of thanks. As an activist, and as the teacher who first introduced me to the social history of art, he continues to be a source of inspiration for me. Most of all I would like to thank my brother Allan, to whom this book is dedicated. As one who shares so many of my intellectual concerns his input over the years has been invaluable, as has his enthusiasm.

November 1991

• INVENTING BERGSON •

WHEN the French philosopher Henri Bergson read Jean Metzin-ger's "Cubisme et tradition" in November 1911, his assessment of the text was far from favorable. Having read Metzinger's claim that the Cubists incorporated "time" in their works by moving "around the object, in order to give . . . a concrete representation of it, made up of successive aspects," he responded in an interview that Metzinger's essay "is very interesting, is it not, as theory?" He continued:

> I regret that I have not seen the works of these painters. . . . What is common today, is that theory precedes creation . . . yes, in everything: in the arts as in the sciences. . . . It was the contrary, formerly. . . . For the arts, I would prefer genius, and you? . . . But we have lost simplicity, it is necessary to replace it with something.[1]

Art, we are told, should be the product of genius, of "intuitions," not theorizing; theory, in fact, is a substitute for creativity, which in former times preceded it. When asked two years later to assess the relation of Cubism to his philosophy, Bergson returned to this dichotomy to condemn the movement for analyzing artistic practice instead of intuitively performing it.[2] Bergson deemed the Cubists' attempt to move from analysis to artistic creativity an impossible one, for, as he states in the "Introduction to Metaphysics," "from intuition one can pass on to analysis, but not from analysis to intuition."[3] Cubism was seen as yet another example of the invasion of intellectual modes of thought into a field conducive to intuition alone.

Bergson's endorsement of Cubism, however, was far from necessary to the artists and critics who thought of themselves as "Bergsonists." What is more relevant in this regard is the use made of Bergson's ideas by the Parisian avant-garde at a time when Bergson's philosophy was part of a cultural controversy that began around 1905 and reached its apex in the months preceding the First World War. Bergson, arguably the most celebrated thinker of his day, had become an international celebrity following the 1907 publication of *Creative Evolution*. Previously, Bergson had published two books

on the metaphysical import of the creative nature of time. *Time and Free Will* (1889) described the temporal dimension of human consciousness as synonymous with creative freedom, while *Matter and Memory* (1896) applied his previous findings to a philosophical analysis of the relation of mind to body. After 1900, Bergson disseminated his ideas through public lectures at the Collège de France and on tours that took him to Italy (1911), England (1911), and America (1913). Aside from attracting such period luminaries as Charles Péguy, the editor of the *Cahiers de la Quinzaine*, the Catholic Thomist Jacques Maritain, and the anarcho-syndicalist Georges Sorel, Bergson's weekly lectures also drew an educated public so numerous that it spilled out of the lecture hall (fig. 1). Péguy, in 1902, encountered this diverse range of auditors at what were popularly termed "Five o'clock Bergsonians":[4]

> I saw elderly men, women, young girls, young men, many young men, Frenchmen, Russians, foreigners, mathematicians, naturalists, I saw there students in letters, students in science, medical students, I saw there engineers, economists, lawyers, laymen and priests, . . . I saw there poets, artists, I saw there M. Sorel, I saw there Charles Guieysse and M. Maurice Kahn, I saw there Emile Boivin, who takes notes for someone in the provinces; they descend from the *Cahiers*, from *Pages libres* . . . they come from the Sorbonne and I think the Ecole Normale; I saw there well known bourgeois types, socialists, anarchists.[5]

Bergson's fame as a speaker was matched by his eminence as a writer—all his major works had been translated into English, German, Polish and Russian by 1914.[6] At its height, the Bergsonian vogue even led to what the historian R. C. Grogin has called "mystical pilgrimages" to Bergson's summer home in Switzerland where "locks of his hair at the local barber's were treated as holy relics."[7] This popularity in part engendered the accusation that his intuitional philosophy trumpeted irrationalism at the expense of analytical reason, and that the alleged pantheism and nominalism stemming from his philosophy undercut the Thomist ideology of the Roman Catholic Church. Indeed, Bergson's philosophy had affected the Catholic intelligentsia to such an extent that, in 1914, the Holy Office put his writings on their Index of Prohibited Books. That same year Bergson was elected to the Académie française following a widely publicized debate over his candidacy, launched by the royalist Action française. The Action française's leader, Charles Maurras, thought Bergsonism was leading France to ruin, and his opinion was seconded by Julien Benda who pilloried Bergson from the standpoint of the Cartesian tradition Maurras upheld. At the other end of

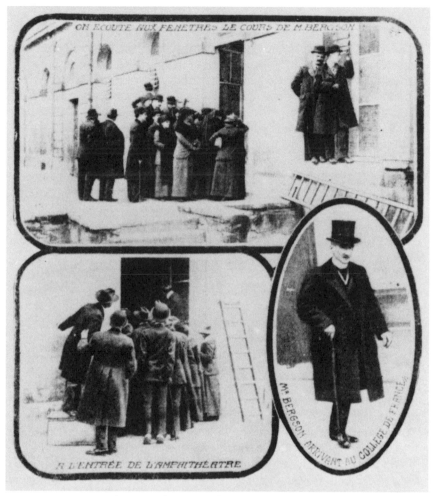

1. *On écoute aux fenêtres le cours de M. Bergson, Excelsior,* 14 February 1914

the political spectrum the anarcho-syndicalist Georges Sorel had provoked a controversy of a different sort by utilizing Bergson's ideas to justify class warfare in his celebrated book *Reflections on Violence* (1908). Three years later, in 1911, Henri Massis and Alfred de Tarde made Bergsonism the springboard of their attack on what they thought were "rationalist" and "Germanic" biases of the Sorbonne. Publishing under the pseudonymn "Agathon," Massis and de Tarde initiated a debate over the condition of French culture that lasted until the war. The extent of this controversy was captured by

Gaston Picard and Gustave Tautain in their 1914 "Enquête" on Bergson's influence, published in *La Grande revue*.[8]

Bergson's influence, particularly among writers, has been the subject of numerous studies, as has his legacy in the realm of political thought.[9] Recently, R. C. Grogin has analyzed the more popularized understanding of Bergson's philosophy to illuminate the role of his ideas in the debates mentioned above.[10] Yet despite widespread acknowledgment in other fields of Bergson's centrality to cultural debates in France before the First World War, the field of art history continues to treat Bergson as if he were a marginal figure on the cultural landscape. Although there have been scattered studies of Bergson's "influence" on individual members of the Fauvist, Cubist, and Futurist movements,[11] the Bergsonian theory of such artists has yet to be considered as part of a larger cultural matrix. Moreover, on the whole art historians have restricted their consideration of Bergson's impact on art to questions of aesthetics, thereby limiting the relevance of Bergson to the realm of formal innovation. Although the work of scholars like Daniel Robbins, David Cottington, Nancy Troy, and Patricia Leighten[12] has initiated a revision of our formalist understanding of avant-guerre Cubism by relating the criticism and art of that movement to the cultural politics of France, the cultural phenomenon known as Bergsonism is an aspect of avant-garde cultural politics the significance of which has yet to be charted.

This book seeks to break that silence by elucidating the seminal role of Bergsonism in shaping the art and politics of the Fauvist, Cubist, and Futurist movements. To understand the intersection of art and politics, however, requires that we gain a more general understanding of the historical circumstances that gave rise to the dialogue between these factions of the avant-garde and the political movements that were for or against their philosophical positions.

The evolving political climate in France between 1900 and the First World War witnessed the rise, on both the right and the left, of groups opposed to the Republic.[13] On the right, this opposition was largely made up of followers of Charles Maurras, the principal founder, in 1899, of the Action française; on the left was a broad anarchist movement made up of anarcho-individualists, anarcho-communists, and anarcho-syndicalists, who founded the Confédération Générale du Travail (C.G.T.) in 1895 in order to organize labor in strike actions against the Republic. In addition, the socialist Gustave Hervé, editor of the incendiary *La Guerre sociale* (1906–1915), and the anarcho-syndicalist theoretician Georges Sorel, who celebrated the violence entailed in class struggle, led autonomous fac-

tions within the anti-republican movement. Those willing to work within the republican form of government included luminaries sympathetic to both ends of the political spectrum: on the left was the socialist Jean Jaurès, who attempted to reunite all left factions in a "Bloc des Gauches" after 1906; on the right were men like Raymond Poincaré and Henri Massis, individuals who sympathized with some of the conservative values proffered by the Action française but did so in the name of a strong republic.[14] Figures like Maurras, Sorel, and Hervé have been described as "radical" by the historian Eugen Weber because of their principled stand against any coalition with a republican parliamentary system they wished to overthrow.[15] However, as both Weber and Paul Mazgaj have shown, principle was frequently compromised when various factions within the radical camp entered into unstable alliance, or when these same groups vied for the support of moderates within their royalist or syndicalist constituencies.[16] Georges Sorel, for instance, only entered into a temporary alliance with the Action française when the syndicalist general strike met with repeated failure, culminating with the Clemenceau government's bloody reprisal in 1908 against strike actions organized by the C.G.T. at Villeneuve-Saint-Georges. When Gustave Hervé's policies were defeated at a Socialist Party Congress of 1907, he too looked for support elsewhere; thus in the wake of the massacre at Villeneuve-Saint-Georges, Hervé called upon workers to abandon his rival socialist Jean Jaurès's collusion with the republican government and collaborate with the Action française in anti-republican protest. Hervé himself set an example in this regard, for between 1908 and April 1911, *La Guerre sociale* took up the royalist anti-Semitic strategy that accused the governments of Clemenceau and Briand of repressing workers at the behest of Jewish big business.[17]

During these same years the Action française launched a campaign to win the support of labor, primarily through an alliance with Sorelian syndicalists. As a more militant counterpart to the conservative corporatism advocated by the Catholic conservative La Tour du Pin and the royalist Firmin Bacconnier, a Sorelian faction within the Action française founded the *Revue critique des idées et des livres* (1908–1924) to promote their syndicalist ideology. Led by Jean Rivain and Georges Valois, the *Revue critique*'s royalists Gilbert Maire and Henri Clouard succeeded in usurping the more staid *Revue de l'Action française* as the voice of the militant right, which in turn caused friction with the editor of the *Revue de l'Action française*, literary historian Pierre Lasserre.[18] The *Revue critique*'s appearance lent credence to royalist claims of labor support, claims

supplemented by the royalist Léon Daudet's active campaigning in the working quarters of Paris after March 1909.[19] In November 1908 the royalist Maurice Pujo further strengthened the *Revue critique* group by organizing the Camelots du Roi, a gang of militant thugs whose direct-action tactics against state institutions, parades, and individuals initiated a series of public scandals.[20] From November 1908 to the spring of 1909 the Camelots repeatedly invaded the Sorbonne to protest against the historian François Thalamas. In early 1910 their notoriety increased when Camelot Lucien Lacour slapped Premier Aristide Briand at an official ceremony, and in March 1911 their anti-Semitic attacks on the production of Henri Bernstein's "Après moi" at the Comédie Française forced France's official theater to cancel the play. As a sign of their working-class allegiances the Camelots joined Daudet on his tours of proletarian districts, and the prominent Camelot Henri Lagrange wrote criticism for the Sorel-oriented *Revue critique*.[21] Maurras in turn began expressing his support for worker militancy and, in response to the Villeneuve-Saint-Georges incident, declared "revolutionary syndicalism" to be "much less a threat for country, religion, and order than the consortium Clemenceau-Fallières-Briand."[22]

However, dissension, on both practical and theoretical grounds, soon undermined the viability of a right-left rapprochement. For Hervé, a schism with the reactionary right occurred in April 1911, primarily because of fear that the collaborative anti-Semitic campaign would ultimately weaken his support within leftist circles. Following Aristide Briand's success in October 1910 in defeating the C.G.T.'s attempt to foment a general strike in support of striking railway workers, Hervé had taken up royalist anti-Semitism by linking Briand's strikebreaking policy to the business interests of the Rothschilds.[23] The Action française's success in popularizing this line culminated in the decision, on the part of the syndicalist Emile Pataud and royalist syndicalist Emile Janvion, to hold an anti-Semitic rally at a Parisian union hall in April 1911. Pataud's endorsement of this anti-Semitic campaign in the pages of *Action française*, combined with the Camelot du Roi's anti-Semitic attacks on the playwright Henri Bernstein during the winter of 1911, confirmed Hervé's fear that fellow socialists would mistake his class-based anti-Semitism for the outright racism exemplified by the Camelots' activities.[24] Thus in a dramatic volte-face in April 1911, he joined the C.G.T. in condemning both Pataud and the Action française's "racial nationalism" and organized the Jeunes Gardes révolutionnaires as a socialist alternative to the Camelots du Roi.[25] Then by mid-1912 Hervé was criticizing the C.G.T. for its anti-

parliamentarianism, and calling for a reformation of the Bloc des Gauches.[26] With the loss of Hervé's allegiance, the only group still supportive of a left-right, antidemocratic front were the small group of Sorelian intellectuals associated with the *Revue critique*.

For Maurras, alliance with this Sorelian camp had proven problematic from the start. He feared that such relations would erode his support among Catholic and royalist conservatives, groups with whom he sought to make peace following his June 1911 take-over of the Duc d'Orléans's Paris Political Bureau.[27] In addition serious philosophical differences separated Maurras from his Sorelian followers. While Maurras adhered to La Tour du Pin's and Firmin Bacconnier's advocacy of a doctrine of corporatism which would place workers' guilds under the control of the monarchy, Valois, Maire, and the *Revue critique* équipe called for the continuation of class conflict under the restored monarchy and followed Sorel in identifying class antagonism as fundamental to national regeneration. Further, the latter group's avowal of violence for violence's sake, in the name of Sorel's antirationalist theory of class consciousness, was particularly abhorrent to Maurras, who founded his philosophy on the rationalist tenets of the French positivist Auguste Comte. As early as August 1908 Maurras condemned the Sorelians for promoting a violent "coup de force without the public salvation that legitimizes it," a clear indication that Maurras, unlike Sorel, Valois, or Maire, saw violence as a means to an end, not an end in itself.[28] Sorel for his part was equally ambivalent about Maurras, choosing never to involve himself directly in the various royalist-syndicalist journals forged by his *Revue critique* disciples. To underscore his autonomy, Sorel founded a journal in 1911 appropriately titled *Indépendance*, and although royalists like Maire and Clouard were frequent contributers, the author of *Reflections on Violence* (1908) was resolute in declaring his official separation from the Action française. Thus when the syndicalist Berth joined *Revue critique* staffers in founding the *Cahiers du cercle Proudhon* (1912–1914) the following year, neither Sorel nor Maurras would involve himself in the project.[29]

Moreover, by the time the *Cahiers* made its appearance, Maurras was finding his Sorelian allies more of a liability than an aid to his cause. By 1914 the Catholic allies of La Tour du Pin and Bacconnier had become deeply alarmed by the secular and syndicalist orientation of the Sorelians. In an attempt to shore up his Catholic support, Maurras not only excommunicated the Sorelian Henri Lagrange, a prominent leader of the Camelots du Roi, he also, in his book of 1913, *L'Action française et la religion catholique*, denied any con-

nection between the *Revue critique* and official Action française policy. Maurras requested that the *Revue critique* publicly endorse his reprimand, which led the Sorelians Maire and Clouard to sever their ties with Maurras.[30]

Weber has noted that another element in this schism was Maurras's outrage over "the appreciation shown for Henri Bergson by Clouard, Maire, and their followers."[31] As we shall see such appreciation was inevitable, since Bergsonian ideas were at the heart of Sorel's revolutionary doctrine. In order to adhere to Sorel, Maurras's followers had to embrace the Bergsonian tenets of his syndicalism, tenets which utterly contradicted the positivist and rationalist bases on which Maurras justified his monarchism. Such conflict also led to disagreement among literary exponents of Maurras's ideology. Although united in their condemnation of the Symbolist movement because of its "anarchic" individualism, Maurras's literary interpreters differed in their judgment of what exactly constituted Symbolism's anarchic component. More doctrinaire followers, such as Lasserre and Jean-Marc Bernard, the founder of *Les Guêpes* (1909–1913), supported Maurras's association of French art with a rationalist tradition rooted in the Cartesianism of the seventeenth century and the Greco-Roman culture of classical antiquity. They pitted their neoclassicism against the anti-intellectual and Bergsonian tenets of the neo-Symbolist movement, as it was represented by figures like Jean Royère, editor of *La Phalange* (1906–14), and poet-critic Tancrède de Visan, an associate of *Vers et prose* (1905–1914). Concurrently, the Sorelian royalists Maire and Clouard attempted to synthesize their Bergsonism with Maurras's neoclassical ideology, going so far as to claim Bergson's philosophy to be rationalist, and accusing Bergson's Symbolist followers of distorting his philosophy. Throughout the prewar period the writers for *Revue critique* and *Revue de l'Action française* remained divided over the value of Bergson's philosophy, a situation further exasercbated by Maurras's repeated attacks on Bergson himself.

The ideological evolution of the Cubist, Fauvist, and Futurist movements cannot be understood apart from the cultural politics outlined above. In the pages that follow I will show that the Bergsonism of these movements was continuous with that of their neo-Symbolist allies, and that the various artists under study participated in these ideological debates over Bergson's cultural and political import. When related to such debates the Bergsonian Cubism of artists like Albert Gleizes, Jean Metzinger, and Henri Le Fauconnier compares and contrasts tellingly with the Bergsonian Fauvism of Dunoyer de Segonzac, J. D. Fergusson, and Anne Estelle Rice as well

as the Bergsonian Futurism of Gino Severini, Umberto Boccioni, and Carlo Carrà. The legacy of their cultural politics is analyzed in a concluding statement on the ideological ramifications of their organicist and vitalist doctrines. Drawing on analyses by intellectual historians, cultural geographers, and literary critics, I show that their aestheticism of violence and their "organic" definition of the nation-state were part of a matrix of ideas that contributed to the rise of fascist ideologies in the post-war era.

That the Bergsonism of these art movements bears comparison to the ideological precepts underpinning fascism is, perhaps, one of the more disturbing conclusions of this study. R. C. Grogin has noted that, before the war, "there was no greater intellectual assault upon the rationalist bases of French democracy than Bergsonian vitalism," while the historian Zeev Sternhell has demonstrated that the Sorelian Valois founded the French fascist party, the *Faisceau*, in the name of these vitalist principles.[32] The antidemocratic vitalism of these figures contrasted sharply with the political views of Bergson himself, who abhorred racism and defended republican and democratic principles throughout his life.[33] Members of the Bergsonian avant-garde failed to heed Bergson's example because they attempted to subsume human history in mythic and organicist theories of collectivity. Their politics is part of the legacy of Bergsonism, rather than of Bergson.

On the theoretical level, that ideological legacy constitutes what Richard Terdiman has called a "dominant discourse," that is, a sign-system that claims hegemony over others on the basis of its supposed "transparent and radically ahistorical" nature.[34] By asserting that intuition established an immediate relation between signifier and signified, Bergson and his followers proclaimed their ability to create "natural" signs, signs whose temporal properties—reflective of the personality—were anterior to and at the origin of all conventional sign-systems. Under the rubric of the transparent sign were numbered all those signs whose properties were deemed qualitative, rhythmic, and organic, as opposed to quantitative, non-rhythmic, or mechanical. Thus the differentiation Bergson's followers made between intuitive and intellectual signs entailed a radical schism between the immediate and mediated, the natural and conventional, the temporal and spatial, the spiritual and material.

Yet the terms of this organicist discourse bear the seeds of their deconstruction, particularly with regard to the mimetic properties of intellectual and intuitive signs. In Bergsonian theory, Cartesianism was condemned for falsely claiming to "mirror" the world by rational means. In its place Bergson substituted intuition, a faculty

able to emulate the generative activity of the *élan vital*. Thus artis-
tic creativity in Bergsonism imitated creative production in nature.
No longer premised on rational cognition, artistic creativity became
the light of being itself, whose luminosity was reflected in its artis-
tic creations. For example, in *Du Cubisme* the Bergsonian Cubists
Gleizes and Metzinger claimed to express the organic "light of or-
ganization" in their paintings even as they condemned *la lumière
de la raison*.[35] In short we are still in the realm of specular mimesis,
despite the apparent shift from one metaphor to another. As I will
argue in the first two chapters, the Bergsonists' valorization of one
mimetic discourse over another was an ideological maneuver de-
signed to justify the artists' elite position in society, what Derrida
has termed "economimesis."[36]

The organic metaphor itself is a construct possessing a determi-
nant logic that overruns the powers of origination it is said to em-
body. Organic form is typified in Bergsonian criticism by its creative
freedom, its continual invention, whereas mechanical form is pre-
determined, a lifeless fabrication. However, there is an inherent
contradiction in this system, for while artistic invention is not me-
chanically predetermined, its relation to the organicist metaphor of
growth or self-generation constitutes another determinant.[37] When
Bergson declared human creativity a manifestation of the cosmic
élan vital, he understood artistic creativity as both the product and
producer of a meta-creative process. In short, the personality was
decentered as the origin of creativity, for as an instance of the mate-
rialization of the élan vital, the organic form bore within it creative
capacities that did not originate with the artist. To enter into intui-
tive relation to the self was, paradoxically, to dissolve self-presence
altogether, an issue that complicates the Bergsonists' differentiation
of the élan vital's creative capacities according to gender.[38]

An analysis of Bergson's theory of the personality demonstrates
that within Bergson's system there is no pure vital impulse prior to
its spatialization into form, with the result that distinctions be-
tween natural and conventional signs become blurred. Since time in
the guise of the élan vital is creation, it is inextricably bound to the
forms that it creates. Indeed when one scrutinizes Bergson's meta-
physics it becomes clear that no radical break separates the tem-
poral from the spatial; instead there are gradations of "extensity"
linking the intensive and extensive, pure *durée* and its material
manifestations.[39] In the Cubist theory of Gleizes, Metzinger, and Le
Fauconnier, Bergson's preference for the intuitive over the intellec-
tual took the form of a contrast between the perspectival, quantita-
tive construction of space by artists like Gérôme, and the Cubists'

usage of *passage* to create an intuitive sensation of extensity, as in Metzinger's *Le Goûter* of 1911 (fig. 4). According to the Bergsonists, Albertian perspective claimed to present the viewer with a transparent window onto the world, when in fact quantitative measurement *distorted*, rather than mirrored, a qualitative, durational reality that could only be grasped through intuition. Like Bergson, these Cubists linked our faculty of sight to the intellect's utilitarian and anti-temporal biases. Appropriately, their own work was made up of pictorial signs they associated with the synaesthetic fusion of sensations that Bergson identified with an intuitive experience of the mixture of time and space. Since Bergson associated the feeling of extensity with a grasp of the rhythmic properties innate to duration in an extensive state, the Puteaux Cubists substituted rhythmic *passage* for the quantitative measurement of space, and they claimed to order that space in response to a mixture of tactile, musical, and gustatory sensations.

Thus Metzinger's *Le Goûter* not only represents a woman savoring tea but also alludes to a form of aesthetic discernment the Cubists associate with an intuitive grasp of the durational properties of their work. "Le goût," or taste, allows the viewer to grasp the durée of rhythmic *passage* which serves to bind the canvas into an organic whole. However, the fluctuant mixture of time and space that *passage* embodies results in an ambiguous dialectic of the élan and form, wherein the élan is not an observable reality in its pure state. When Bergson confronted this ambiguity in his book *Matter and Memory*, he acknowledged that his distinction between intuitive and intellectual signs was an ideal one, for in the realm of concrete experience, every form, even the most quantified, contains within it a trace of the durational rhythm that created it. Thus forms of mediation and determination are inscribed into the élan from the very start, and hard distinctions between types of spatial form become arbitrary, a matter of *social* rather than metaphysical determination. And the fusion of temporal and spatial structures developed by Bergson's followers resulted in a plurality of temporal typologies, each with its own narrative concerning the ideological import of Bergsonian durée. In effect, the boundaries of organic form remained unstable, with each group vying with another to define a frame of reference with which to constitute organic unity.

In sum, Bergson's natural or transparent signs are not anterior to cultural conventions but are, to paraphrase Richard Shiff, standardized signs empowered—that is, socially authorized—to represent the intuitive.[40] To uncover the power relations implicit in such authorization is to reveal the transparent sign's ideological import:

that is the project undertaken in this book. In the process I analyze the political debate over transparent signs that divided both Bergsonians and anti-Bergsonians as well as factions within the Bergsonian camp itself. This debate underlies the Bergsonian critique of the royalist ideology of Charles Maurras, who exalted Cartesianism as a philosophical system able to "mirror" nature. By applying Bergson's critique of the intellect to Cartesianism, the neo-Symbolists and their Cubist allies condemned Cartesianism as a system that distorts rather than reflects reality. For an artistic sign-system based on vision and reason, they substituted intuitive signs whose rhythmic and organic properties they celebrated as truly "natural." Albert Gleizes evoked these same precepts when he declared the Cubist style an organic and thus "natural" embodiment of the élan vital of the Gallo-Celtic race. His extension of the organic metaphor to a definition of the racial parameters of a nation-state served to separate a faction within the Cubist movement from other groups within the Bergsonian camp, who either limited the metaphor to the realm of class consciousness or declared all extensions of the intuitive metaphor to collective configurations a false construct. As we shall see, these differing interpretations of the ideological import of the natural sign united the Puteaux Cubists and Bergsonian Fauvists even while it separated both groups from the Italian Futurist adherents of Sorel. While members of the former movements linked Bergsonian organicism to racial definitions of the nation-state, the Futurists followed Sorel in defining class conciousness as a transparent sign amenable to the concept of a proletarian nation. These avant-garde factions were in turn challenged by a group of anarcho-individualists, members of Action d'art, who condemned any attempt to co-opt the Bergsonian notion of the intuitive state of "self-presence" to arguments for collectivity on any scale. Rather than subsume the individual within a group, reportedly reflective of a broader élan vital, they stood for individual autonomy in opposition to nationalist or ethnic ideologies.

The Bergsonism of the prewar era serves as an important precedent for what Zeev Sternhell has termed the "romantic" fascism of the postwar period, and what Jeffrey Herf has called the "reactionary modernism" of Nazi Germany.[41] Fascist proponents of reactionary modernism developed an organic definition of the nation-state by trumpeting the qualitative temporality of a given racial group as an ideological alternative to the quantitative systems of temporal organization promoted by international capitalism. By universalizing its temporal system, the ideology of capitalism laid claim to the hegemonic condition of the transparent or natural sign.[42] Thus the

qualitative and organicist definition of time and space developed by "romantic" fascism is a counter-discourse to this capitalist ideology. At the same time, however, proponents of reactionary modernism saw fit to subsume modern technology within organic metaphors of race or national *volonté*, by untethering technology from the Enlightenment reason and democratic ideology that they associated with capitalism. Besides equating organicism with a *völkisch* return to the soil or a pastoral aesthetic, "they succeeded," to quote Herf, "in incorporating technology *into* the symbolism and language of *Kultur*—community, blood, will, self, form, productivity, and finally race—by taking it *out of* the realm of *Zivilisation*—reason, intellect, internationalism, materialism, finance."[43] In Bergsonian terms the rhythm of the machine could be united to the temporal rhythm of a given racial group, if the notion of qualitative extensity could be extended to encompass the inanimate. Indeed this is just what leftist artists like Gleizes did when they applied the organic metaphor not only to painting, but to the industrial production of the French proletariat. That such a maneuver, which Herf has related to fascist and Nazi ideology, was first developed in the cradle of modernism might seem surprising, but only because the ideological import of much modernist criticism has been ignored. By looking at the fabric of cultural discourse, with all its political passion and complexity, I hope to reveal how the enthusiasm of a generation for Bergson's life-affirming organicism could combine anticapitalist ideologies, sometimes unwittingly, with the politics of reaction.

Cubism, Classicism, and the
Body Politic

IN HIS pioneering dissertation of 1981 and recent book, *Esprit de Corps: The Art of the Parisian Avant-Garde and the First World War, 1914–1925*, Kenneth E. Silver opened the field of right-wing politics and the French avant-garde to study. Focusing on the period of World War I and its aftermath, Silver found that the rise of cultural nationalism among the avant-garde in France was defined almost exclusively in terms of a rhetorical embrace of the supposed "Latin" and "classical" roots of the French race on the part of the wartime Cubist movement. Other scholars have endorsed Silver's findings that references to national self-identity in Cubist-related writings of the post-1914 era were made in response to the Action française's repeated accusation that those who did not embrace their monarchist centralism were themselves anti-French, indeed pro-German. Thus in *Cubism and Its Enemies* Christopher Green, citing Silver, concluded that during the war years the alliance

> between an ideal of Classicism which was essentially Latin and a deep sense of French identity propagated on the far Right before the war by Charles Maurras and *Action Française* had been so thoroughly and widely absorbed in France that it had become acceptable even to those who were obviously hostile to the political Right. . . . From an initial impetus on the Right, a simplistic tendency to oppose French and Germanic culture in terms of an opposition between Latin order and barbaric anarchy, classic reason and Gothic mysticism had become a dominant.[1]

While Silver and Green correctly interpret the avant-garde's approval of Maurrasian classicism during the war as a strategy of appeasement in the face of nationalist condemnations of Cubism as "foreign," some art historians have conjectured that avant-garde attempts to appease the right had their origins in the burgeoning nationalism of the prewar period. Indeed, this *rapprochement* is the subject of Robert Lubar's recent analysis, in *On Classic Ground*, of

the reception in Barcelona of the spring 1912 Puteaux Cubist exhibition held at the Galeries Dalmau. Lubar cites references to the Latin genealogy of Cubism proffered by Metzinger and Gleizes in 1911 and associates this with the Cubist critic Roger Allard's reference, in the November 1910 edition of *L'Art libre*, to the Cubists' desire to broaden "tradition in the direction of a future classicism." On this basis Lubar asserts that the classicism of the Puteaux Cubists echoes that of the Maurrasian-oriented Catalan critics Eugeni d'Ors and Josep Maria Junoy.[2] Among the judgments Lubar considers indicative of such political "affinities" are d'Ors' location of Cubism "within the French Cartesian tradition, emphasizing the overiding intellectual and mathematical order of Cubist painting," and his association of Cubism with the "collective, Latin values" championed by Maurras.[3] Moreover, d'Ors is said to echo the critique of Impressionism developed by Allard when he located Impressionism in the latter half of Maurras's classical/romantic equation. "Structuralism," said d'Ors, "represents the exact opposite of Impressionism. The latter, romantic, maintained the cult of Sensation. The former, classic, maintains the cult of Reason."[4] "Catalan Cubist criticism" therefore "offers many insights into the ways in which the conservative and counterrevolutionary arguments of writers like Maurice Barrès and Charles Maurras could be used to define a broad cultural politics." Lubar concludes, furthermore, that

> the ways in which Cubist criticism engage[s] in discourses of pre-war French nationalism may point to the essentially conservative elements in the movement, as Eugeni d'Ors immediately grasped. As Cubist painting retreated into idealism, Cubist criticism more visibly reflected the cultural conservatism that was its counterpart.[5]

Indeed, we could infer that the Cubist "retreat" was in fact a total rout, for, in the history of French modernism charted above, the "nationalist discourse" of prewar Cubism is deemed compatible with the Cartesian classicism of d'Ors and Maurras, with no hint that its ideological import differed from the "conservative and counterrevolutionary" views advocated by the Action française. Cubist classicism would seem to be a perfect vessel for the Action française's reactionary ideas on culture and society.

This conflation of Maurrasian classicism and avant-guerre Cubist classicism, however, does not stand up under close scrutiny. Besides expounding a Cartesian definition of classicism in the prewar years, Maurras and his literary allies Pierre Lasserre and Jean-Marc Bernard condemned the Symbolist movement as antirationalist, exemplified by the Symbolists' allegiance to the intuitionist philosophy

of Henri Bergson.[6] Such criticism implicated the Cubists, for between 1910 and 1914 the Bergsonian Albert Gleizes and Jean Metzinger published in Symbolist-oriented journals such as *Vers et prose*, *Les Bandeaux d'or*, and *Pan*; additionally their literary supporters Roger Allard, André Salmon and Guillaume Apollinaire were all major figures in the neo-Symbolist milieu. Gleizes later underscored this interrelation by noting that, in 1912, "Cubism refreshed peoples' memories of Mallarmé, and the Symbolists were once again in vogue."[7] In other words, by using Cartesianism to disparage the still vital Symbolist movement, Maurras was in fact condemning its pictorial bedfellow, Cubism. In response Albert Gleizes and his neo-Symbolist allies Roger Allard and Tancrède de Visan self-consciously opposed the royalists' trumpeting of Cartesian classicism with a counter-definition of classicism based on Bergson's anti-Cartesian doctrine of intuition. For example when Roger Allard defined Cubism as leading to a "future classicism" in the Symbolist journal *L'Art libre* (November 1910), he did so by claiming that the rhythmical properties of a Cubist canvas reflected the musical structure inherent in durée, the Bergsonian term for the temporal flow of consciousness. Allard defined Cubism as classical because he judged the Cubists' innovative style to be representative of their "intuitive" grasp of the collective durée of the French people. Moreover, on the basis of their Bergsonism, Allard and his colleagues claimed that this French *esprit* could not be rationally discerned, and in the process declared Maurras's correlation of classicism with rationality invalid.

To understand this transformation and the role of Bergsonism within it, some preliminary remarks are in order. Since the chapter at hand is the first of two concerned with a debate—yet to be charted—between the Action française and Bergson's apologists among the avant-garde, an overview of the Action française's critique of Bergson's followers is necessary. What this response reveals is a kind of ambivalence within the Action française over the value of Bergsonism, particularly as it was represented by the syndicalist Georges Sorel who, as we have seen, had a considerable influence among royalists associated with the *Revue critique*. To begin with, Sorel employed Bergson's theory to bolster his doctrine of class integralism; yet the Action française's admiration for Sorel was coupled with a repugnance for Bergson's Jewish background, and the "Germanic" roots of his philosophy.[8] In effect while their theory of integral nationalism led the Action française to laud the syndicalists for critiquing bourgeois democracy, the Bergsonian terminology of Sorel's analysis was itself subject to criticism by the movement's

major protagonists, Charles Maurras and Pierre Lasserre.[9] Though willing to form an alliance with the Sorelians, Maurras and Lasserre remained wary of their methods, especially in the cultural sphere. While Sorel glorified Greek culture on the basis of the combative *volonté* uniting members of the Greek *polis*, Maurras's idealization of Greco-Latin culture was derived from the supposed rationality of Athenian society, the legacy of which was to be found in the Cartesian rationalism of the French seventeenth century.[10] In the sphere of politics the Action française sided with the Sorelians in condemning the bourgeoisie for their excessive individualism, yet in the cultural sphere rationality, as well as corporatism, were lauded as a justification for monarchical "order". This political order was deemed a natural order, reflective of the French Cartesian spirit. And it was this correlation of Cartesianism and natural order that the avant-garde set out to undermine, by equating natural order with the theory of organic and intuitive order Bergson had developed to critique Cartesianism. Moreover, the Cubists' equation of organic and aesthetic order, to the detriment of a rational order labeled mechanistic, had its roots in the romantic tradition Maurras and his colleagues wished to refute.[11]

The response to Bergson within the Action française can be seen in the writings of Charles Maurras and four of his followers: Pierre Lasserre, Jean-Marc Bernard, Gilbert Maire, and Henri Clouard. Lasserre and Bernard shared Maurras's opposition to Bergsonism in all its forms; Maire and Clouard, writers for the Action française journal *Revue critique des idées et des livres*, were opposed to the Bergsonism of Cubo-Symbolist circles, but remained sympathetic to the Bergsonism of Sorel. In fact, Maurras's and Lasserre's attack on Bergson caused Maire and Clouard to break with the movement in February 1914. Significantly this debate was given an airing in such Cubist oriented journals as *L'Art libre* and *Montjoie!*, thereby confirming the avant-garde's cognizance of Bergson's volatile effect on the monarchist movement.[12]

In a book titled *The Bergsonian Controversy in France*, Robert C. Grogin has made the first attempt to examine the critique of Bergson on the part of the Action française and to reveal the divisions within the movement that occurred as a result.[13] Focusing primarily on the criticism of Léon Daudet, Charles Maurras, and Pierre Lasserre, he notes their shared contempt for Bergsonism as exemplary of the "nineteenth century romantic ideal" they wished to combat. Lasserre, whose *Romantisme française* (1907) had codified the movement's attack on romanticism, set out to apply the thesis of that volume in a series of lectures devoted to Bergson, held at the

Institut d'Action française over the winter of 1910–11. In a later interview Lasserre summarized his attack on Bergson in the following manner:

> [The Bergsonians] contest our assertion that there are such things as necessary laws governing societies, and more particularly that these laws can be discovered from past history. It is useless, they say, to search in the past for general truths which shall be applicable to the present. . . . If we ask why, we are told that Bergson has now proved that Time is real, that every moment is a unique one, and paralleled by nothing in the past. . . . If we point out that history does or does not show us any prosperous, strong and conquering nation, which was at the same time a democracy, they retort, history would not be history if it were not change itself and perpetual novelty.[14]

Lasserre's refutation of this Bergsonian threat was deemed important enough to warrant publication in the March 1911 issue of *Action française*.[15] In that article Lasserre went into some detail in defining just who the Bergsonians were and how the Action française should counter them. But to begin with he outlined the movement's theory of royalist corporatism, which he considered antithetical to the "democratic and liberal institutions issuing from the French Revolution."[16] To replace democracy, Lasserre advocated "decentralized monarchy," a monarchy recognizing "the autonomy of natural social groups (regions and crafts) and leaving to them the administration of interests which are proper to them." Such natural groupings, however, would be subject to the control of the monarchy itself, since it alone constitutes "the organ of the general interest of the nation" and is able to define "the Common good of the State."[17] In effect, labor organizations (craft guilds), or racially definable regional groups are the decentralized social organisms which would voluntarily subject themselves to monarchical authority, the body of the nation. Or as the monarchist Firmin Bacconnier put it in 1909: "A monarchy can be said to be corporative when the state is master and sovereign in general matters and the corporations are supreme, under state control, in purely local, corporative matters."[18] In contrast to the syndicalists, who limited corporatism to the syndicate itself, the Action française subsumed such organisms within the "body" of the state.[19] On this basis Lasserre felt obliged to criticize members of the "school of Sorel" who, in exalting the intuitive collective of the syndicate, "exclude from their social plans an element without which any government would be unable to exist: political government." Their Bergsonism, therefore, leads to anarchy since it lacks the monarchical authority upon which the

good of the state can be maintained. Lasserre's condemnation of Sorel on the basis of corporatism reiterated the views of Maurras himself, who also sought to subsume class interests within Bacconnier's corporate structure.[20]

Lasserre then goes on to describe the "natural and necessary relations" corporative monarchy upholds as reflecting the "intellectual discipline" of "laws which express what we know in the political and social order of relations, of connections, and necessary determinations."[21] Having dismissed any political system that values the individual over the state, Lasserre justifies monarchical corporatism on the basis of the "rationality" of such laws. Although quick to separate the laws of society from those found in the sciences, he nevertheless concludes that both systems produce "intellectual results."[22]

The laws governing human nature are equated with reason, and just as democracy departs from these laws to produce anarchic individualism, romanticism, its literary equivalent, leads to the "egoism of the individual."[23] Rather than derive their themes from nature, as the classicists did, the romantics take the self alone as their subject, a self divorced from nature's beauty, and mired in its own lurid imagination. As a result, "reason will be offended," and our "moral nature" distorted.[24] Since a conception of beauty "excludes the absurd," and beauty is derived from the study of natural laws operative in the universal order, an art of beauty, rather than egotism, is eminently reasonable.[25] Thus for the classicists, "observation of the truth, study of nature have always been the fundamental rule." Classicism also recognizes the "nature of mankind itself" and the "ties which attach the individual to the family, to the profession, to the land of birth, to the common nation." In opposition to absurd, anarchic individualism, classicism recognizes the natural laws governing humanity, a posteriori laws discovered through induction. Romanticism, by contrast, is "divorced from nature and reason."[26]

Romanticism's philosophical bedfellow, Lasserre asserts, is Bergsonism, a philosophy "profoundly hostile to [the L'Action française's] discipline," and a doctrine that values "sentiment" and "intuition" over "experience" and "reason," i.e., inductive reason.[27] Bergsonism is a form of "pantheism" Lasserre further defines as "German pantheistic evolutionism."[28] This attack on Bergson's philosophy as foreign to the French spirit was shared by other monarchists outside the orbit of the *Revue critique*. Jacques Rocafort, for example, dismissed Bergsonism by declaring France to be "an intellectual country, reasoning and reasonable," while Maurras himself

declared Bergsonism a "metaphysics of instinct and *Creative Evolution*" that aimed at the "systematic degradation of the power of intelligence."[29] Appeal to the intellect, Lasserre tells us, does not rule out the function of sentiment and imagination in creativity, but serves to subject both to nature's laws and the laws of society. Without reason, anarchy reigns in art as it does in politics, hence this general rule: "political reform implies a general intellectual reform" in all areas of human endeavor.[30]

Before Bergson's rise to fame, the "naturalism" of such rational methods remained unquestioned, but under the sway of Bergson, "the intellectual aspect" of the monarchist platform is declared "vacuous, like all logic," by Lasserre's adversaries.[31] And in the hands of Bergson's followers, the Action française's logical analysis of history is said to deny the heterogeneous nature of historical time. Lasserre and his colleagues hope to draw political conclusions from the past, but they are rebuked by Bergsonists who declare that "there is no common measure between the after and before" because history is "change itself and perpetual novelty."[32] To try to predict the future on the basis of a retrospective view of historical events is to impose a deterministic and finalistic criterion on the creative evolution of human time. "To what we judge and pronounce in the name of reasoned interpretation of experience," Lasserre states, "the Bergsonians oppose what they call 'life' "; that is, "the unforeseeable and incalculable absolute," which transcends any retrospective view on "accomplished things," and the "logical chain, connections of cause to effect" that the intellect introduces when it "decomposes" time.[33] Thus what the Action française calls "organization"[34]—the establishment of deterministic laws of causality on the basis of historical events—ignores the relation of such events to time's heterogeneous nature. Lasserre cites the case of Capetian France: to his mind, the "constant effect" of Capetian monarchy was French hegemony; therefore if this effect is to be repeated, the cause, monarchy, must be reinstituted. "Illusion say the Bergsonians. Ancient France is magnificent in effect, but a unique type, on which you could reason and found some theories after the fact, but which . . . surpasses all your calculations."[35] Lasserre's inductive reasoning is thus transcended by a heterogeneous time that belies reason's cause and effect relations. Bergson's argument, therefore, boils down to "a metaphysical justification of the refusal to think."[36]

In a final gesture of anti-Bergsonism, Lasserre attacks Gustave Lanson, a noted literary historian who taught at the Sorbonne. The "republican" Lanson had been instrumental in introducing educa-

tional reforms the Action française regarded as leading to the moral decline of France,[37] and Lasserre saw Lanson's praise of the romantics as proof of the irrational basis of his criticism. Moreover Lanson had reportedly fallen under the spell of Bergson: without noting his source, Lasserre cites Lanson's conviction that all literature "seeks to express the profound self," another term, Lasserre states, for Bergson's notion of the "fundamental self." Since this self is free of logical constraints, Lasserre sardonically concludes that it is also free of "that which distinguishes human personality from the animal."[38]

For the most part, Lasserre was content to place Bergsonism in the philosophical context of romanticism; it was left to Jean-Marc Bernard to extend his critique to an analysis of the neo-Symbolist movement. Bernard, who had previously written diatribes against Mallarmé, Mallarmé's neo-Symbolist disciple, Jean Royère, the Unanimists, Guillaume Apollinaire, and René Ghil, published his "Discours sur le symbolisme" in the May 1910 edition of *Les Guêpes*, a magazine to which Henri Clouard contributed.[39] Noting that his "Discours" could have been titled "Discourse on Romanticism," he claimed that the Symbolists mimicked their ancestors' "contempt for all established rules," followed instinct and taste when constructing poetry, and therefore fell prey to the "terrible individualist current" that "blew in with the Revolution." Appropriately, Bernard describes the choice between Maurrasian classicism and "romantico-symbolism" as one between "discipline and absence of discipline, order and anarchy." Bernard's essay leaves little doubt as to his choice: monarchism is the cause, discipline and order the effect. He concludes his essay with "the axiom of the Action française: Politics First!"[40]

In Bernard's essay the neo-Symbolist Tancrède de Visan's Bergsonian theory of introspective intuition is subjected to a scathing attack, all the more zealous because both Bernard and Clouard regarded Visan as a monarchist who had strayed from the fold. While I cannot outline Visan's complex political beliefs here, it is sufficient to note that he remained a fervent Catholic and royalist throughout his life, despite his ambivalent relationship to the Action française and attachment to the less orthodox Puteaux Cubists. Visan even published two articles in *Les Guêpes*, attacking the Catholic Modernist movement for importing the spirit of Germanic Protestantism into France.[41] However, in the April 1909 edition of the journal, Clouard cited Visan's *Lettres à l'élue* (1908) as evidence of his "fear of the spirit of reason" and attempts to "free himself from our neoclassicism."[42] Bernard's "Discours" of 1910 declared that freedom complete, and aside from his essays on Catholic Mod-

ernism, Visan's writings never again appeared in the journal. Adding insult to injury, Bernard mocked the release of Visan's Bergsonian apologia *L'Attitude du lyrisme contemporain* (1911) by advertising the book in High German script, with a notice of its impending translation "from the German."[43] In an oblique reference, in his "Discours sur le symbolisme," to both Visan and Sorel, Bernard stated: "It is curious to see Monarchists avow themselves symbolists, as it is odd to hear anarchists proclaim principles of order and hierarchy as soon as it is a matter of literature!"[44] Clearly, in 1910, Bernard was hostile to Bergsonism in all of its guises, including its antidemocratic variations.

According to Bernard, Visan had embraced intuition in an attempt to express his whole self; but the whole self, Bernard states, includes the bad as well as the good, and thus "forbids us from choosing and forces us to get rid of all the established rules."[45] Hence the anarchical nature of Symbolism, which has as many rules as it does authors, all of whom are "directed by their temperament alone" in a tumult of "disordered subjectivity."[46] Bernard also bolstered Lasserre's association of Bergsonism with German pantheism by correlating that doctrine with Visan's claim to grasp nature absolutely by means of intuition. This "subjective lyricism," this "continual aspiration to merge with the all," is a "sort of pantheism, or better Hegelianism" that makes "the soul the center of the all." "We do not reproach M. de Visan these metaphysical preoccupations," Bernard states, "we simply remark that this soul the Symbolist poets identify with nature, is not that of nature, it is theirs."[47] Literature should not be a "spontaneous product of the spirit," but instead a manifestation of "social order." Social order takes the form of laws of nature and literary form, "superior to the individual," that "our classicists" have followed.[48] The emotional equivalent to "intuitive poetry" is "sincerity," but "sincerity is not poetry, because sincerity equals spontaneity, and poetry composition." Such compositional laws, Bernard asserts, were the common measure for writers of France's classical age, the seventeenth century. And far from inhibiting personal expression, these laws served to check unbridled instinct, so that only the best qualities in a writer were developed. If the Symbolists had followed classicism's rules they would recognize the rational character of nature's laws, as well as those that should govern their anarchic temperaments.[49]

In sum, the main theme permeating the writings of Lasserre and Bernard is the contrast of rational order with intuitive disorder. Bergsonian intuition, we are told, leads to the disorder of excessive individualism, in which individuals are divorced from the bonds of

family, profession, and nation. The Action française counters this social anarchy with a royalist model of government. This governmental model is derived from the lessons of history, analyzed in terms of rational cause and effect relations. In the Action française's estimation, logic and reason are modes of cognition, equivalent to the methods used in the sciences to establish laws of nature. What the a posteriori laws of human society reveal is the rational basis on which a corporate monarchy could be founded.

When confronted with Sorel's notion of class corporatism or Visan's doctrine of intersubjectivity, the responses of members of the Action française were twofold. Lasserre admonished Sorel for failing to place his corporative entity under the power of the state, and rejected the intuitive basis upon which this supposed corporatism was founded. Social relations should be established on the basis of rational laws and royal authority. In Lasserre's world view, Bergsonian intuition has nothing to do with laws of social relations. Intuition is wholly self-referential; thus Lanson's Bergsonian version of romanticism exalts individual expression to the detriment of reasoned restraint and social responsibility. In essence, intuition is a totally negative term, standing for the absence of reason or even of the ability to think.

Bernard applies a similar thesis to Symbolism and elaborates upon it in his critique of Visan's theory of intuitive intersubjectivity as it was expounded in his "Essai sur le Symbolisme," published in Visan's early book, *Paysages introspectifs* (1904). Since Visan followed Bergson in condemning logic and promoting intuition as the only means of achieving the kind of corporative harmony with nature and humankind the Action française valued, it was crucial to reply to Visan's claims. Bernard's solution in this regard is simple: intuition is not a cognitive faculty like reason, but a pretext for self-expression. Any assertion to the contrary, whether it takes the form of a doctrine of intersubjectivity or a pantheistic merger with the spirit of life, is a form of self-delusion.

But the challenge that remained unanswered was the Bergsonian critique of the historical record. The Action française based their political agenda upon a deterministic model of historical development that the Bergsonians had declared untenable. And when the neo-Symbolists responded to Bernard and Lasserre, they used this Bergsonian paradigm to counter the Action française's historical justification of classicism as the product of monarchical order.

Once again Visan's writings are the touchstone to such criticism, for he was the first Symbolist to respond in print to Bernard's article in *Les Guêpes*. Visan's rebuttal, titled "La Philosophie de M. Berg-

son et le lyrisme contemporain," was published in the June issue of *Vers et prose*, one month after Bernard's polemic.[50] In the next chapter I shall analyze this article's summation of the central theses of Bergson's theory of art; what I would like to stress here is Visan's linkage of Bergsonism to a dismissal of the literary and philosophical tradition the Action française sought to uphold. The aim of his article was to show "those who consider symbolism to be an anarchist mentality, without cohesion and deprived of roots, that the substance of this lyrical doctrine is contained in *Time and Free Will*, and that on two parallel planes, the aesthetic plane and the speculative plane, we rediscover the same intellectual orientation."[51] That Symbolism was an anarchical art form, untethered to anything beyond self-aggrandizement, was just the criticism leveled against the movement by the Action française. But Visan turns the correlation of Bergsonism with Symbolism into a virtue, by describing both as the product of the *historical zeitgeist*, grounded in a *collective* mentality. Moreover, where Lasserre points to Lanson's notion of the "profound self" as an example of exaggerated individualism, Visan cites the same author in his formulation of a theory of Symbolism's historical development. Drawing upon Lanson's comparison of Corneille's aesthetic and Cartesianism, Visan concludes that each era possesses an intensive or extensive "direction," an orientation manifest in the "spiritual activity" of the period.[52] Since poetry and philosophy are two activities of this type, he holds that there should be a "similitude of speculative and lyrical ends" uniting these fields of endeavour. However, he is quick to add that such parallels do not follow any "law of psychological determinism"— there is no law of cause and effect that says poetry precedes philosophy or vice versa as a manifestation of such ends. Indeed the spirit of the early twentieth century resides in a rejection of "the associationist, determinist and intellectualist theses."[53] According to Visan's criteria, the Action française's notion of historical and psychological determinism would clearly be out of step with the times.

Moreover, "it is necessary to go back to Descartes, the father of modern intellectualism" to find the source of such theses. Cartesianism in turn was matched by "the aesthetic of the seventeenth century" whose ideal was "the ideal of clear ideas."[54] As the embodiment of this ideal, Visan holds up Racine—the very figure Lasserre and Bernard single out as exemplary of Cartesianism in their texts. In Visan's literary history, Racine's poetic doctrine is slighted for producing a "static and purely formal art" based on "general and

abstract ideas." What Racine's and Descartes's formulations ignored were "all the particular sentiments, profound passions, the soul of life, these live sources of lyricism." Under the banner of "clear ideas," "quantity" was introduced "into consciousness." "An ensemble of qualities" and "the dynamism of life" were replaced by "the mechanism of the discontinuous concept."[55] Such an approach, Visan states, kills poetry and substitutes "oratory art or didactic poetry" for the poetry of lyrical inspiration. "To push away these interior *élans*," what Visan identifies as the source of lyricism, "is to deprive poetry of all originality."[56] Intuitive originality has its poetic corollary in pantheism. Referring to his "Essai sur le Symbolisme"—the very text Bernard had so vehemently attacked—Visan describes the Symbolists as attempting "to establish an interior lyricism, and, by a sort of *organizing pantheism*, by placing themselves in the interior of things, to give us a *central vision* of objects known by virtue of states of the soul."[57] Here as elsewhere in Visan's criticism, central vision makes us aware of "the modulations of our consciousness, and the vibrations of our self" as "a portion of nature penetrates into our consciousness." Far from being formless or the product of self-absorption, Symbolist poetry is the product of the soul's vibration in its harmonic convergence with life.[58] In short, Visan's organizing pantheism is the inner or vital order Bergson had pitted against Cartesian or geometric order.[59] For the mimetic "clarity" of Cartesianism, Visan substituted the spiritual luminosity of "central vision."

It was Joseph Billiet who wedded this vital order to a new definition of classicism and introduced it into Cubist circles. The doctrine was formulated in an essay for the Summer 1911 edition of *L'Art libre*, which had published a pro-Visan review of Bernard's "Discours sur le symbolisme" that winter.[60] Moreover, Billiet made his own allegiances explicit by following his classicism article with a laudatory review of Visan's *L'Attitude du lyrisme contemporain*, in which he correlated his ideas on classicism to Visan's on Bergson.[61] In Billiet's opinion, Visan's book proved that the Symbolists had created a "renaissance" born of "an intuitive idealism which marked the end of the nineteenth century, a renaissance whose trajectory was still not finished." Aside from reviving "the lyricism killed by the rationalist reaction of the seventeenth century, buried under the verbal jumble of eighteenth century reasoning," Visan's book made clear which literary tradition "has a chance of building up to a living classicism."[62] Obviously, this "living classicism" was not the reasoned classicism the Action française advocated. And it

is probable that Gleizes was familiar with both types of classicism, since Billiet endorsed Allard's Bergsonian art theories in *L'Art libre* and had previously commissioned Gleizes to do a frontispiece for a volume of his poetry.[63]

Billiet's discussion of classicism was contained in the concluding summary of a survey of writers' statements on whether a classical renaissance in modern literature was in the offing. As the organizer of the Enquête, Billiet framed the survey with an introduction and conclusion,[64] in which he held forth with his own opinions. He posited a conception of classicism oriented to the future rather than to the past—his question was how a work "will *become* classical."[65] Determination of a work's classical value should not be measured in terms of imitation of past styles or methods; rather our place in the literary tradition is a function of the "novelty that we are able to bring to it." Since the individuals we now refer to as classical were the innovators of their day, we should not fall into "a sterile imitation of the seventeenth century . . . under the pretext that Corneille and Racine came before us."[66] In defining what one should avoid, Billiet points to those writers whose methods the Action française would have us imitate. Thus he highlights the difference between himself and Bernard by describing the latter's notion of classical imitation as innately flawed; it denies the true basis of the classical in the novel.[67]

Creative novelty allows a writer to come into direct contact with durée as a force in the human species. "Human beings," Billiet declares, "are one of the means of manifestation of nature and our value depends on our aptitude to contain and transmit the natural forces not by quantitative science, erudite and inactive, but by qualitative knowledge (co-naissance), evolutional, tied into duration."[68] Qualitative, rather than quantitative, knowledge gives us insight into the natural order. If art is to become classical it should be established "on the solid compost of the epoch, deeply rooted in the life of the times." As a result "it will be rich with universal sap and will spread its tense branches of youthful force towards the absolute."[69] Like Bergson himself, Billiet employs organic metaphors to make artistic creation synonymous with creative evolution, and the evolution of culture in general. To his mind intuitive creativity will spawn "a new barbarism," a literary art form born of "a new palpitation of total life."[70] The relation of Billiet's notion of art to Visan's organizing pantheism is self evident, for in both cases poetic form should manifest the creative evolution of society. Furthermore, by contrasting "qualitative knowledge" with "quantitative science,"

he follows Visan in declaring the latter methodology antithetical to the natural order. And the relation of this paradigm to the literary debates of the day is made plain in the following passage:

> The sensualist contribution of Symbolism's reaction against the methodological intellectualism of naturalism seems analogous to me to the situation in the sixteenth century when the Greek influence fertilizing our Celtic qualities was threatened by the abuse of Latin logic and Anglo-Saxon metaphysics from the bastard Middle Ages.[71]

Billiet counters the Action française by incorporating their phraseology into a Bergsonian paradigm antithetical to Maurras's own principles. He divorces the term "classicism" from the "Latin logic" advocated by the Action française while simultaneously usurping their support of Greek culture, albeit in the guise of supplementary cultural "fertilization." And most important, the sense of rational order and collectivity that the Action française associated with classicism is absorbed into an order of an intuitive and vitalistic nature. The novelty of individual expression—what Bernard and Lasserre would call romantic anarchy—now stands for the novel characteristics of an era. In the process, individual creativity as Bergson understands it becomes creativity writ large, the creativity springing from France's "Celtic qualities." By identifying Greek and Latin culture as foreign influences fertilizing or retarding French cultural development, Billiet cleverly legitimizes Celtism as the true source for Symbolism's "sensualist idealism," an idealism "supplying by its sense of universal life, of interior vision, the elements of a synthesis that we must realize."[72] Intuitive vision allows the Symbolist to grasp the inner structure of France's Celtic qualities. Greco-Latin culture as the Action française understood it is foreign to the qualitative nature of the French nation or the élan of its evolutional, organic development.

Billiet extended his findings to the pictorial domain in his December review of the Lyons Autumn Salon.[73] The theories expounded there echo a text seminal to the formation of the Cubist movement: Roger Allard's review of the 1910 Salon d'Automne, published in the November 1910 issue of *L'Art libre*.[74] In that essay Allard praised the work of Gleizes, Metzinger, and Le Fauconnier for signaling a new departure in art, the tenets of which he outlined in his two-page article. That Allard's essay precipitated the artists' own awareness of their aesthetic affinities is a widely acknowledged fact;[75] what has hitherto gone unnoticed is the theoretical relation Allard's article had to Billiet's discussion of the Salon d'Automne de

Lyon, published a month later in the same journal. Indeed, a note appended to Allard's seminal text indicates that Billiet originally intended to publish the two articles together.[76] Instead, Billiet's Salon review appeared in *L'Art libre*'s December issue, in tandem with René Vachia's praise of Visan's "La Philosophie de M. Bergson et le lyrisme contemporain" for establishing "the proper relation which exists between contemporary lyricism and the philosophy of Bergson."[77] Taken together, the art criticism of Billiet and Allard attempts to do for Cubism what Visan had done for Symbolism: forge a relation between Bergsonism and a contemporary art form.

Billiet's article is devoted to those artists he regards as "diligent intermediaries" preceding the innovators discussed in Allard's article.[78] According to Billiet, both groups are part of an aesthetic renewal whose primary tenets betray their Bergsonian origins. Thus Billiet contrasts the visually oriented and psychologically shallow art of Impressionism with that of the "intermédiaires" who are able to plumb the depths of their souls by means of intuition. Impressionism created an "exterior" art form conducive to "a joyous, but deceiving satisfaction with visual sensuality." As a result its practitioners had "the misfortune of not knowing how to extend emotion into depth."[79] Billiet sets his condemnation of Impressionism in opposition to those artists who call for a "recasting of canons . . . far from the procedures of the *école* and Impressionist fantasies."[80] The latter base their art on "culture forte" and a "consensus as to the synthetic fate of art. Roger Allard in this very journal saluted the researches of the rational reformers."[81] These artists divorce themselves from "visual sensuality" to embrace a doctrine of sensual idealism identified, as in his article on classicism, with emotional profundity and intuitive insight. In short, Billiet transforms Visan's *vision centrale* paradigm into an apologia for the Cubism of Gleizes, Metzinger and Le Fauconnier.

That these "rational reformers" are practitioners of what Bergson called the "logic of the imagination" is made clear by Billiet's subsequent statements. To his mind the artists Allard supported, along with a select group of precursors, had followed a particular "spiritual orientation . . . towards a renewal of idealism." They are artists "who interpret a vision, long elaborated in the interior crucible, according to an intuitive conception . . . of a desire (volonté)."[82] As a result artists such as Moïse Arnaud reject "a posteriori and theoretical" techniques to express "a temperament inaccessible by its natural activity to the preoccupations of the École."[83] A posteriori methods, whether advocated by the Action française or the École, are unrelated to the natural order. Artists of the École des beaux-arts are

preoccupied with pre-conceived form based on general laws whereas the form Billiet promotes should be as novel as the time taken to create it. It is part and parcel of the natural activity of creative evolution that is the true source of France's "culture forte." Novel form is constructed in response to "ardent enthusiasm" and "the sincerity of interior research."[84] Like other Bergsonians, Billiet associates intuition with depth of feeling: Berthe Morisot's "idealism," for instance, allows her to transcend Impressionism, to become "a subtle and grave poet" of the landscape, one for whom "no improper emotion comes to trouble plastic feelings."[85] Whereas Morisot's achievement in this regard is only "fortuitous, in any case, incomplete," artists such as Pourchet or Combet-Descombes are said to have consciously developed their intuitive sincerity. "Lofty sobriety," "grave," and "strongly expressive" are among the phrases Billiet associates with their "plastic feelings." In terms of subject matter, such phraseology brings to mind the anthropomorphized landscapes Combet-Descombes was producing at this time.[86]

On a formal level, Billiet's terminology resonates with pre-Cubist works such as Gleizes's *Paysage* (fig. 2) reproduced in the January 1910 edition of *L'Art libre* or his Cubist *Woman with Phlox* (1910–1911) (plate 1) which he exhibited the following year at the Salon des Indépendants. "Interior research" had led Gleizes's contemporaries to a "renewal of linear technique" and the creation of "plexual" form, that is, an integration of a painting's elements into a structurally synthetic system.[87] The "gravity" of intuitive emotion caused them to subordinate color to form; similarly a turn to "visual deformation" reminiscent of Cézanne "builds to a synthetic crystalization, somber, far from Impressionism." The result is a "quasi-Mallarméan" art form, the "most severe technique, most logical in terms of the plastic requirements of the conception."[88] "Had there ever been an art more concerned with discipline, more 'classical,' than that of Mallarmé?"—such was Vachia's response to Bernard's correlation of intuition with disorder in the same journal.[89] That Mallarméan logic stood for Bergsonian order in Vachia's and Billiet's texts underscores the allegiance of both authors to Visan's conception of an intuitive zeitgeist animating the various arts of the day.

Thus "the sense of the melodic value of lines and tones" in painting "characterize[s] a research that surpasses the immediate sensation."[90] As a result, "line, the symbolic expression most purified, and equilibrium: architecture, synthesis, harmony" meld "into a complex unity of linear symbols."[91] As in Bergson's theory, melody, harmony, and synthesis constitute the deep structures compatible

2. Albert Gleizes, *Paysage*

with the logic of the imagination. And in Billiet's estimation, such structures are the collective, creative legacy of an artistic generation. The "recasting of canons,"[92] that is, of the aesthetic values just mentioned, occurs in the crucible of intuitive consciousness. Through "volonté" this aesthetic heritage will again be transformed into "plexual" forms of personal expression, equally indicative of the character of an era.

Billiet ends his article by praising the modern movement for avoiding a "bastard classicism" and returning to "the continuity of the Occidental tradition called Gothic, to a renaissance, in our flesh and our heart, of our idealism."[93] The bastard classicism referred to is undoubtedly Maurras's Greco-Roman variant. Based on a servile imitation of seventeenth-century aesthetic forms he deems rational, Maurras's classicism does not renew France's cultural legacy in the intuitive crucible of individual creativity. By relating his idealist renaissance to Gothic art Billiet not only underscores the Celtic origins of Cubism's 'living classicism', but identifies Greco-Roman influences as exterior to the nation's "natural" growth patterns. In short, his art criticism forges the key link connecting an

anti-monarchist, Bergsonian vocabulary to the art of Gleizes and his colleagues.

Indeed, Allard's discussion of those artists in "Au Salon d'Automne de Paris" takes up many of the themes Billiet was to elucidate a month later. Billiet's "Au Salon d'Automne de Lyon" called for an adaptation of the plastic canon to the heterogeneous nature of artistic creativity. In this manner, canonic elements would be made "plexual," fully conducive to the "melodic" structure of durée. "Sincerity" or "sobriety," the deep emotions fundamental to the intuitive, idealist state of mind, could again find expression in works of art. Since such emotions and deep structures were antithetical to Impressionism, intuitive artists turned away from the "visual sensuality" of colour to emphasize form and line, in an attempt to give their paintings "architecture." "Equilibrium," "synthesis," "harmony," and "melody" were the time-honored terms that Billiet associated with the new art. The recasting of these canonical but "natural" elements in the crucible of novel creation would, with time, be declared classical, as an embodiment of what was unique not only to the artist, but to the era.

Allard's "Au Salon d'Automne" iterates all these concerns. Cubism, according to Allard, will "free genius to dilate tradition in the direction of the future classicism."[94] Like Billiet, Allard defines classicism as a future possibility, premised, he states, on "the blossoming of an eternal canon in a transitory but imperious form."[95] The art of a given period is simultaneously part and parcel of the changing nature of the artist's soul and the soul of the society he or she is a part of. The aesthetic heritage of such activity embodies the élan of the nation—it captures what is "enduring" or "imperious" in the duration of each new generation. Only "a sincere artist" can create it, and, as in Billiet's criticism, recourse to this deep emotion constitutes "a cure of sobriety" after the "Impressionist débauche."[96] That Impressionism grasps surface appearances rather than psychological depths is made clear from Allard's appraisal of Metzinger's *Nude* (fig. 3): "Thus is born at the antipodes of Impressionism an art that, with little concern for copying some incidental cosmic episode, offers to the viewers' intelligence, the elements of a synthesis situated in durée."[97] Since Cubist works express an artist's sincerity, we can be sure that the durée in which these elements are synthesized is that of the artist, "dilated" in the direction of a future classicism. Billiet had lauded "interior vision" as a psychological mechanism able to provide us with "the elements of a synthesis we must realize";[98] Allard simply applies that terminology to a beholder's response to a work of art.

The "elements of a synthesis" alluded to are usually identified with the multiple views found in Metzinger's *Nude*,[99] when in fact this reference to the painting's structure should be understood in a broader sense. In Billiet's essay the "synthetic elements" are those of a newly plexual canon—the venerable traits of equilibrium, tone, form and line, all adapted to the melodic structure of inner duration. Allard asserts that Metzinger, Le Fauconnier, and Gleizes also hope to create "integral" canvases through "the restoration of a plastic canon." And in keeping with the paradigm Billiet advocated, Allard identifies the integral aspect of a canvas with duration's deep structures. "Equilibrium" in Le Fauconnier's *Ploumanach* is "the result of an accord, rich in harmonious dissonances, of colors integrated to volumes."[100] Equilibrium is the extensive manifestation of the harmonious dissonance of integral, intensive order.

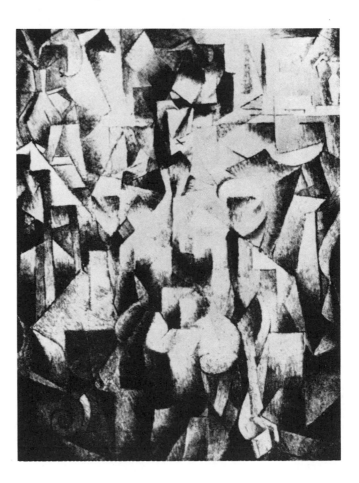

3. Jean
Metzinger,
Nude, 1910

Jean Metzinger voiced similar concerns in his "Note on Painting," published in the October 1910 edition of *Pan*. In keeping with the Bergsonian rebuttal of royalist classicism, Metzinger rejected "the stability of any system, even one called classical," which did not subject artistic form to "intuition." The Cubist "organizes" a picture's elements into "the sensible and living equivalent of an idea," with the result that "the total image radiates in time [la durée]." By infusing duration into pictorial form, Metzinger claimed to encompass the work in a "dynamic process" that converted the painting into an organic structure. A year later Metzinger repeated this assertion, adding that the composition in Léger's *Nudes in a Forest* (1909–1911) "is a living body whose trees and figures are the organs."[101]

In sum, the Action française's adversaries deployed three interrelated themes in their effort to counteract the monarchists' political and aesthetic agenda. To begin with, they dismissed the monarchists' synthesis of Cartesianism with the "natural" order of society by critiquing the logical basis on which Cartesian order was premised. The Action française's retrospective "decomposition" of social evolution distorted rather than mirrored the natural order, an order synonymous with creative evolution as Bergson understood it. By privileging intuitive order as more natural than forms of order modeled after the intellect, Visan, Billiet, and Allard appropriated the powerful ideological claim to be natural for the Bergsonian camp.

Bergson's Symbolist supporters then link the Action française's penchant for "clear ideas"—*les lumières de la raison*—with their interpretation of Impressionism's ocular and utilitarian biases. Both movements, we are told, fail to penetrate reality and capture the internal structure of duration, and unwittingly intellectualize reality as a result. In the case of the Impressionists it is the inner nature and structure of reality that is lost from view. Impressionism lacks the formal elements Billiet and Allard identify as indicative of this inner structure. Similarly, the Action française misses what is living in classical form because of their intellectual interpretation of its elements. In fact, classical form properly understood is the aesthetic legacy of an intuitive rather than reasoned response to reality; it constitutes the inner structure that Impressionism had failed to grasp. A classical canon embodies the inner dynamism of the culture that produced it, but to recapture this dynamic element does not necessitate imitation of its outward manifestations. Instead the creation of a living classicism calls for a return to classical form's durational origins. The canon must be subjected to intuition in order to return it to its dynamic or plexual state. Specular reason is

thus relegated to the realm of the utilitarian and intellectual, while the mystical light of intuition is privileged as the sole analogue for creative freedom. This recasting of the canon infuses the letter with the spirit of the age as well as that of the artist.

Thus the spirit of an age can never be logically discerned or expressed, nor can the national élan be called logical. France's élan may occasionally be extensively directed, as it was in the French seventeenth century, but this is a deviation from its evolutional development. Or if a particular cultural trait is deemed to be logical by nature, it can simply be dismissed as foreign to the intuitive character of the French people. To paraphrase Billiet, the Action française may declare the French spirit rational, but the Greco-Roman culture that spirit is identified with betrays its foreign origin. The introduction of Greek culture into France plays a supplementary role at best; at worst the imposition of Latin logic on French culture is comparable to grafting an aberrant stock onto an otherwise healthy plant. French culture at its roots is intuitive, idealistic, and Celtic.

While Billiet limited his appropriation of the Action française's agenda to classicism and Greek culture, Gleizes, Metzinger, and Le Fauconnier were to go further by claiming that intuitive order had its cultural corollary in Greco-Roman and seventeenth-century art forms.[102] In effect they concurred with Billiet on a Bergsonian notion of classicism, but followed Allard in his later attempt to synthesize his Bergsonism with the Greco-Roman terminology lauded by the Action française. Significantly, Allard's explorations in this arena do not appear in Billict's *L'Art libre*, but in a June 1911 essay published in *Les Marches du Sud Ouest*, and an article titled "Les Beaux Arts," which appeared in the August 1911 edition of *La Revue indépendante*.[103] David Cottington has provided us with an admirable summation of that criticism, its Bergsonian agenda, and its implications with regard to the art of Gleizes and Le Fauconnier before the fall of 1911.[104] According to Cottington there is a tension in Allard's criticism between an interest in "simultaneity," the "qualities of dislocation and dynamism that [concept] conveyed," and "the principles of stasis and order on which Allard's classicism was founded."[105] In Bergsonian terms, that tension led to an attempt to "reconcile the burgeoning interest of the Cubists in the dynamic implication of both Bergsonian philosophy and modern life with the imperatives of the classical tradition."[106] "Qualities of simplicity, completeness and logic," Cottington states, were praised by Allard, Metzinger, and Gleizes, along with the usage of multiple views to indicate durée.[107] On the formal level that reconciliation produced

the concept of "dynamic equilibrium," a concept that informs Allard's, Le Fauconnier's, and Gleizes's favorable view of Poussin and the French art of the seventeenth century.[108] By infusing dynamism into canonical form, that form could be revised in light of the dynamic, fluctuant qualities of temporal experience and modern culture.

This establishment of a historical genealogy for Cubism is related by Cottington to a conception of durational continuity in the criticism of Allard. He then notes the close resemblance of Allard's views to those of Adrien Mithouard, whose notion of classicism focused on "the awareness of all that binds one to a particular and continuous history," that history including France's Gothic and Celtic heritage in Mithouard's case. Although Allard did not take up the Gothic element in Mithouard's formulation, Cottington maintains that the notion of historical continuity Mithouard expounded found its way into Cubist circles, primarily through the critical vocabulary found in *L'Occident* or *La Nouvelle Revue Française*.[109] And as Cottington has convincingly shown, Bergson's conception of temporal continuity was evoked with reference to that paradigm, a paradigm which, in his view, allowed Allard to reconcile Bergsonian dynamism with the conservative cultural principles upheld by Maurras and his followers.[110]

But having been made aware of the role of Bergsonism in a debate between the *Art libre* circle and the supporters of Cartesianism, we can now see Cubism's classicism as part of an aggressive campaign to consciously undermine the theoretical framework in which Maurras's cultural views were couched. If we consider Allard's cultural program in light of Visan's and Billiet's strategic maneuvers, it becomes clear that his notion of internal, intuitive order stands in stark opposition to classical order as Maurras understood it. Moreover, we should see a Bergsonian critic's identification of French culture as Celtic or Greco-Roman, Gothic or Poussinesque, as indicative of a given degree of conservatism relative to the anti-Maurrasian agenda entailed by any Bergsonian dialogue. That Allard, Gleizes, and Metzinger all endorsed Greco-Roman culture before 1912 indicates their appropriation of the Bergsonian rhetoric of royalists like Maire and Clouard, who as we shall see rejected the Bergsonism of the avant-garde. Similarly, the gradual disappearance of Greco-Roman references in the criticism of these artists after the fall of 1911 suggests a move away from this ideological position. Indeed when Gleizes and Metzinger joined forces the following year in writing *Du Cubisme*, they pointedly excluded all references to clas-

sicism or Greco-Roman culture from that text, a striking departure from their earlier writings. And, as we shall see, that essay announces their wholesale embrace of the Bergsonian tenets of their neo-Symbolist allies. What I would like to do now is to consider that affiliation in more detail in order to chart the Puteaux Cubists' development of a Bergsonian aesthetic.

Du Cubisme between Bergson
and Nietzsche

[A] polite little man in a lecturer's morning coat took his stand before
me and started to question me about Cubism. The theoretical painters
of the fourth dimension were at that time hoping that the philosopher
of intuition would provide the exegesis for their plastic ideas. Bergson,
the plastic, led me gently towards the Giaconda's smile. Insidiously, I
side-tracked him towards *Creative Evolution*. . . . It was during an in-
terval of silence that I caught his concentrated gaze.[1]

THE INFLUENCE of Henri Bergson upon Cubism has, like the
Giaconda's smile, remained enigmatic. Much of the problem in
this regard is, I believe, summarized in the above quotation, penned
by the painter Jacques Émile Blanche in his reminiscence of a por-
trait sitting with Bergson in 1912.[2] Bergson, to Blanche's mind, had
a theory of art which differed markedly from that of the Cubist
movement. For Blanche, Cubism's fourth-dimensional underpin-
nings could not be reconciled with an intuitionist aesthetic that
Bergson himself linked to images such as Leonardo da Vinci's *Mona
Lisa*.

In my view, however, the theoretical chasm presented by Blanche
can be bridged through a critical reading of Albert Gleizes's and Jean
Metzinger's text of 1912, *Du Cubisme*, since *Du Cubisme* was writ-
ten with Bergson in mind. For it is clear from Blanche's hitherto un-
noticed statement not only that Bergson was interested in Cubism
in 1912, but that the Cubists were encouraging that interest during
the period in which Metzinger and Gleizes formulated their essay.
In fact, by June 22, 1912, the critic André Salmon could publicly re-
cord Bergson's tentative agreement to write a preface to the Section
d'Or exhibition of 1912 "if he was definitely won over by their
ideals."[3] The effort to so persuade Bergson had begun a year previ-
ously, in 1911, with Salmon's declaration that the Symbolist critic
Tancrède de Visan "who encounters these men [Metzinger, Gleizes,
Le Fauconnier, and Léger] at the *Vers et prose* soirées seems abso-

lutely committed to present them to the illustrious metaphysician."[4] In short, the first attempts to align Cubist theory with Bergson's ideas were contemporaneous with Gleizes's and Metzinger's initial assessment of their own respective views in preparation for the writing of *Du Cubisme*.[5]

Yet no sustained comparative analysis of Cubism's precepts with those of Bergson has been undertaken thus far.[6] Attention has focused rather on the effect of Bergson's literary interpreters upon the movement. Jules Romains's poetic doctrine of Unanimism and the related poetry of René Arcos have been studied in this regard. Both writers were participants in the short-lived "utopian" community known as the Abbaye de Créteil that included Albert Gleizes among its members. Unanimist theory held that the individual could directly experience the thoughts of others, and so participate in a collective consciousness. Intuition, defined by Bergson as an ability to immediately discern our own inner being as well as the thoughts of others, is rightly associated with Unanimism; in fact one of Romains's earliest Unanimist poems is titled "Intuitions."[7] The Cubist scholar Christopher Green has drawn attention to Romains's later writings, such as the *Death of a Nobody* (1911), and related them to Bergson's ideas on memory. Romains's theories, Green argues, had a visual parallel in Cubist imagery after 1911.[8] The Cubists reportedly became familiar with Bergson's notion of a temporal continuity connecting the remembered past to a dynamic present through Romains. Cubist works such as Léger's *Study for Three Figures* (1911) are held by Green to employ multiple viewpoints and combine images from disparate temporal and spatial contexts to evoke Bergson's conception of psychological time, known as duration. In effect Green's argument echoes a reading of Bergson first presented by Christopher Gray, who asserted that the amalgam of viewpoints in works such as Metzinger's *Le Goûter* (fig. 4) represents the artist's accumulated experience of the model over a period of time.[9] Similar interpretations had been put forth by Roger Allard in 1910, and by Jean Metzinger in 1911.[10]

In *Du Cubisme* Gleizes and Metzinger note that "the fact of moving around an object to seize from it several successive appearances" enables the artist to "reconstitute it in time."[11] Gleizes subsequently attributed this theory to Metzinger, stating that in *Le Goûter* it is possible to see "the consequences of this movement [of the artist] introduced in an art that did not until that time include a plurality of perspectives."[12] For Gray, Cubist simultaneity is a reflection of an artist's psychological experience, but for some proponents of a Kantian interpretation of Cubism these same multiple

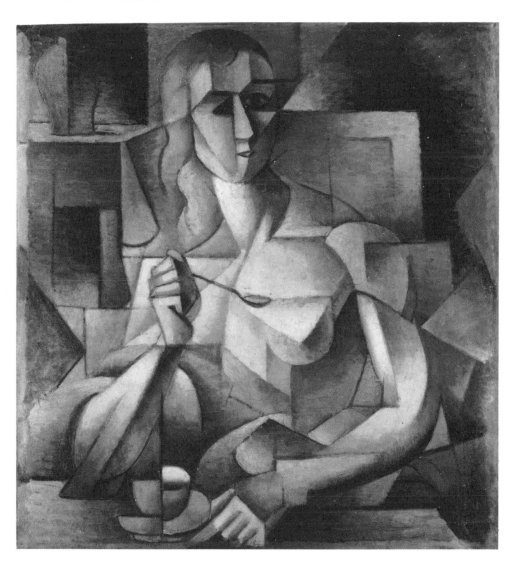

4. Jean Metzinger, *Le Goûter*, 1911

views are the artist's conceptual means of grasping the thing-in-it-self. According to this Kantian schema, the Puteaux Cubists aban-doned the optical representation of an object by way of linear per-spective, in favor of a conceptual representation, in which multiple views allow both artist and viewer to synthesize the object into a single image of the thing as it is rather than as it appears.[13] In short,

we are confronted with two conflicting views of the significance of simultaneity.

My analysis of *Du Cubisme* will reconsider these two interpretations and their relation to Bergson's theories. In addition I shall also argue that Gleizes and Metzinger came to study Bergson through their interest in the writings of Tancrède de Visan.[14] According to André Salmon's statement of November 1911, it was Visan, not Romains or Arcos, who intended to introduce the Cubists to Bergson. Indeed the choice was a logical one: Visan was a well-known Symbolist poet who had begun attending Bergson's lectures before 1904, and whose *Paysages introspectifs* (1904) was the first extended discussion of the theoretical parallels of Bergson's ideas and the Symbolist idiom.[15] In 1912, Visan joined Gleizes in signing Henri-Martin Barzun's manifesto of simultaneity *L'Ere du drame* (1912);[16] the previous year he had published his own volume of literary criticism, titled *L'Attitude du lyrisme contemporain* (1911). This volume, which drew together studies previously published in such magazines as *Vers et prose*, was widely heralded as the definitive application of Bergson's theories to the study of Symbolist literary techniques.[17] By correlating Visan's ideas with the aesthetic of both Cubism and Bergson and reassessing the theoretical significance of Unanimism within the Cubist aesthetic, I hope to underscore Visan's crucial role as the primary Bergsonian theorist within Cubist circles. In this manner the relation of *Du Cubisme* to neo-Symbolism will be elucidated.

In their effort to define Cubism as a vanguard movement, the authors of *Du Cubisme* distinguish the artist's perceptual abilities from those of the average human being. "To discern a form" the public must "verify it by a pre-existing idea, an act that no one save the man we call an artist can accomplish without external assistance."[18] For the public, unlike the artist, it is art itself which aids in the discernment of a form: "Before a natural spectacle, the child, in order to coordinate his sensations and subject them to mental control, compares them with his picture book; culture intervening, the adult refers himself to works of art."[19] This social application of a perceptual theory of conventionalism in effect privileges the artist as the inventor of new visual conventions to be taken up by a docile public. Docility, however, can soon turn to hostility; although the work of art "forces the crowd . . . to adopt the same relationship [the artist] established with nature," this same crowd "long remains the slave of the painted image, and persists in seeing the world only through the adopted sign. That is why any new form seems monstrous, and why the most slavish imitations are admired."[20]

Having asserted the artist's vanguard position as the arbiter of new visual conventions, Gleizes and Metzinger now seek to explain how the artist goes about escaping from the tyranny of past pictorial conventions to behold nature anew. They update an old avant-garde doctrine that allies unconventional seeing directly to the expression of one's personality. "To establish pictorial space we must have recourse to tactile and motor sensations, indeed to all our faculties. It is our whole personality which, contracting or expanding, transforms the plane of the picture." And elsewhere: "The art which ceases to be a fixation of our personality (unmeasurable, in which nothing is ever repeated), fails to do what we expect of it."[21]

Since artists do not organize their sensations by adopting the visual conventions established through artistic tradition, they must have recourse to the organization of their own bodily sensations, defined in *Du Cubisme* as "tactile and motor sensations." As Linda Henderson has so cogently pointed out, the Cubists, in referring to tactile and motor sensations, embraced the perceptual theories of Henri Poincaré, who proposed that our perception of space is the product of an internal coordination of our various sensory faculties into a spatial gestalt we mistakenly identify as external to us.[22] Gleizes and Metzinger associate Poincaré's contrast between geometric space and sensory space with the distinction between Euclidean geometry and the non-Euclidean and fourth dimensional space they identify with tactile and motor sensations. Space is no longer an absolute category of experience, but a relative one—relative to our sensory faculties, and secondarily, to a given culture's accepted conventions of artistic representation. Since the artist does not rely on social conventions to arrive at a conception of space, the Cubists associate pictorial space with personal expression. Furthermore, a spatial gestalt synthesizes our intellectual faculty of organization with our artistic sensitivity to sensations: the Cubists, like Cézanne, master the "art of giving to our instinct a plastic consciousness."[23] Spatial construction in a Cubist painting is the product of the interrelation of consciousness and feeling.

For this reason Cubist space is a reflection of the whole personality. From the temporal point of view, a Cubist painting should somehow embody the heterogeneous nature of our "unmeasurable duration in which nothing is repeated."[24] In achieving this end, the artist has "the power of rendering enormous that which we regard as minuscule and as infinitesimal that which we know to be considerable: he changes quantity into quality."[25] In Cubist theory, "qualitative" space is the pictorial analogue to temporal heterogeneity and the non-Euclidean. They also combine multiple views of an object

or personage to figure motor movement as a pictorial analogue to the fourth dimension.

"Torn from natural space," the objects represented in this manner "have entered a different kind of space, which does not assimilate the proportions observed."[26] Observed space, the space of science, is the product of proportional measurement, whose pictorial analogue is "traditional perspective."[27] Cubist space, as an imprint of the heterogeneous personality, shares its "unmeasurable" quality. And for a spatial construction to reflect the personality, relations between objects in that space must be established in a *qualitative*, non-scientific manner. To apprehend space qualitatively, artists become acutely aware of their instinctual and emotive response to sensation, which Gleizes and Metzinger relate to an artist's faculty of discernment or taste. The importance of the concept of "taste" (*le goût*) may be expressed in Metzinger's image of sensory discernment—both the sitter's and his own—*Le Goûter* of 1911 (fig. 4). The resulting dichotomy sets scientific, quantitative space— identified with traditional perspective—against an artistic, qualitative treatment of space which the Cubists associate with the ordering of space in a non-quantifiable manner. The former spatial schema, traditional perspective, constitutes an impersonal, measurable medium estranged from its creator, whereas the latter qualitative projection is a synthetic expression of the whole personality.

A similar dichotomy exists, in fact, in Bergson's separation of intellectual, scientific modes of inquiry from the faculty of intuition, which he related to artistic perception and metaphysical modes of inquiry. Bergson's notion of artistic intuition is discussed in *Creative Evolution* (1907), but its roots are in the critique of the intellectual treatment of time found in his early book, *Time and Free Will* (1889). According to Bergson, intellectual time—the conception of time propagated within the natural sciences—should not be confused with the time we experience directly in our daily lives. The time of science is a mathematical conception, symbolized as a unit of measure by our clocks and chronometers. In keeping with the quantitative nature of such measuring instruments, scientific time is represented as an extended, homogeneous medium, composed of normative units (years, hours, seconds).[28] But these symbols or units distort rather than reflect our inner experience of time; they satisfy the impersonal, practical conception of time which regulates society, but are inadequate as symbols of our individual, felt experience of time.

Psychologically, the intellect can never comprehend movement or duration because its spatial models treat movement as something

complete; with regard to our own activity, we gain an intellectual perspective on it only in retrospect and, as such, any intellectual or logical cognition of an act is itself a product of that act.[29] This is so because all action entails a process of externalization, in which duration, with its interpenetrating moments, becomes spatialized into quantifiable instants, each external to the next. For example, a line is a representation of a generative act, it is not the act itself.[30]

Similarly, in Bergson's schema there are other forms of self-representation that, owing to their spatialized properties, fail to mirror our experience of inner duration, which Bergson identifies as cognition of the "profound self."[31] Words, for example, are spatial in orientation. Just as standardized mathematical units of time constitute impersonal representations of our individual experience of time, so words such as *love* or *hate* are impersonal labels applicable to everyone regardless of the individual character of our emotions. As impersonalized repesentations of the self, words are convenient counters adapted to social discourse; but from the standpoint of the personality experiencing the emotion, they are impoverished, generalized symbols.[32] Yet the intellect is a faculty adapted to social life, and most of our activities are "intellectual" rather than deeply expressive of our character. Only the artist is able to transcend social conventions and give form to individual thoughts and feelings in all their freshness and novelty.[33]

Bergson's critique of scientific and socially conventional modes of self-representation as unable to signify the personality corresponds to the Cubists' rejection of science and society in an attempt to capture the whole self in a work of art. Moreover, both Bergson and the Cubists define this inner self as existing in heterogeneous time, which cannot be represented with "quantitative" signs. And for Bergson it is artists who transcend social conventions and obtain a direct cognition of their durational being.

How then do artists grasp, let alone express, this profound self? The artist must begin by recognizing that the intellect and its signs do not reflect the true nature of our inner being. Logic distorts the self; mechanistic or deterministic interpretations of durational experience are the products of such distortion.[34] And such interpretations fail to recognize the freedom inherent in any act that is the product of the profound self: if "we penetrate into the depths of the organized and living intelligence, we shall witness the joining together or rather the blending of many ideas which, when once dissociated, seem to exclude one another as logically contradictory terms."[35] Thus the novelist by "tearing aside the cleverly woven curtain of our conventional ego, shows us under this appearance of

logic a fundamental absurdity."[36] Freedom is at the heart of dura-
tional activity, and determinism is the spatialized product of
activity itself.[37] Thus "there is no need to associate a number of con-
scious states in order to rebuild the person, for the whole personal-
ity is in a single one of them . . . And the outward manifestation of
this inner state will be just what is called the free act, since the self
alone will have been the author of it, and since it will express the
whole of the self."[38]

The free act, as a reflection of the profound self, is at the same
time both a conscious act and one deeply imbued with feeling. Ex-
pressive of the whole personality, it is what Bergson ultimately
defines as an intuitive or artistic act.[39] In order to act artistically,
Bergsonian artists must first take up a sympathetic attitude with
regard to their own being. Since intellectual modes of thinking and
their signs afford only a superficial image of the self, they must be
rejected—transcended—in favor of an empathetic but conscious re-
lation to one's inner self. This act of sympathy demands a great deal
of effort, for to empathize consciously with something is to go
against the intellectual habits that normally dominate conscious-
ness.[40] By transcending the intellect's passive, fragmentary view of
the self, one experiences the self in the process of self-creating, that
is, free activity.[41] This deep self is organic in nature, since it is filled
with interpenetrating thoughts and feelings. Thus "ideas which we
receive ready-made" will remain external to the profound self, and
"float on the surface" of the mind "like dead leaves on the water
of a pond."[42] Furthermore, "as the self thus refracted and thereby
broken to pieces is much better adapted to the requirements of so-
cial life in general and language in particular, consciousness prefers
it, and gradually loses sight of the fundamental self."[43] This social or
predetermined self is antithetical to the artistic temperament.

"The artist," therefore, "aims at giving us a share in this emotion,
so rich, so personal, so novel, and at enabling us to experience what
he cannot make us understand."[44] However, no sign in and of itself
can fully represent the artist's internal intuition, nor can it repre-
sent this immediate experience to others. The artist can only sug-
gest intuition through the medium of an art work, not represent it.
What then are the structural principles operative in an art work
which enable such suggestion to take place? And, finally, how can
such precepts be related to *Du Cubisme*?

To begin with, for both Bergson and the Puteaux Cubists, a work
of art is a projection of our conscious reaction to deep-seated feel-
ings. Bergson distinguishes the felt or intuitive act from a "scien-
tific" or non-emotive activity. Only the former is able to express the

whole self, which is by definition both conscious and alogical. The Cubists echo Bergson when they declare their desire to give "instinct" to their "plastic consciousness." The scientific temperament cedes to the artistic state of mind, and measurement is no longer the guiding principle behind the spatial organization of a canvas. Instead relations between objects are established qualitatively, that is, after the dictates of feeling.[45] Linear perspective, being a mathematical system of representation, is to be avoided.

However, the conception of qualitative space outlined in *Du Cubisme* appears at first glance to depart from Bergson, who is commonly held to have drawn a sharp distinction between quantitative space and qualitative time, with no room for intermediary conceptions.[46] If space is intrinsically quantifiable, it follows that the term qualitative can only be applied to psychological time, and no spatial medium can reflect the mixture of feeling and thought in our psychological duration. Space, therefore, must be an intellectual and impersonal medium. Acknowledging this apparent divergence, the Cubist scholar Christopher Gray declares that Gleizes and Metzinger failed "to realize that the problem of giving experience to their sense of dynamism is not a problem to be solved in terms of symbols for space." Dynamism, says Gray, "is a problem that can only be solved by the development of symbols for change, which has as its roots the concepts of time and duration which are such a fundamental part of the philosophy of Bergson."[47]

But Bergson actually did envisage an intermediary state of mind in which space is felt, rather than conceptualized rationally. In *Time and Free Will*, he wrote of an experience of spatial "extensity" quite apart from an apprehension of quantitative properties. "We must," he said, "distinguish between perception of extensity and the conception of space." For instance, it is arguable "that space is not so homogeneous for the animal as for us, and that determinations of space or directions do not assume for it a purely geometrical form." By experiencing space in a perceptual rather than conceptual manner, animals are able to grasp 'extensity' directly as a feeling, say, of direction. Differences in direction may even be designated "qualitative differences," for Bergson does not see why "two concrete directions should not be as marked in immediate perception as two colours."[48] There is no intellectual process interposed between extensity and feeling which actively distorts both with its geometrical schemas.

Unfortunately, evolution has exaggerated humankind's intellectual capacities to the point where consciousness is permeated by the tendency to geometrize.[49] And it is in this context that the art-

ist, as one who recovers felt experience, may also apprehend the qualitative properties of both colour and space. In *Du Cubisme* Gleizes and Metzinger claim to render these pictorial elements qualitatively precisely because "all plastic qualities guarantee a built-in emotion," that is, they circumnavigate the intellect.[50] Thus extensity is no longer treated quantitatively, and Gleizes and Metzinger establish a method of structuring their images in keeping with the Bergsonian paradigm.

Let us briefly review our findings. In Bergson's philosophy, every expressive medium, whether it be plastic, literary, or musical, is the end of a process whereby the inner, manifold self becomes spatialized through the process of self-representation. Psychologically, such externalization is manifest in the transition from a highly emotive and alogical state to a non-emotive, rational state of mind. The temporal analogue for this change is the transposition of indivisible duration into a multiplicity of moments each external to the next, whose divisible state veils their inner interpenetration. This fragmented self is both rational and adapted to social life. Thus it becomes evident that all forms of self-representation would seem self-defeating—inevitably the profound self is refracted and impoverished through the very mechanism of self-representation. Nonetheless, there are degrees of spatialization within these modes of self-representation. As we have seen, Gleizes and Metzinger drew upon Bergson's notion of qualitative extensity to arrive at a notion of plastic space closely allied to the profound self. This qualitative treatment of space accounts for the seemingly arbitrary scale employed in Cubist works: we should read such spatial disjunctions as the plastic equivalent to durational being.

Given this paradigm one must now ask how the painted *medium* induces a state of *immediacy* or intuition in the beholder. For this is what is implied by the definition in *Du Cubisme* of pictorial space as a "sensitive passage between two subjective spaces."[51] Cubist space puts the beholder in immediate contact with the artist's personality, since "this plane reflects the personality back upon the understanding of the spectator."[52] To maintain fidelity to the self, spatial scale is related to feeling, but we are now told that such adjustments somehow influence the beholder's cognitive reaction to a work. How then does the pictorial medium act on the beholder to assist him or her in experiencing it from the artist's point of view? How does the beholder gain an intuition of the artist's state of mind through a mode of self-representation?

Bergson regarded all forms of representation as distorted refractions of a profound, ineffable self. Thus any form of signification can

only be an indirect conduit to the artist's fundamental self, and all expressive mediums can only "suggest" an intuition, which is inexpressible.[53] Likewise since expression is itself a process of externalization, an original intuition may become intellectualized. We may choose to translate our intuition into a painted image, but the very act of doing so leads to the quelling of inner emotion. If an artist goes so far as to structure an image analytically, even the capacity for suggestion will be annulled. The beholder in turn will have no access to an artist's intuition, because an analytically structured canvas deadens any emotional response. In effect, the painting is no longer a sensitive passage between two subjective spaces; it is a barrier to intersubjectivity. As Bergson stated, "from intuition one can pass on to analysis, but not from analysis to intuition."[54] If an intuition is to be suggested, the art work itself must induce an alogical state of mind in the beholder.

Bergson addressed this issue by developing a theory which closely approximates the Cubist notions of simultaneity. The origin of this theory lies in his analysis of the perceptual image. Previously I noted the philosopher's distinction between the perception of qualitative extensity and the conceptualization of space; I now wish to emphasize the relation he drew between pure perception and an immediate grasp of inner duration. Our psychological duration, Bergson stated, is made up of unstable, fluctuant sensations, which constitute our felt impressions of the world. Through socialization we affix labels or words to these immediate impressions. The word that "stores up the stable, common and consequently impersonal element in the impressions of mankind . . . overwhelms or at least covers over the delicate and fugitive impressions of our individual consciousness."[55] To name something is to conceptualize experience and lose sight of the deep-felt impression that sensations would otherwise evoke in our innermost being.

Thus the image, as a form of representation, is more conducive to self-expression than the written word, and by implication poetry must transcend the words it uses. If poets are to express a felt intuition through language, they must think in terms of images before arriving at a pattern of speech. "The poet is he with whom feelings develop into images, and the images themselves into words."[56] As readers we convert these words back into images, and "seeing these images pass before our eyes we in our turn experience the feeling which was, so to speak, their emotional equivalent."[57] But our translation of words into images, and images into an original artistic intuition, can only occur if such verbal imagery provokes an alogical and dynamic state in the reader's mind. In his resolution of this

problem, Bergson developed a literary technique that Tancrède de Visan would later refer to as the doctrine of "successive or accumulated images."[58] Visan applied this concept to the poetry of Maeterlinck in 1907, and later codified it in an article on Bergson published in 1910. This theory was first discussed by Bergson in the "Introduction to Metaphysics," which reads:

> To him who is not capable of giving himself the intuition of the duration constitutive of his being, nothing will ever give it, neither concepts, nor images. In this regard the philosopher's sole aim should be to start up a certain effort which utilitarian habits of mind tend, in most men, to discourage. Now the image has at least the advantage of keeping us in the concrete. No image will replace the intuition of the duration, but many different images, taken from quite different orders of things, will be able, through the convergence of their action, to direct consciousness to the precise point where there is a certain intuition to seize on. By choosing images as dissimilar as possible, any one of them will be prevented from usurping the place of the intuition it is instructed to call forth. . . . By seeing that in spite of their differences in aspect they all demand of the mind the same kind of attention and, as it were, the same degree of tension, one will gradually accustom consciousness to a particular and definitely determined disposition, precisely the one it will have to adapt to . . . to produce the desired effort and, by itself, arrive at the intuition.[59]

The importance of this section for our understanding of simultaneity cannot be overestimated. Bergson begins the passage by acknowledging that most of us cannot intuitively discern our profound self—our consciousness is dominated by the intellect's "utilitarian habits of mind."[60] Words are well adapted to these intellectual habits, but images are closer to our immediate, or "concrete," experience. Thus the image, as a literary tool, can draw us towards apprehension of the inner self, for which it is the emotional equivalent. "No image will replace the intuition of duration," but these same images "can direct consciousness to a precise point where there is a certain intuition to seize on." To guide consciousness, the writer selects images which are as "dissimilar as possible"; they must bear no logical relation to each other. In this way the mind can be drawn into a particular alogical disposition described as a kind of attention or degree of tension signaled by the emerging interrelation we posit to connect these images. In grasping their interrelation "in spite of their differences," our mind has moved from an extensive or intellectual state to an *intensive* or intuitive one. Thus we arrive at the state of "attentive tension" that characterized the original intui-

tion underlying the images, and what Bergson termed "the unity of the directive idea," the mental counterpoint to our qualitative sense of physical direction.[61] Through the suggestive mechanism of these images the writer has put us in the mental disposition we have come to define as intuition. Moreover, since we ourselves produced the effort needed to transcend the intellect, our apprehension of a writer's intuition is itself an intuitive act which involves our whole being. The philosophical text, as the product of an intuitive insight, persuades the reader to instigate another creative act in kind, and these two intuitions commingle in the condition of intersubjectivity. Paradoxically, the reader must arrive at an internal intuition before being able to grasp immediately the philosopher's profound intentions.

This passage is devoted to philosophical intuition, but elsewhere Bergson employs a similar psychological model in a discussion of Leonardo da Vinci's *Mona Lisa*.[62] Here the intuition to be apprehended is Leonardo's experience of his model, and the mechanism of suggestion is the arabesque distribution of lines on a canvas that leads us "toward a virtual center located behind the image."[63] The beholder will seek behind the lines "the movement the eye does not see, behind the movement itself something even more secret, the original intention, the fundamental aspiration of the person: a simple thought equivalent to all the indefinite richness of form and colour."[64]

Both the writer's image and the artist's line can provoke an intuition: the image, by its alogical relation to other images, and the line, by its rhythmic effect upon the beholder's subliminal mind.[65] In both cases these devices *suggest* rather than represent intuition— they evoke a virtual center of convergence where the mind perceives a purely mental unity. Their means may differ, but the end sought by philosopher and artist is virtually synonymous.

The Cubist aesthetic of Gleizes and Metzinger was surely informed by Bergson's methods for evoking intuitive states. Tancrède de Visan had outlined both procedures in a 1910 article devoted solely to Bergson, which quoted in their entirety passages I have cited.[66] For Visan, Bergson's pronouncements on artistic intuition find their parallel in the dissolving sinuous forms painted by the Symbolist Eugène Carrière while the method of accumulated images is captured in the poetry of the Symbolist Maurice Maeterlinck. Maeterlinck, we are told, "accumulates disparate images, turning over and over an initial impression, a clever play of analogies, despite an apparent discord, with a mind to grasping this impression in its total complexity."[67]

By 1912, Gleizes and Metzinger were conversant enough in such Bergsonian theory to incorporate a conception of viewer intuition into *Du Cubisme*. Having determined that portions of the canvas should be set in irregular relation to one other so as to assure that the whole remain immeasurable, qualitative, and therefore "organic," they go on to conclude: "in order that the spectator, ready to establish unity himself, may apprehend all the elements in the order assigned to them by creative intuition, the properties of each portion must be left independent, and the plastic continuity must be broken up into a thousand surprises of light and shade."[68] Thus the Cubist breaks up the canvas's unity in such a way as to allow the spectator's own "creative intuition" to "establish unity," and so ascertain the painter's integral and intuitive conception. The canvas's existence as an "organism" is ascertained through a mental process wherein the beholder is led, as in Bergson's example of the *Mona Lisa*, "little by little toward the imaginative depths where burns the light of organization."[69] The unity implicit in the work of art also resides in the mind of the beholder.

To provoke an intuitive response, the plastic elements of the canvas must first arouse the viewer's emotions. "The diversity of relations of line to line must be indefinite; on this condition it incorporates quality, the immeasurable sum of the affinities perceived between that which we discern and that which already existed within us; on this condition a work of art moves us."[70] The qualitative organization of the canvas not only reflects the luminous depths of the artist's personality but also triggers an internal emotive response in the viewer. Similarly, to capture an intuitive rather than analytical sensation of "fullness," the Cubists use Cézanne's technique of *passage* to evoke an apprehension of "the dynamism of form."[71] "Between sculpturally bold reliefs, let us throw slender shafts which do not define, but which suggest. Certain forms must remain implicit, so that the mind of the spectator is the chosen place of their concrete birth."[72]

The dynamism of form is thus directly related to the beholder's psychological reaction to a given work. This reaction, following the tenets of *Du Cubisme*, leads us to perceive dynamic form as an expression of the profound self. By connecting ideas such as quality and heterogeneity to the division of the canvas into unmeasurable rhythmic patterns, we discern the non-quantifiable and thus dynamic quality of volumetric space. Furthermore, the two words, *dynamism* and *form*, exemplify a Bergsonian combination of images which logic or common sense would declare mutually exclusive.[73] Dynamism calls to mind movement, yet form evokes the idea of

stasis, and dynamism of form, the notion of an unchanging object moving through space. In *Du Cubisme*, however, dynamic form constitutes a *Cézannean* type of spatial extensity unrelated to the division of space into bounded objects. Gleizes's *Bridges of Paris* (1912) (plate 2), which was illustrated in *Du Cubisme*, embodies this type of amorphous space. In the painting, a multiplicity of views is transversed by transparent shards which both overlie and interconnect the imagery beneath. Objects portrayed (for instance, the two houses in the bottom left portion of the canvas) frequently dissolve into abstract planes, causing our attention to fluctuate between the representational content and the non-representational volume. It is the rhythmic interrelation of such volumes which instigates our intuitive apprehension of the painting's organizational matrix. As for the imagery couched in this qualitative space, according to Gleizes and Metzinger, it should be as disparate as possible, "with a view to a qualitative possession of the world":[74]

> Without using any allegorical or symbolic literary artifice, but with only inflections of lines and colors, a painter can show in the same picture both a Chinese and a French city, together with the mountains, oceans, flora and fauna, peoples with their histories and desires, everything which in exterior reality separates them.
>
> Distance or time, concrete thing or pure conception, nothing refuses to be said in the painter's tongue.[75]

Cubist imagery is not derived solely from observation of the exterior world; it emerges out of the durational flux of consciousness. The selection of such imagery is governed by subjective criteria such as "taste" and "sensitivity," both of which are subordinate to will, for artistic will alone can "develop taste along a plane parallel to that of the consciousness."[76] Creative intuition, as we have seen, entails a willed effort to transcend logical patterns of thought—these disparate images, whose interrelation is determined subjectively, echo that transcendence.

The Cubist conception of pictorial simultaneity may have its genealogy in Futurist theory as well as in Visan's Bergsonian criticism. If the Cubists sought a pictorial analogue for such theory, they had only to consult Gino Severini's *Travel Memories* of 1911 (fig. 5). By his own admission, Severini painted this image in response to his reading of Bergson's "Introduction to Metaphysics," and as a member of the poet Paul Fort's *Vers et prose* circle, he was probably familiar with Visan as well.[77] For this painting, Severini selected a vast array of memory images related to travel and distributed them around a central image of a well, taken from his home town.[78] In

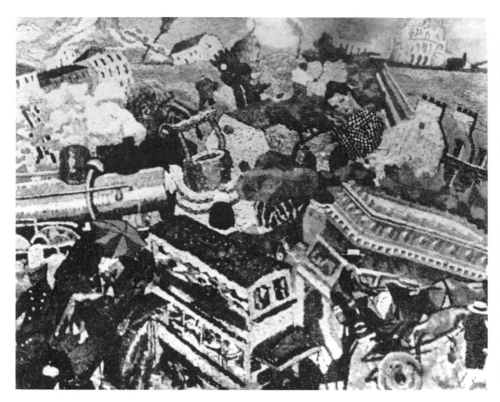

5. Gino Severini, *Travel Memories*, 1910–1911

Bergsonian and Cubist terms, the work is a paradigmatic example of simultaneity: the scale of these images defies "perspectival" logic; they are disparate, yet bear a thematic relation to each other; and their radial arrangement suggests the idea of "convergence." To arrive at his conception, Severini had an intuition of the idea of travel, and since he had been reading Bergson, and Bergson equated consciousness with memory, Severini's internal meditation on the theme resulted in the welling up of an array of remembered images bearing a synthetic relation to the intuition of travel.

A comparable example of this technique is Gleizes's 1911 portrait of his close friend and future brother-in-law, the author Jacques Nayral (fig. 6). Nayral, whose interest in Bergson led him to correspond with the philosopher, asked Gleizes to do his portrait in 1910, a task the artist completed over the course of 1911. In Gleizes's opinion, this portrait, like Metzinger's *Le Goûter*, exemplified certain ideas that were later codified in *Du Cubisme*.[79] In fact Gleizes's

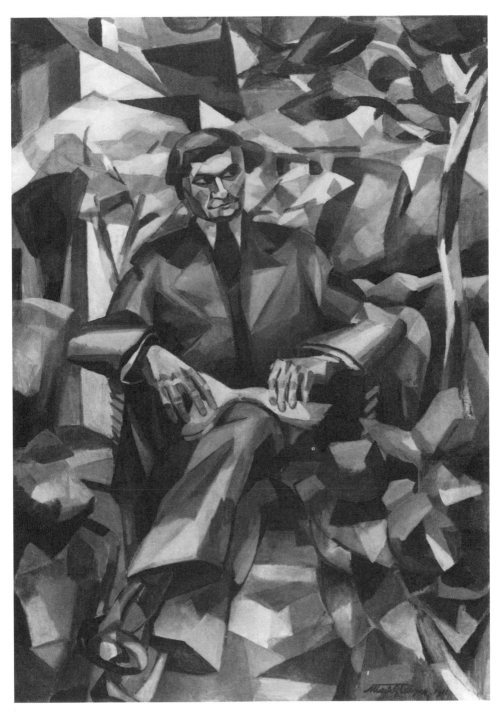

6. Albert Gleizes, *Portrait of Jacques Nayral*, 1911

autobiographical notes suggest that the theory of alogism propounded in that text may have been broached in Cubist circles as early as 1910.

Like Severini, Gleizes completed the painting from memory. Though he did a number of sketches of Nayral, and although he set the writer in the tangible space of his garden, the portrait itself was "executed without recourse to the model."[80] Gleizes was able to formulate a mental image of Nayral after prolonged observation of his habits of walking, speaking, and gesticulating. The artist and writer developed a strong friendship over the course of the sittings and Gleizes later described Nayral as one of the most sympathetic individuals he had ever met. Their interaction, Gleizes recalled, allowed him to extract "some essential traits" from the "jumble of details and picturesque elements" that obscured "the permanent essence of a being."[81] In addition the artist focused on physiognomic elements, such as the "well-defined planes" of Nayral's face and the "undulations" of his hair, that served as the springboard for the volumetric treatment of imagery in the portrait. Nayral's expressive acts and physical appearance "suggested to me immediately recollections, relationships, penetrations, and correspondences with the elements of environment, the land, the trees, the houses."[82] As Daniel Robbins suggests, "Gleizes's conception involves the search for qualities that relate apparently diverse phenomena, comparing and indeed identifying one aspect with something else—for example, the hair of Nayral with the wind tossed foliage of trees."[83] In short, this synthetic vision was the product of Gleizes's *sympathetic* response to the expressive acts and physiognomic traits he deemed indicative of the poet's character. Both form and content in the work were the result of Gleizes's mental associations while working from memory. The procedure was not unlike that of Severini.

In addition, Gleizes's contrast between a jumble of details and permanent essence, surface appearance and psychological depth, is a theme permeating the Bergsonian-oriented criticism of the period. Visan, in his 1907 essay on Maeterlinck, drew a similar distinction, pitting the descriptive or "peripheral" poetry of the Parnassian school against the "central vision" practiced by the Symbolists. According to Visan the former group describe the surface appearance of their subject in minute detail, while the Symbolists employ sympathetic intuition to enter into the soul of a given subject and grasp its inner duration. The analytic methods of the Parnassians reportedly cause them to privilege the sense of sight and focus on a subject's external appearance rather than their emotional response to it. Since the Symbolists' central vision is the product of an empathetic

response to a subject, it is spiritual rather than merely optical (and thus intellectual) in orientation. Having penetrated beneath surface appearances to grasp the psychological depths of living duration, they then externalize their ineffable vision by means of rhythmic cadence and accumulated images, as I noted above.[84] In an important essay on poetic intuition, titled "La Poésie immédiate" (1909),[85] Jules Romains adapted these ideas to a discussion of what he called literary Impressionism. The essay, which was recognized by Romains's peers to be Bergsonian in import, described "intuition" as the agent for "perpetual revelation," able to capture the "living unity" of "duration."[86] On this basis Romains concluded that the intuitive poet does "not juxtapose impressions":

> The terms impression, impressionism . . . evoke the capricious sensation without depth, the diary in which one takes notes, the small sketch in front of the mountain, in sum, a recreation of travel. This art, which is not impressionism, is no longer an imitation of nature. Far from copying nature, it expresses the world. There is no use in describing [nature], with an attention, a patient minuteness which would better be employed in botany. Why would a poet exhaust him or herself to know from the outside a reality that the soul feels and probes from the inside?[87]

Impressionism, like any "science," only knows its objects "from the outside with the aid of measure and according to their quantity." "Without being preoccupied with reproducing an exterior arrangment," poetic intuition can rediscover "through penetration, the internal order of the thing." Like Visan, Romains condemns descriptive poetry as non-expressive and unable intuitively to penetrate surfaces to obtain "an immediate knowledge of the soul."[88]

In effect Romains has taken up a theme first broached by Signac and Matisse and given it a decidedly Bergsonian stamp. In the "Notes of a Painter" (1908), Matisse even condemned Impressionism on the same basis, disparaging the movement for ignoring a subject's "essential character" and representing "only one moment of its existence [durée]."[89] Romains embellishes this Bergsonian allusion with Visan's poetic paradigm, concluding that the Impressionist, like the Parnassian, intellectualizes subject matter, thereby fragmenting duration and only capturing surface appearances. And as we have seen, Joseph Billiet and Roger Allard applied this poetic terminology to a defense of Cubism as early as 1910.[90]

The same argument resurfaces in a more developed form in *Du Cubisme*. In that text Impressionism's focus on surface appearances not only shows that "the retina predominates over the brain" in

their art, but is cited as proof of "the incompatibility of the intellectual faculties and artistic feeling."[91] Cubism, on the other hand, does not copy surface appearances but instead directs the beholder's mind "toward the imaginative depths where burns the light of organization," an organization suggested through a painting's rhythmic structure. By discerning this *internal* order the Cubist will be able to "express supposedly inexpressible notions of depth, density and duration."[92] In their interpretation of Impressionism in *Du Cubisme*, Gleizes and Metzinger condemn the movement for its intellectual focus on external form rather than the self. The Cubists claim to remove this intellectual veil, to introspectively discern and express their profound self. In grasping what Bergson called "the fugitive impressions of our individual consciousness," they obtain an impression of their own individuality rather than of the individuality of some external object. Having stripped away the intellect to capture the unique quality of their impressions, the Cubists direct their empathetic attention wholly to the individuality of their felt responses, rather than to the individuality of what they are responding to.

Yet in Bergson's philosophy, cognition of the individuality of both the self *and* an external object should emerge from such immediate impressions. Artistic perception, we are told in "Laughter," "has no other object than to brush aside the utilitarian symbols, the conventional and socially accepted generalities," but in so doing artists not only discern their own individuality, but that of "actual things themselves."[93] The intellect is limited to perceiving the "impersonal aspect of our feelings" and "commonplace aspect of the thing," but by attending empathetically to the "impressions of our individual consciousness" we "enter into immediate communion with things and ourselves."[94] An artistic impression not only makes an artist aware of the deeply felt emotion an object may elicit: it is "the inner life of things that [the artist] sees appearing through its form and colour."[95] Or as Bergson put it in "The Perception of Change" (1912): "What is the aim of art if not to show us, in nature and in the mind, outside of us and within us, things which did not explicitly strike our senses and our consciousness?"[96] In the case of the fine arts, a work by "a Corot, a Turner" will reveal "a brilliant and vanishing vision" that "the pale and colourless vision of things that is habitually ours" had "perceived without seeing."[97] As beholders we declare such works to be "true" because in addition to being the products of an artist's imagination, such images reveal the subliminal perceptions that utilitarian thought veiled from us. Painting then is not only a matter of self-expression but also of "im-

itation," and "the great painters are people who possess a certain vision of things which has or will become the vision of all people."[98] In Bergson's system immediate perception is of a reciprocal nature, since any object-image in consciousness is simultaneously a part of the world as well as the self. And with regard to painting in particular, Bergson suppresses the expressive component of his theory and emphasizes the imitative one, comparing artistic vision to the chemical bath which operates as the "revealing agent" for a photographic image.[99] To claim that empathetic attention is exclusively self-referential in its revelatory powers is to deny a portion of Bergson's mimetic theory that the philosopher himself relates to Impressionism's forebears, Turner and Corot.

Furthermore, this distinction explains why the art theory of Gleizes's close friend, René Arcos, did not gain currency in Cubist circles. The poet's theory, published in July 1912 under the title "La Perception originale et la peinture,"[100] is clearly based on Bergsonian premises. But whereas Gleizes and Metzinger wish to sweep aside utilitarian perception to discern their inner being, Arcos hopes to transcend the same utilitarian orientation to gain an immediate perception of the individuality of things. Paraphrasing a tenet found in *Matter and Memory*, Arcos describes humankind as surrounded by images that "reflect, to an exact measure, our power to act on the world around us."[101] Yet the utilitarian nature of such action assures that "ordinary people" pay "furtive and fleeting" attention to an object, so that only the most "brilliant" or "exceptional perceptions" penetrate "the thick skin of indifference and habit." For the artist this veil of habit is lifted, and objects are perceived as individualized impressions: these replace the fragmentary, generalized images adapted to utilitarian activity.[102]

In "Laughter" Bergson described the results of such perception in some detail. Painters attending to the objects in their field of vision apply themselves "to colours and forms," and since the artist "loves colour for colour and form for form; since he perceives them for their own sake and not for his own, it is the inner life of things that he sees appearing through their forms and colours."[103] Inner life is evident not only in the individuality of a given object's appearance, but in the "original harmony" that binds a group of objects into an ensemble, a harmony which in Bergson's theory is the outward manifestation of inner duration.[104]

Arcos replicates this thesis in his imaginative reconstruction of "the daily stroll of a painter from his house." Instead of throwing fleeting glances at things in the course of habitual activity, the perceptually gifted artist "lingers on objects" and continually "discov-

ers them" anew. As a consequence, artists are "immediately as-
sailed by a hundred movements," by a "hundred tints" vying for
their attention. "Wherever his eyes look, nothing escapes them,"
even "the paving stones that he treads upon will present all sorts of
colors and shapes to him." In surveying a landscape or street "an
inner voice says simply: green, red, grey, and blue together, blue
against red." Colors and forms are perceived for their own sake and,
as in Bergson's criticism, it is their harmonious arrangement that
appears through their forms and colors. Thus during the course of
the stroll Arcos's artist "composes some large ensemble" out of
these impressions, producing "an order that he isolates in an ideal
frame." This process occurs endlessly because of the unending nov-
elty that the painter encounters.[105]

Arcos follows Bergson in privileging artists as those who create
images that the public then take up as true to "natural" appear-
ances. "Ordinary people," Arcos states, "do not see for themselves";
they see through the eyes of artists who "invented the first percep-
tion of these objects." Through painting, artists continually convey
a novel vision to the ordinary person, who "is the inheritor of a rich-
ness he does not understand, having always had it."[106] This state-
ment recalls sentiments expressed in *Du Cubisme*. In that text, an
equally ungrateful public is said to object to an artist's new vision
on the basis of images they themselves unwittingly inherited from
artists of an older generation. And this older generation met with
the same incredulity in their day.

Arcos then parts from Bergson in a subtle but significant way. For
the philosopher, there are only naturally intuitive artists, and a doc-
ile public whose perceptual capacities forever follow the artist's
lead; in Arcos's theory such gifted artists are followed by the public
and hackneyed artists, those whose minds are "filled with memo-
ries from museums," and whose paintings are pastiches of the work
of others. Since they are "incapable of perceiving and conceiving for
themselves," they familiarize themselves with the work of an intui-
tive artist, "to exploit a province of his originality."[107]

Bergson and Arcos would have artists fashion images that are
deemed true because they *imitate* external reality; but Gleizes and
Metzinger deny that such imitation is possible. In their view such
images are an expression of the personality of an artist, which the
public mistakenly identify as imitations of external appearances.
Du Cubisme is unequivocal on this point: "Henceforth objective
knowledge at last regarded as chimerical, and all the crowd under-
stands by natural form proven to be convention, the painter will
know no other laws than those of taste."[108] The law of taste dictates

that every art work and its imagery be a form of self-expression, with the result that the Cubists "will fashion the real in the image of his mind, for there is only one truth, ours, when we impose it on everyone."[109] Cubist paintings are true because the artist is true to himself, not to some external reality.

Their conception of perceptual conventionalism also sets Gleizes and Metzinger apart from Romains and Visan. When Romains declares in "La Poésie immédiate" that "far from copying nature" his poetry "expresses the world," his meaning is different from that implied in Gleizes's and Metzinger's attempt to take "qualitative possession of the world." In the case of Romains, he is able to express the world because he has entered into intuitive correspondence with it. He has experienced what Visan would call a "vision centrale," which precedes the translation of that ineffable state into rhythm and accumulated images. Thus both Romains and Visan enter into an object and express *it* as well as themselves.

A look at the evolution of Cubist criticism from 1910 to the publication of *Du Cubisme* reveals a shift away from this neo-Symbolist and Unanimist paradigm to an art theory preoccupied with self-expression. This state of affairs is most evident in the declining value given to the model of intersubjectivity that Gleizes and Metzinger adapted from Romains and Visan. While Romains's text, "La Poésie immédiate," did not outline the theory of accumulated images developed by Visan, his usage of intuition to expound a notion of collective consciousness has its parallel in Metzinger's writings. The earliest examples of Unanimist-informed Cubist criticism are datable to around 1910, with Metzinger's interpretation of Delaunay's Eiffel Tower paintings.[110] In a year that witnessed Romains's declaration that Bergsonism could be the predominant philosophy of the period,[111] Metzinger describes Delaunay's *Eiffel Tower* image (fig. 7) as an intuitive amalgam of the public's thoughts about this icon of modernism: "Intuitive, Delaunay has defined intuition as the brusque deflagration of all the reasonings accumulated each day."[112] Like Severini and Gleizes, Delaunay is known to have painted the work from memory, but in this case the memory images themselves are purportedly collective and therefore Unanimist in nature.[113] Aside from entering into intuitive relation to the self, a Unanimist's primary goal is to enter into intuitive correspondence with others.[114] And Delaunay's image, like Romains's poem "Intuitions," is a utopian ode to the possibility of collective consciousness, and with it, collective fraternity.

With Gleizes's *Portrait of Nayral* (1911), however, there is a shift away from an interest in an intuition of a collective nature to intui-

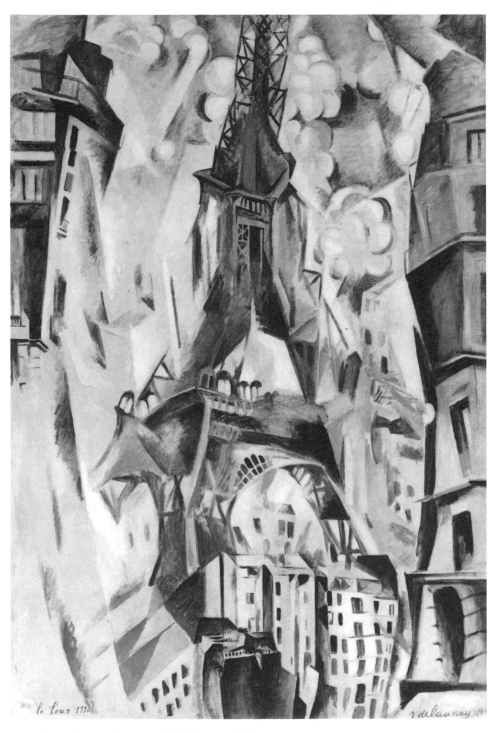

7. Robert Delaunay, *Eiffel Tower*, 1911

tion between two individuals. And very soon Gleizes's interest in the "permanent essence" of another human being would give way to a singular focus on the self. No longer interested in intuiting the world, Gleizes and Metzinger only wish to possess it in order to express their *relative* viewpoint of it, by way of an *absolute* grasp of themselves. They then impose this personal viewpoint on everyone else. Through the art work, the artist does not allow us to have an immediate perception of the individuality of things themselves, but rather of the artist's individual vision of those things. As a result, the public is forever beholden to the artist's point of view, which is only mistakenly identified with "natural" appearances. Far from envisaging a collective fraternity of intuitive individuals, *Du Cubisme* preaches a social hierarchy, with artists forever imposing their vision of themselves on others. In this manner an aesthetic of self-expression is made compatible with the classical precepts Billiet and Allard propounded in 1910. By virtue of the novelty of their paintings, Gleizes and Metzinger, in *Du Cubisme*, claim to embody the creative élan of a public who remain mired in utilitarian perceptions. Intuitive self-expression, therefore, can fulfill the mandate entailed in a notion of Bergsonian classicism without recourse to a Unanimist, collective consciousness as Romains envisaged it.

I would therefore agree with John Nash that the primary concern of the text *Du Cubisme* is with the distinctive psychological make-up of the artist,[115] but would also temper Nash's strict association of Gleizes's and Metzinger's statements concerning artistic will with a Nietzschean notion of the will to power. While the Nietzschean outlook is compatible with the model of perceptual conventionalism Gleizes and Metzinger adopted from Poincaré, it cannot account for the discussion in *Du Cubisme* of the artistic means of individual expression. Given their subtle adaptation of Bergson's conception of how the artist willfully transcends the intellect to attain access to an alogical deep self, I would suggest that Nietzschean and Bergsonian conceptions of will were conflated by Gleizes and Metzinger, as they were in Metzinger's 1911 text on Mercereau, or in texts written by any number of their Bergson-oriented contemporaries. As Nash and Patricia Leighten have shown, this Nietzschean conception of the artistic *surhomme* not only permeates Apollinaire's art criticism, it may have informed Picasso's conception of his own capacities as a protean creator, always one step ahead of those Apollinaire designates as his imitators. Indeed, the Nietzschean and Bergsonian language permeating *Du Cubisme* may constitute Gleizes's and Metzinger's response to the Nietzschean rhetoric of Apollinaire, who in his review of the 1910 Salon d'Au-

tomne labeled a work like Metzinger's *Nude* (fig. 3) "a listless and servile imitation" of "an artist who is endowed with a strong personality," namely "Pablo Picasso." "It is ironic," remarks Nash, "that history has decided that Gleizes and Metzinger are among the herd of Picasso's followers," for in *Du Cubisme* they clearly saw themselves as Picasso's creative equals, whose "imitators" were a public slow to adapt to their aesthetic innovations. It is equally ironic that Nash's and Leighten's attempts to historicize such terminology have been largely ignored, with the result that the aesthetic precepts of Picasso are still commonly dissociated from those pronounced in *Du Cubisme*, despite the Nietzschean rhetoric informing both.[116]

By synthesizing their Nietzsche-oriented perceptual conventionalism and Bergsonian intuition, the authors of *Du Cubisme* limit their power of absolute insight to discernment of themselves. Spurning theories of intuition that claim to grasp the world or others absolutely, they declare Cubism to be self-referential, and any assertion on the part of the public that it is otherwise, to be an illusion. Yet while proclaiming both the public and themselves incapable of entering into intersubjective relation with each other, they are ready to impose their vision of the world on the public by means of their art. In other words, the act of viewing a painting is proclaimed a catalyst to an intersubjective state impossible to achieve under any other circumstances. And it is in this regard that the elitism of Gleizes's and Metzinger's theory becomes explicit. Bergson had created a hierarchical relation among human beings by declaring artists to be perceptually gifted. In his opinion most of us do not perceive the world with any clarity or completeness; it is the artist's role to enrich our perception in this regard, by revealing the inner life of things to us. But the reason we declare art works to be true is because the artist's vision is not relative but absolute. An artist's vision is "transparent," and in revealing the individuality of something to us transcends the relativity of the artist's viewpoint.

But if this viewpoint is itself the subject of a work of art, the same transcendence occurs: "The poet and the novelist who express a mood certainly do not create it out of nothing; they would not be understood by us if we did not observe within ourselves, up to a certain point, what they say about others."[117] What Bergson states about a poet's intuition of others would presumably apply to an intuition of the self. And if the fine arts are also self-referential, would the accumulated images serving to spark our creative intuition not lead us to observe within ourselves what painters have observed in themselves? And if so, does intersubjectivity through an art work

not result in something other than the *imposition* of the artist's per-
sonality on the viewer; is it not a means of revealing something of
our own personalities to ourselves? This issue not only opens up the
problem of intersubjectivity, but also suggests that art's revelatory
function is not wholly one-sided: it is more than the artist which is
revealed to us, it is ourselves. Gleizes and Metzinger say as much by
evoking creative intuition in reference to a beholder's response to
their paintings. Such evocation makes plain the contradiction im-
plicit in their simultaneous privileging of artistic perception over
and above that of the masses.

In addition, the extent to which Bergson regarded the fine arts as
an expressive art form is a complex issue. When Bergson speaks of
painting, truth to the self is sometimes treated as a negative term,
secondary to truth to appearances. Hence Bergson's distinction be-
tween "true art," and art that is "pure fancy," the product of a vivid
imagination. If we declare art to be fanciful, it is because we say
artists "have not seen but created, that they have given us the prod-
ucts of their imagination, that we adopt their inventions because we
like them and we get pleasure from looking at nature through the
image the great painters have traced for us." While acknowledging
that "it is true to a certain extent," this does not explain why "we
say of certain works—those of the masters—that they are true."[118]
As the statement implies, an artist's status as "true" does not de-
pend on whether an art work represents the individual artist, but on
whether it represents the world.

But does it not follow that the self-expression Bergson declares
true in a poet's work, is deemed somehow untrue—fancy—for the
painter? Why can a painting not express a mood we recognize as true
because we have felt it in ourselves? Why is the poet true to the self,
the painter true to natural appearances, but not true in the same
manner? The answer lies in Bergson's differentiation between the
arts and their mediums, based on a hierarchy of perceptual faculties.
In his various publications he values our sense of hearing above
sight, describing the latter faculty as a perceptual tool serving our
utilitarian needs. Bergson's predilection for sound over sight is most
obvious in his comparison of durée to a melody, and our recourse to
images in describing it is a habit, we are told, which usually suc-
ceeds in dividing and "intellectualizing" duration. In *Creative Evo-
lution* Bergson describes our intellectual faculty as preferring to
study a subject's surface appearances rather than to focus on its
inner being, as our "inner eye" would. If "our faculty of seeing is
tied to our faculty of willing,"[119] that is, if we see empathetically,
our 'inner' and 'outer eyes' would be made one, and vision would

transcend its utilitarian function to discern inner duration, the melody of the soul. And since intuitive vision is native to artists, they alone can perceive the "original harmony,"[120] the durational cadence for which harmony of color and form are the material or "surface" equivalent. An artist brings color and form into harmonic alignment as an expression of "the inner life of things that [the artist] sees appearing through their forms and colours." Unlike the artist we are not used to "listening to the uninterrupted humming of life's depths" because "our auditory perception has acquired the habit of absorbing visual images." Our association of visual images with this unbroken melody causes us to divide it into "befores and afters," a "juxtaposition of distinct notes."[121] Thus auditory perception is naturally attuned to the soul's inner music, and vision to the intellect's divisive biases.

The question thus arises whether music is superior to the plastic arts. If an artist uses the sense of sight to discern the inner harmony manifest in outer appearances, does it not follow that artists are to a greater extent tied to surfaces than to depths? That implication is prevalent when Bergson describes musicians in contrast to poets or painters as delving "deeper still" to grasp "certain rhythms of life and breath that are closer to man than his own feelings."[122] Unlike the artist who "applies himself to colours and forms" or poets who reveal an emotional state "by the rhythmical arrangement of words," musicians delve "beneath these joys and sorrows which can, at a pitch, be translated into language [to] grasp something that has nothing in common with language," namely those "rhythms of life" mentioned previously.[123] There is then an artistic hierarchy in Bergson's theory, based on his association of each art form with the "natural" disinterestedness of a particular sense.[124]

By aligning Impressionism with utilitarian perception as Bergson understood it, Gleizes and Metzinger divorced their expressionist aesthetic from any art form that seeks to imitate external reality. There can be no happy union of the "inner" and "outer" eye if an artist aspires to an absolute perception of anything outside the self. By applying Bergson's critique of vision to an assessment of the visual impression, *Du Cubisme*'s authors limited vision centrale to the parameters of introspection, to the expression of the self alone. In the context of Bergson's hierarchy of the arts they sought to elevate painting to the condition of poetry and music.

Rhythmists, Cubists, and the
Politics of Gender

I T IS A TRUISM in the history of art that Fauvism and Cubism are two diametrically opposed movements. Fauvism, we are told, was the product of another century, while Cubism inaugurated a new and radically different era. For despite the interest Derain, Vlaminck, and Matisse had in both primitive art and an expressionist use of color, their Fauvist aesthetic was, to quote Edward Fry, "essentially conservative . . . in its consummate summing up of tendencies in late nineteenth-century painting, combined with a lingering flavor of Jugendstil arabesque."[1] "Above all," Fry states, works such as Matisse's *Joy of Life* (fig. 8) did not "put forth any new conceptions of space, although depth is compressed somewhat in the manner of Manet's *Luncheon on the Grass.*"

This "failure to revolutionize pictorial space" was combined with another crucial flaw: lack of theoretical underpinnings. John Golding has given us a summation of this assessment which concurs with that of Fry:

> viewed in retrospect, Fauvism seems to have belonged as much to the nineteenth century as to the twentieth. For in so far as Fauvism existed as a style or movement—that is to say . . . between 1904 and 1906—. . . it was a synthesis of elements drawn from the art of the past fifty years: Impressionism, Divisionism, the decorative rhythms of Gauguin and the expressionism of Van Gogh, all contributed equally to its appearance. And since Fauvism evolved no really consistent technique of its own and was not governed by any very clearly defined aesthetic, it was not a style that could have anything more than a very fleeting existence.[2]

More recently, Ellen Oppler concluded that Fauvism lacked any prescribed aesthetic doctrine beyond that of individualism.[3] Thus the sum of its parts could never form a coherent whole; after the movement's fleeting existence, its main practitioners (Matisse, Derain, and Vlaminck) went their separate ways. And the disciples

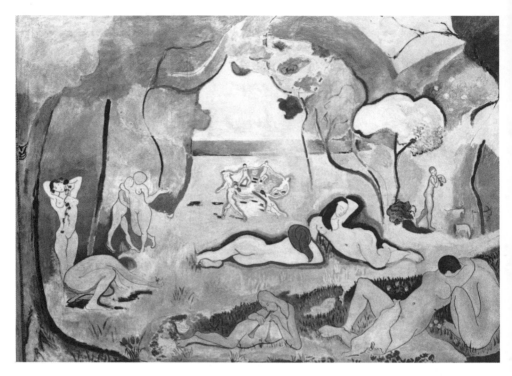

8. Henri Matisse, *Joy of Life*, 1905–1906

of Matisse after 1908 were "grouped around an acknowledged master rather than constituting a spontaneous movement."[4]

This lack of a spontaneous movement was most evident, according to these authors, in the quick dissipation of a Fauvist school in the public salons after 1907. Since Golding and Fry describe the Cubist revolution as focusing on spatial and volumetric form, they both point to Cézanne's influence after 1906 as giving the coup de grâce to Fauvism. Artists such as Braque, Dufy, and Friesz renounced Fauvism's "unnaturally bright or arbitrary colours" and instead turned to "the more structural aspects of Cézanne's work."[5] The same argument has resurfaced in the recent exhibition titled *The Fauve Landscape*, which follows John Elderfield in designating 1908 as the terminal date for the Parisian Fauve movement; Alvin Martin and Judi Freeman again attribute that demise to the fact that Fauvism's practitioners "were coming to terms in 1907 with Cézanne, whose solidified forms and figures provided a powerful counterforce to the Fauve palette."[6] Finally, both Fry and Golding speak of a shift in these circles from a form of gestural expressionism tied

to sensory data to a cerebral, reasoned technique of a conceptual rather than optical nature. The pictorial corollary to such terminology is a move away from decorative rhythms and sensual color to the rigor of hard-edged, grid-like structures and a muted palette. Golding makes the dichotomy between cerebral Cubism and corporeal Fauvism explicit when he describes Cubism as "conceptual and intellectual rather than physical and sensory." And although Jack Flam has argued that the "empirical and inductive" art of Matisse and the "conceptual and deductive" art of the Cubists both constituted responses to the art of Cézanne, he too notes the demise of a Fauvist movement at the Parisian Salons after 1908, where Cubism's Cézanne took precedence over Matisse.[7]

Such is the history as we know it, firmly focused on the canon of modernist masters. But that history needs revision, for we now know not only that Puteaux Cubism, as a thoroughly Bergsonian movement, was far from "intellectual," but also that a self-proclaimed Fauvist movement continued to thrive in 1908 and after. Its adherents were not those artists referred to above, but an international group of artists living and working in Paris and known to the earlier Fauves and their supporters, whose banner these Fauves carried forward. The major protagonists in this circle were J. D. Fergusson and Anne Estelle Rice; fellow travellers included Dunoyer de Segonzac, S. J. Peploe, Marguerite Thompson, and Jessica Dismorr; literary allies included Huntly Carter, J. M. Murry, Francis Carco, and Tristan Derème. Their existence as a movement was not only acknowledged by Carter in *The New Age*, but advanced by the artists themselves in an English journal titled *Rhythm* (1911–1913), which was founded by Fergusson and Murry for that very purpose. To express their Bergsonian convictions, they referred to themselves as Rhythmists as well as Fauvists, and—in addition to showing at the annual Salons des Indépendants and Salons d'Automne—held group shows at the 1912 Internationale Kunstausstellung des Sonderbundes at Cologne, and at London's Stafford Galleries that same year.[8] The Rhythmists' French literary allies Carco and Derème contributed to *Rhythm* from its inception, as well as expounding their related poetic theories in *Ile sonnante* and *Cahier des poètes*.[9] Thus like the Puteaux Cubists, the Rhythmic Fauvists had all the trappings of an art movement: public exhibitions, a group identity, and a number of critics willing to advance their cause in a literary journal.

Most significantly, the Rhythmists shared the Puteaux Cubists' embrace of Bergson, and in fact *Rhythm*'s critics utilized Bergson's philosophy to redefine Fauvism well before Gleizes and Metzinger

consolidated their Bergsonian views in the text *Du Cubisme* (1912). This shared Bergsonism led to gendered theories of creativity that were central to both movements and need consideration from a feminist perspective. By associating the female reproductive processes with Bergson's concept of the élan vital, these artists defined feminine creative capacities as synonymous with those found in nature, thereby denying women the power to realize that creative potential in spheres of cultural production, such as art. As Sherry Ortner has shown,[10] the identification of biological reproduction as woman's primary creative capacity in patriarchal societies has stood in stark contrast to the type of creativity attributed to the male, who "lacking natural creative functions, must assert his creativity externally," that is, through cultural means. In this schema, social functions such as child-rearing are declared "natural" to women by virtue of an identification of such care "as an extension of her natural nursing bond with children."[11] This tendency to restrict a woman's activities to those deemed "natural" to her in effect subsumes women within the realm of the "instinctual", the "animal" or "primitive", and privileges the male gender as uniquely able to transcend such natural functions and create cultural artifacts. The Bergsonists, however, were prepared to interrelate cultural production with productive forces in nature. In keeping with Ortner's paradigm they identified women as the product of such forces, by declaring female fecundity an example of the élan vital's productivity. Women were the product of this élan, but men, by virtue of their intuitive powers, were both product and producer of the élan vital. Both art movements not only associated their own artistic capacities with the conversion of this élan into forms of cultural production but also extended such attribution to other male activities like boxing or football, subjects frequently portrayed in their paintings. That such activities were associated with the national "regeneration" of French male volonté in writings of the period is further evidence of the gendered import of such imagery.[12]

In the process these Bergsonists transformed a female-as-nature/male-as-culture dichotomy prevalent among Symbolists of the previous generation. As Patricia Mathews has shown, the Symbolists, including Aurier and Gauguin, related male creativity to a desired state of mental instability, even while they declared females bereft of this creative capacity due to their biology. This "supposed inability to focus their madness into channels of creativity" was said to result in "hysteria," a term whose etymological root in the Greek word for womb, *hysteron*, makes plain its gendered origin.[13] How-

ever, in the period leading to World War I, writers like Henri Massis and Ernest Psichari were attributing a declining French birthrate and lack of military preparedness to the neurasthenic dandyism of the previous generation.[14] In reaction they turned to Bergson's vitalist doctrine of élan vital, and looked for evidence of its resurgence in *les jeunes gens*, those vigorous young men who had rejected the lethargy of the older Symbolist generation. This was gender politics writ large, and it is essential to place the Bergsonian precepts of the Rhythmists and Cubists within this cultural matrix. I will begin with a brief sketch of the Rhythmist movement before considering the gendered aspects of the art and criticism of both the Rhythmists and Cubists.

John Duncan Fergusson's Paris years began in 1907, when he moved from Edinburgh and rented an apartment at 18 Boulevard Edgar Quinet. The previous year he had met the American artist Anne Estelle Rice whose work was to parallel his own up to the time of Fergusson's departure from France for London in August 1914. In 1907, Fergusson became a part-time instructor at Jacques Emile Blanche's Ecole de la Palette, and it was there that he met Dunoyer de Segonzac, who was to become a lifelong friend. His decision to begin exhibiting at the Salon d'Automne that same year eventually resulted in his election as *sociétaire* in 1909. Through his membership Fergusson met artists such as Bourdelle, Friesz, and Pascin; concurrently he shared Segonzac's fascination with the Ballets Russes and the décor that fellow sociétaire Léon Bakst was designing for the troupe's performances.[15] In the literary sphere Fergusson came to know Tristan Derème and Francis Carco, two members of *les poètes fantaisistes* who would later contribute regularly to *Rhythm*.[16] Following his 1908 move to Notre Dame des Champs he began frequenting the Montparnasse cafés La Closerie des Lilas and Café d'Harcourt. The former establishment was one of the meeting places for the Puteaux Cubists associated with the magazine *Vers et prose*. Figures such as the Bergsonian critic Tancrède de Visan, the Cubist apologist André Salmon, and the poet-artist Jean Metzinger regularly attended Paul Fort's weekly meetings at the Closerie. The Café d'Harcourt in turn was a rendezvous for members of Fergusson's immediate circle, and it was there that John Middleton Murry met Rice and Fergusson in the winter of 1910–1911. In short, by at least 1908 Fergusson was fully aware of the Symbolist and emerging Cubist circles in Paris: his position at La Palette meant that he taught alongside Segonzac, Metzinger, and Le Fauconnier, while his inclusion in *Rhythm*'s Winter 1911 edition

of a Derain woodcut for Apollinaire's *L'Enchanteur pourrissant* is indicative of his familiarity with Fauvism's legacy within the neo-Symbolist milieu.[17]

Fergusson's and Murry's shared enthusiasm for Bergson led the latter to enlist his Oxford friends in the founding of *Rhythm*. Frederick Goodyear and Michael Sadler were won over to the project, and following an April 1911 visit of Sadler and Murry to Fergusson's studio, the artist became the magazine's art editor. In the literary domain, Murry and Fergusson obtained the help of Tristan Derème and Francis Carco, thereby associating *Rhythm* with the Fantaisiste school, as it was represented in the journal *Ile sonnante*. Fergusson's editorial association with *Rhythm* lasted until November 1912, when the magazine underwent serious financial difficulties. As Sheila McGregor has noted, Fergusson's withdrawal as art editor resulted in a decline in the journal's internationalism: the contributions of Derain, Dunoyer de Segonzac, Herbin, and Friesz were replaced by those of a more parochial English camp, consisting of figures such as Horace Brodsky and Albert Rothenstein. In the months following *Rhythm*'s demise in the spring of 1913, Fergusson effectively entered a new phase, leaving his Paris studio to take up residence in the south of France, at Antibes. In the meantime, Rice had also left Paris for London, and the sequel to *Rhythm*, known as *The Blue Review*, signaled Murry's gradual shift away from *Rhythm*'s aesthetic program.[18]

John Middleton Murry's interest in both Bergson and Fauvism first emerged during his student years at Oxford, thus predating his contact with Fergusson over the winter of 1910–1911. Upon entering Brasenose College in 1908, Murry joined the College's Pater Society where he met four youthful enthusiasts of French Symbolism: Frederick Goodyear, Michael Sadler, Joyce Cary, and Philip Landon. Under their tutelage, Murry gained exposure to Maeterlinck, Mallarmé, and Bergson, and with Landon's encouragement he decided to go to Paris in the winter of 1910 to attend Bergson's lectures while reading *Creative Evolution*. In the aesthetic realm, Murry saw Fauvism as the artistic complement to his literary and philosophical interests.[19]

These interests became personified, as it were, following his encounter with J. D. Fergusson at the Café d'Harcourt in December 1910. According to Murry, Fergusson had overheard him discussing Bergson and immediately issued forth with his own assessment, with the result that Murry became enthralled with the "Scottish philosopher-painter."[20] There can be no doubt that *Rhythm* was Bergsonian in import. In January 1911 Murry persuaded Sadler to

become *Rhythm*'s coeditor, and commissioned Goodyear to write a Bergsonian statement outlining the magazine's social theory. Murry and Sadler returned to Paris toward the end of March to see Fergusson and ensure his participation as art editor. It was during this stay that Murry wrote a polemical article on Bergsonism for the magazine's first issue, titled "Art and Philosophy."[21] Since he and Fergusson saw the Fantaisiste movement as the literary corollary to their Bergsonian Fauvism, he apparently sought out Carco and Derème who were to contribute to *Rhythm* up to February 1913. The appearance of *Rhythm* was in turn noted in *Ile sonnante*, and the close relationship between Murry and the Fantaisistes was signaled by Derème's dedication of a poem to Murry in 1912.[22] The next year, Carco published his *Chansons aigres-douces* with illustrations by Segonzac, Rice, and Fergusson, thus underscoring the close connections between the Rhythmists and Fantaisistes.

Fergusson's oeuvre before 1914 is largely made up of portraits of women and a series of iconic nudes executed after 1910. Portraiture was an experimental genre for Fergusson, for all his portraits were uncommissioned, and invariably his subjects were close associates within his artistic circle. Portraits such as *The Red Shawl* (1908) (fig. 9) or *Manteau Chinois* (1909) (fig. 10) are clearly indebted to Whistler's full-length portraits. Moreover, his interest in the decorative led him to title his paintings after the fashionable apparel worn by his female sitters. His portrait of the American artist Bertha Case is titled *The Pink Parasol* (1908), that of Anne Estelle Rice, *Le Manteau Chinois*, and his painting of Rice's friend Elizabeth Dryden, *The Red Shawl*. In a public setting the parasol or oriental robe is a form of decorative self-representation; in Fergusson's work, the placement of such figures in a Whistlerian decorative interior reinforces the merger he cultivated between his own decorative sensibilty and that of his sitters.

In fact this interrelation is fundamental to Fergusson's subsequent development of a Fauvist aesthetic after 1907, which he would define along Bergsonian lines in 1910. Throughout this period he related his own self-image as an artist to that of his chosen subjects and his means of representing them. In Fergusson's case that image was of the self-taught artist, unfettered by academic conventions, whose Fauvist aesthetic was a direct expression of his personality. Thus in his 1909 review of the Salon d'Automne, Fergusson trumpets the "Matisseites" as those who are not concerned with academic procedures but instead subordinate their technique to the dictates of emotive expression.[23] Fergusson in turn insisted that his subjects must provoke an emotional response. For him, the emo-

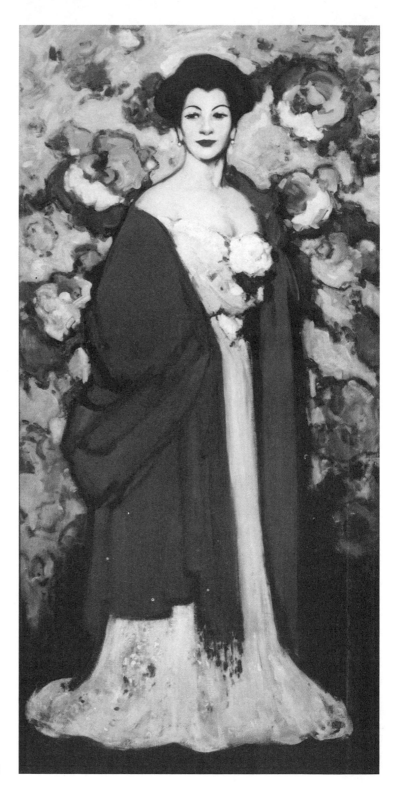

9. J. D.
Fergusson,
*The Red
Shawl*, 1908

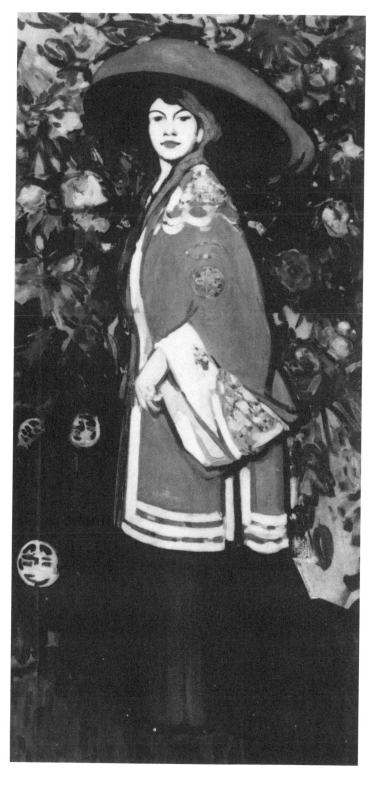

10. J. D.
Fergusson,
*Le Manteau
Chinois*, 1909

tions most conducive to the Fauvist aesthetic were of a sexual type, since he deemed sexual urges elemental and a priori to the social conventions designed to constrain them. It is for this reason that he frequented the Café d'Harcourt, a bar devoid of "respectable girls" where he met women "not concerned about respectability."[24] The sexual behavior of the café "girls" was therefore free of any socially imposed inhibitions (and ripe for the advances of an artist who saw himself as equally liberated).

That Fergusson would restrict such "liberated" sexuality to women of the lower class, and define the café as a sexualized space devoid of the bourgeois propriety he associates with women of his own socioeconomic background, is paradigmatic of how class and gender were interrelated during this period. Lower class women were frequently the object of sexual exploitation on the part of bourgeois men, and the public spaces in which these two classes mixed were considered off limits to women of the upper classes.[25] Indeed when Fergusson wished to initiate a female bourgeoise—including artists from his own circle—into the Fauve world he did so by taking her to the café as a kind of rite of passage into the sexually charged realm of the lower classes.[26] In effect Fergusson's protest against bourgeois male-female relationships only results in the fabrication of a stereotyped Other. The café women and the Fauve palette in which they are depicted are signs for a bourgeois escape from the conventional into the realm of the "natural."[27]

This class-bound attitude about sexual mores was just one component in his programmatic construction of a Fauvist aesthetic meant to fully reflect the "primitive" character of these café women. Fergusson the self-taught artist reported that the women he painted at the Café were self-taught dress- and hatmakers who "wore things they were working at, mostly too extreme from a practical point of view, but with that touch of daring that made them *very helpful*—they were very helpful to me."[28] Fergusson's quick, spontaneous style of drawing at the café echoed the gestural language of the café women, "who were quite pleased to be drawn and didn't become self-conscious or take frozen poses."[29] He would later select images from this gestural repertoire and develop them into works such as his *Blue Beads, Paris* (1910) (plate 3). The painting is an exemplary fusion of subject matter and style. Stereotypical Fauvist elements include the loose brush work and also the use of green in painting the visage of the woman and of a high-key red complement for the lips. Since the café regulars are hatmakers, a large plumed hat is given suitable presence as a symbol of feminine display, which echoes tellingly with her half bared breast. Thus the

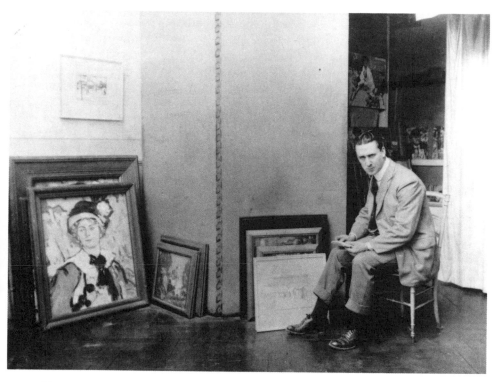

11. J. D. Fergusson in his studio with *The Pink Parasol: Bertha Case* (1908), 1909

self-taught artist has painted self-taught milliners in a style he deems conducive to their unconventional deportment, character, and sexualized sensibility.

Study of their decorative language was not confined to the café: Holbrook Jackson described Fergusson's spartan living quarters in 1909 (fig. 11) as containing "furniture painted white or a flesh-coloured pink, with vivid coloured cushions and bowls of brightly painted dried oranges." The café ambiance was recalled by way of a "dark bowl full to the brim, not of flowers, but of those peculiarly shrill pink matchsticks that were at that time a common object of the Parisian café table."[30] To some, Fergusson's atelier reportedly "looked more like a ladies' boudoir than a studio."[31] That his subjects were part and parcel of his own self-image as a Fauve finds no better confirmation than in the studio décor itself.

In 1909 Fergusson wrote an important review of the Salon d'Automne in which he distanced his expressive Fauvist aesthetic from

the Whistlerian decorative schemas that until then were prominent in his paintings. His contrast between the two styles was couched in terms of the materialistic rather than expressive import of Whistlerian design. In the Whistlerian tradition, "the materialistic point of view" regarding decoration predominates, with the result that artists "make their oils go with the dining room furniture or their watercolours with the drawing room wallpaper."[32] Such practices, he says, are still dominant in America and England, but in France the "Matisseites . . . insist on expressing themselves frankly and fearlessly. . . . The paint that best expresses their emotions is to them the right paint." In effect decorative structure in the Whistlerian tradition bears no relation to a human emotion, for the subject is the relation of color to color, or form to form. It is a doctrine of art for art's sake, in which the painting's formal elements above all signify themselves, rather than some object in space, or a painter's psychological reaction to it. Fauve decoration, on the other hand, is a direct reflection of the artist's emotional response to a subject. It is a sign for an artist's psychological reaction to an object or sitter's personality, and is therefore an immediate form of self-representation.

The ability to give such emotions pictorial form requires *une vision spéciale*, and while the practitioners of this vision "are more in sympathy with each other than any society I know, I cannot think of any two of them who work alike." This special visual faculty, in allowing one to express one's emotions, also guarantees the development of an individual style. Due to adherence to a recipe of inherited and therefore anonymous techniques, academic style in no way captures the individuality a Fauvist seeks to cultivate. Creating an academic painting is comparable to taking a photo: in both cases the means of representation is mechanistic and thus unable to capture the emotional response a subject may evoke. The "photographic accuracy" of academic art can never signify the self-expression empathetic vision purportedly ensures.[33]

Middleton Murry took up this dialogue in his Bergsonian essay "Art and Philosophy" in a discussion of "aestheticism." Whereas Bergsonian intuition leads artists to concentrate their empathetic attention on an ongoing present, practitioners of aestheticism purportedly focus on past "convention and tradition" and make a "rigid system" out of past styles. The ready-made formulae of Academicism epitomize this development; the Fauvists, on the other hand, "reject a chronology which esteems the past because it is the past" and thus "rise above the mere reactions of a dull mechanical routine."[34] Such mechanical techniques are antithetical to a theory of

intuitive self-expression and to the direct transposition of emotional reactions that Murry deems essential to the Fauvist aesthetic. Thus intuition and vision spéciale are two terms for the same aesthetic principle: a rejection of anonymous pictorial conventions in favor of an emotively expressive style.

In Fergusson's schema, the feeling of "intensity" is reportedly integral to "vision spéciale." Such intensity is most evident in figural distortions. For example, in Rodin's work, "the whole treatment expresses the intensity of action, the definiteness of shapes, the grip of the edges, everything intense"; Maillol's sculpture expresses "the intensity of a still night" by way of a nude's "tremendous simplicity," while "the utmost simplicity of treatment" in Chabaud's paintings creates "a most intense realism." The latter comment is important since Chabaud's use of heavy outline to emphasize the decorative surface of his work is thought to have influenced Fergusson in his usage of a reddish blue outline to achieve the same results.[35] Indeed, virtually all of Fergusson's nudes of the 1910–1912 period combine this outlining with the simplification of volumetric mass, to emphasize the visual interplay of the figures with the decorative surroundings in which they are placed (plate 4).

After 1909 Fergusson's attempts to represent his vision spéciale became part of a more complex theory concerning the function of rhythm in Fauvism. His opinions were encapsulated by his close friend Frank Rutter in a December 1911 article for *The Studio*,[36] an article devoted to Fergusson's portraits and based on theories expounded in *Rhythm* around this time. Rutter begins by acknowledging Fergusson's debt to Whistler before noting that the innovation fundamental to his Fauvist phase is the "application of rhythm to the expression of character in portraiture."[37] The role of rhythm in this regard is twofold: it records "with emotional emphasis [Fergusson's] personal experience" and serves to "particularize each person he portrays."[38] To particularize his models, Fergusson reportedly emphasizes those physiognomic lines most indicative of the sitter's character and then repeats them throughout the canvas. In *The Red Shawl* (fig. 9), "the significant lines of the forehead and chin, for example, are balanced and repeated in the contours of the petals to her left."[39] Therefore, such decorative backgrounds "never distract our interest from the central figure" but "simplify for us the essential characteristics of the personality portrayed."[40] Rutter's summation of the psychological import of these rhythmic "significant lines" was not lost upon Murry and other critics associated with *Rhythm*. Where Rutter, paraphrasing Fergusson, explains how the artist extracts the significant lines from a "central figure" to form a decora-

tive rhythm, Carter in *The New Age*[41] talks of how the Rhythmists "extract the fundamental design" from a "central object of vision" by means of Bergsonian "intuition." This design is then repeated in the work in order to give it emphasis and unite the object with a surrounding decorative ensemble. Murry, in the inaugural edition of *Rhythm*,[42] describes how artistic intuition captures "essential forms" by disengaging "the rhythms that lie at the heart of things." In the process, artists do not focus on the visual appearance of the subject in question; instead their "intense gaze" only discerns lines and colors which will embody the inner, vital rhythm of a subject.[43] This "intense gaze" fulfills a function not unlike that of the "feeling of intensity" Fergusson related to empathetic vision: in both cases a type of photographic realism is replaced by abstraction and figural distortion in response to one's emotions. Rutter noted that these essential lines serve to particularize the person portrayed; both Carter and Murry repeatedly state that intuitive vision and its rhythmic correlate embody the individuality of a subject.[44] In effect, Carter and Murry redefine Fergusson's empathetic special vision as intuitive or "immediate vision,"[45] while incorporating Rutter's later dialogue on rhythm's psychological essence into a Bergsonian context.

By employing musical metaphors in his description of Fergusson's rhythmic structures, Rutter was able to stress the psychological rather than "materialistic" significance of decoration that Fergusson had broached two years previously. Through rhythm, color and line are "blended into one harmonious whole" so that "not a single note stands out so prominently as to disturb the unity of the whole in tone or mass."[46] Since rhythm is used "to particularize each person [Fergusson] portrays," each painting possesses a distinctive musical character, unique to a given sitter. The wealth of accessories in *La Dame aux Oranges*, for instance, "is again an orchestration of the curves and contours peculiar to the sitter, a rhythmic fugue in line and colour." Presumably, a stately fugue could give way to an allegro, depending on the sitter's personality. Thus according to Rutter, Fergusson is able to "emphasize by a change in metre the dignified repose of Miss Elizabeth Dryden" (fig. 9) and the "sparkling vivacity" of the *Spotted Scarf* (fig. 12).[47] The harmonic interpenetration of the painting's rhythmic elements give us a unified image of the individual personality represented.

The correlation of personality with personal rhythm and the transferral of this rhythm into pictorial design was key not only to Rutter's evaluation of Fergusson, but to the Rhythmists' interpretation of Bergson. As Gabriel Marcel notes, Bergson frequently used a tune as his ideal metaphor for pure duration. He spoke, in fact, of

how our past and present mental states permeate one another to form an organic whole with a particular rhythm.[48] Rutter, it would seem, simply transposes that description into a pictorial context. Thus Fergusson reportedly uses empathetic vision to grasp the inner rhythm of a sitter, and makes it the leitmotif of his rhythmic compositions. In Murry's criticism the paradigm is still more explicit: time, in the guise of the élan vital, constitutes "the essential music of the world," and the "rhythms" fundamental to our own individual élan become a painting's "essential harmonies of line and colour" by means of intuition. Such qualitative harmonies reflect the "great continuity" intrinsic to time as a creative force in humankind.[49] Carter concurs, and also describes the "rhythmic vitality" nascent in the élan vital as fundamental to an artist's creativity. Thus the "internal law of continuity" which rhythm represents is part of a painting's structure. Through intuition artists are producing "inspired pieces of music, putting together new pictorial material, composing lyrics in colour, lyrics in line, lyrics in light to the new diety, rhythm."[50]

12. J. D. Fergusson, *The Spotted Scarf*, 1908–1909

Carter's references to a new deity and the élan vital signal an amplification of rhythm's meaning beyond that envisaged in Rutter's article on Fergusson. In his discussion of Fergusson's portraits, Rutter sees rhythm as an analogue for individual psychological duration, not some pantheistic life force latent within artistic creativity. By way of contrast Murry describes rhythm as an analogue not only for personality but for "the great divinity immanent in the world."[51] Likewise, for Carter, rhythm represents "the apprehension of the Reality underlying forms of life, of things living and evolving."[52] Rhythm in Fergusson's portraits would have surely meant more to these critics than it would seem to have meant to Rutter. But there is a problem here, namely, how does one relate an intuitive aesthetic of individualism keyed to Fergusson's portraiture to the individually transcendant aesthetic Carter and Murry were then forg-

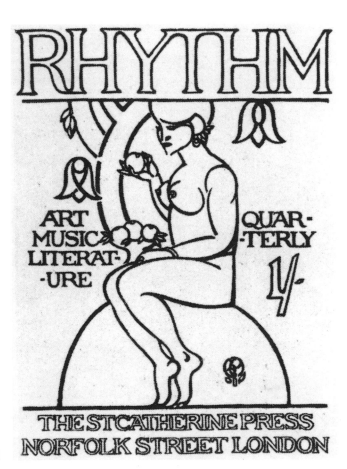

13. J. D. Fergusson, cover of *Rhythm*, 1/1, Summer 1911

ing, with its emphasis on the inner vitality of matter rather than the psychological durée of the human mind?

The series of female nudes Fergusson was executing at the time Rutter's article was written would seem to embody the ideas Carter and Murry were formulating in *The New Age* and *Rhythm*. Indeed, one image from the series, titled *Rhythm* (plate 4) and exhibited at the 1911 Salon d'Automne, was based on a prototype designed especially for *Rhythm* magazine's cover (fig. 13). Fergusson seems to have used the same model for almost all of these works, but she is clearly presented as no woman in particular in the fiction of the paintings. By portraying her naked in abstract settings, he removes her from any modern-day or social context and suggests a mythological one; by giving these works titles such as *La Force* (1910) or *Rhythm* he makes her role as a symbol for some vitalistic principle self-evident. Frequently, her facial features are not only generalized, but also half veiled in shadow (fig. 14), to suggest an air of psychological intangibility. Elizabeth Cumming has reached the following conclusion regarding the significance of such works:

14. J. D. Fergusson, *Torse de femme,* 1910–1911

The power of the nude of "La Force" and "Torse de Femme" [fig. 14] led directly to these representations of the female personification of the spirit of life. Woman appears as the source of natural life, which in "Rhythm" relates to her in the form of a gently curving tree and its product fruit. There is a sense of calm, of growth and conclusion in the work, its subject a summer goddess of nature, a Ceres or an Eve; to Fergusson she was the Bergsonian impulse of life.[53]

In fact the Bergsonian interpretation of rhythm within Fergusson's circle had dual significance when applied to his art. In reference to his portraits, rhythm represented the individualism of both sitter and artist, the qualitative difference of which was discernable to the artist by way of a vision spéciale, later equated with intuitive vision by Fergusson's associates. Significantly such portraits were usually of women from the bourgeois circles in which he moved, and Rutter's essay was in fact devoted to images of this type. Unsubjected to the sexual objectification he reserved for women of the lower classes, Fergusson focused on their physiognomy as a sign of their spiritual rather than corporeal nature. However, when Fergusson de-particuliarizes his female sitters, they become amenable to the vitalistic presuppositions entailed in Carter's and Murry's discussions of intuition. Rhythm for Carter was proof that Fergusson not only employed intuition to perceive individual character, but also to capture a more fundamental durational impulse native to all living species. A parallel progression exists in Bergson's writings, for it was only in *Creative Evolution* that his analysis of psychological duration in *Time and Free Will* became firmly rooted in a more general notion of a cosmic élan vital.[54] In the process, artistic creativity was transformed from a form of individual expression into an agent for a vitalistic creative force. Time itself was now creative; biological procreation one of its manifestations, and artistic creativity, the exemplary case of how time *is* creative. Thus while disinterested vision had only allowed artists to reveal "the individuality of things and beings" in "Laughter,"[55] in *Creative Evolution* their manner of perceiving and acting assures their privileged participation in the creative activity of the universe. By identifying time with creativity or invention, Bergson is able to describe the time needed to create a work of art as a "vital process."[56] On this basis duration in the universe must "be one with the latitude of creation which can find place in it."[57] Artistic creativity is no longer an end in itself, but instead the vehicle for vitalistic forces which transcend it. As a depersonalized Ceres or Eve, the female nude in Fergusson's *Rhythm*

could stand for such biological, procreative forces. At the time of its creation *Rhythm* was interpreted in just this way: Huntly Carter noted that the "strong decided line" in the painting "was intended to express a great elemental truth—namely, there is a line of continuity underlying life which has bound all Eves ever since the world began."[58]

The vital forces personified in *Rhythm*, *La Force* and *Torse de Femme* are inherent in the time taken to paint them, and Fergusson has once again created images reflective of himself. The result, however, is a series that divides the creative process along gender lines. For while Fergusson's pictorial creations are a sign for his conversion of an elemental élan vital into a cultural artifact, the élan itself is emblematized in images of the primeval woman, a catalyst for artistic creativity who herself is subsumed within the creative forces of nature. The male artist alone is able to creatively mold the rhythmic élan vital in his own image.

The primal symbolism of a Ceres-Eve also connects Fergusson to the legacy of Fauvism as interpreted by André Derain. In a recent article Jane Lee has done much to illuminate Derain's relation to Apollinaire and the neo-Symbolist milieu.[59] In particular she sees "woman" operating as a symbol for the mystery of creation in Apollinaire's *L'Enchanteur pourrissant* (1909) and the woodcuts Derain executed for that text, one of which was illustrated in the Winter 1911 issue of *Rhythm*. In Apollinaire's poetic symbolism the birth of Eve is said to predate that of Adam, and to have been synonymous with the creation of the universe itself. Thus woman in *L'Enchanteur pourrissant* is inscrutable by her very nature, and her mystery is a threat to man. She is identified with the ominous primal forest, or with Viviane, a demonic force who buries the Arthurian Merlin while the latter is still alive. Lee then relates such symbolism to the iconic female figures in Derain's *La Danse* (1906). Derain's painting represents an episode from Apollinaire's book in which three *fées* feverishly dance over the serpent of temptation, while the Gauguinesque figure of Viviane rests near the tomb of Merlin. The dancers are iconic emblems of non-European civilization or the remote past: one figure wears classical Greco-Roman drapery, another is derived from erotic Indian statuary, and the third is the North African slave girl in Delacroix's *Women of Algiers*. Thus "each of the personages in *La Danse* is a facet of the original woman, three exotic and mysterious Eves from distant lands."[60] Their stylized facial expressions have a function akin to the African-masked women in Picasso's *Les Demoiselles d'Avignon*: in

both cases their stylized physiognomy conveys a sense of estranged sexual difference, fraught with disturbing implications for the male viewer.

In Fergusson's painting we are not confronted with a man-eating siren or threatening sphinx; woman in *Rhythm* takes the form of a benign earth goddess, a feminine principle of fecundity more conducive to the optimistic world view found in *Creative Evolution*. To symbolize woman's proximity to a "natural" condition, Fergusson conflates her role as child bearer with nature's fecundity, by picturing her as the bearer of nature's fruit, the apple. But how do the painting's formal characteristics relate to such imagery? As previously noted, Carter referred to the decorative line in *Rhythm* as a vitalistic "line of continuity underlying life."[61] The relation Carter posits between the procreative forces the woman personifies and Fergusson's manner of portraying her neatly exemplifies the kind of incorporation of meaning into abstract form that Fergusson had been developing over the previous five years. That symbolic language had its origins, Fergusson states, in a flower arrangement he had seen in 1906. This decorative combination of organic forms had given him "the first idea of the strength of the most delicate things" which led him to use "very durable paint to give [it] permanent expression."[62] Given Fergusson's previous association of floral hats with decorative display, and his placement of half-naked female figures in decorative floral settings (fig. 15), his new association of the feminine and nature's bounty with the biological rhythm of nature seems a logical progression. As for durable paint's vital properties, the thick, sinuous reddish blue line delineating the nude's form embodies that, and his use of the same colors to paint the background tree reminds us of the origin of *Rhythm* in nature. In writing about this period, Fergusson's colleague Raymond Drey sheds further light on the symbolic import of such durable paint:

> Fergusson was a man of stubbornly held opinions and theories about art. The word "solidity" was constantly on his lips, to be realized by the direction of brush-strokes (drawing in paint he called it) no less than by opposition of light and shade defining formal relationships. He was often rather over obsessed ... by an exaggerated kind of sexual symbolism. Sometimes in his nudes this fullfilled itself. ... Some of his portraits suffered from this tendency to overemphasize a voluptuous curve and pigmentation of the lips and to change slender necks into columns of sculptural form [fig. 16]. This heightened the feminity of the sitter at the expense of character and individuality.[63]

15. J. D. Fergusson, *Voiles Indiennes*, 1910–1911

16. J. D. Fergusson, *Rose Rhythm: Kathleen Dillon*, 1916

In Drey's account the vitalistic strength of Fergusson's durable paint becomes a metaphor for female sexuality, thus forming a link between these generative nudes and his early Fauve images of milliners. No doubt, the exaggerated musculature of the nude in *Rhythm* or the broad-necked woman in *Rose Rhythm* (1916) (fig. 16) exemplify what Drey had in mind. Indeed, as the title suggests, *Rose*

Rhythm: Kathleen Dillon is an attempt to combine his ideas on portraiture with those subsequently developed in his iconic nudes. The resulting image converted the psychological import of his portraiture into a sign for women's proximity to the elemental élan vital. In describing the work Fergusson outlines this synthesis:

> When I came back to London at the beginning of the First World War in 1914, I met one of Margaret Morris' best pupils, Kathleen Dillon, a very good looking, charming and intelligent girl. . . . One day she arrived with a remarkable hat. I said "that's a very good hat you've got." She said, "Yes isn't it? I just made it!" It was just like a rose, going from the centre convolution and continuing the "Rhythm" idea developed in Paris and still with me. Looking at K I soon saw that the hat was not merely a hat, but a continuation of the girl's character, her mouth, her nostril, the curl of her hair—the whole character (feeling of her)—like Burns' love is like a red, red rose. So she, like Burns again, lighted up my jingle and I painted "Rose Rhythm"—going from the central convolutions, to her nostril, lips, eyebrows, brooch, buttons, background cushions, right through. At last, this was my statement of a thing thoroughly celtic. Kathleen is Irish, in the Celtic referred to as "Dillon son of the Wave," and the movement was a wave movement—and was a movement not only in the hat she had created, nor in my picture, she created it in herself through and through, which was evident in all her dances we had the good fortune to see in MM [Margaret Morris] theatre at Flood Street Chelsea.[64]

The relation of the image to Burns's ode to love is most obviously symbolized by the heart-like shape of her head. Dillon is presented in a frontal pose wearing a coat and hat, with her head cupped in her right hand. That hand and arm are reduced to a series of curves rather like the crest of a wave, and such crests cascade throughout the painting: in her hair, coat, blouse, and most prominently in the hat itself. Their rhythmic reverberation, following the precedent of his earlier portraits, is echoed in the abstract crests and arcs forming the decorative background. This decorative unity is reinforced by Fergusson's choice of colors. The tan colors of Dillon's straw hair, pink lips and brown-gold eyes resonate with the decorative backdrop's pastel hues.

Rose Rhythm then was a pictorial nexus for ideas going back to the prewar period. The basic inspiration Fergusson derived from Dillon's hat has its pictorial genealogy in the Café d'Harcourt paintings previously discussed. Fergusson feels the same sexual affinity with Dillon that he felt with the milliners; moreover, his "feeling of her" reportedly mirrors Kathleen's feeling about herself, as it is expressed

in the decorative hat of her own making. Fergusson's empathetic vision allows him to "intuit" her character. Dillon's hat expresses that character in an unconventional and thus equally immediate form; and Fergusson seeks to replicate the wave movement that empathetic vision has revealed to be the essential one. In capturing this undulating rhythm he does not resort to the open brushwork of his early Fauve style but delineates forms in a manner recalling his nudes. Similarly, while repeating earlier assertions that decorative rhythm should embody a sitter's character, Fergusson goes on to note that Dillon's personal rhythm is found not only in her hat and physiognomy but also in her dances, and even in the Celtic genealogy of her name—"Dillon, son of the Wave." Presumably all Dillons share this wave-like character, and the revelation of that rhythm in Kathleen's diverse activities, whether they be dance or clothing design, reflects not only her particular character but also the rhythmic élan of her family forebears. There is something in her individual rhythm that transcends it, since psychological duration and biological procreation are directly interrelated in *Rose Rhythm* as they were in *Creative Evolution*. Dillon's dance, her hat, her very physiognomy thus become emblems of nature's rhythmic élan, whose sexual pulse is barely hidden under the thin veneer of her artisanal endeavors.

That dance for Fergusson was an expression of primeval rhythms touches on another important element in his Bergsonian vocabulary: rhythm, for Fergusson and his associates, was the underlying element in all the arts, and thus the leitmotif for a synaesthetic system. Murry in his autobiographical reminiscence of the prewar period recalled that Fergusson saw rhythm as

> the essential quality in painting or sculpture; and since it was at that moment that the Russian Ballet first came to Western Europe for a season at the Châtelet, dancing was obviously linked, by rhythm, with the plastic arts. From that it was but a short step to a position that rhythm was the distinctive element in all the arts and that the real purpose of this modern movement . . . was to reassert the pre-eminence of rhythm.[65]

While Diaghilev and Bakst were certainly an inspiration for the Rhythmists, it is arguable that Jacques Dalcroze's doctrine of eurythmics held greater theoretical import for the group.[66] Carter discussed Dalcroze's eurythmics as part of his evaluation of *Rhythm*'s first issue;[67] Sadler drew comparisons between eurythmics and modern art's means of expressing the soul's "inner harmony";[68] and Fergusson's monumental *Les Eus* (1911–1912), or *The Healthy*

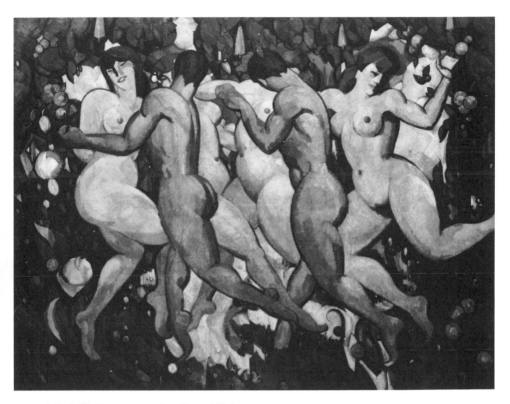

17. J. D. Fergusson, *Les Eus*, 1913

Ones, derived its title from Dalcroze's theories (fig. 17).[69] Having
noted the Bergsonian tenets of *Rhythm*, Carter remarks on Dal-
croze's parallel discovery of a method of expressing a dancer's "nat-
ural music," also termed "the rhythmical life of the human body."
By allowing his pupils to compose their own "musical movements"
with a series of notes, the students are able to "move through life in
compositions in which spontaneous melody and rhythm, and not
mechanical, logical, or meaningless actions, are essential."[70] Since
these actions are not logical they are, to use a Bergsonian term, intu-
itive. What Dalcroze was doing for physical movement, the Rhyth-
mists were doing for artistic vision and expression. In effect,
Dalcroze's method is part of the Rhythmists' "revolutionary move-
ment designed to promote the expression of the rhythmical life of
mankind."[71] Appropriately, the chapter in Carter's *The New Spirit
in Art and Drama* devoted to modern art ends with an illustration of
the Dalcroze system (fig. 18), and a note that Fergusson's colleagues,

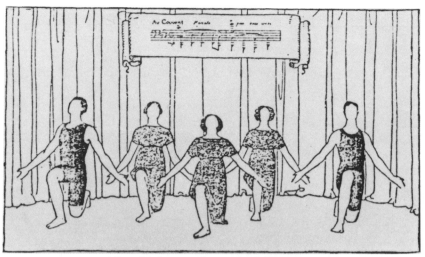

The Dalcroze System of Dancing.

18. M. Thévenez, *The Dalcroze System of Dancing*

like Dalcroze, "are seeking an external harmony that will express the internal harmony of a subject."[72] As Carter relates, eurythmics, in calling a vast number of the body's muscles into play, aids their development, and nurtures the aesthetic potential of all our sensory faculties. Eurythmics' salutary effects are clear to be seen in the athletic figures in *Les Eus*, and their "natural music" most evident in the portrayal of these Dionysian dancers in their natural state, surrounded by a fertile landscape whose élan they will undoubtedly emulate. *Les Eus* is unique in this regard, for it is the only work in Fergusson's oeuvre in which both sexes are subsumed within nature's primeval rhythms.

Fergusson's series of generative nudes also posed a challenge to the Cubists, for the similarity of *Rhythm* (plate 4) to Le Fauconnier's *L'Abondance* (fig. 19) is unmistakable. Indeed, among Fergusson's entries to the 1911 Salon des Indépendants where the much anticipated *L'Abondance* was on view were two paintings from his series of nudes: *Torse de Femme* (fig. 14) and a study for *Rhythm* which heralded the monumental *Rhythm* exhibited at the next Salon d'Automne. *Rhythm* and *L'Abondance* shared the same content: both were paintings of a monumental nude symbolizing the regeneration and fecundity of nature. In Le Fauconnier's case, the nude female not only gathers nature's fruit but is accompanied by a child, the organic product of her own fecundity. Moreover, as Green

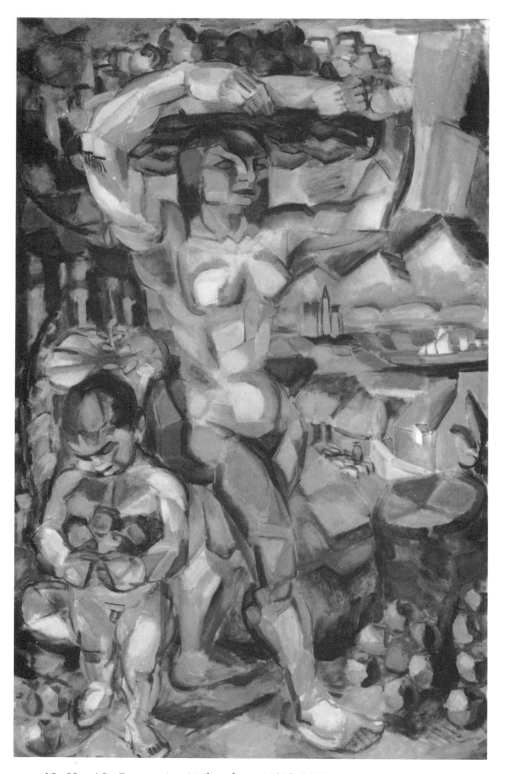

19. Henri Le Fauconnier, *L'Abondance*, 1910–1911

notes, the themes of regeneration and fruitfulness in the painting were meant to echo Mercereau's poetic and Bergsonian ode to female fecundity in his "Paroles devant la vie" (1911). The relation of Mercereau's theme to Le Fauconnier's work "is not difficult to establish," says Green, "since for Bergson organic regeneration and evolution were especially powerful expressions of la durée."[73] David Cottington has additionally suggested that the painting's rhythmic structure bears comparison to Visan's Bergsonian interpretation of *vers libre*, which treated the rhythmic constant as variable rather than inflexible.[74] The association of rhythmic structure with generative imagery is equally clear in Fergusson's *Rhythm*, and its Bergsonian allusions would have been self-evident to Gleizes and his Cubist colleagues.

When the Rhythmists and Cubists developed a male counterpart to images like *Rhythm*, they invariably represented a cultural activity, competitive sports. The feminine élan vital exemplified by the decorative principle operative in Fergusson's *Rhythm* had its male equivalent in another painting shown at the 1911 Autumn Salon, Dunoyer de Segonzac's *Boxers* (fig. 20). This raises the issue of Segonzac's place in Parisian modernism, for although Segonzac exhibited with the Puteaux Cubists from the 1911 Salon d'Automne onward, his status as a Cubist was never assured: writing of the 1910 Salon des Indépendants, André Salmon labeled him "a Fauve whom it is impossible to classify, not really a Cubist," while in his review of the Autumn Salon of 1911, he referred to Segonzac as among those who were "merely cousins of the Cubists."[75] That assessment was echoed by Gleizes, who in his review of the same Salon separated Segonzac from those who "were considered Cubists," though he acknowledged that Segonzac had "similar concerns." However those concerns were apparently not adequately met by Segonzac's entry to the famous Salle 8: Gleizes reproached Segonzac for the slightly caricatural style he employs in his *Boxers*, "exaggerations" whose aim is "more decorative than plastic." Gleizes condemns these decorative distortions as having their origins in Segonzac's 1911 drawings of Isadora Duncan, which he dismisses as "curious notations on a reduced scale."[76] Nor did Segonzac's status improve in 1912; although he exhibited in the October 1912 Salon de la Section d'Or, neither Gleizes and Metzinger in *Du Cubisme* (1912) nor Apollinaire in his *Les Peintres cubistes* (1913) make any mention of his work.

By way of contrast *Rhythm* devoted a whole article to Segonzac's *Boxers*, and Carter in his review of the same Salon condemned Gleizes and the Cubists before declaring "M. de Segonzac's 'Boxers'

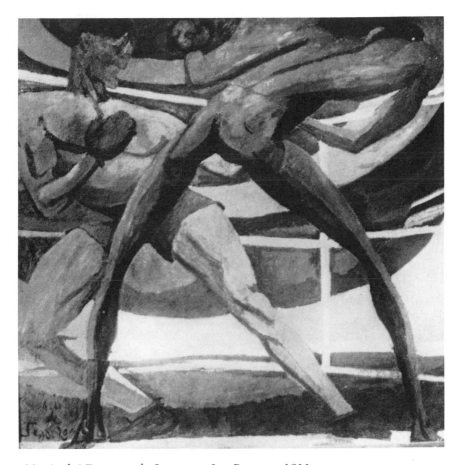

20. André Dunoyer de Segonzac, *Les Boxeurs*, 1911

one of the finest examples of direction of line in the Salon."[77] The affinity between Segonzac and the Rhythmists existed on a personal level as well: Segonzac, who first met Fergusson in 1907, remained close to the Scottish artist throughout his life. Upon Fergusson's death in 1961, Segonzac wrote a eulogy to the artist in which he referred to Fergusson's role as "the editor of a very interesting review *Rhythm*, to which I myself contributed."[78] One of Segonzac's contributions was a drawing after his painting *The Boxers*, which was reproduced in the Spring 1912 issue of *Rhythm*; another may have been his introduction of Fergusson to the Ballets Russes, which had a profound impact upon the decorative aesthetic promoted by *Rhythm*.[79]

The Rhythmists' critical reception of *The Boxers* suggests Segonzac's adherence to the *Rhythm* group's decorative and Bergsonian principles. The distortion and formal simplification of the boxers themselves, combined with the transformation of the audience into an abstract sweep of lines, are calculated to integrate foreground and background into a decorative whole: this is the very procedure Fergusson utilized in *Rhythm* to suggest the vitalist theme uniting the representational and abstract elements of his painting. Although Segonzac, in *The Boxers*, differs from Fergusson in his use of what Gleizes termed "gray color," the figural distortion and linearity he uses "to heighten the decorative effect"[80] that Gleizes found so objectionable are pictorial elements that Fergusson and Segonzac share.

Moreover, the *Rhythm* critics were quick to align the Bergsonian rhetoric utilized in reference to Fergusson to the subject matter and decorative form of *The Boxers*. Arthur Crossthwaite, in an article published in *Rhythm*'s 1911 winter issue, described Segonzac's "vital" image as "the Life force in man made manifest," the "great primeval instinct" and "will" of which is antithetical to the "restful Madonnas" at the Louvre.[81] This theme of a distinctly masculine volonté was also taken up by Carter, who declared the canvas exemplary of Segonzac's "will to power." "The canvas," Carter asserts, "throws its will upon the spectator," and the sensation of will comes "not only from the combatants in the foreground, but from the mind of the audience symbolized in the background by a tremendous direction of swishing line."[82] The restful repose of *Rhythm*, Fergusson's icon of the feminine élan, is absent from Segonzac's *Boxers*, which celebrates a male "life force," or what Bergson himself termed the *volonté créatrice* associated with the revived interest in sport among French youth.[83] Bergson's views on the regenerative capacity of sports were shared by others of his generation: Paul Adam in *La morale des sports* (1907) described sports as able to increase "man's dexterity, courage and power," while the Republican Victor Margueritte cited sports as a means of combating the "vital weakening" of France and instilling a "cult of energy" in French youth that would "preserve the race and extend its strength." Moreover Bergson's correlation between male volonté, sport, and the creative capacities of French youth was taken up in Agathon's *Les Jeunes Gens d'aujourd'hui* (1913), a highly popular book which employed Bergson's terminology in a celebration of French nationalism. Citing Bergson, Agathon associated the youth's "life energy" with their "anti-intellectual" attitude and love of sport. "Sport", we are told, has created a "patriotic optimism among

young men"; further, "collective sports like football" produce a "spirit of solidarity" reflective of "military virtues."[84] As John Bowditch has shown, Agathon's description of this Bergsonian esprit de corps echoed prewar military rhetoric which eulogized the "qualitative" élan vital of the French soldier as a psychological weapon able to compensate for any shortage in numbers when compared to the Germans.[85] David Cottington in turn notes that Agathon's nationalistic celebration of sport may be the inspiration behind Gleizes's *Football Players* 1912–1913 (fig. 21), a painting which Apollinaire described as "vigorous," with "élan" as its subject matter.[86] However the full import of Segonzac's or Gleizes's images of sport only emerges when these odes to male volonté are considered in relation to their female equivalents, Fergusson's *Rhythm* or Le Fauconnier's *L'Abondance*. That male élan is signified by a cultural activity like sport, with its metaphoric relation to armed combat, is the counterpart to a discourse that would restrict the feminine élan to biological reproduction. And as Ortner states, this formulation speaks

> to the great puzzle of why male activities involving the destruction of life (hunting and warfare) are often given more prestige than the female's ability to give birth, to create life. . . . we realize it is not the killing that is the relevant and valued aspect of hunting and warfare; rather it is the transcendental (social, cultural) nature of these activities, as opposed to the naturalness of the process of birth.[87]

In fact, competitive sports, whether boxing, football, or cycling, became an important Cubist theme by 1913, with artists like Delaunay, Archipenko, and Metzinger portraying male athletes engaged in such "cultural warfare." For instance, Metzinger's *Le Cycliste* of 1911 (Peggy Guggenheim Collection, Venice) focuses on a sport Eugen Weber has described as a French creation, and one affordable for the working class by 1900. To underscore the French genealogy of the sport, Metzinger's cyclist is flanked by a poster advertising the Paris-Rouen race, a reference to the first long-distance cycle race, inaugurated by the French in 1869. By way of contrast, the English origins of Rugby, or *le football* in French usage, were embodied in the very title of Delaunay's *The Cardiff Team* of 1912–13 (Stedelijk Van Abbe Museum, Eindhoven), and throughout the prewar period it was the English who dominated international competition and made up the majority of the roster of French football teams. Thus sport, though associated with French moral and physical regeneration, was a symbol that frequently transcended national barriers, an imported tradition the French sought to emulate as a metaphor for their own national strength and military preparedness. The

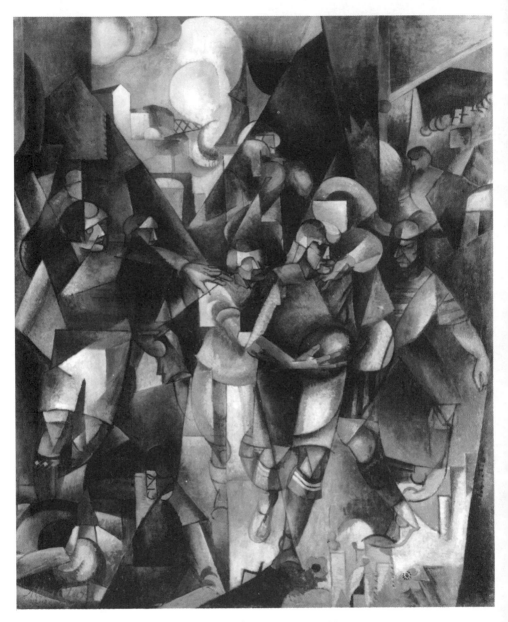

21. Albert Gleizes, *The Football Players*, 1912–1913

Cubist and Rhythmist images of sport may have intersected with other discourses as well. At the time Gleizes painted his *Football Players*, Bergson's philosophy was under sustained attack from factions on the right, particularly members of the royalist Action française and their apologists. Within these circles, Bergson was not only accused of being anti-intellectual, his philosophy was condemned for favoring feminine instinct over male intellect. Thus in an article of 1914, Charles Maurras labeled Bergsonism a form of "feminine romanticism" that advocated the "systematic denigration of intelligence" in the name of "instinct." In *Le Bergsonisme* (1912) and *Une Philosophie pathétique* (1913), the antirepublican Julien Benda not only declared Bergson's philosophy "feminine," he went on to condemn the Parisian avant-garde for emulating Bergson's cult of "pur devenir." Such rhetoric was also repeated in the conservative press: when Etienne Rey sought to parody Bergson's public lectures at the Collège de France, he contrasted Bergson's austere appearance with the "pretty and frivolous Parisiennes" who reportedly listened "with a touching and comic attention." Likewise a writer for the satirical *Fantasio* noted that Bergson, in contrast to his gaily dressed female audience, "dressed completely in black," in order to "show that he is a philosopher." In 1914 *La Vie heureuse* published a drawing showing Bergson inundated with flowers from female admirers, with the memorable caption: "Mais . . . Je ne suis pas une danseuse." Clearly those who wished to ridicule Bergsonism did so by labeling his philosophy "feminine," and just as clearly the Cubists' and Rhythmists' masculinization of that aesthetic constituted a counter-discourse to such rhetoric.[88]

The Bergsonian precepts linking Fergusson's *Rhythm* to Segonzac's *Boxers* thus define the gender politics of Le Fauconnier's *L'Abondance* when compared to Gleizes's *Football Players*. In both cases a cultural activity, dominated by men, is said to represent an élan vital whose feminine equivalent is a function of nature's fecundity. Bergsonism, in its pictorial manifestations, constitutes yet another example of the subordination of women in the realm of cultural production.

Yet this discourse contains further levels of complexity, for despite the opposition posed here between female and male principles it should be remembered that both were conjoined in the primal élan vital. Any of the élan vital's gendered manifestations could possess varying amounts of female or male élan, and Fergusson, in his decorative works, conflated the signs of male and female sexuality in an attempt to grasp durée at its pansexual origin. On the same basis the *Rhythm* critics could assert that a female artist was in pos-

session of a male gendered artistic "will to power," a claim they in fact made for Anne Estelle Rice. Thus the binary opposition between male and female élan could dissipate, and gender categories become unstable, depending on the ideological import of the art or art criticism. Any conception of artistic creativity as an end in itself, or of male artists as the "origin" of such creative forces is likewise negated. In Bergson's monistic theory of creative evolution, the élan vital transcends its gendered manifestations, both male and female.

Just as gender distinctions become blurred when Fergusson grasps the élan vital intuitively, distinctions between the élan and its material products are lost when the Rhythmists and Cubists intuit the rhythmic properties of "extensity," the concept of qualitative space the Cubists associated with passage. Gleizes and Metzinger in *Du Cubisme* counsel artists to join areas of passage rhythmically, so that they may suggest the artist's intensive but ineffable personality to the beholder. In short, rhythmic extensity evokes an intensive duration, synonymous with the personality of the artist. In the case of the Rhythmists, it is the personality of each individual which possesses a rhythm, and having grasped it, artists add their own inner duration to it, to create pictorial form. Rhythmic unity in a painting produces what Huntly Carter terms an external harmony, equivalent to the internal harmony experienced during the moment of "will-impressionism."[89] But if rhythm is native to both extensity and duration, and duration is termed a more intensive form of rhythm, does it not follow that rhythm is the connecting link between pictorial extensity and psychological duration? And is not rhythm—the recurrent pattern within a duration of tones—a mixture of space and time? Bergson, in fact, proposes just that in his analysis of rhythm's relation to extensity in *Matter and Memory*.[90]

By defining extensity as a quality, Bergson hoped to defuse the intellectual prejudice that would identify the inextensive with quality and extensive with quantity. In reality, Bergson states, concrete extensity is composed of nothing more than changes of tension and energy, in short, qualitative movement. And to Bergson's mind "these movements, regarded in themselves, are indivisibles which occupy duration, involve a before and after, and link together the successive moments of time by a thread of variable quality which cannot be without some likeness to the continuity of our consciousness."[91] This tension, therefore, is comparable to a melody, a linear succession of tones that cannot be divided. Even if a melody is stopped, "it would no longer be the same sonorous whole, it would be another, equally indivisible."[92] Indeed, all that distinguishes the

melody of matter from that of our own duration is the faster rhythm of the latter in comparison to the former. Our duration has its own determined rhythm, and since all movements possess a rhythm "it is possible to imagine many different rhythms which, slower or faster, measure the degree of tension or relaxation of different kinds of consciousness, and thereby fix their respective places on the scale of being."[93] In Bergson's cosmology, matter itself possesses a latent consciousness, taking its place as the slowest rhythm on the scale of being whose degrees of rhythmic tension are a function of the degree of freedom inherent in their activity. The individual is decentered as the origin of creativity, and the closed system of organic form opens into the monistic élan vital.

By demarcating quantitative or intellectual order from qualitative durée in its intensive and extensive state, Bergson did not banish "order" from duration altogether—quite the contrary, he wished to unveil an order of a different nature, a rhythmic order internal to durée. It is rhythm, manifest in sensations of melody, harmony, or degrees of tension, that an artist translates into a work of art. Intuition, we are told, gives us access to what Bergson termed the "logic of the imagination that is not reason," whose laws "hold the same relation to imagination that logic does to thought."[94] An overview of the literature studied so far bears witness to the pervasiveness of this paradigm in Cubist and Rhythmist circles. When Romains describes intuition as allowing us to discover "through penetration the internal order of the thing,"[95] or Gleizes and Metzinger extol intuition as able to direct the viewers of their paintings "toward the imaginative depths where burns the light of organization,"[96] it is evident that the organization and order referred to are Bergsonian in nature. Statements of a similar sort are numerous in the criticism of the Rhythmists, whose references to duration's "inner harmony" or "spontaneous melody and rhythm" make the correlation of durée with a painting's internal order even more explicit.[97]

On this basis we could describe actions of a more utilitarian nature as moving at a slower rhythm than those of an artistic type. And when Gleizes and Metzinger describe the only difference between Cubists and Impressionists as a "difference of intensity,"[98] they are relegating their peers to this slower rhythmic realm. Likewise when Huntly Carter defines the Fauvists' artistic perception as typified by "intensity of vision carried to its highest pitch,"[99] or Murry, Drey, and others describe the work of Rice and Fergusson using the same terminology, they are placing the Rhythmists on the same plane of higher rhythmic being that the Cubists wish to inhabit.

So much for the difference between intensive and extensive rhythms, but what of the difference between *passage* and the decorative unity in Fergusson's work? Why does Fergusson delineate objects in space while the Cubists condemn such delineation as antithetical to Bergsonian extensity? A partial answer to this problem resides in Bergson's separation of quantitative and qualitative differences. Duration is made up of such differences, since it is composed of qualitative sensations bound together by a particular rhythm. Each rhythm is itself a quality, so that the universe is made up of slower or faster rhythms. Quantitative differentiations do not take account of qualitative differences, with the result that scientists prefer to subsume all durational rhythms into a single, homogeneous time or arbitrarily to divide the extensive continuum. Bergson describes the distinct outlines delineating an object—the surfaces and edges of things—as a product of our utilitarian need to act on them.[100] Such clear-cut outlines are arbitrary divisions in a continuum of colors and shapes that would otherwise be resolved into a harmonious whole. Thus artists in Bergson's philosophy perceive the inner life of things by grasping the "original harmony" of "forms and colors" that binds them into an ensemble.[101]

Quantitative divisions are imposed on the extensive continuum from without, but there are systems whose differentiation is the product of their internal structure, the rhythm of their duration. Such for example is the case with the living organism that, as the product of creative evolution, has been separated by nature itself, given a particular rhythm, and composed of parts which form an undivided whole.[102] Having compared duration to a melody in *Time and Free Will*, Bergson went on to liken time to "a living being whose parts, although distinct, permeate one another just because they are so closely connected." However, despite their apparent closure, durational organisms are not separate; rather they are joined by their sympathetic relation to each other. Bergson finds evidence of this sympathy in a mother's relation to her child, which proves that "the living being is above all a thoroughfare, and that the essence of life is in the movement by which life is transmitted."[103] From a Cubist's or Rhythmist's perspective, a beholder's sympathetic reaction to the rhythm of the canvas could stand for a union of this type. But in the case of the Rhythmists the rhythm suggested is that of the organic subject portrayed. Gleizes and Metzinger, on the other hand, claim that their pictures imitate nothing, and that subject matter in their work is soon to be left behind once they reach "the level of pure effusion."[104] Since their doctrine of percep-

tual conventionalism would declare the Rhythmists' "will-impressionism" to be an illusion, any motif, whether it be an object or an organism, is a mere pretext for self-expression. In short, for a brief moment in 1912, Gleizes and Metzinger claim to be on the road to abstraction, but this rhetorical stance is belied by the continued relevance of subject matter in their works. Gleizes's *Football Players* (1912–1913), for example, demonstrates his desire to grasp not only his artistic esprit, but the élan of his generation.

From this standpoint Bergson's description of art as the indivisible product of a vital process takes on new significance. For Fergusson not only portrays an organic form in *Rhythm*, but the painting is itself an organism composed of qualitative elements bound together as an undivided whole. The "organic relation" rhythm produced in Fergusson's paintings led Carter to announce the Rhythmists' discovery that art like life "is based on rhythmic vitality, and underlying all things is the perfect rhythm that continues and unites them."[105] And Gleizes and Metzinger tell us that a Cubist painting "does not harmonize with this or that ensemble, it harmonizes with the totality of things, with the universe: it is an organism."[106] As the product of an intuitive act, a Cubist or Fauvist painting is "internally" organized, just like the organisms that creative evolution has produced. But an artist's ultimate raison d'être is to convey this creative capacity to others, by way of our intuitive reaction to paintings. Thus an artist's relation to the public is not unlike the relation of the élan vital to its organisms, for in Bergson's words "everything leads us to believe that the role of each individual is to create, as if a great artist had produced, in the guise of works, other artists."[107]

In sum, there is a tension here between a conception of the painting as a self-contained, organic entity and its role as a catalyst for creative thinking on the part of the beholder. The same tension pervades Bergson's identification of biological reproduction with creative activity in nature. Organic form may be "closed off by nature herself" but this "tendency to individuate" is everywhere matched by "the tendency towards reproduction."[108] It is through reproduction that biological organisms imitate duration, for "life, like conscious activity, is invention, is unceasing creation."[109] A similar activity underscores our personal development since our personality also "shoots, grows and ripens without ceasing."[110] Growth, whether psychological or biological, is the result of free activity, and in this light a work of art can be numbered among its organic manifestations.

In *Creative Evolution* Bergson identifies the "tendency towards

reproduction" with a tendency towards organic unity nascent in the
élan vital. Since every individual is a "bud that has sprouted on the
combined body of both its parents," where, Bergson asks,

> does the vital principle begin or end? Gradually we shall be carried . . .
> back up to the individual's remotest ancestors. . . . Being to a certain
> extent one with this primitive ancestor, he is also solidary with all
> that descends from the ancestor in divergent directions. In this sense
> each individual may be said to remain united with the totality of living
> beings by invisible bonds.[111]

In psychological terms, these invisible bonds are operative when-
ever willed sympathy enters into the behavior between organisms,
allowing them to grasp the "harmony" underlying the élan vital's
diverse tendencies.[112] Bergson cites a number of instances in which
this tendency is evident in nature: paralysing wasps, for instance,
are said to sympathize with their victims, an activity whose "varia-
tions are subordinated to the structure of the victim upon which
they are played."[113] That "variations" should be understood in the
musical sense is confirmed by Bergson's description of the activity
in a beehive in the same passage. In their collective activity, bees
form a "single organism," so that each individual bee becomes part
of a "musical theme, which had first been transposed, the theme as
a whole, into a certain number of tones, and on which, still the
whole theme, different variations had been played, some very sim-
ple, others very skillful."[114] In other words, their cooperative or
sympathetic activity subsumes them within a greater harmony or
"musical theme" reflective of the élan animating the activity of
every living species.

Perhaps, then, artists are meant not only to perceive the organi-
cally circumscribed melody of their own souls, but to sympathize
with humanity itself, to perceive the musical theme or higher
rhythm underlying social interaction. Bergson implies as much
when he describes social interaction as tending "to melt the associ-
ated individuals into a new organism, so as to become itself an indi-
vidual, able in its turn to be part and parcel of a new association."[115]
In a hitherto unnoticed statement Bergson identified this associa-
tion with the "quality of the spirit of the nation"; moreover, "the
artist, the philosopher himself must feel himself carried by a spirit
common to those of their generation, they must have the same sen-
timent." Their grasp of this spirit is "fundamental, necessary so
that emulation would result. When a people has no common ideas,
it is divided, it can have no élan."[116] World War I encouraged Berg-
son to extend the metaphor of a social élan to the French nation

itself, which he contrasted with the intellectual spirit of Germany. Germany we are told had to "choose between the rigid and ready-made system of unification, mechanically superimposed from without, and the unity that comes from within by a natural effort of life."[117] Under Prussia's influence Germany's "organic self-development" or "unity from within" was abandoned in favor of "mechanical form."[118] France, however, remained true to its organic nature and opted for the "more flexible order which the wills of men, when freely associated, evolve of themselves."[119] Thus, beginning in 1912, Bergson utilized his ideas on artistic and biological creativity to formulate a political model of the nation-state. And as we shall see, he was not alone in this regard, for the transferral of this paradigm into a geopolitical context had profound ramifications within the Parisian avant-garde during the years leading up to the First World War.

The Body of the Nation: Cubism's Celtic Nationalism

WHEN Albert Gleizes published his essay "Cubisme et la tradition" in *Montjoie!*—the self-styled "organ of French artistic imperialism"—in 1913, he entered into a heated nationalist debate over France's cultural identity.[1] With the election of Poincaré to the presidency in January 1913, France adopted an increasingly militarist posture internationally, and within the perimeters of the French nation itself a form of cultural nationalism became all-pervasive. The historian Eugen Weber has traced the origins of that cultural rhetoric to the bellicose pronouncements of the royalist Action française, and recent art historical discourse has followed in his wake.[2] Yet little has been said by either historians or art historians about the equally nationalist ideology of self-styled leftists and their role in this influential debate over cultural politics and national destiny. In fact, "Cubisme et la tradition" places Cubism in the context of a hitherto unnoticed aspect of this nationalist dialogue by adopting the antiroyalist, anarcho-syndicalist, racial ideology of an organization known as the Celtic League (founded 1911). In that essay, Gleizes identifies the French proletariat as the incarnation of a "Celtic" national genius, condemning both "Latinism" and monarchism as foreign to France's true racial essence. By politicizing the message of *Du Cubisme* (1912), coauthored with Metzinger and resultingly homogenized, Gleizes presents himself as the ideological voice for Cubism in the public sphere, a logical extension of his previous involvement in the Abbaye de Créteil, a "socialist" commune of artists and writers.[3] His attempt to redefine Cubism politically both signals the central importance of cultural nationalism and reveals the complexity and range of the debate over national identity on the eve of the First World War.

Between the summer of 1911 and the publication of Gleizes's "Cubisme et la tradition" in the February 1913 editions of *Montjoie!*,[4] the notion of classicism discussed in chapter 1 became tied to one of Celtic nationalism. The praise of Celtic roots and Gothic cul-

ture as "truly French" in Cubo-Symbolist circles was part of a con-
certed attempt to counter the trumpeting of Greco-Latin culture by
the Action française. This maneuver also involved Bergson, whose
philosophy of intuition was deemed compatible with the idealist
and pantheistic spirit found in Gothic art and bardic poetry. In the
spring of 1911, Robert Pelletier had founded the *Lique Celtique
Française*, and the journal *L'Etendard celtique*, to expound the
Celtic movement's anti-Greco-Latin agenda. By the time *L'Eten-
dard celtique* was replaced by *Revue des nations* in February 1913,
the League's membership had expanded to include many figures
associated with the Puteaux Cubists, the most prominent being
Gleizes and Metzinger's close friend Alexandre Mercereau, the
founder of *Vers et prose*, Paul Fort, and the publisher of *Du Cub-
isme*, Eugene Figuière. Over the course of that year Fernand Divoire,
who contributed regularly to Barzun's *Poème et drame* and *Mont-
joie!*, the Cubist critic Olivier-Hourcade, and Bergson's major Sym-
bolist apologist Tancrède de Visan all joined the movement.[5]

Along with the linguist and league member Charles Callet, this
group of writers promoted Pelletier's anti-Latin, pro-Celtic platform
in a variety of journals. *Ile sonnante*, the literary journal most
closely associated with the *Rhythm* group, was among the first to
publicize Celtic nationalism. From December 1909 to December
1913, *Ile sonnante* published twelve articles devoted to the subject,
including a Callet essay of August 1912 lauding Pelletier's Celtic
League.[6] Callet's criticism also appeared in Olivier-Hourcade's
short lived *La Revue de France et des pays français*,[7] along with fa-
vorable reviews of Callet's writings by Olivier-Hourcade himself. In
February 1912, Olivier-Hourcade referred approvingly in his journal
to Callet's declaration in *Ile sonnante* that "France is not Latin, not
German, it is, and should remain Gallic."[8] In another article pub-
lished in May of that year, he recommended Callet's writings to the
literary historian Gustave Lanson and neo-Symbolist Jean Royère,
two writers the Action française had attacked as Bergsonists. Lan-
son and Royère, we are told, could find "new forces" in Callet's
ideas "to combat the Latinist epidemic."[9] Olivier-Hourcade made
his position in this "Latinist and anti-Latinist" debate clear by pub-
lishing Jean Florence's laudatory evaluation of Visan's *L'Attitude
du lyrisme contemporain* in the same issue.[10]

Concurrently, Gleizes's and Metzinger's criticism became associ-
ated with journals promoting the Celtic League's agenda. When an
excerpt from *Du Cubisme* was published in the first issue of *Poème
et drame*, it was preceded by an article by Callet signaling Henri-
Martin Barzun's approval of Celtism.[11] In February 1913, Jacques

Reboul, another promoter of Celtic nationalism,[12] helped launch *Montjoie!* as a kind of literary complement to Pelletier's *Revue des nations*, which began publication that same month. Contributors to *Revue des nations'* first issue included Paul Fort and Alexandre Mercereau, and the journal also had a lengthy article on Bergson's philosophical legacy.[13] Pelletier's own inaugural article outlined the League's artistic purpose as the promotion of medieval corporatism, federalism, and the idealist and pantheistic spirit personified by the French "primitive" artists of the fourteenth century and artisans of the Gothic era. Pelletier's synthesis of medieval corporatism and federalism has a resounding echo in Albert Gleizes's "Cubisme et la tradition," published in the first issue of *Montjoie!*. Gleizes's inclusion, in this article, of a woodcut after Clouet by Jacques Villon (fig. 22) suggests that at least one other artist in the Puteaux circle was sympathetic to the Celtic cause. A newfound interest in Gothic art and architecture was also registered by Raymond Duchamp-Villon. In an essay of 1914, published in *Poème et drame*, he compared the engineers who built the Eiffel Tower to the "medieval masons" who constructed Notre Dame. In Duchamp-Villon's opinion these "French" edifices were far superior to the "utilitarian" structures of the "Romans."[14] Thus when Visan, in July 1913, described Paul Fort's *Vers et prose* group as "une sorte de corporation renouvelée du Moyen Age,"[15] or Reboul lauded Gleizes's essay for embodying the spirit "qui conduisit nos prédécesseurs il y a sept siècles à réaliser l'art des cathédrales,"[16] they signaled a political and artistic closing of ranks within the Cubist movement in the face of a hostile, Greco-Latin opposition. Charting the evolution of that response will highlight the metamorphosis of Gleizes's Bergsonism into a theory of the body politic.

With the appearance of Barzun's *Poème et drame* in November 1912, the ideas of Gleizes, Metzinger, and Le Fauconnier were to play a key role in Barzun's consolidation of a new literary-artistic coterie. Thus it is not surprising that Visan and Gleizes endorsed Barzun's manifesto of Dramatism, *L'Ere du drame* (1912), that year, nor that the first edition of Barzun's journal reproduced the section of *Du Cubisme* devoted to simultaneity. Indeed, Barzun adapted that theory—as well as the Bergsonian critique of the Action française—to his own doctrine of polyphonic poetry in "D'un Art poétique moderne," an essay published in the same issue. The following year he cited Gleizes's confirmation that "the Cubist aesthetic adheres absolutely to this principle of simultaneous rhythms," adding that the artist intended to write a text for *Poème et drame* outlining the *rapprochement*.[17] The essay was never writ-

ESTHÉTIQUE DES ARTS PLASTIQUES

Le Cubisme et la Tradition

Des différents courants où leur paraît entraînée la peinture française, il ressort, à entendre la plupart des critiques, une anarchie manifeste. Ceux-là même qu'irritent les recherches les plus audacieuses ne sont guère moins atrabilaires lorsqu'il s'agit des peintres qui détiennent la consécration officielle. Routine ou audace sont mêmes sujets de soucis et leur colère s'apaise pour faire place à la plus béate des satisfactions seulement devant les productions des conciliateurs habiles et astucieux. Tel assure, avec une candeur et une autorité reconnue, qu'il n'est pas possible d'admirer à la fois Claude Lorrain et les Impressionnistes, tel autre, que le voisinage de Cézanne serait infamant pour les chefs-d'œuvre qu'abrite le Louvre, répétant aujourd'hui ce qu'on disait hier pour Manet. Assertions toutes gratuites, ne dépassant pas le domaine restreint de l'opinion personnelle, mais qui

Et qui contesterait l'influence alors de ce regain de sève, de luxe, de pompe, de cet amour de la vérité si visible dans les arts de l'époque à Paris, à Bourges, à Dijon sur les directions artistiques aussi bien des Flamands que des Italiens? Depuis le début du XIVe siècle, la France est le noyau de toutes les manifestations de l'esprit humain et si la Guerre de Cent Ans arrête un moment cet admirable essor, c'est une floraison nouvelle, sitôt la rafale essuyée. En Bourgogne Jean Malouel, en Bourbonnais, le Maître de Moulins, en Avignon Nicolas Froment en sont les principales illustrations et avec notre plus glorieux ancêtre Jehan Fouquet, c'est le triomphe de notre génie national si sobre et si émouvant dans ses rapports de la nature à l'humain.

Mais l'irréparable va se produire. Celui qui avait tant fait pour l'hégémonie de l'art français devait être l'instrument de sa ruine.

phaël, de Michel-Ange, de Léonard au XVIe. Cela est si vrai qu'un siècle plus tard, chez un des plus grands parmi les peintres qui n'échappèrent pas à cette emprise redoutable, chez Nicolas Poussin, il nous la faudra déplorer dans tout son œuvre, suite de Raphaël et de Vinci par le Dominiquin : c'est cette admiration sans limite pour ce passé fastueux qui lui fera briguer toute sa vie le titre de peintre italien et il nous faut convenir en vérité qu'il appartient beaucoup plus à cette période de débandade qu'à la lignée véritable de laquelle nous nous réclamons aujourd'hui.

Le mal est fait. La lutte sera chaude et longue pour chasser complètement les intrus que la cour a mis à la mode : mais on n'arrête pas les destinées d'un peuple et les descendants robustes et vrais des vieux imagiers l'emporteront sur les favoris cosmopolites guindés et factices que l'on tenté de leur opposer. Les courtisans se plieront aussitôt devant la volonté du Roi mais en même temps nous voyons avec les Clouet l'ancestrale vérité reparaître indiquant la route à ceux qui auront assez de foi et de courage.

(A Suivre) ALBERT GLEIZES

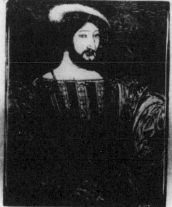

JACQUES VILLON Est. gravé d'après CLOUET

Bessarion
ou
Marc d'Ephèse

A propos de la Question d'Orient

témoignent néanmoins du manque absolu de clairvoyance dans l'historique de notre peinture ; et leur admiration désordonnée explique l'impuissance à coordonner ce qui fut et ce qui est. Nous considérons à l'encontre, les œuvres des artistes les plus volontaires d'aujourd'hui comme issues des sources de notre tradition nationale. Aussi importe-t-il de savoir, au cours des siècles morts, quels peintres lui furent attachés, quels surent le plus profondément traduire les généralités de la race et de leur temps, et s'affranchir des mesquines contingences de la mode.

Dans l'histoire de notre art la pression le plus désastreuse qui fut commise, à cause de la direction malheureuse qu'elle imprimait, fut incontestablement l'invasion officielle appelée la Renaissance du XVIe siècle.

Au lieu de peser, d'une part, le patrimoine artistique, colossal et si original que nous possédions alors, d'autre part, cet art italien si éloigné de nos aspirations primordiales et si imprégné de l'antiquité grecque, de gaieté de cœur, sur le rosier vigoureux qui avait fleuri les roses de nos cathédrales, nous avons accepté la greffe du rameau latin, déjà épuisé, dont le feuillage envahissant allait des siècles durant retarder la floraison de la branche maîtresse.

N'avions-nous pas eu d'ailleurs, notre Renaissance, plus profitable et plus conforme aux espoirs de la race, plus belle et mieux à son heure, près de deux siècles auparavant?

La mort de René d'Anjou fut en effet le signal imprévu de la Renaissance, puisque les guerres d'Italie en sont les raisons profondes, la venue officielle à Paris du Rosso et du Primatice à la verve étincelante, à la virtuosité consommée, au clinquant conventionnel, signifie nettement la direction que veut imposer à nos destinées celui qui est le maître de l'heure. Et c'est l'engouement le plus intransigeant pour tout ce qui vient d'au-delà les Alpes, une griserie de pédantisme et d'artificiel pénètre l'aristocratie, bouleverse les cervelles, et devient raison d'état. De nombreux peintres demeureront ignorés à cause de ce fol enivrement de goût italien que nos chevaliers rapportent en croupe des expéditions ultramontaines, de nombreux peintres trop épris de leur terroir, trop sincères pour renier leur foi, trop respectueux de l'héritage des ancêtres seront méconnus pour n'avoir pas accepté le joug de cet art dont l'apothéose s'achève en marches triomphales et qui, dans l'éclat sonore des trompettes, parmi les oriflammes claquantes entre en France en conquistador.

Si de Cimabue à Raphaël le cycle avait été parfait ce n'est pas une raison, surtout au moment précis où les imitateurs en affirment la décadence, pour porter sur lui tous les espoirs de notre race. Aussi négative au résultat fut pour l'Italie l'influence de nos « tailleurs de pierres » du XIIe siècle, aussi négative pour la France sera l'influence de Ra-

ten, but an analysis of the series of texts published in *Poème et drame*'s first issue bears testimony to the ongoing debate between the Action française and the Puteaux Cubists' literary apologists, a debate continued in the journal *Montjoie!*

In order of appearance those texts ran as follows. First, the Celtic League's Charles Callet published an ode to the Celtic nationalism of his father, Auguste Callet, under the title "Rêverie sur un centenaire."[18] Callet's article disparaged those who would impose "Latin oppression" or "the spirit of Caesar" upon French culture, stating that such doctrines had an Italian genealogy.[19] In its wake came the elder Callet's "Études et méditations linguistiques," a six-page tract expounding the Celtic rather than Latin roots of French culture. After this diatribe an excerpt from Gleizes and Metzinger's recently published *Du Cubisme* made its appearance,[20] along with a reproduction of Gustave Lanson's "Préface à l'anthologie des poètes nouveaux"(1912).[21] This latter anthology drew together poems by Allard, Apollinaire, Barzun, Florian-Parmentier, Mercereau, Nayral and Visan, among others—thus Lanson's preface attests to his high standing in these circles. Given the hostile attack on the Bergsonian Lanson by the Action francaise, and Visan's favorable references to the same in his article on Bergsonian symbolism, such endorsement hardly seems surprising.[22] What is surprising, and worthy of analysis, is the close relation Lanson's preface has to ideas developed in Barzun's "D'un art poétique moderne."[23] Barzun closed *Poème et drame*'s first issue with this summary statement on modernism, and in the process drew together key Bergsonian themes broached in the preceding articles. And implicit in Barzun's and Lanson's thoughts on the rhythmic dissonance of the modern era were the Bergsonian ideas of Henri Le Fauconnier, as they were expounded in his October 1912 preface to the Moderne Kunstkring exhibition held in Amsterdam.[24] The essay was published in tandem with *Du Cubisme* and served as a complementary foil to Gleizes and Metzinger's text. It was Le Fauconnier's way of measuring himself against his peers and claiming those aspects of the Puteaux Cubists' shared vocabulary conducive to his own. By aligning Le Fauconnier's "La Sensibilité moderne et le tableau" to *Poème et drame*'s artistic program, I intend to illustrate just how thoroughly the avant-garde defined itself in Bergsonian terms by the period marking *Du Cubisme*'s publication.

Le Fauconnier starts his essay by noting that each epoch produces an aesthetic sensibility reflective of social developments, and that the resulting art embodies the "qualitative value" of a given era.[25] In the modern period, industry has subjected us to "bizarre disso-

nances," exemplified by the "hard angles" of machines and "movements and force" of their activity. Since the artistic mind "registers a new rhythm" of forms, lines and colors, the "chiaroscuro" and "equilibriums" of the past will be replaced by "new elements of beauty" conducive to a new "language of self-expression."[26] The "schema" of this language—found in the "arabesque or abstract line of the painting"—allows artists to create "a relation of volumes, of forms, of colored strokes." Similarly, "the perspective of his precursors" is discarded so that "the modifications undergone" by objects in space may be captured in "a concise inscription which multiplies tenfold the representation's force."[27] This "new inscription" also frees shadow and light from their traditional role as instruments of verisimilitude, thereby insuring that the "mobility" native to the modern sensibility is expressed.[28]

The same procedure occurs with regard to colors; thus the "harmony" which governed an older generation's sensibility is broken "in a desire to animate the colored surface with a life more multiple, more intense."[29] Transitions in tone are diminished so that they appear juxtaposed, to enhance the sensation of rhythmic dissonance. Le Fauconnier sums up his program as follows:

A too often neglected preoccupation is that of the materials which, dedicated to a new role, are able to endow the work with a power of expression. . . . The choice of materials, thin, thick, fluid, transparent or neutralized, rich in color or broken, present that artist with a multiplicity of resources to translate the vivacity of his emotion or to crystalize its complexity. He is not concerned exclusively with obtaining, on the colored surface, sentiment of the substance of things (realist preoccupation) or their fugitive appearances (impressionism) but of putting to the service of intuition this astonishing suggestive power and this interior life that the power can contain in its splendor, in its transparent mysteries, or its profound radiance.[30]

In other words, when the suggestive power of these formal innovations is put to the service of introspective intuition, only then do they signify the modern artistic sensibility, the rhythmic dissonance of which is expressed by way of the new role given to the painterly medium. Aspects of Le Fauconnier's aesthetic are readily discernible in his *Mountain Village* (1911) (plate 5), a version of which he exhibited at the Moderne Kunstkring exhibition. This painting of a village and watermill nestled in the mountains of Savoie contains sudden shifts in viewpoint, so that the spectator does not regard the whole from a single position, as in traditional perspectival images. Moreover, as Ann Murray points out, there are a

number of elemental shapes—lozenges, jagged lines, triangular and circular forms—whose repetition throughout the canvas serves to emphasize its abstract, surface qualities. Combined with abstract areas of blue, green, and ochre color, these formal innovations fulfill Le Fauconnier's stated aim of increasing "the representation's force" by means of "a relation of volumes, of forms, of colored strokes." Perhaps Le Fauconnier found a rural equivalent to the modern sensibility's "rhythmic dissonance" in the rugged, jagged landscape of this mountainous region, and the technological harnessing of its forces, symbolized by the village watermill on the lower right.[31]

In his essay Le Fauconnier repeatedly underscores the role of intuition in artistic expression. The sensibility of past artists was governed by it, and if intuition is disparaged in the art world, it is by those who subordinate their sensibility to logic. They are the "theoreticians" who convert emotivity into a "coefficient" that is then used to construct innumerable "small systems."[32] These systems, exemplified by the neoclassicism of Armand Point or the art of Emile Bernard "create a logical convention inadequate to the sensibility's expression," for expression could not exist "without the intuition, that interior fire which animates and generalizes concepts."[33] "The amplification of expression, which springs from a series of concepts elaborated in the unconscious" necessarily rejects the "a priori visions" of past artistic conventions.[34] But "the theoretician who hates intuition" is unable to understand this omission; nor does he or she "appreciate the qualitative differences (power, charm, subtlety, etc.) of works which often seem to be on the same plane for vulgar spirits."[35] Theorists only perceive what paintings hold in common, rather than what serves to distinguish them. Likewise their servile imitation of a priori styles is evidence of their own lack of distinguishability from each other. Their logical as opposed to intuitive faculties cannot discern qualitative differences based on an emotional reaction to a painting or the sensibility of the modern era.

In sum, Le Fauconnier would have contemporary artists reject logical thought processes and turn to intuition when expressing their sensibilities. By embracing intuition they also reject past artistic conventions, or art forms based on a logical systematization of emotion. Any conceptions they might have spring directly from the unconscious—style constitutes an "internal" order, born from within rather than imposed from without. Intuition allows artists to express such concepts, which are the product of their alogical sensibilities. In Le Fauconnier's estimation, artists are not concerned

with an external object's substance or with the effects of light upon its surfaces, as were the Impressionists. Instead they turn their intuitive attention inward to grasp their emotional reaction to the qualitative changes surrounding them. Intuition also plays a role in the beholder's evaluation of art, for critics can only grasp a work's qualitative uniqueness, its charm or power, if they rely on intuition. Otherwise they will only discern what paintings hold in common. Such normative forms of analysis have no role to play when artistic quality is the thing to be evaluated.

Quality, which stands for the sensibility of an artist, is by implication also indicative of the sensibility of humankind during particular historical periods. Just as an art work's quality reflects the unique sensibility of an individual, any given society will have its own "qualitative value" serving to distinguish it from its own past or the social groupings around it. And the only ones equipped to discern such qualitative differences are artists who are in command of the powers of intuition. According to Le Fauconnier, the qualitative value of his era resides in rhythmic dissonance, the new form of beauty unique to the industrial age.

When considered in relation to the tenets of the Rhythmists as well as those that Gleizes and Metzinger professed, Le Fauconnier's pronouncements leave little doubt as to the shared origin of their ideas. The strong contrast Le Fauconnier draws between logic and intuition, and his call upon artists to reject past art forms and shift their attention to an intuitive expression of their sensibilities, replicates the Bergsonian program mapped out by his peers. *Du Cubisme* called upon artists to avoid past artistic conventions and respond to intuition rather than logic to express their alogical personalities. The critics for *Rhythm* were also unanimous in regarding logic as the death knell to any attempts at self-expression, since introspective intuition is the only means of achieving that. The *Rhythm* critics and the Cubists Gleizes and Metzinger proposed that subjective criteria should govern the manner in which a painting's qualitative structure is created. Le Fauconnier reiterates this paradigm, insisting that an artist's qualitative conception of a painting's structure emerge from the subconscious, and that every pictorial element be an expression of this alogical self.

Le Fauconnier's admonition against theorists follows a line of argument that Gleizes, Metzinger, and the *Rhythm* critics used in their evaluation of past art movements. Theorists, Le Fauconnier states, are guilty of converting emotivity into a "coefficient," a mathematical term standing for the measure of some property or characteristic. By declaring this terminology to be "logical" rather

than "intuitive," he condemns theoreticians for treating a quality (emotion) as if it were quantitatively measurable. In *Du Cubisme* Gleizes and Metzinger single out extensity and color as two pictorial qualities of an unmeasurable nature. Sadler in *Rhythm* attacks the neo-Impressionists for subjecting qualitative color to quantitative criteria, and Carter admonishes the neo-Impressionists and Futurists for analysing color and emotion in this manner.[36] In short there is a consensus that qualitative sensations should not be subject to any form of logical or quantitative analysis. Likewise, to ensure that sensations such as color or extensity maintain their qualitative characteristics when transformed into pictorial form, the act of transformation must be in response to introspective intuition. This faculty alone guarantees self-expression.

Le Fauconnier's attack on Emile Bernard in this regard, and his claim that rhythmic dissonance represents the "qualitative value" of his society, follows premises we have come to identify with the Bergsonian notion of the body politic. At the time, Emile Bernard was a royalist sympathizer and art critic for *Revue critique*, whose theory of tradition was grounded in "logic", the very faculty Billiet and the Symbolists attacked.[37] Thus we can read Le Fauconnier's condemnation of Bernard and other neoclassical theorists as an extension of Billiet's earlier campaign. Le Fauconnier's discussion of the nature of rhythmic dissonance is likewise an elaboration on the theme of collective duration implicit in the theory of classicism analyzed in chapter 1. Le Fauconnier imbues the social collective with duration by suggesting that societies, like individuals, experience qualitative change, and that the rhythm they produce is perceived by means of intuition. The rhythms of industry in Le Fauconnier's opinion are the qualitative expression of Europe's cultural evolution. Unlike the Rhythmists, Le Fauconnier does not identify rhythm with nature's procreative forces, nor does he identify the collective durée under discussion with French culture or the "Celtic" roots of that culture, as Gleizes would later do. Instead, rhythm is the analogue for modern life in a sense akin to that propagated by the Futurists.

Gustave Lanson's "Préface à l'anthologie des poètes nouveaux," reproduced in *Poème et drame*'s first issue, utilized Le Fauconnier's thesis to define Symbolism's impact upon a new generation of poets. On the basis of their adherence to Symbolism, Lanson separated the poets in his anthology from their contemporaries, including groups like the Action française who called for a return to the "most ancient moment of the French tradition," namely a classicism based on the sixteenth century or Greco-Roman antiquity.[38]

PLATE 1.
Albert Gleizes,
*Woman with
Phlox*, 1910

PLATE 2. Albert Gleizes, *Bridges of Paris*, 1912

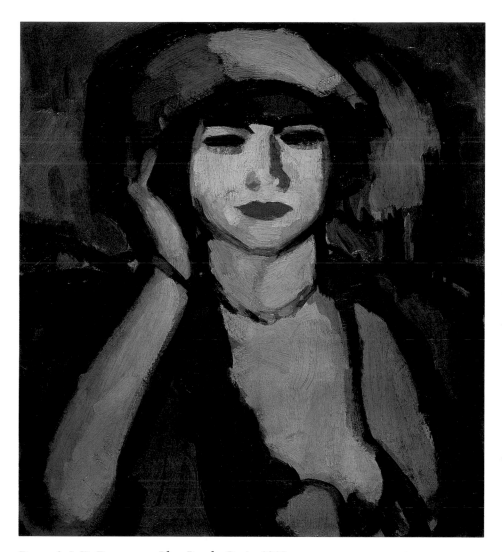

PLATE 3. J. D. Fergusson, *Blue Beads, Paris*, 1910

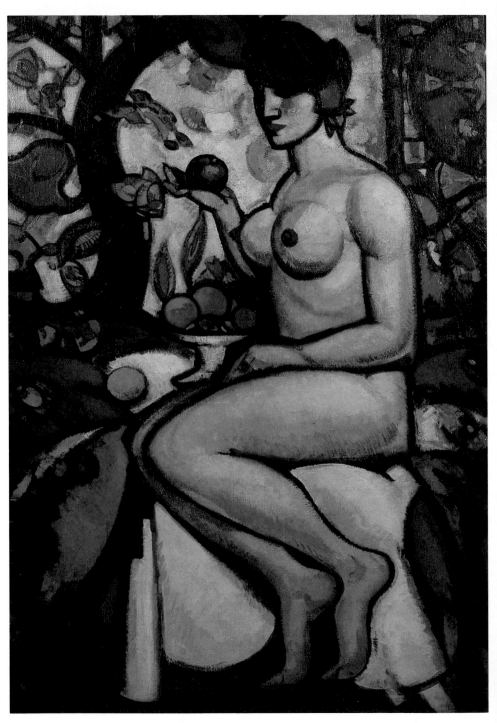

PLATE 4. J. D. Fergusson, *Rhythm*, 1911

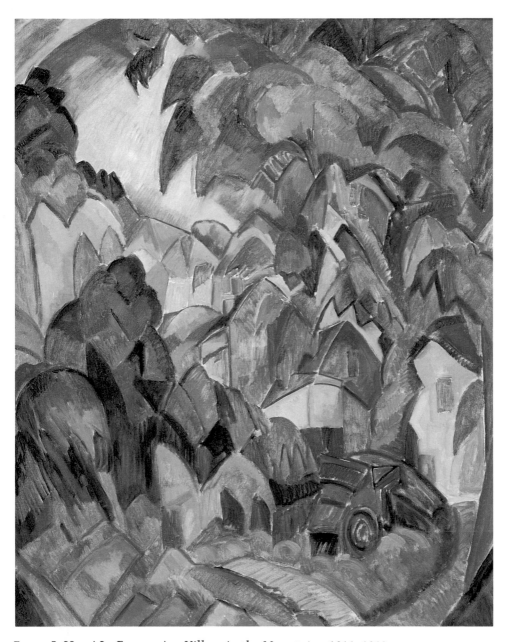

PLATE 5. Henri Le Fauconnier, *Village in the Mountains*, 1911–1912

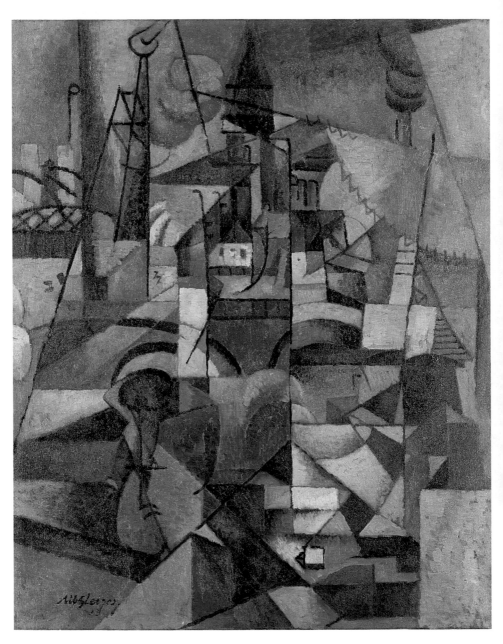

PLATE 6. Albert Gleizes, *The City and the River (La Ville et le fleuve)*, 1913

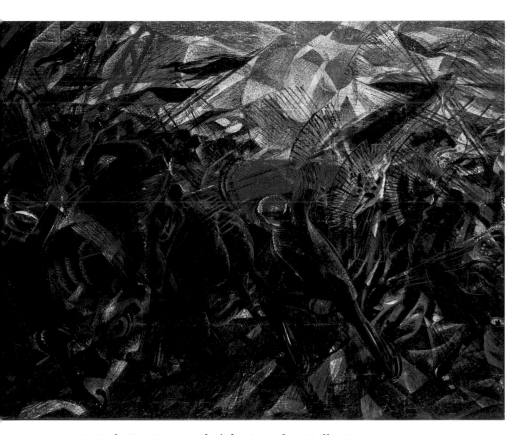

Plate 7. Carlo Carrà, *Funeral of the Anarchist Galli*, 1911

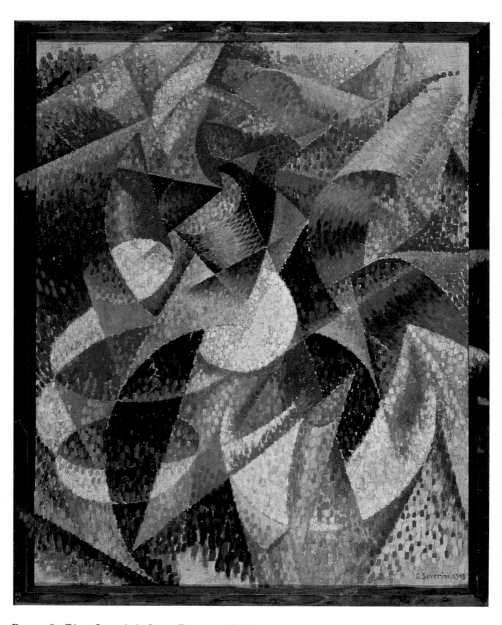

PLATE 8. Gino Severini, *Sea = Dancer*, 1914

Though the latter think Symbolism is dead, "les poètes, dont on lira ici les vers, ne le croient pas,"[39] and Lanson's preface attests to his approval of their position.

Lanson uses a Bergsonian vocabulary to define these poets' debt to Symbolism. Although the writers in his volume are "true to the ideas that inspire the Symbolists, they are not subjugated by them." They do not engage in servile imitation, or repetition of Symbolism's stylistic conventions, for to do so would be to follow an imitative pattern Billiet and Barzun had identified with the "intellectual" methodology of the Action française. Appropriately, Lanson describes the "new poets'" rejection of "les mesures régulières" and "les strophes fixes" in terms of an opposition between mechanically produced art and that expressive of the self:

> They do not reject clarity on principle. They do not fabricate mechanically, and by formulae, from the symbol. They know that effervescence, paroxysm, all the extreme notes of poetry are not attained by laborious application, by a reflective will executing a program of tumultuous effects known in advance, and that the beauty of these eruptions stems from their spontaneity, from their internal inevitability.[40]

Lanson then follows Le Fauconnier in identifying the inspirational source for this "internal" poetry as "la vie moderne," "the world in which we live in 1912 . . . the science and industry of today." The modern industrial landscape therefore contains a "poésie latente." "Sooner or later," Lanson conjectures, "the special beauty of the unique time we are a part of, in the villages where the syndical revolution rumbles, on the soil bristling with factory chimneys, under the sky that airplanes begin to crisscross, this new beauty will have its sovereign poetry."[41] In his opinion we should look no further than his volume to discover the modern era's poetic voice.

It was Barzun, in *Poème et drame*'s inaugural November 1912 issue, who joined Lanson's evaluation of the Symbolist movement to classical and Gallo-Celtic themes. Barzun's "D'un art poétique moderne" begins by proclaiming the need to redefine old aesthetic terms such as classicism, and in so doing arrive at definitions that "characterize the effort that this generation must make in order to acquire its absolute personality."[42] Since "each epoque, each generation" possesses a personality, it must "recreate the meaning of words it is obliged to use."[43] Similarly the novel nature of any given era's artistic production makes the application of an "old ironclad" critical vocabulary developed for the art of a previous generation untenable. "Every generation," we are told, has "its own manner of

living, speaking, perceiving and realizing itself." In sum, "there is only one factor" that governs "this capital differentiation: it is time, it is *the life of the times*."[44]

Barzun concurs with Le Fauconnier and Billiet that artistic production reflects the novelty of an era, and that each era is unique as a result. Furthermore, by tying this model to Billiet's conception of classicism, Barzun weds Le Fauconnier's Cubism to a political agenda close to that of Billiet himself. Barzun, in fact, broadens Billiet's campaign by redefining the terms "tradition," "freedom," "discipline" and "classicism" in a manner we can now recognize as Bergsonian. He follows that model by rejecting any doctrine that identifies tradition with the retrospective imitation of past styles. Since social evolution is typified by the novelty of its artistic forms, any rote imitation of the past ignores what is novel and therefore classical about its own period. Although artistic tradition is composed of "the succession of past art creators," adherence to tradition does not require "the imitation of one among them."[45] Truth to tradition requires "freedom," newly defined as "the independence of the artist with regard to these past arts, with the will to choose, to define, to affirm his effort according to his epoch."[46] Without this freedom, the poetic spirit is subject to "inorganic dispersion"—a telling phrase that conjures up the dialectic between inorganic and organic order that the Bergsonian Symbolists used to criticize the imitative methods celebrated by the Action française.

The terms "discipline" and "classicism" are also redefined from a similar standpoint. "Discipline," for example, "is not a general rule imposed from without like a public law";[47] in artistic experience "it is the ascending force of [the artist's] psychological expression" exemplified by "the obligation to create."[48] Barzun's contrast between general rules imposed from without and a creative force emerging from within neatly encapsulates the dichotomy of external and internal order fundamental to Visan's and Billiet's Bergsonian paradigm. The same argument is operative in Barzun's appraisal of classicism. In his estimation, that term should not be equated with "the servile copy of such or such past art. Art cannot be classical like another or in relation to this other. Art becomes classic in relation to itself, to its origin, to its ascending curve up to the point of consecration."[49] This internal, ascending force or curve embodies the "novel force" intrinsic to artists and their epoch: it is novelty that now "proclaims itself classical."[50] Under these circumstances classicism does not stand for the "recommencing" or "recopying" of artistic styles; on the contrary, what is novel to each successive period becomes classical and traditional in its turn. "Thus for us

the romantic, Parnassian, naturalist, Symbolist arts became successively classical. It is from now on forbidden to anyone, under fear of national disqualification, to exclude them from French art."[51]

Once again classicism is defined as a future possibility, the collective legacy of an era's creative novelty, here identified with the "personality" (or what Le Fauconnier called the "qualitative value") of a period. However, the "personality" referred to is that of the French nation. Thus Barzun pits his definition of classicism against one based on a "Greco-Latin," "neoclassical current."[52] Barzun's classicism will "break the canons" of this "false art" and "denounce its flat molds, forms, regularities, symmetries, repudiate its immobile and cold reason, its artificial equilibrium, its perfection as peaceful as death."[53] Barzun's condemnation of regularity, symmetry, and equilibrium tied to an immobile and "moribund" cold reason metaphorically echoes the attack upon "logical" art forms prevalent in neo-Symbolist circles. And like Billiet, he regards "rational" art forms as foreign to the national genius of the French people. "Our national art," Barzun asserts,

> cannot be, must not be Greco-Latin without signaling its decline. It is a crime against our racial genius to want to subject it . . . to the rules and artistic credos of extinct civilizations. Neither two centuries of the Renaissance, nor humanism can make us forget these fifteen centuries of national and social autonomy . . . which have left us unique treasures: *our cathedrals.* Enough of Parthenons and mythologies! . . . That our art is above all that of our audacious *Gallo-Celtic* race, and is free, enthusiastic, living and passionate like it, on this condition alone will it be able to take its place in the *highest* tradition of peoples of the earth, where Greek art took its place *in its time,* according to its genius, its race.[54]

"According to its genius, its race": clearly the Greco-Latin or neoclassical art forms that the Action française upholds are far removed from the racial origins of French creativity. In this passage Barzun joined the neo-Symbolists' Bergsonian critique of the royalist opposition to the Celtic League's racial nationalism. And in this essay the traits that Barzun identifies with the "Gallo-Celtic race" have a decidedly Bergsonian ring. They stand in stark contrast to doctrines founded on "classical imitation," the "perpetual rehashing of the Greco-Latin" that "can only atrophy, for a long time, our novel faculties, that is, the living sources of our national genius."[55] Only an art form "capable of succeeding Symbolism" can save French culture from the "multiple legions of professional hacks" that constitute the "neoclassical current." By embracing "unfailing ancient

concepts" based on "an all-purpose discipline," neoclassicism's "mediocre talents" divorce themselves from the "diverse originality" that typifies the Gallo-Celtic people.[56] Removed from the novel spirit of the French nation, neoclassicism is allied to the "cold reason" of a foreign culture. Lurking behind Barzun's Bergsonian and racial categories is the spectre of Maurras's Action française and the literary campaign Visan and Billiet had mounted to rebut the attack on Symbolism that movement launched.

In sum, the publication of *Du Cubisme* in Barzun's journal placed that aesthetic tract in a political context unaddressed in the book itself. Since *Du Cubisme* was the product of a consensus between Gleizes and Metzinger, we could infer that the absence of references to classicism, Latinism or Celtism in this joint publication indicates their differing opinions over such issues. Likewise while *Du Cubisme* limits revelatory powers to artistic novelty and self-realization, Le Fauconnier and Barzun relate the novelty of artistic creativity to the creative élan of society in general in the case of Le Fauconnier or that of the Celtic race in the case of Barzun. Indeed, it was Gleizes alone who endorsed Barzun's theories, and translated *Du Cubisme*'s Bergsonian terminology—its references to Realism, intuition, and organic form—into the context of Celtic nationalism, particularly in his later "Cubisme et la tradition." To understand the degree to which he drew upon the Celtic League's aesthetic agenda to do so, requires an overview of the political genealogy of Celtic nationalism, its relation to the Celtic League's cultural program, and the League's impact upon the writers for *Montjoie!*, the journal in which "Cubisme et la tradition" appeared.

The association of *le peuple* with the Celtic *gaulois* reflects a leftist discourse with a venerable history dating to the eighteenth century.[57] Critics of the French monarchy routinely identified the proletariat of France as a Gallic people subjected first to Roman rule and then to subsequent domination by the Franks, a tribe of supposed German origin who came to constitute the French aristocracy. Indeed, as one historian has noted, "by 1789 the assimilation of Franks and ruling class was so common that, in his seminal pamphlet, Abbé Emmanuel Sieyès called on the Third Estate, descended from the Gauls, to send the aristocrats packing back to their Germanic forests."[58] After the Revolution, the incorporation of such rhetoric into republican ideology resulted in the widespread popularity of the *coq gaulois* as a national symbol and the founding in 1805 of an Académie celtique to resuscitate France's Celtic heritage. Moreover, the interpretation of the Revolution as an ethnic conflict between plebian Celts and their Germanic overseers

found its most compelling advocate in Augustin Thierry, a Saint-Simonian whose *Considérations sur l'histoire de la France* (1840) claimed a Gaulish nationality for the Commons and the Third Estate. The radical split along racial lines that Thierry drew between this plebian class and the Frankish aristocracy influenced a wide spectrum of left-leaning intellectuals, including Saint-Simon, Victor Hugo, and Pierre-Joseph Proudhon.[59]

Thierry's left-wing critique of the ethnic origins of the French monarchy had a significant impact on socialists and republicans who wished to establish a definition of what was truly "French" in the realm of art. In the wake of Louis-Philippe's restoration of Primaticcio's decorations at Fontainbleau as a symbol of the continuity of the French dynasty, leftist art critics such as Théophile Thoré, Ernest Chesneau, and Jules Antoine Castagnary attacked the Italian art identified with that patronage.[60] After the revolution of 1848 they called upon artists to reject the Italianate style promoted by the monarchy in the name of a return to France's Gothic and Realist roots, exemplified by the art of Clouet, Le Nain, Watteau, Chardin, and their "realist" followers, Courbet and Manet. "The seeds of a national art," Castagnary asserted in his review of the 1866 Salon, "were beginning to grow in the various intellectual centers of our old provinces [when] Italian art suddenly invaded France, carried by the gentlemen of Francis I."[61] In Castagnary's essay Rosso Fiorentino, Primaticcio, and other artists affiliated with the court of Francis I were rejected wholesale as foreigners who had undermined a French "realist" spirit with roots in the Gothic.

By the turn of the century the debate over France's Gallo-Frankish roots had not only influenced republicans, but also prompted a vigorous response on the part of Maurras's Action française. In contrast to Thierry, the Action française wished to undermine any history of ethnic division along class lines by subsuming both Celts and Franks within a Latin cultural and ethnic genealogy. Following an argument first developed by Fustel de Coulanges, Maurras held that the Gauls, though conquered by the Romans, had in fact assimilated the best that Rome had to offer, and in turn romanized the Germanic Franks when they subsequently invaded. As a result, the civilizing mission undertaken by the Romans was continuous with that of the kings, who ruled under the guidance of the Roman church. Among Maurras's colleagues, it was the art historian and Catholic royalist Louis Dimier who gave cultural sanction to this view by exalting the Roman-oriented patronage of Francis I in a monograph on Primaticcio, published in 1900. Maurras's and Dimier's claims that France's roots resided in a Latin south did not

go unanswered, for in 1904 Henri Bouchot launched a counter-offensive in the form of an exhibition titled *Les Primitifs française*. Bouchot lamented that "the French works of the Clouets and of Corneille de Lyon, compositions still Gothic and national" were "soon to be submerged by the sad movement of the Renaissance. The influence of Italy in its decadence, of Cellini, Primaticcio, Rosso [had resulted in] these frail, false, lifeless, thoughtless forms that the School of Fontainebleau imposed everywhere."[62] Charles Rosen and Henri Zerner note that Bouchot's assessment proposed "a break between the Gothic Primitives of the fifteenth century and the Renaissance," which condemned the latter "as a foreign intrusion." In effect Bouchot's diatribe slighted both Italian culture and its royal patrons as foreign oppressors, a maneuver that provoked a heated response from Dimier.[63]

As Eugen Weber reports, Maurras's adversaries were also prepared to adapt Thierry's theme of class war to the conflict between northern celts and romanized meridionals. One such writer was Gaston Méry, whose novel *Jean Révolte* (1892) held that the descendants of the Celts had been oppressed by corrupt Latins who pillaged the Gauls as they would any foreign people. In Méry's estimation it was this Latin elite, rather than the bourgeoisie, who were the true enemies of the Celtic people, and as Weber states, "Méry also turned against the Ecole Romane, denouncing the likes of Jean Moréas and Charles Maurras as alien Moors."[64] In effect, Méry transformed Thierry's war between classes into a battle for survival on the part of Celtic France in the face of foreign invasion. The priority Méry gave to race over issues of class in his Celtic polemic illustrates how easily Thierry's formulation could slip into outright racism.

As the direct inheritor of this volatile discourse, Pelletier's Celtic League combined Thierry's history of an ethnic class war, with the realists' critique of monarchical patronage, and Méry's diatribe against the meridional politics of the Action française. The latter stance was taken up in *L'Etendard celtique*'s first issue, where Pelletier sketched out the league's political position with regard to French foreign policy.[65] Thus he justified the controversial Franco-Russian alliance, in opposition to Italy and Germany, on the basis of the "threat" of "Latino-Germanism" to the Slavic and Celtic peoples.[66] In the past the incursion of "Latin ideas" into "a Celtic nation" like France had proven "disagreeable to [the Celtic] race" and "the cause of decadence and subjugation." Such subjugation could be cultural as well as political, for in Pelletier's estimation the very spirit of "Latino-Germanism" was antithetical to the Celtic sensibility. By including Germany in his Celtic critique Pelletier iden-

tified the Germans as yet another cultural group "naturally" estranged from "the peoples of ancient Gaul."[67]

Turning to the cultural arena, he called upon French artists to abandon "the Latin cult of form, matter, and force" and embrace "the idea of spirituality and justice" innate to their "common Celtic heritage." By adopting an idealist rather than materialist attitude they would produce "works of beautiful form, inspired by elevated ideas." In the process France would be infused with "the germs of a new vitality" able to impart "to the race the greatest well-being, grandeur and glory." Pelletier marshaled the metaphors of organic vigor and decay to describe the effects of the Latin cult of material force and form on France, implying, like Billiet before him, that "Latino-Germanism" is a disease, retarding the vitality of the native seed. The "subjugation" of the French cultural organism to Latin ideas can only result in decadence. If the "germs of a new vitality" are to save France, they must have their origin in that country's "vigorous and fertile tradition."[68]

That tradition, however, is not monarchical, just as it is not Greco-Latin. Instead, Pelletier finds the political corollary to France's Celtic heritage in the "renovation of corporations and communal associations of the Middle Ages." That "great epoch of the Celtic Renaissance," we are told, has its modern day equivalent in forms of "syndical organization" and veneration "pour le travail manuel" of artisans.[69] On this basis another writer for L'Etendard celtique could describe "the churches of the Middle Ages" as the only "truly national architecture," and point to "the cathedrals of Strasbourg, Colmar, and Cologne" as proof that Alsace-Lorraine belonged to Celtic France instead of "the Latin and Germanic race."[70] Thus Pelletier's journal glorified syndicalism and medieval corporatism as an "organic" expression of the Celtic race's political order.

Two years later, Pelletier charted the historical conflict between that "natural" order and the "Latin" politics of France's elite. In "La Ligue celtique française: sa doctrine, son but,"[71] published in Revue des nations, political views only hinted at in L'Etendard celtique are brought to the fore, in the guise of Pelletier's division of the romanized and Celtic elements in French society along class lines. Before "le moyen age celtique," Pelletier asserted, the ordinary peasant retained more of the Celtic cultural and linguistic tradition than France's "romanized" elite—the nation's "clerics, writers," and "humanists."[72] This state of affairs only ended during the "Celtic" Middle Ages, when France overthrew the Roman yoke and reinstituted tribal and corporative forms of organization comparable, in Pelletier's opinion, to the syndical organizations "of the proletariat

today." Thus he noted with satisfaction that the head of the Confédération Générale du Travail (C.G.T.) called for "the reestablishment of the medieval social state," a reformation which would revive the medieval "République des Justes" that had synthesized "les droits de l'intelligence et du travail manuel."[73] The rise to political prominence of a figure like France's first minister Suger, "le fils d'un serf de l'Ile de France," exemplified the leveling of class distinctions possible under a Celtic République des Justes. Suger, rather than Louis VI or Louis VII, was the true "Père de la Patrie."[74] Likewise, France's medieval cultural heritage, embodied in the artisanal production of "the painters called primitive" and the "Gothic sculptors" who worked on the cathedrals, "brought to light" the nation's "Celtic origins." "Voilà, la tradition que représente et veut défendre la Ligue Celtique Française."[75]

According to Pelletier, the Celtic era of "political liberty," religious tolerance, and social egalitarianism ground to a halt with "the introduction of the Roman code" and the supression of the Druidic religion in the fifteenth century.[76] Concurrently the taste of the French aristocracy succumbed to that of the Italian Renaissance, and the medieval "primitives" like Clouet fell out of fashion. This "retour du Romanisme" proved disastrous for French civilization. The monarchy and upper classes were once again 'Romanized', and divorced from the Celtic origins of their plebian subjects. Subsequently, the "republican" orientation native to Celtic culture was suppressed. Though the Revolution of 1789 gave France a brief respite from this situation, "napoleanic Caesarism repeated the errors of the romanized Monarchy," by imposing on France a "totally latinized" code of law.[77] In a strident, pro-Federalist vein Pelletier encouraged the French people to "renew the tradition of the thirteenth century, to resume the work of the Revolution," and undo the damage caused by the "Helléno-Latins."[78] "It is necessary to free anew the Gauls, to free individuals, families, communes, the corporations of the provinces, from oppressive centralization," in order to reinstitute "the federation of Gauls."[79] "France, a Celtic nation," will then unite the Celtic peoples of the United Kingdom, Ireland, Belgium, and Switzerland in "a moral federation," a term echoing Bergson's 1912 association of the "creative will" of the French youth with the moral regeneration of the nation.[80] By rejecting ideas derived from the Latin or Germanic race, "le corps de la Patrie" will once again be identified with "the idea of the Celtic race," rather than "the personage of the King."[81] Clearly, Pelletier excluded the Action française's monarchical politics and its Helleno-Latin cultural program from his conception of the body politic.

Therefore, "sur tous les champs d'activité intellectualle, en art, en littérature, en philosophie, le Celtisme proclame, à l'encontre du culte romain de la Forme, de la Matière et de la Force, la religion gauloise de l'Idée, de la Spiritualité et du Droit."[82] Echoing earlier statements in *L'Etendard celtique*, Pelletier described the legacy of Celtic culture in terms of Idealism. On this basis, he declared "sagesse druidique" to be "perfectly adapted to the genius of the race." In his estimation, "l'esprit contemporain" had a good deal to learn from "sagesse druidique."[83] And elsewhere in the *Revue des nations* Pierre Florian placed Bergson's philosophy in this idealist mould. Indeed, Florian's "Le Mouvement philosophique: Le Bergsonisme" aligned Bergson's notion of intuition with the spiritual aspirations Pelletier had declared "native" to the Celtic mentality.[84] His article exalted intuition as a means of discerning a spiritual realm inscrutable to "le positivisme et le scientisme," and declared it to be in harmony "avec les méthodes de raisonnement en usage dans la philosophie bardique."[85] Thus Bergson's theories met the key criteria indicative of "philosophic Celtism": his philosophy was spiritual in orientation and "bardic" by virtue of its intuitive methodology.

The correlation of Bergsonism with an idealist and Celtic spirit, antithetical to that of the Action française, was likewise taken up in the journal *Montjoie!*. In fact, a series of articles published in that journal form part of a philosophical dialogue between the Bergsonian-oriented writers for *Revue critique des idées et des livres* and Bergson's supporters among the contributers to *Montjoie!*, Jean Muller and René Gillouin.[86] Though Muller remained equivocal on the subject of Celtism's relation to Bergsonism, Gillouin advocated such a synthesis. And both Muller and Gillouin agreed that Bergson's philosophy justified and spurred on the Symbolist movement, despite Gilbert Maire's and Henri Clouard's attempts to prove otherwise.

Muller's opening salvo in this debate appeared in *Montjoie!*'s February edition, in the form of an evaluation of André Thérive's attack on romanticism in *Revue critique des idées et des livres*. Muller accused "M. Thérive et ses amis" of reducing "order" to "a dead and geometric conception" divorced from the "organization" immanent in "le flux du monde."[87] Such a response totally contradicted Maire's claim in *Revue critique*, and Clouard's assertion in *Montjoie!*, that intuition is a form of "refined intelligence," which imposes "geometric order" on a chaotic and fluctuant "vital order" comparable to garden "scrub."[88] Thus it was with some irony that Muller's reply to Maire's dialogue in a March issue of *Montjoie!* opened by comparing Bergson's philosophy to a "garden of ideas,"

the fruits of which were menaced by vulgarizers like Maire himself. Maire allied himself to "Maurrasian orthodoxy" in excessively "reducing intuition to intelligence, in sacrificing, also, in a manner too cavalier, the vital order to the geometric order." On this basis Maire "condemns all art freed from disciplines called classical" and "talks as if Bergson had never discussed art." But "the formulas by which Bergson defines the various modes of aesthetic activity, the hierarchical order in which the different arts appear to him seems very distant from the classicism M. Maire and his friends recognize." On the contrary, Muller claims that Bergson's "conception of art" restored the Symbolists to honor, and it is the criticism of Gillouin that he recommended as a corrective to Maire's "Maurrasian orthodoxy."[89]

Indeed, Gillouin, whom his admirers described as "the most insightful commentator on Bergsonian philosophy,"[90] accused Bergson's supporters in the Action française of confusing intuition with analytical modes of thought. Gillouin first broached this theme in the introduction to his *Essais de critique littéraire et philosophique* (1913), wherein he made clear his allegiance to Bergson's philosophy.[91] Thus his introduction contrasted the "living unity" running through his essays with the "rigid unity" of those critics who follow "the methods of the positive sciences." The latter "aspire to know through analysis the whole of their object which is pure quantity, but in the spiritual order, which is quality, creation, liberty, analysis only attains the circumstantial and accessory, the materiality of the work or human being."[92] The most austere adherents to a "theory of reason" were members of the Action française, whose "leader Charles Maurras . . . reduces the true, French tradition" to three authors: Racine, La Fontaine, and Ronsard.[93] Gillouin found this doctrine to be thoroughly opposed to the qualitative, spiritual order open to writers on account of Bergson's intuitive methodology. And in his reply to Picard and Tautain's 1914 enquête on Bergson's influence, he used this assessment to judge the Bergsonian Symbolists and their classical adversaries:

> From the artistic point of view there is an evident harmony between Bergsonian philosophy and the symbolist tendency. . . . the *success* of Bergsonism is of extreme importance for the future of Symbolism, not only because it furnishes to those who continue the Symbolist movement the philosophy which its initiators too evidently lacked, but even more because the Bergsonian philosophy constitutes in itself a living example, an elegant proof that the symbolist principle, totally opposed as it is to the classical principle since it proceeds . . . from in-

tuition to analysis and not from analysis to intuition, excludes nothing of the perfect clarity, order, proportion, and measure which characterize classical works.[94]

Far from being absurd or chaotic as Maire would have it, the poetry produced by the Symbolists in response to "pure vital order" is here declared to have all the "ordered" qualities of classical works themselves. Furthermore this order stems from their adherence to one of the fundamental tenets of Bergson's "Introduction to Metaphysics," which, in Bergson's opinion, "cannot be too often repeated: from intuition one can pass on to analysis, but not from analysis to intuition."[95] By condemning the classicists for contradicting Bergson's instructions, Gillouin labels Maire's call for artists to "re-descend from forms and generalizing concepts to singular intuitions" an affront to Bergson's intuitive method.[96] And for Gillouin the alternative to classicism lay in the synthesis of Symbolism with a revival of Gallo-Celtic culture. "We have in Jean Moréas and in Charles Maurras, authentic Greeks," wrote Gillouin in an article on Paul Claudel, but "we have in Charles Péguy, in Paul Claudel, men of the thirteenth century."[97] Claudel, we are told, had an "aversion pour la monarchie" and "droit roman" only matched by his love for "the feudal age." Moréas and Maurras claimed to be part of "a French tradition which proceeds from analysis to intuition," but "M. Paul Claudel goes from intuition to analysis," basing his poetry on "the most secret sources of life."[98] In contrast to those of a Greek temperament, Claudel's vision of the Middle Ages was that "of a society truly humane, where people are never treated as objects, and are united to each other by bonds of fidelity and honor, love and sacrifice." "I am surprised." Gillouin wrote, "that against the 'Romans' Paul Claudel is not claimed by the 'Celts.'"[99] By claiming Paul Claudel as their own, the "Celts" would also lay claim to his Bergsonian methodology, which Gillouin aligned to the spirit of the Celtic Middle Ages. With the publication of this article for *Montjoie!*'s April 1914 edition, Gillouin endorsed an interpretation of Bergson actively propagated by Pelletier's Celtic League.

Albert Gleizes had reached similar conclusions over a year earlier. Between the fall of 1911 and the publication of "Cubisme et la tradition" in *Montjoie!*'s February issues, Gleizes's aesthetic views had evolved from an unquestioning trumpeting of Greco-Roman culture to an outright attack on that cultural heritage as foreign to the Celtic roots of France.[100] In his early evaluation of the art of Metzinger for the September 1911 issue of *La Revue indépen-*

dante, Gleizes had identified the contemporary return to "the French tradition" with qualities of "grandeur, clarity, equilibrium and intelligence"[101] stemming from the "Greco-Roman traditions" of "occidental cultures." If a modern renaissance conducive to "our racial tendencies" is to occur, it can not be in response to "Hindu, Chinese, Egyptian and Negro plastic signs." Instead Greco-Roman art, and the cultural legacy of that art in the painting of David, Ingres, and Delacroix, must serve as the guide for occidental artists.[102]

Yet in his review of the 1911 Salon d'Automne, published three months later, all references to Greco-Roman culture are conspicuously absent. Although "our French tradition" is equated with "composition, organization of the painting, the equilibrium of masses and inscription of forms,"[103] these elements are tied to "certain affinities of race" deemed "essentially French."[104] Just what Gleizes regarded as essential to the French race remains nebulous, and the relation of such affinities to Greco-Roman art is unclear in this essay. That status, however, was clarified a year later when Gleizes disparaged classicism as a Greek invention, foreign to French culture. Significantly, this refutation of his own former position occurred in an article published just prior to Callet's and Barzun's attacks on the Greco-classicism of the Action française in *Poème et drame* in November 1912. In his search for "the most pure tradition" Gleizes now informs us that he must look "beyond the Renaissance, a foreign art borrowed from Greece, and classicism, to Gothic art, which is the art of our race, born spontaneously of our soil." Moreover, adherence to the Gothic is not a matter of imitation or a "pastiche" of its stylistic conventions, but simply the result of racial affinity with "the links of centuries that are Poussin, Ingres, Delacroix, Corot, Manet, Renoir."[105] We can thus infer that Gleizes would have found the Action française's Greco-Roman classicism anathema to the Gallo-Celtic tradition.

Gleizes's racial nationalism reached new levels of intensity in "Le Cubisme devant les artistes," an article published in December 1912, one month after *Poème et drame*'s appearance. Designed as a reply to the criticism of his peers, Gleizes's essay departed from his coauthored text and applied the Bergsonian tenets found in *Du Cubisme* to an analysis of the French tradition. As a result, Gleizes's and Metzinger's stated affiliation, in *Du Cubisme*, to a Realist tradition stemming from the art of Courbet, Manet, and Cézanne, became subsumed within Gleizes's attack on the influence of Italian art and royalist politics in France. In many respects this text was a condensed version of the article in *Montjoie!* that was to follow.[106]

Like "Cubisme et la tradition," the commentary in "Le Cubisme devant les artistes" signaled Gleizes's full adherence to Pelletier's Celtic ideology, to which he now added the notion of Bergsonian classicism developed by Billiet and Barzun.

In both essays Gleizes follows Pelletier in vilifying the Renaissance as a period of Italian cultural hegemony over France. In "Cubisme et la tradition," he judges "the official invasion called the Renaissance of the sixteenth century" to constitute "the most dangerous pressure" ever exerted on French culture.[107] Gleizes's "Cubisme devant les artistes" even characterizes the Cubists as liberators of a French tradition previously crippled by "the detestable Italian influence, the sad heritage of the Renaissance of the sixteenth century."[108] In the same essay Gleizes traces the lost period of French cultural dominance back to the Gothic era, whose cultural representatives are "our primitives and our cathedrals."[109] In "Cubisme et la tradition" he describes Gothic art's practitioners— the "*imagiers* of the middle ages"—as truly embodying the nation's Celtic origins.[110] It is from Gothic artists, "and not from the Italian masters," that French artists should take their lead, for as he states in his earlier article "the Italian masters are not of our patrimony" and their "creative genius is inferior."[111] In turning to the Celtic roots of their own culture, French artists should extract "the elements which are its essence, and develop them in this spirit; an affair of intuition, of tact, of will." Intuition causes artists to develop a painting's "plastic qualities," those elements of design and form whose interaction produces "plastic integration."[112] In "Cubisme et la tradition" the same interaction is related to the "plastic dynamism" emanating from "rhythmic relations" established in response to "sensibility and taste." Speaking of taste in the earlier essay, Gleizes noted that spectators too can "savor (*goûter*) the tableau as an organism," as an object "with its own raison d'être."[113] Having rediscovered the Celtic origins of French art, Gleizes would have French artists "develop" said origins through intuition, to create an "organic" art as rooted in the French tradition as the Gothic art of their Celtic forbears.

Besides echoing Pelletier in his condemnation of the harmful effects of the Italian Renaissance on France's Celtic heritage, Gleizes's "Cubisme et la tradition" replicated Pelletier's analysis of the class divisions stemming from this influence. Gleizes blames royal authority for the imposition, onto France, of an Italian art "impregnated with Greek antiquity" and hostile to France's "primordial aspirations."[114] With the arrival at Fontainebleau of the artist Rosso Fiorentino, an "intoxication with pendanticism and the artificial

... penetrated the aristocracy," and became "the will of the state."[115] The court's "cosmopolitans, stilted and artificial," "soon bowed before the King's will" and rejected France's Gothic primitives in favour of Italian mannerism.[116] Only artists like Clouet had "enough belief and courage" to adhere to the "ancestral truth" of Gothic art. Instead of imitating the Italian style, Clouet cultivated the "plastic values" of design and form mentioned previously. As a result his art captured "the freshness and naturalness of our origins," rather than the "affectation and preciousness" of Italian "mannerism."[117] Clouet's style, like that of the Cubists, is deemed "natural", a reflection of Celtic origins untainted by foreign elements "unnatural" to it. To underscore this lineage, Gleizes published a woodcut by Jacques Villon "après Clouet," in *Montjoie!*'s publication of his article (fig. 22).

Since the aristocracy was divorced from these natural origins, their taste could only be as decadent and mannered as that of the artists they admired, the school of "Rosso." Pelletier's diatribe against the decline of France under a Romanized monarchy is transcribed by Gleizes in terms of the decadence of an aristocracy enamored of Italian mannerism. Gleizes and Pelletier regard Italian art as a foreign blight on French soil, and they both use organic metaphors to describe the harmful effects of Italian culture upon France. Gleizes laments the aristocracy's acceptance of "the graft of an Italian art, already exhausted" on to "the vigorous rosebush on which flowered the roses of our cathedrals." It was the "overrunning foliage" of Italian culture that would subsequently "retard thc flourishing of the main branch."[118] Like Gleizes, Pelletier too regarded Italian culture as harmful to France's own "vigorous and fertile tradition."

The revival of that tradition required that the term "classical" be redefined, to distinguish it from the Greek classicism that Gleizes considered abhorent. It was an Italian art "impregnated with Greek antiquity" that inspired David and Ingres, the slavish imitators of Raphael whose "descendants . . . are the students of Cabanel."[119] Theirs is an art of "frozen attitudes,"[120] of plastic stasis, and "neo-Greekness" in subject matter.[121] The Gallo-Gothic tradition, however, lived on in Chardin, "who incarnates an entire race, full of sap." His followers, Géricault and Delacroix, replaced the "frozen attitudes" of Ingres and David with an artistic "dynamism," "fiery and lyrical" in its effect. Ultimately the legacy of their efforts was found in the "plastic dynamism" nascent in Cézanne's "study of primordial volumes," and the Realism of the Cubists themselves.[122] In Gleizes's history of the battle between the Classics and Roman-

tics, it is the latter and their Realist followers who gain the upper hand.

On this note Gleizes returns us to the Bergsonian definition of classicism forged by Billiet and Barzun. In so doing he synthesizes the pronouncement, in *Du Cubisme*, that Cubist painting reflects the creative novelty of the artistic elite, with Billiet's and Barzun's definition of the classical élan of the nation. For although he criticized artists like Poussin for imitating the Italian style, he does not encourage his peers to treat the French primitives in the same manner. We would be "untrue to their memory if we suppose [we are] being true to them by imitating or copying them." Since paintings emanate "from human thought," they cannot be "fixed in form." Art, like human thought, "evolves without ceasing and without ceasing gives its tribute to the field which it inherits."[123] This ceaseless change, this creative evolution, is antithetical to an art form based on retrospective repetition of past styles. "The desire that the painting of today have the same aspect as that of the twelfth century" confuses the imitation that Billiet had condemned with adherence to tradition.[124] And in a manner reminiscent of Billiet and Barzun, Gleizes admonishes those who, in attacking Cubism, do not see in the novelty of its forms the basis for a future classicism. As a result, "the same insults that people formally employed" with reference to "the art now called classical" are applied to the Cubists.[125] However, Gleizes and his colleagues are ready to accept such criticism, since they "know that comprehension moves much more slowly than the creative faculties."[126] The practitioners of artistic intuition are destined to become the classics of tomorrow, once the public comprehends their novel forms. Already those who first exhibited Cubist works at the Independants (Room 41) are "surprised to see that many [of the critics] who deny recent productions already acknowledge the paintings of that period."[127] "Is not tradition the ensemble of works that have succeeded, and which, in their day, were revolutionary?"—so asked Gillouin in an article written by Reboul defending Gleizes's "Cubisme et la tradition."[128] Gleizes, Reboul, and Gillouin all assure us that the revolutionary art of their day will become France's classical art, provided Cubism's practitioners remain true to an intuitive method reflective of the Celtic spirit of their race.

The program mapped out in Gleizes's "Cubisme et la tradition" has a resounding echo in his paintings of the period. Gleizes's eulogy to Gothic art and the Celtic roots of plebian culture has its pictorial equivalent in his *Harvest Threshing* (1912) (fig. 23), a celebration of peasant life thought to be inspired by Barzun's epic poem *La*

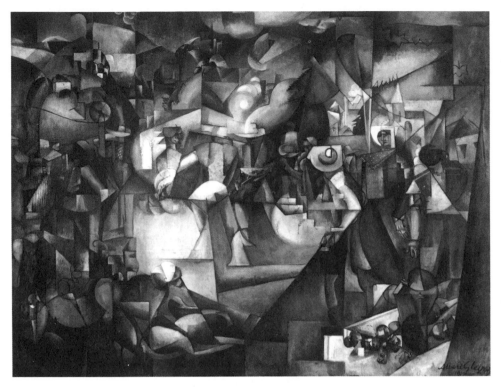

23. Albert Gleizes, *Harvest Threshing*, 1912

Montagne (1908), which was the centerpiece of the Section d'Or ex-
hibition. Barzun's poetic ode to the sense of collectivity and love
garnered through a return to *la vie naturelle,* has its parallel in his
Harvest Threshing, a monumental painting that idealizes rural
labor in a panoramic landscape, including three villages, one with a
prominent church spire.[129] The pictorial rhythms and earthen pal-
ette binding the painting into an organic whole have their equiva-
lent in the painting's subject matter, wherein the rhythm of human
labor is at one with the organic rhythm of the seasons. This is the
ideological import of Gleizes's *Harvest Threshing*: it is a pictorial
confirmation of Pelletier's praise of the collective esprit and durée
of the Celtic peasant, which was at the heart of Gleizes's Bergsonian
cultural agenda by the autumn of 1912.

Gleizes's and Pelletier's association of the Celtic élan with
Gothic architecture was celebrated by Gleizes in his *Chartres Ca-
thedral* (fig. 24), and a year later *The City and the River* (plate 6), a

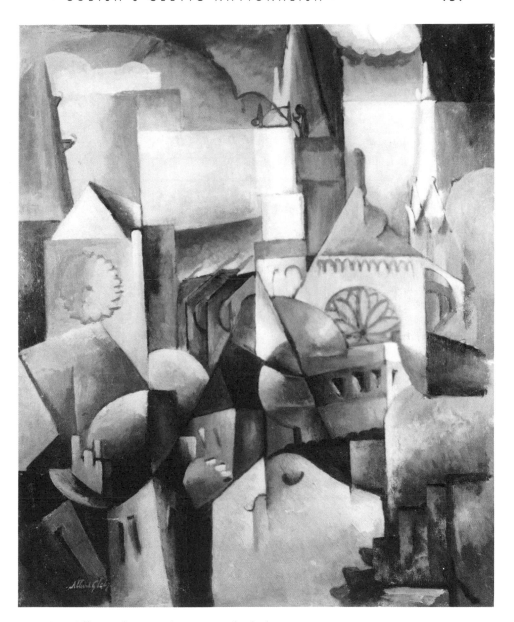

24. Albert Gleizes, *Chartres Cathedral*, 1912

work described by Robbins as his major painting of 1913.[130] Both Robbins and Cottington have noted that Gleizes's placement of Gothic edifices at the center of these paintings symbolized the temporal continuity uniting past and present, a continuity also signified by the ebbing flux and flow of the river in the latter picture.[131] One might add that the church spires in both canvases break the picture frame, emphasizing their role as a transitional device between matter and spirit, with the spirit here being that of the Celtic race. But whereas Cottington describes the theme of cultural continuity evident in such subjects as in stark contrast to "simultanist devices" that make up the painting's pictorial structure,[132] I would identify both form and content as indicative of the organic durée of the Celtic race, a durée expressed by Gleizes's association of the "novelty" inherent in creative evolution's organic growth with the pictorial form *and* subject matter of these paintings. Far from being indicative of Gleizes's "uncertainties over traditionalist and modernist impulses," the organic and novel impulse of the traditional and modern are intertwined in works like *The City and the River*. That Gleizes places a Gothic cathedral in the midst of a contemporary urban landscape, complete with iron bridges, French flag and modern worker in the foreground, is not a contradiction in terms; it rather celebrates what Le Fauconnier termed the "qualitative value" of the modern era, what Lanson, Barzun, and Gleizes saw as the novel rhythm of French society, and what Gleizes identified as the latest manifestation of a racial élan with artisanal roots in the Gothic era. Thus the collective labor that went into the building of Gothic cathedrals had its modern day equivalent in the rural labor depicted in *Harvest Threshing*, or the industrial labor of the urban worker in *The City and the River*. In all these cases the rhythms of human labor, whether rural or technological, were subsumed within the larger organic rhythm of the Celtic race's creative evolution.

In sum, Gleizes's "Cubisme et la tradition" synthesized the Bergsonian tenets fundamental to *Du Cubisme* with those of a burgeoning racial nationalism, albeit of a 'Celtic' rather than 'Latin' type. By taking up Billiet's and Barzun's Bergsonian definition of classicism, Gleizes reconciled the Cubist style with a temporal notion of the French race's "creative evolution". His endorsement of Pelletier's historical separation of France's Latinized aristocracy from a Celtic, plebian culture, in turn allowed him to join the communal values of the Abbaye de Créteil with a racial doctrine.[133]

On this basis we can set Gleizes's political views in relation to those of the critics associated with *Rhythm*. Prior to Murry's re-

placement of *Rhythm* with the *Blue Review* in May 1913, its contributers had already begun to reassess their aesthetic principles. Fergusson's editorial association with the journal ended in November 1912, and six months later he left Paris to settle in Antibes. Although *Rhythm*'s director, Middleton Murry, remained close to Fergusson, he became less sympathetic towards the Symbolist interpreters of Bergson associated with Gleizes's circle. In an article of June 1913,[134] Murry openly renounced Symbolism and embraced the definition of classicism developed by Henri Clouard, whom he called "the chief critic of the *Revue critique*."[135] In the same essay he praised the poetry of the Fantaisistes—Francis Carco's *Chansons aigres-douces* being his prime example—for fulfilling Clouard's desire to find a balance between "analysis and experience."[136] As we have seen, the monarchists Clouard and Maire sought this balance in the subjection of intuition's sensory data to "rational" control. Although Murry praised Clouard and Maire for their reconciliation of intuition and rationality, he appropriated their artistic program to justify a distinctly different aesthetic based on individualism. "Fantasy in the sense that the Fantaisistes use it," says Murry, "is a quality of temperament and not aesthetic dogma."[137] That Murry found that "quality of temperament" in a volume by Carco illustrated by Fergusson, Rice, and Segonzac indicates that the Rhythmists had, in fact, entered into the political controversy over Bergson.

The Rhythmists' Fantaisiste contingent injected a racial component into Murry's individualist aesthetic. In November 1912 *Rhythm*'s French associates Derème and Carco had joined Charles Calais, the leader of the Fantaisistes, in staking a middle ground in the Celtic versus Latin debate. Their position on the subject is most clearly stated by Calais in the November 1912 issue of *Le Cahier des poètes*[138], a journal founded to promote the Fantaisistes:

> The modern Frenchman, descending from the intuitive Celt and deductive Latin tends to establish his equilibrium and the study of this equilibrium repeatedly gives rise to the state of disequilibrium which is evolution. *Vers libristes* and Classicists—Symbolists and Realists, this is the battle of shadow and light, the precise and imprecise, of the North against the South, an opposition that is not only between individuals, but is within the individual himself. . . . Is it necessary to approve the Celtic campaign of Charles Callet, or the Latin campaign of the *Ecole Romane*?[139]

Calais does not think that either campaign is worthy of approval, for while the dialectical synthesis of these two tendencies produces

"very real progress," every time any one tendency "frees itself" from its opposite, "excess is translated into mistaken ideas."[140] Calais, in short, advocates a Hegelian form of evolution, a dynamic fusion of the "intuitive Celt" and "deductive Latin," innate to "le Français moderne." At the same time he judges this synthesis to be different for each individual temperament,[141] thereby reiterating one of the fundamental tenets found in *Rhythm* and in Carco's and Derème's criticism: that of radical individualism, free of aesthetic formulas. Proclaiming both "Celtic" and "Latin" cultures part of the French national character, the Fantaisistes' stance is one of consensus, albeit racial consensus. In sum, the Cubists' and Fauvists' artistic and literary apologists may disagree on what that character is, but by 1913 they are united in their opinion that a racial character exists—a sure sign that the Bergsonism propagated in these circles had taken a reactionary turn.

From Bergson to Bonnot: Bergsonian Anarchism, Futurism, and the Action d'Art Group

Some discover affinities between [my ideas] and Symbolist poetry. That is quite possible, but that is how I am accused of favoring literary anarchy, of taking a position against the classical aesthetic, of introducing into art some subversive doctrines.[1]

SUCH WAS Bergson's own assessment of the affinities between his philosophy and Symbolism in a conversation with Gilbert Maire in 1913. It was the accusation, on the part of Lasserre and Maurras, that anarchic individualism and Bergsonism went hand in hand that Bergson may be alluding to in this passage. Indeed, the Action française's penchant for labeling all groups they opposed anarchists of an ultra individualist type was taken up by the popular press which declared the whole avant-garde an anarchic disorderly rabble. Patricia Leighten has noted the repeated usage of this derogatory terminology in a wide range of journals, from the radical socialist *Les Hommes du jour* to the conservative *Gaulois*. The writers for these journals shared a disdain for anarcho-individualism, a doctrine identified with the *propagande par le fait* of an earlier symbolist generation but continued in the inflammatory art criticism of Apollinaire and Salmon. Such anarchist-baiting reached its height when a movement arose in the Chamber of Deputies to curtail the Cubists from exhibiting in government buildings such as the Grand Palais. Leighten reports that the December 1912 debate in the Chambers was carried in virtually all the newspapers, and was undoubtedly followed by the Cubists themselves.[2] That the Puteaux Cubists recognized the Action française as a rhetorical source for such criticism is inevitable given their extended campaign to counter the royalists.

As we have seen, Maurras's identification of Bergsonism with anarchy caused Bergsonian royalists like Maire to break with the Ac-

tion française, and provoked the creation of an organicist, federalist version of Bergsonism on the part of Gleizes and his colleagues. And if Bergson had been aware of this Cubo-Symbolist response he might well have asked on what basis the Action française could still identify the Bergsonian Symbolists with anarcho-individualism, when, by 1913, their theories were thoroughly collectivist in import? Could we not consider this political formulation invalid by the time that Gleizes published "Cubisme et la tradition" as an organicist counterpart to such criticism?

One answer to this question would be that Bergson's royalist critics had more than just Gleizes in mind, for concurrent with the publication of Gleizes's essay, a group of anarchists with strong ties to Cubo-Symbolist circles launched a journal that advocated a Bergsonian form of anarcho-individualism. The journal in question was titled *Action d'art*; the movement's major figures were the Bergsonian critic André Colomer, the Mexican artist Atl, and anarchist theoretician Gérard Lacaze-Duthiers.[3] Colomer explicated the Bergsonian elements of the group's program in a regular column titled "De Bergson à Bonnot: Aux Sources de l'héroisme individualiste," which began with the journal's inception in Febuary 1913 and ended with its demise the following November.[4] In that series of articles Colomer distinguished his Bergsonian anarchism, based on the radical individualism of Max Stirner, Frederich Nietzsche, and Gérard Lacaze-Duthiers, from anarchism's collectivist theories, whether they be those of Kropotkin's "scientific" anarchism, Proudhon's Federalism, or the anarcho-syndicalist movement. In Bergsonian terms, Colomer's overarching concern was to merge Bergson's notion of the artistic nature of intuitive acts with a theory of radical individualism. He defined intuition as a faculty of self-knowledge, in opposition to those who would consider it a catalyst for collective consciousness. In Colomer's theory no Sorelian myth of the mass strike could intuitively unite the working class, nor could intuition be related to a Celtic or French national temperament, as the Cubists and Rhythmists argued. Far from being a theory of national consensus, Colomer's anarchical Bergsonism trumpeted an individualist revolt against society in the name of artistic or intuitive self-expression.

Colomer thought his merger of art, intuition, and anarchism compatible with Symbolism, and in particular, with the aesthetic program advocated in Paul Fort's *Vers et prose*. For instance, in the May edition of his regular column devoted to "Les Revues et les journaux," Colomer praises Fort's and Visan's contributions to the

journal, noting that under their direction *Vers et prose* does not "remain frozen in the formulas of Symbolism and is open to all the manifestations of lyricism," including that of *Action d'art*.[5] When the Action d'art collective founded a "Librarie de l'Action d'art" in July 1913, a number of Cubo-Symbolist texts were listed among those Colomer deemed in keeping with the group's "essentially individualist and anarchically idealist tendencies."[6] Besides Symbolist writings by Gustave Kahn, Florian-Parmentier, René Ghil and Paul Fort, the Librarie also sold Gleizes and Metzinger's *Du Cubisme* (1912) and Apollinaire's *Les Peintres cubistes* (1913), two texts whose orientation was both Nietzschean and individualist—indeed "anarcho-individualist" in the case of Apollinaire.[7]

Members of the Symbolist milieu acted in kind by lending their support to the journal and its protagonists. This support was given despite the fact that the *Action d'art* art critic, Atl, was unsympathetic to both Cubism and Futurism.[8] Atl's views did not prevent Apollinaire from writing a sympathetic review of an exhibition of the artist's work in 1913.[9] Nor did Atl's negative appraisal of Gleizes and Metzinger's *Du Cubisme* prevent the Cubist critic and poet Roger Allard from lending his support to the journal in the form of a poetry reading at an *Action d'art* benefit, held at the *Maison Commune* on July 12th.[10] And when Atl derided Futurism as a pictorial variation of the American "Fony Papper" [sic],[11] *Action d'art*'s editors published a rebuttal by the Futurist Gino Severini and then allowed Severini to follow that rebuttal with a hitherto unnoticed essay on Boccioni's sculpture.[12] Perhaps then, Atl's hostility towards the Cubists and Futurists was balanced by the presence of the Bergsonian Colomer on the journal's staff. Perhaps too Colomer's sympathy for the *Vers et prose* circle extended to their artistic allies, which could account for the inclusion of Severini's articles in the journal as well as the sale of *Du Cubisme* in the movement's bookstore.

The willingness of the journal to publish Severini's criticism may in turn account for the painter's fond reminiscence of the Action d'art group in his 1946 autobiography, *La Vita di pittore*. Referring to Paul Fort's weekly meetings at the Closerie des Lilas, Severini went on at length about "the wildest poets of the Closerie" who

referred to themselves as The Companions of Action d'Art. In fact they published a bi-monthly journal titled *Action d'art—Organ of Heroic Idealism*, in which they expounded their ideas, not without interest. They were likeable to everyone at the Closerie, nevertheless one did

not give their ideas a lot of weight. These young men were called Atl, Banville d'Hostel, André Colomer, René Dessambre (these last two were brothers, and the first of the two would be killed in World War I). The group included other young men, among whom Gérard Lacaze-Duthiers and Paul Dermée would later be found in *L'Esprit Nouveau*. That their theory coincided more or less with the anarchist movement, there can be no doubt; nevertheless, it remains that what we are dealing with here is a special anarchism; it was a movement, in any case, which placed the social dimension behind the aesthetic in problems concerning humanity. According to the anarchist principle it was, above all, on an absolute independence and an absolute individualism that they had constructed their movement, that they even called Artistocracy in opposition to Mediocracy. An impassioned study of being ontologically understood, and thus an intentional harmony between the physical and intellectual was also at the base of their ideology. There was, thus, in them, in spite of an immorality more a matter of appearances than substantial, a tendency towards the ethical, towards the spiritual; indeed they saw life as a work of art. Like some anarchists, they revolted against the established hierarchy of society in whatever form it was then organized, and they used to say there were no classes in society, there were only those who were for or against beauty. In the first category belonged men of free spirits . . . in the second group were spirits made for enslavement. . . . Even if at first sight such ideas can appear to be crazy dreams or youthful utopias, nonetheless it remains that these young men were deeply dedicated, and this merits respect.

And besides is it such a crazy principle to apply an aesthetic criteria to all our activity, in any circumstance? . . . In opposition to democratic ideas of equality [the Action d'Art group] left these aphorisms of the 'I' integral:

All men are not equal.

There do not exist two identical human beings, etc. . . . At this time our young friends . . . knew of Nietzsche . . . from whom they did not deny their paternity; furthermore Marinetti, also inspired by Nietzsche, had with Futurism some years after sketched a theory of the supremacy of the aesthetic, but unfortunately with him it became aestheticism and literature. In essence these so-called "Artistocrats" were the most direct precursors of the Futurists, given that their first Manifesto, called "Mouvement visionnaire" dated from 1907 and the earliest Marinettian Manifesto dated from 1909. In their exposition of ideas we are told of the necessity of resorting to violence to defend "the dignity and pride of art." "Long live violence against everything which renders life ugly" was their battle cry.[13]

Severini's reminiscence is remarkable, both for its documentary accuracy and its evident sympathy for and identification with this anarchist movement—even to the detriment of F. T. Marinetti's Futurism. Such identification may account for Severini's contribution to *Action d'art*, whose anarchist program he clearly respected as complementary to his own Futurist aesthetic. Indeed one of the goals of this chapter will be to establish the Bergsonian ground for this interrelation, in order to cast the Bergsonism of Gino Severini and the Futurists in a completely new light.

For what Severini has given us, nearly forty years after the fact, is evidence of his complete familiarity with the genealogy of the Action d'art movement. For instance, the 1907 "Mouvement visionnaire" manifesto referred to above was penned by none other than André Colomer, on behalf of the "Groupe d'Action d'art," for *La Foire aux chimères*, the official "Organe du Mouvement visionnaire."[14] Banville d'Hostel and Lacaze-Duthiers—two other figures mentioned by Severini—joined Colomer in founding *La Foire aux chimères*, which ended publication in 1908. The doctrine of "Artistocracy," mentioned by Severini as fundamental to the group's theory, was first formulated by Lacaze-Duthiers in 1906[15] and permeated the criticism of the movement from 1907 onward. Between 1907 and 1913 the future "companions of Action d'art" collaborated on a number of journals devoted to the theme of Artistocracy: *La Foire aux chimères* (1907–1908), *Les Actes des poètes* (1908–1911), *La Forge* (1911), *Le Rhythme* (1911–1912), and *Action d'art* (1913) being chief among them.[16]

Though he was aware of the movement's origins, Severini's autobiography makes clear that his encounters with the group at the Closerie des Lilas occurred after the founding of *Action d'art*—a supposition borne out through an analysis of his description of their program. Severini links their "absolute individualism" to a rejection of democratic ideas, but that correlation, in fact, was only developed in the movement's later phases. Florian-Parmentier, in his 1914 study of Parisian literary movements, noted that the writers for *La Foire aux chimères* had originally declared their "visionary" aesthetic "perceptible pour les masses," but had renounced this populist view by the time *Action d'art* was founded.[17] Lacaze-Duthiers, in his book *Vers l'Artistocratie* (1913), stated that he originally conceived of the doctrine as a form of democratic renewal, and only later replaced this theory of collectivity with one focused exclusively on the individual. In that book Lacaze-Duthiers related his later views to the opposition of the "Artistocratie" to "Mediocratie" mentioned by Severini.[18] Most importantly he declared Colomer's

defense of Artistocracy from the standpoint of Bergsonian intuition to be Colomer's "personal conception of Artistocracy."[19] By Lacaze-Duthiers's own admission Colomer's Bergsonian anarchism constituted his own unique contribution to the Artistocratic doctrine, and it is thus to Colomer that we should turn to gain insight into the nature of this linkage, and its possible ramifications for the Futurist movement.

Colomer's Bergsonian theories have a rich anarchist genealogy relatable not only to the ideas of Lacaze-Duthiers, but to the wider context of what Severini deemed "a special anarchism," namely, a doctrine of anarchist individualism, as distinct from a "scientific" or "collective" notion of anarchism. In his column titled "De Bergson à Bonnot," Colomer traced the paternity of this doctrine to the writings of Max Stirner, as they were propagated by the journal L'Anarchie (1905–14).[20] Moreover the title of his column, alternating between "De Bergson à Bonnot" and "De Bergson à banditisme," explicitly links his Bergsonism to the anarchist doctrine of illegalism which L'Anarchie supported. Illegalism's chief proponent was L'Anarchie's founder Libertad, who had arrived in Paris from Bordeaux in 1897. In October 1902, he joined the anarchist Paraf-Javal in setting up the Causeries populaires, which held weekly discussions at their headquarters behind Sacré Coeur. By 1904 Libertad's organization had opened up a bookstore and begun selling pamphlets on Stirner, as well as the writings of the anarchist and future Action d'art associate, Han Ryner.[21] When Libertad and Paraf-Javal founded L'Anarchie in 1905, one of their main contributors was Lorulot, whom Colomer would later praise as an anarchist theoretician whose views resembled those propagated by Action d'art.[22] Lorulot, along with L'Anarchie's future editor, Victor Serge, shared Colomer's contempt for the "scientific" faction of the individualist movement. More generally the editors of L'Anarchie and Action d'art rejected any form of anarchism premised upon class analyses, since both groups followed Stirner in considering the term "class" a collectivist label designed to suppress an individualist conception of the self.[23] Colomer, in the seventh article of the "De Bergson à Bonnot" series, called upon the anarchist to "no longer be a person of a class," but to adopt instead "an antisocial attitude, an individualist attitude." Thus the anarcho-individualist can come "from the ranks of the bourgeoisie or proletariat," since Colomer's chief concern is with an individual's psychological "attitude" rather than class origins.[24]

Moreover, Lorulot, like Colomer, based his support of the concept of "illegalism" on the writings of Stirner. The notion of illegalism,

or *reprise individuelle*, had a long history in France, with theoreticians such as Emile Pouget, Proudhon, Kropotkin, and Jean Grave advocating it and burglars such as Marius Jacob and Vittorio Pini practicing it before the turn of the century.[25] What separated the early theoreticians of the creed from the writers for *L'Anarchie* or *Action d'art* were the bases on which they justified such acts. In the opinion of Stirner's followers, anarchists like Proudhon justified theft on moral grounds, since Proudhon thought the vast accumulation of wealth on the part of a few a crime against humanity.[26] At the same time Colomer differed from Kropotkin, who developed a scientific justification for reprise individuelle, suggesting that the hoarding of wealth contradicted the system of mutual aid, which was the basis for species behavior in the natural state, wherein wealth is shared equally for the good of all.[27] The advocates of Stirner's theories rejected moral and scientific criteria as collective concepts that would inhibit rather than nurture self-expression. That critique was most clearly stated by Stirner himself in *Der Einzige und sein Eigenthum* (1845), later translated into French as *L'Unique et sa propriété* in 1900. According to Stirner theft had no other purpose than to serve one's self-interest. Thus to follow Proudhon in declaring that "property is theft," is in fact to condemn theft per se on the basis of "the idea of morality."[28]

The younger generation took up Stirner's new "Egoist" theory of illegalism, just when those of an older generation had decided to repudiate illegalism all together. Thus by the time of the founding of *L'Anarchie* in 1905, figures like Jean Grave, the editor of *Les Temps nouveaux*, had come to condemn reprise individuelle as little more than a bourgeois act of robbery, motivated by a capitalist desire for individual gain.[29] Grave and others of his generation came into increasing conflict with the Stirnerite writers for *L'Anarchie*, whose alliance with illegalism culminated in their open support for Jules Bonnot, the founder of the notorious Bonnot Gang, who along with Octave Garnier, Raymond Callemin, René Valet, Edouard Carouy, and André Soudy had embarked on a crime spree in 1911. Their self-declared "anarchist" revolt against society ended in the killing of Bonnot, Valet, and Garnier, the suicide of Carouy, and the sentencing to death of Callemin, Soudy, and Monier in April 1913, after a well publicized trial which began February 3rd and ended on the 27th of the same month.[30] Colomer had begun publishing his column "De Bergson à Bonnot" just as the trial of the Gang was getting under way, a trial that included editors of *L'Anarchie* among the defendants.

In many respects this trial was a virtual remake of the famous

1894 "Trial of the Thirty," when anarchist theoreticians such as Félix Fénéon were accused of inspiring the burglaries of the Ortiz Gang.[31] The difference between the trial of 1894 and that of 1913 was that the "theoreticians" in question had long-established contacts with the so-called "bandits tragiques" who in turn were avid readers of L'Anarchie.[32] Carouy and Callemin, for instance, were old friends of Victor Serge, who replaced Lorulot as L'Anarchie's chief editor in 1911.[33] In 1911 Lorulot, Serge, and future Bonnot Gang members Callemin, Carouy, and Garnier were all part of an anarchist commune in the Parisian suburb of Romainville, which also acted as headquarters for L'Anarchie. When the Bonnot Gang pulled off the first ever bank robbery by car in December 1911, Serge was quick to publish his full support of their actions in the January 1912 edition of L'Anarchie.[34] In addition Serge was accused at the trial of having provided arms for the gang members, with the result that his evocation of a distinction between the theoreticians of illegalism and its practitioners in his defense was viewed with skepticism. While such reasoning had enabled figures such as Fénéon to escape prosecution in the 1894 Trial of the Thirty, in the Bonnot Gang trial that separation failed to sway the jurors, and Serge was sentenced to five years imprisonment.[35]

Throughout the period of the Bonnot Gang's exploits there was a schism in the anarchist movement between those who condemned illegalism and those who defended it. Jean Grave, Kropotkin, and socialist activists such as Alfred Rosmer (La Vie ouvrière) and Gustave Hervé (La Guerre sociale) were among those who condemned the gang as petty thieves;[36] aside from L'Anarchie's editors, illegalism's supporters were few in number, but Colomer and the writers for Action d'art were prominent among them. When the Fédération Communiste-Anarchiste held a Congress in Paris in August 1913, they threw out the illegalist faction and, in the words of one historian, "condemned all forms of individualism as bourgeois and incompatible with anarcho-communism."[37] In the August 25th edition of Action d'art, Colomer noted this expulsion with disdain, and then reproduced a sardonic statement of "conversion" to anarchism penned by Charles Omessa, a writer for L'Intransigeant who found the Congress's declaration amenable to his ideas on civic order. That commentary is worth recalling, not only because Colomer reproduced it as a sign of his contempt for the Congress's anti-individualist position, but also because Omessa thought the public was deluded when it concluded that there is "as little relation between order and anarchy as between art and cubism." Colomer on the other hand thought that anarchy, art, and cubism were united in

their opposition to what Omessa called the "order and collective harmony" propagated at the Congress.[38]

In analyzing that interrelation I plan to begin with Colomer's critique of competing ideologies within the anarchist movement. Thus my attention will first focus on Colomer's condemnation, on Bergsonian grounds, of what he called scientific anarchism. I will then turn to his separation of Bergsonian intuition from any notion of collective consciousness in a tacit dismissal of those who would associate intuition with syndicalism or an organicist form of the body politic. Concurrently Colomer also evoked Stirner and Lacaze-Duthiers in these arguments in an attempt to unite Bergsonism to the Artistocratic state of mind. Finally his relation of various Bergsonian terms to a theory of how artistic activity and anarchy might be united will be considered from the standpoint of Futurist art and art theory, to show how Colomer's anarchism differed from that of Severini and his Futurist associates.

Colomer's dismissal of scientific anarchism had a direct relation to debates within the anarcho-individualist milieu of which he was a part. He was particularily sensitive to the controversy over the scientific basis for individualism which pitted *L'Anarchie*'s Lorulot and Serge against those associates of the journal who justified illegalism on scientific grounds. Lorulot, in fact, gave up his editorship of *L'Anarchie* in 1911 as a result of his differences with a faction led by Raymond "La Science" Callemin—a future Bonnot Gang member who had joined the Romainville commune. Serge, who took over the journal's editorship, shared Lorulot's disdain for Callemin's theorizing, and left the commune as a result of what he later described as the dogmatic nature of Callemin's scientific doctrine.[39]

According to Serge, Callemin's group deemed irrational or emotive behavior anathema to anarchism, which they claimed to practice on purely rational grounds. They justified that association on the basis of the writings of Félix Le Dantec, a biologist in the Lamarckian tradition whose association with anarchist circles went back to the 1890's.[40] Le Dantec, who advocated an extremely mechanistic view of evolution, had developed a theory of egoism that Callemin judged compatible with his own illegalist doctrine.[41] In *L'Egoisme, base de toute société* (Paris 1911), Le Dantec claimed that his conception of society was based on the same "objective" scientific methods he had applied in his biological research. As the title of this book suggests, Le Dantec's vision of society was of unending competition, wherein individuals only aid each other when it serves their "egotistical" ends, such as the repulsion of a common enemy.[42] In contrast to Kropotkin, whose doctrine of mutual aid put

the stress on cooperation rather than competition, Le Dantec's vision of humankind's natural state was of rampant, unbridled egoism. On this basis anarchists like Raymond "La Science" proclaimed their individualist revolt a reflection of biological "laws" in complete contradiction to those "laws" of mutual aid which served Kropotkin in his justification of federalism. Reflecting upon such contradictions shortly after he left Romainville, Lorulot concluded that the proliferation of scientific theories produced "petits pédants" whose conflicting views only created "une sorte de Tour de Babel où chacun d'eux, employait tout son zèle à éblouir le voisin de son érudition."[43]

Lorulot also shared Colomer's fear that the rationality of Callemin's anarchism would stifle individual self-expression. Colomer, in *Action d'art*, quoted Lorulot to the effect that the advocates of science and reason were "combatting too systematically the impulsivity of individuals." Colomer then concluded that "a weariness of scientific reasonings" would lead "anarchist-individualists" to absolve "their action of all social comprehension," thereby "rendering the personality alone master of one's attitude."[44] Thus Colomer saw scientific reasoning as a "social," rather than "anarcho-individualist" justification for human activity. But while Colomer's followers could regard "scientism" as "a dogma, like religious and social dogmas," anarchists like the editor of *Individualiste scientiste* dismissed "the anarchists of *Action d'art*" as "fanatics of intuition" whose "enthusiasm is anti-individualist" because reason alone "is the basis of individualism."[45] In short Colomer's opponents in the scientific camp condemned his correlation of anarcho-individualism with intuition as irrational and therefore out of keeping with the rational basis on which the anarchist doctrine should rest. For Colomer on the other hand their "rational" and "deterministic" suppositions were innately flawed, since he regarded scientific laws as somehow fundamentally anti-individualist. Indeed the essence of Colomer's objections resided precisely in his adaptation of Bergson's critique of rationalism to an analysis of the anti-individualist orientation of scientific laws, and the "scientific" denial, as a result of such laws, of the intuitive and thus individual nature of human activity.

Crucial to Colomer's theory was an identification of scientific reasoning with Bergson's critique of the intellect as a utilitarian and deterministic faculty. Thus in an article published in *Action d'art's* first issue, he qualified his praise for *L'Anarchie* by noting that some among its staff saw the Bonnot Gang as "victims of social determinism" and therefore "put too much trust in scientific theories."[46]

Having concluded that the "physiological and physical laws" of this faction only led to "a fatal determinism," Colomer went on to discuss the genealogy of that discourse in decidedly Bergsonian terms:

> Science, only occupied with the objective and the general, possesses some universal laws, some common laws. . . . Borne of practical experience [science] has no other goal than to serve our action. To want to subordinate our whole being to it, to reduce our consciousness and our will to its determinism, is to render the individual slave to an instrument.[47]

Colomer, like Bergson, dispels the notion that scientific knowledge can be applied to an understanding of human consciousness by identifying scientific thought as the product of utilitarian need, with a tendency to reduce "our consciousness and our will" to its deterministic ends. Human consciousness, divorced from determinism, is related by Colomer to "what a contempoary philosopher calls *intuition*"[48]—an association that laid the groundwork for his Bergsonian critique of scientific anarchism. That critique was fully developed in two articles from the series "De Bergson à Bonnot": one of May 13th, subtitled "La Science & l'intuition: Leurs Rôles dans l'individualisme,"[49] and another bearing the headline "Illusions sociales et désillusion scientiste."[50] Colomer's purpose in these two articles was to show how "Bergson distinguished between intuition and intelligence" and in so doing counteracted those who "wanted to reduce human will to an absolute mechanism."[51] He also let his readers know that this critique was aimed explicitly at certain anarchist-individualists who identified themselves as "scientists."[52]

In his article of May 1913, Colomer noted that while science fulfilled "a practical role" by allowing us to "act on matter," it could not discern our own inner being, since its chief preoccupation was with "external necessities." The deterministic nature of scientific knowledge assures that science is unable to focus on "being itself, its consciousness, its life," which constitutes a "free and creative center"—an allusion to Bergson's description of human consciousness in *Matter and Memory* as a center of "indetermination."[53] Colomer then relates the inability of scientific knowledge to grasp the free nature of our consciousness to a distinction between two types of thinking. While scientific thought relies upon "analysis and logic" as a "means of discerning the external world," our own consciousness is only discernable through "intuition," which is "a force of synthesizing what is personal in us, it is the individual axis of vision which forms a particular being, it is an original force of

sensation, of sentiment, of consciousness."[54] In Colomer's theory, intuition is both a means of focusing on the freedom inherent to human life and a "force" fundamental to the free activity of consciousness. It is from this standpoint that Colomer would come to identify anarchist acts as artistic, for "art is the daughter of intuition . . . the free expression of an individuality which does not recognize any other law than that of its individual harmony." Whereas science reveals "universal facts," an artistic state of mind "invites us . . . to disassociate ourselves from collective thought, from common sense, from universal sentimentality, to realize individual harmony."[55] The "individual harmony" in question was clearly divorced from the "collective harmony" upheld by the 1913 Fédération Communiste-Anarchiste. It is instead that harmony described by Severini as "an intentional harmony between the physical and the intellectual,"[56] an alignment of individual will with human action that collectivist concepts had torn asunder. This was in keeping with Lacaze-Duthiers's use of the term in his description of the Artistocrat as one who seeks a "harmony, in the individual, of thought and action, of sentiment and reason, a living synthesis, like art."[57]

Thus Colomer associated the deterministic methods of science with those collectivist labels Stirner had critiqued as instruments of oppression. The fundamental thesis of Stirner's theory of egoism was that governments and kings evoke "a higher cause"—whether it be "God," "truth, freedom, humanity" or "the great cause of the nation"—in order that individuals subordinate their "personal or egoistic interest" to the interest of those in power.[58] These higher causes are merely tools for oppression, collective ideas that serve to veil the individual self-interest of those that seek to impose them. To act egotistically is to respond to one's "corporeal self," to exercise one's will in the interest of one's own body. However when individuals are asked, say, to go to war in the name of "God, Emperor, Pope, Fatherland, etc.," they are called upon to submit their will and corporeal self-interest to a collective idea, which in reality is no more than the egotistical interest of another.[59] Stirner extended this critique to include moral concepts such as good, evil, justice, and criminality, as yet more examples of how the individual is trained to subordinate his or her ego to that of others. Going beyond socially sanctioned notions of good and evil thus became an expression of egotistical will and self-creation, and it is not surprising that both Nietzsche's and Stirner's anarchist adherents drew parallels between Nietzsche's notion of will to power and egotistical will as Stirner envisioned it.[60] As we have seen, Bergson's followers in the

Rhythmist and Cubist movements had already synthesized Bergsonian intuition and the Nietszchean concept of will: Gleizes and Metzinger had advocated such a synthesis in their most individualist-oriented text, *Du Cubisme*. Colomer for his part set these Bergsonian and Nietzschean precepts within the parameters of Stirner's egoism.[61] In calling upon anarchists to avoid society's strictures, Colomer included moral criteria in his list of what should be rejected. "'This is good'," states Colomer, "is equivalent to 'this is according to the orders of society'; 'this is bad' is synonymous with 'this is against the orders of society.'" In either case, "good" and "bad" are reducible to what "the God-Society ordered"—one must go beyond socially sanctioned notions of good or evil to act egotistically.[62]

Moral criteria are not the only ones that Colomer associates with anti-individualist rhetoric—concepts of humanity, fraternity and altruism are all condemned on similar grounds. "Christendom had taught Human fraternity [as well as] altruism" and therefore had been "par excellence a study in anti-individualism." Unfortunately "the anarcho-communists today follow this humanitarian and altruistic ideal, this belief in a universal concord and in an egalitarian fraternalism to which the individual must sacrifice himself."[63] Colomer singles out "anarcho-communists" like Kropotkin and Jean Grave as theoreticians particularly guilty of such collectivist thinking. "Not concerned about individualism" these writers became "obsessed by ideas of universal good and fraternalism," and "sank into socialism or syndicalism" as a result. They subsumed the individual in "a collective and fatal battle of classes"; furthermore, "the individual in the anarchism of Kropotkin, of Jean Grave, of Sébastian Faure and [Georges] Yvetot, counts for nothing beyond his or her utility among humankind or among proletarians. The lot of Humanity, the lot of the Proletariat, this is all that preoccupies the anarchist." "How could the artist, the poet," Colomer argues, "be interested in such a cause?" The causes in question are those of "corporatism or communism," systems no different from the Christian precepts of "the existing Bourgeois society."[64]

In Colomer's opinion, scientist-individualists also fail to transcend such criteria when they posit "common ideas in order to create an 'anarchist' opinion, an 'anarchist' state of mind, an 'anarchist' crowd." Their general laws, inapplicable to "the individual sensibility, personal intuition, the sense of our uniqueness," are no different from the "moral laws" of "bourgeois educators" who employ them to fabricate "a 'sane public opinion.'" Moral doctrines, like scientific laws, advocate "social determinism," since "morality

assimilates us to a crowd of other beings; a morality makes the individual the cell of a social organism."[65] By divorcing Bergsonism from any notion of the "social organism," Colomer states his opposition to any Bergsonian form of the body politic, with the result that, unlike Le Fauconnier, Fergusson, or Gleizes in his Celtic phase, Colomer divorced intuition from any notion of collective consciousness.

This correlation proved particularly valuable when Colomer set out to refute those who would interpret Bergson in a religious or nationalistic manner. He took up both themes in two articles in the "De Bergson à Bonnot" series, published in March and April 1913. The first, titled "Bergson et *Les Jeunes Gens d'aujourd'hui*" was an attack on a text written by Alfred de Tarde and Henri Massis, who then published under the pseudonym "Agathon."[66] That book was composed of a series of articles, originally published in the journal *L'Opinion*, that claimed to give the reader a comprehensive view of the youth of France, based on a survey of the elite students enrolled in the various *grandes écoles* in Paris.[67] To fully understand the import of Colomer's objections to Agathon's text we must therefore take a brief look at the book's contents, to grasp the Bergsonian import of Agathon's findings.

Henri Massis—one half of the Agathon equation—was an avid student of Bergson who wished to popularize the view that Bergson's philosophy lent itself to patriotic and religious fervor. His first attempt to do so had come in the form of an attack on the so-called "New Sorbonne," which de Tarde and Massis had published a year previously.[68] In the words of the historian Robert Wohl, Agathon had accused the Sorbonne faculty "of 'Germanizing' French culture and of replacing classical learning with Teutonic sociology and meaningless erudition."[69] The erudition and sociology in question were described in Bergsonian terms as overly intellectualized and anti-individualistic. As R. C. Grogin states, Massis and de Tarde characterized French society as locked in a debate

> between the *esprit de géométrie*, represented by the Sorbonne, and the *esprit de finesse*, the true spirit of French culture, ably represented by Henri Bergson at the Collège de France. For Agathon, the *esprit de géométrie* was identified with secular rationalism, Cartesianism, and positivism; it shunned general culture and emphasized scientific methods. The *esprit de finesse*, on the other hand, emphasized the spontaneous, the intuitional, the metaphysical, and was responsible for all that was best in classical culture. Bergsonian philosophy was an integral part of the latter tradition, emphasizing as it did an intuitional

approach to philosophical problems. Bergson was an acknowledged enemy of sociology and an ardent defender of the humanities. Through his efforts, Agathon pointed out, he had created a philosophical renaissance. Knowing this, Agathon charged, the Sorbonne had contrived to keep Bergson from teaching there.[70]

Agathon, in his portrayal of Bergson, describes him as a defender of classical studies in opposition to a sociological methodology grounded in Cartesianism. In this respect, Agathon's attack on the Sorbonne in the name of classical values differed fundamentally from the attack on the Sorbonne launched a year later by the Action française. This royalist organization refused to follow Agathon in equating the "Germanic" sociology of Durkheim with the Cartesian methods they identified as at the heart of the French culture.[71] It is that schism which, in part, accounts for the support given to Agathon's campaign by Bergsonian Symbolists like Visan, whose colleagues had already developed a Bergsonian theory of classicism before Massis's attack on the "New Sorbonne" was launched.[72]

Thus the Bergsonism of Agathon's *Les Jeunes Gens d'aujourd'hui* was in large part predicated upon his campaign against the *esprit de géométrie*, launched the previous year. In the new book Agathon simply applied his Bergsonian vocabulary to characterize the revolt of a whole generation against a sterile, scientific world view propagated by the generation of 1885. Agathon's generation, as Wohl summarizes it, "was tired of relativism, hankered after absolutes, and inclined towards Catholicism," because Christianity offered "the faith and discipline they craved as well as the basis for coherent action."[73] In this regard, Agathon was able to marshal Bergson's critique of scientific relativism and rationalism, as the means by which this generation could justify a turn to religious absolutes. Agathon avidly endorsed the response of one youth who claimed "it was Bergson who opened up the new road that we followed in the wake of Le Roy, Blondel, and Father Laberthonnière."[74] According to Agathon those like himself who cast Bergson's philosophy in a religious light saw the philosopher's critique of positivism as "a preparation for our doctrines and our guidance."[75]

A vogue for religious Bergsonism among "the youth" was coupled with a revival of national pride and a desire to counter German advances on the political front. This nationalism was founded on the basis of a national volonté, antithetical to a sterile form of republicanism whose chief apologists were the scientific rationalists at the Sorbonne. Although Agathon claimed that the younger generation was sympathetic to the nationalism of the Action française, Massis

and de Tarde did not endorse the Cartesianism of Maurras as indicative of the kind of nationalism their generation supported. In *Les Jeunes Gens d'aujourdhui*, they characterized the nationalism of French youth as a form of "realism," adding that advocates of democracy among *les jeunes gens* were "the most numerous" and "most truly realistic." As a result youth harbored a mistrust of "the purely rational order" of Maurras, and "the formal perfection" of a royalist doctrine "that scorns interior perfection." Massis and de Tarde, in their concluding remarks, noted that "the fiercest objections" to Agathon's findings came "from the Action française group—from Charles Maurras and his young disciples in the *Revue critique des idées et des livres*," who sought to reconcile their Bergsonism with Maurras's politics.[76] In many respects Massis's position with regard to Maurras was no different from that of Maire and Clouard, for in their attempt to reconcile Bergsonism with a conservative political agenda all three had to grapple with the anti-Bergsonism of Charles Maurras.[77]

Thus Colomer's essay on *Les Jeunes Gens d'aujourd'hui* was an attack on Bergson's conservative allies, who utilized Bergson's philosophy as an apologia for a Catholic revival and resurgent nationalism. Agathon's book reportedly linked Bergson's theories to "a renaissance of national sentiment, of an awakening of a taste for discipline, and an irresistible drive towards Christian spiritualism."[78] By separating "intuition from individualism," Agathon saw that faculty as "a sort of moral policeman, guardian of honest principles" amenable to the ideals of the Church and the state. Thus "order, discipline, social solidarity, patriotic duty" are all justified on the basis of intuition. As one of the "best students of M. Loyola," Agathon reportedly derived such values from Bergsonian intuition and "the lessons of energy and heroism of Nietzsche." Agathon's separation of Nietzschean and Bergsonian terminology from its individualist roots meant that "our famous young people of today" were characterized as having no other courage "than that of the soldier, no other battle than that of the citizen and no other energy than that spurting forth from the 'unanimous heart of the nation.'"[79]

In Colomer's opinion, Agathon's synthesis of Bergsonian and Nietzschean principles in the name of a collective, national ésprit was little more than a "caricature" of their theories. Appropriately, he subjected Agathon's book to a Stirnerite critique, by drawing parallels between the "collectivist" values Agathon attributed to Bergsonism and the jingoistic rhetoric of the state. Colomer summed up the political agenda of Agathon in the phrase "From

Bergson to Poincaré"—a reference to the Republic's newly elected president.[80] But while this Bergsonian right was to be condemned, Colomer was equally despondent about the failure of the left to link the "renaissance of energy" stemming from Bergson's philosophy to anarcho-individualism. Instead, the advocates of "socialism and syndicalism drowned themselves in questions of economic organization." However followers of "the individualist teaching of Stirner" were "not duped by the charming words" of the proponents of "neo-nationalism" or "syndicalism." Colomer set out to show "everyone what the individual can find of liberty, of internal harmony, in intuition" in order to satisfy the anarchist's "desire for autonomy and his taste for heroic actions."[81]

Colomer recognized that his emphasis on the individualist element of Bergson's philosophy put him in conflict with Bergson himself. "Bergson can agree today with Catholicism," Colomer stated in 1913, but "this does not prevent me from saying that his first works, *Time and Free Will* and *Matter and Memory*, are the tumultuous sources of my heroic individualism."[82] At the time Colomer wrote, Bergson, in addition to praising the conservative interpretation given to his ideas by Agathon, had taken his first tentative steps on the road to religious belief.[83] Moreover, by not including *Creative Evolution* among the sources of his "heroic individualism," Colomer distanced himself from the primary source for the religious views of Bergson's followers. In effect, he rejected a book that would subsume individual creativity into creative evolution, whose teleological corollary in the popular press of the day was the existence of God.[84] With his intuitive theory of radical self-creation Colomer explicitly opposed those who merged Bergson's early theory of individual free will with an organic and corporatist conception of creative evolution. This constitutes the fundamental difference between the Bergsonism of Colomer's group and that of the Rhythmists and the Cubist proponents of Celtism.

There is no better evidence of this schism than Colomer's adaptation of Bergson's psychological terminology to his artistic conception of anarcho-individualism. That this maneuver was fundamental to the theoretical premises of the "Action d'art" group as a whole is made clear from the joint "Declaration," published in the first issue of the journal: "What we mean by [Action d'art] is not only an action in art, with reference to such or such work of 'fine arts' or 'literature', it is also and especially our attitude in life, the individual acts of someone avid for birth integral and harmonious with their being."[85] In this synoptic statement we are given a good idea of those aspects of Colomer's Bergsonism that the group

deemed amenable to their general program. By describing art as primarily standing for an "attitude in life," as distinct from the creation of "such or such work of fine arts," the group as a whole follows Colomer in associating artistic creation primarily with the creation of a state of mind, rather than with an art object. In his series "De Bergson à Bonnot," Colomer had stated that, though artists "recognize the world of intuition," their restriction of their activity to the creation of art objects "confines it [intuition] too narrowly . . . to an activity of luxury, to put it bluntly."[86] "If," on the other hand, an Artistocrat "writes, sings, paints, sculpts, it is not in order to realize some works for which his homeland, or humanity, or society can reward him, it is in order to realize himself."[87] The true object of an artist's activity should be to "realize his synthesis," "discover his beauty," and "make his life a work of art."[88] Clearly it is the self, not some object, that is to be intuitively crafted into an art object. To adopt the Artistocratic attitude in life, each of us must "sculpt his life after the image of his dream."[89]

In their joint declaration, the Action d'art group called upon anarchists to execute "individual acts . . . integral and harmonious with their being."[90] This correlation of individualism with an internal harmony of being has an unmistakable echo in Colomer's theory, which not only tied intuitive consciousness to "the individualism of Stirner,"[91] but singled out musical metaphors such as harmony as indicative of the individualist state of mind. It is "my spirit which, grouping all its tendencies, all its personal desires, all its images, evokes in me the vision of what I should be, of what I want to be, of what my acts should be. This image of my individual ideal, this image of my harmony, my perfection, my well-being, this is what I call my dream."[92] "Individual harmony" should govern one's course of action, because the sensation of "harmonious unity"[93] alone is unfettered by society's strictures. In *Time and Free Will* Bergson had referred to the soul's rhythmic, harmonic, and melodic properties to underscore its qualitative nature; in "De Bergson à Bonnot," Colomer applied similar terminology to a description of the anarcho-artistic temperament. "The true artist is he who, having discovered in himself his own tendencies, having understood the élan of his heart, of his temperament, of his intuition, wants to realize the most perfect accord, the largest and most intense symphony."[94] The "symphony" in question exemplifies "the push of a personality towards its most harmonious realization, the affirmation of a being."[95] This is because "the quality of my being," what makes it unique, "is only comparable to a musical symphony whose total value, total meaning, resides in the ensemble, independent of

each note that composes it; it is a whole whose parts are inseparable because each of these parts only has value in relation to the whole."[96] Similarly, each individual is told to "live most intensely" by responding to the "particular rhythm of his life," for "psychological activity does not obey the same rhythm as physical or physiological life."[97] Colomer here is evoking a distinction first made in *Matter and Memory*, namely that the rhythm of our consciousness is more intense than that of matter, and therefore typified by a greater degree of free will in its activities.[98] "A consciousness," says Colomer, "organizes itself through synthesis" and in so doing "finds its own rhythm in its own life, in the conditions themselves of its creative force."[99] Like Bergson, Colomer describes the soul as a qualitative entity, whose rhythmic and melodic properties make it an indivisible whole. A crucial distinction however, resides in their usage of the term "harmony" to describe intuitive consciousness. For Bergson, willed sympathy, or intuition, allows us to enter into intuitive relation with others, and grasp the harmonic relation underlying the élan vital's diverse tendencies.[100] Colomer, on the other hand, discerns no other harmonic relation than that of an individual's unity of thought and action, with no underlying rhythmic impulse, or élan vital, to join individual organisms into some greater harmony.

In keeping with his Stirnerite principles, Colomer defined the truly individualist act as one premised upon a sensation of harmony rather than the moral or social import of an act. As Severini stated, the Artistocrats rejected the collectivist notion of class distinctions, asserting that "there were only those who were for or against beauty."[101] In effect he is echoing Colomer's thesis that harmonious activity is beautiful and individual, while any act premised upon "collective" criteria is condemned as unharmonious and ugly. Having rejected moral criteria as a guide for one's choice of action, Colomer posits one guide in this regard: "is it beautiful, is it ugly?" If it is beautiful, "it is in accord with the harmony that produces my being"; if not, it is the product of the "social order," and thus premised "on the disorder and unharmoniousness of individuals."[102] When a person makes "individual force serve a social end," that individual's actions are not "in accord with his temperament" or "in harmony with his consciousness." To act "heroically" and with "beauty" is to cultivate "personal harmony"; to do otherwise is to descend into the "ugliness" of social oppression.[103]

In sum, the object of Bergsonian intuition in Colomer's theory is the self alone, and the sensations of harmony, rhythm, and intensity that intuition reveals are those within the self. Intuition does not

produce a harmony between two individuals, but rather an internal harmony between an individual's thoughts and actions. For Colomer, harmony and rhythm are not relatable to notions of collective consciousness, nor does he draw parallels between the nature of consciousness and the nature of organisms, as Bergson would do in *Creative Evolution*. Aristocrats like Colomer chose to reject the organicist metaphors the Rhythmists and Puteaux Cubists embraced, which accounts in part for the ease with which the latter groups adapted their theories to the nationalist rhetoric of the day.

Colomer's individualist conception of intuitive harmony also separated his anarchism from the type of anarchist harmony envisioned by the neo-Impressionist Paul Signac in a work like his lithograph after his neo-Impressionist mural, *In the Time of Harmony* (1894) (fig. 25). As Richard Sonn and Robyn Roslak have so convincingly argued, the formal harmony Signac sought through the "science" of color contrasts was a metaphor for the painting's subject matter: humankind in a natural state of social harmony. The anarchist theoreticians Kropotkin and Reclus deemed the harmonious interaction of cells within an organism a model for relations in society, and Signac adapted the organicist metaphor to artistic technique. Thus "the political corollary" for Signac's divisionism, was "neither egalitarian uniformity nor atomistic social chaos, but a natural harmony in which the autonomy of each element was preserved and intensified."[104] On this basis Sonn connects Signac's imagery and technique to the general move, in the 1890's, away from "the illegalist and terrorist side of anarchism" towards the collectivist theories proffered by anarcho-syndicalists. He also notes that the "aesthetic anarchism" of the *Action d'art* movement represented an aberration from this general trend.[105] In fact, the scientific rationale underlying Signac's harmony of contrasting colors has some relation to those scientific laws of mutual aid Kropotkin had identified as inherent to species in their natural state. This is most evident in Signac's conflation of industrial imagery, relatable to some future modern utopia, with a technique meant to evoke a "natural" order—an order the temporal scale of which far transcends that of human history. Thus while the subject matter of Signac's work depicts a stage in human history, the formal harmony that this human moment is allied to is immutable in its "natural" laws, and thus, in a sense, eternal. In short, "harmony" in the sense that Signac understood it was rather different from that of Colomer, who would divorce that concept from its "collective" corollaries, whether they be laws of mutual aid or those of syndicalist revolution. Similarly, Colomer considered anarchists who posited an uto-

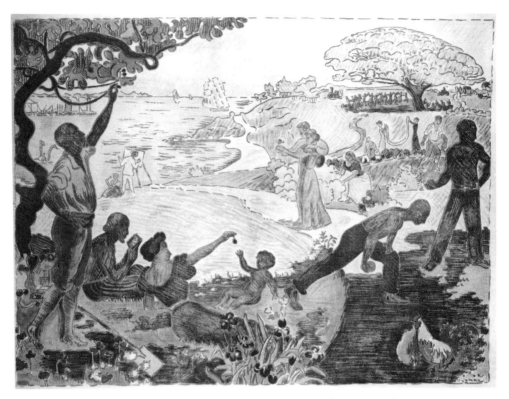

25. Paul Signac, *The Pleasures of Summer (In the Time of Harmony)*, 1895–1896

pian vision such as Signac's to be "lost in vain discussions about a future paradise."[106] Kropotkin's theory of mutual aid, or Signac's *In the Time of Harmony*, both posited some future state of harmony between the individual and society, and Kropotkin's followers such as Grave were ready to justify the social revolt of their day as a means to obtaining this utopian end.[107] For Colomer, on the other hand, no such reconciliation could take place, since harmony was only achievable within the self. An Artistocratic action was both the means and the end of an objective limited to the present: self-development in unfolding durée.

Perhaps the most difficult question is the degree to which Colomer's theory was compatible with Futurism as Severini described it in his autobiography. Although Severini's comparison of Futurism to *Action d'art*'s principles has been acknowledged in the literature on the Futurist movement, no attempt has been made to clarify

the philosophical and political ramifications of that relationship.[108] The interconnection, however, can be elucidated if it is considered from a Bergsonian perspective. In my view the Bergsonian premises shared by Colomer and the Futurists did not extend to the level of political ideology, primarily due to the decidedly Sorelian and nationalistic nature of the Futurist program. For as Giovanni Lista and Zeev Sternhell have pointed out, as early as 1910 Marinetti had aligned his movement with the revolutionary syndicalist circles associated with Octavio Dinale's magazine *Demolizioni*.[109] Among *Demolizione*'s principal collaborators was Paulo Orano, who, along with the syndicalist sympathizers Arturo Labriola and Giuseppi Prezzolini, was part of a very vocal cadre that applied Sorel's doctrine of social myths to a theory of militant nationalism. Nationalism was to be a mythic symbol able to galvanize the proletariat to a revolutionary state of mind. But to understand that transformation, we must first analyze the relation of Sorel's theory of myths to the tenets of Bergsonism.

Sorel's chief innovation was to apply the Bergsonian duality between intellect and intuition to the sphere of leftist politics. Like Bergson, Sorel identified the intellect as a faculty unable to discern durational change or human volonté; and like Bergson he identified intellectualism with Cartesianism, eighteenth-century rationalism, and the scientific positivism of the nineteenth century. But whereas Bergson limited his critique of intellectualism to the realm of metaphysics, Sorel claimed that intellectual modes of thought were at the root of the French Republic's parliamentary democracy.[110] Sorel, states Sternhell, "stigmatized all forms of rationalist optimism, whether Greek philosophy or the natural rights of man,"[111] and identified such "rationalist" values with those of the bourgeois class of his day. Hubert Lagardelle, the editor of *Le Mouvement socialiste* (1889–1914), followed Sorel by praising the proletariat as a group whose activism and ethics were "foreign to the bourgeois society" and thus unlike "the intellectual substance of the bourgeoisie."[112] Roberto Michels, another Sorelian who collaborated with Dinale on the journal *La Lupa* in 1910, called upon leftists in 1907 to educate the proletariat by creating an "ideological unity" meant to strengthen their "courageous will to action."[113] A year later Sorel published his *Reflections on Violence*, a book that proposed the myth of the mass strike as an ideological tool able to unite the proletariat by appealing to their intuitive rather than intellectual capacities. At the same time Sorel hoped proletarian agitation would awaken the bourgeois class from its rationalist stupor, so that it too could be invigorated through intuitive means. With both

classes locked in militant conflict, the parliamentary system would presumably collapse and France's moral regeneration through violence would have its salutary effect. Proudhonian federalism would replace parliamentary democracy as a decentralized system of government.[114]

Sorel's theory of social myths was premised on what he termed a revision of Marx from a Bergsonian perspective. Marx, it seemed, had developed a theory of revolution based on historical determinism, since he posited revolution as a virtual fait accompli in the wake of the inevitable fall of capitalism. As the historian Richard Vernon states, Sorel regarded Marx's projected proletarian revolution as mythical because of "the element of circularity" he detected in Marx's reasoning:

> Marx had projected the downfall of capitalism; but at least part of the reason for the projected downfall of capitalism was the existence of the socialist alternative itself; to justify the socialist alternative by the imminent downfall of capitalism—as though future events were objects of knowledge and not goals to be decided upon—was therefore a logical error. Even if capitalism as Marx knew it became unworkable for strictly internal reasons, it could be replaced by versions of neo-capitalism of which Marx could not possibly know. Marx was obliged, in effect, to assume away the future, by supposing that the potential of capitalism ... had no future. But this supposition, though of undoubted value in provoking action, is theoretically worthless, for it assumes the truth of what is to be demonstrated. . . . There *can* be reflective knowledge of the past, Sorel believed, but not of the present, for the meaning of the present is established by the projection of futures, and this projection is a practical act. Marx's philosophy of history therefore becomes a myth.[115]

Sorel's characterization of Marx's theory as based upon "reflective knowledge" is derived from Bergson's critique of nineteenth-century rationalists who in Vernon's words "supposed that the relation between future and present could be understood in the same manner as the relation between present and past."[116] The intellect's deterministic biases are perfectly suited to the interpretation of past events, since these events are already completed, and therefore readily adaptable to treatment as a finished system. But to then consider events *in the making* or yet to occur as fully predictable on the basis of such retrospective analysis is to deny the radical contingency of human history. In fact to gain knowledge of events in the making requires an act of intuitive sympathy, rather than analysis, so as to discern the internal direction of change unfathomable to

the intellect.[117] In short, Sorel subjected Marx's projected theory of revolution to the same critique Bergson's Symbolist followers had brought to bear on Maurras's theory of history. And since Sorel wished to incite the emotional, revolutionary spirit of the proletariat, he appealed to their *intuitive* sensibilities, by describing his myth of revolution as composed of "a body of images capable of invoking instinctively all the sentiments which correspond to the different manifestations of the war undertaken by Socialism against modern society."[118] Sorel based this definition on the very section from Bergson's *Introduction to Metaphysics* that served as the basis for Visan's idea of "accumulated images," and Severini's conception of simultaneity in the painting *Travel Memories* (fig. 5).[119]

For Sorel, the revolution took on a decidedly psychological tone as a struggle between intuitive and intellectual forces, cast in the guise of a mythic general strike meant to incite class war between the proletariat and the bourgeoisie. "Myth" to Sorel was a positive term for the creation of a revolutionary state of mind. But when Sorel's faith in the myth of syndicalist activism began to falter in 1908, he was prepared to substitute another "body of images" as a means of stimulating the proletariat's intuitive imagination. Sorel, in fact, was to supplement the myth of the general strike with that of a nation founded upon the combative volonté of class conflict. This shift precipitated his alliance with the *Revue critique*'s Bergsonian royalists, and resulted in the founding of the journal *L'Indépendance* (1911–1913), which propagated a corporatist model of national unity that Sorel deemed antithetical to the rational underpinnings of republicanism. In the eyes of nationalists like Gilbert Maire, Georges Valois, and Jean Variot, Maurras's royalist corporatism could be reconciled with Sorelian violence once Maurras recognized the value of intuitive violence as an end in itself. The Sorelians associated with the *Revue critique* wedded Sorel's notion of a decentralized corporative society made up of contesting classes with Maurras's royalism by designating the king as the neutral arbiter of this permanent class conflict.[120]

In the wake of attempts in Italy at a general strike in 1904 and 1908, Sorel's Italian interpreters, Labriola and Orano, followed his example by forging an alliance with extreme nationalists, in a united opposition against what they saw as the parliamentary, rationalist order underpinning the Giolitti government.[121] Their strategy was to separate their conception of heroic nationalism, relatable to Sorel's ideas on how a myth of violence can instill a militant spirit among the working class, from the nationalism of the bourgeoisie who, in Labriola's words, owned the "military industries."

In Labriola's opinion the nationalism of industrial profiteers reflected the mercantile values of the decadent bourgeoisie; that of the proletariat was a "cultural nationalism, patronized by syndicalists, who engender the sentiment of nation among the workers."[122] This latter nationalism of "energy and will" was propagated by Orano and Labriola in the magazine *La Lupa*, founded in October 1910 after the demise of *La Demolizione*. *La Lupa* had Georges Sorel on its editorial board, and not surprisingly the magazine grouped Sorelian syndicalists and anti-parliamentarian nationalists under the banner of a newly created myth of the nation that Sorel now endorsed.[123] It is for this reason that *La Lupa* brought the ultra-nationalist Enrico Corradini into its fold, as one who had used Sorelian arguments to forge a syndicalist-nationalist synthesis in the nationalist journal *Il Tricolore*. For Corradini, nationalism as an idea was superior, in its mythic appeal, to the Sorelian notion of the mass strike it was modeled after. With the failure of the myth of the mass strike as an instrument of revolution, Corradini called upon syndicalists to create a myth of national imperialism and worker imperialism as a means to combat bourgeois decadence.[124] In this manner the myth of class conflict could be transferred to the international plane in the guise of a battle between proletarian and bourgeois nations for global hegemony. "There are nations who are in a condition of inferiority in relation to others," states Corradini in *La Lupa*, "just as there are classes which are in a condition of inferiority in relation to other classes. Italy is a proletarian nation." Citing Sorel's *Reflections on Violence*, Corradini called for the replacement of Italy's moribund parliamentary system by a "new organism," a "corporazione delle corporazioni," which would unite all Italians in an "imperialism of the povera gente."[125] As a proletarian nation, Italy could engage bourgeois nations in a battle for control over colonial territories, and this led *La Lupa*'s staff to call for Italian intervention in Libya, at a time when the vast majority of Italian socialists and syndicalists called for a national strike as a sign of their pacifist position.[126] Rather than follow internationalists like Gustave Hervé in declaring the solidarity of the working class superior to national solidarity, Orano and the editors of *La Lupa* forged a theory of heroic nationalism designed to appeal to a working class they identified as constituting the body of the nation. At a time when Gleizes was creating his Bergsonian conception of organicist, racial unity, Sorel's Italian allies were formulating an organic myth of militant nationalism, able intuitively to unite the Italian people in a global battle against wealthier nations.

The shift on the part of some Italian syndicalists from the myth of

class war to that of international conflict had a direct parallel in the Futurism of Marinetti. "Marinettian Futurism," according to Lista, "is first recognized in the anarcho-syndicalist current" where the Futurist commander in chief in turn became cognizant of the Sorelian "myths of action and violence."[127] Thus Marinetti's *Founding Manifesto of Futurism* (1909) was published in the March 1909 edition of Dinale's *La Demolizione*, the revolutionary syndicalist journal that propagated opposition to parliamentarianism. *La Demolizione*'s stated aim was "to reunite the world in a single body (*faisceau*) to oppose active energies to the inertia and indolence that threaten to suffocate all life."[128] The *faisceau* of *La Demolizione* included all those who shared revolutionary syndicalism's "combative energies," in an attempt to engage "all domains" in "the vast social battle."[129] As Lista points out, Dinale's journal used the term *faisceau*, from which the word fascism derives, to describe a political program explicitly linked to the militancy of Marinetti's Futurism. And in a March 1910 edition of *La Demolizione*, Marinetti underscored the connection in the guise of a manifesto titled "Our Common Enemies."[130] Lista describes the text as

> full of Nietzschean rhetoric where, in the name of violence, messenger of the future, Marinetti preconceives the creation of a common front uniting, beyond all class distinction, the futurist revolt to the revolutionary aspirations of anarcho-syndicalists. . . . Marinetti rests yet again on the idea of the future, considering it as absolute myth, and thus generative image in itself of the action necessary for change. This is the most Sorelian aspect of his thought. But as always Marinetti does not sketch out any project for a new society. The myth of violence and elation for the future of humankind is assumed as such, without indicating in any way the world that would be born out of revolutionary action.[131]

Thus while Marinetti's glorification of violence as a force for social change has a decidedly Sorelian ring, in Lista's view he fell short of describing the mythic social tumult as a *proletarian* revolution. But even before "Our Common Enemies" appeared, and before Dinale, Orano, and Sorel collaborated in the founding of *La Lupa*, Marinetti had already concocted a myth of national regeneration through proletarian violence. In 1909 his *First Futurist Political Manifesto* called upon the youth of Italy to "fight to the finish" against clerical candidates and "cowardly pacifists," in order to aid "the dignity, the growth, the power of the Italian nation." In a discourse delivered in March of the same year, Marinetti described his political program as "far removed from anti-patriotic and interna-

tional socialism."[132] Shortly before Dinale helped launch *La Lupa*'s program of revolutionary nationalism in 1910, Marinetti had given a conference on "The Beauty and Necessity of Violence" in Milan (July 30) and Naples (June 26), outlining a notion of political agitation aligned to Futurism's cultural program.[133] The conference was also meant to augment his political candidacy in the district of Piedmont where the union of nationalism and revolutionary syndicalism had recently been formulated by Corradini in the Piedmont journal *Il Tricolore*.[134] As we have seen, Corradini's synthesis, later published in *La Lupa*, transformed the Sorelian battle between classes into a struggle between proletarian and bourgeois nations. In keeping with the new myth, Corradini was careful to divorce his definition of national *esprit* from the decadent idea of nationalism supported by bourgeois financiers. In essence this new program called upon the working class to abandon their proletarian internationalism and instead identify their interests as workers with the cause of national regeneration. Marinetti's 1910 lecture on "The Beauty and Necessity of Violence" propagated just this synthesis and met with an unruly response on the part of the Milanese proletariat as a result.

The Milanese daily *Il Secolo* reported that Marinetti's lecture was attended by "socialists, anarchists, workers" and a cadre of Futurists, including Boccioni. "When [Marinetti] declared himself a patriot and affirmed that patriotism is the school of national energy, there was a tempest of whistles and cries," reported *Il Secolo*'s journalist. "'I am Italian,' Marinetti exclaimed, 'and I love Italy before all else' —Bravo! commented the Futurists. —But others: —Down with Italy! Down with *la Patrie*! . . . Long live the International Worker!" Clearly Marinetti's eulogy to patriotism as a source of "energy" was unwelcome among workers who advocated international class revolution, but when he launched into "a harsh and violent critique of contemporary Italian society" he met with approval. "Marinetti ended by hoping that the soul of proletarians [would] reimmerse all society in a fearless insurrection, in a burst of heroic violence."[135] This statement echoed those made at the Naples conference, where, in the words of Rosa Clough, Marinetti called upon Italians "to be educated in the virile school of direct action" before advocating "the general strike as the only weapon in the hands of the working people."[136]

Another journalist writing of the Milan lecture noted that Marinetti's "hymn to the fatherland" was interrupted by "the cries of 'Long live Internationalism!'" on the part of the "Milanese proletariat."[137] However,

Marinetti, after having stigmatized the narrow utilitarianism and meanness of reformist democracy, glorified the destructive gesture of anarchists and evoked in a discourse of unsurpassable eloquence, a tragic night of general strike and revolution in a great modern city plunged into darkness by the dominating will of workers and illuminated, from time to time, by the brief flash of gunshot fired against beastly savage policemen. A thunder of applause saluted the superb end of the lecture.[138]

Although "the emotion caused by the violence" of Marinetti's speech "soon vanished," there can be no doubt that Marinetti's images of class warfare, combined with those of national pride, were meant to invoke a vision of national revolution, fully in keeping with Corradini's Sorelian nationalism.

That "one of the most heated defenders of patriotism" in the audience was "the young Futurist painter Boccioni"[139] suggests that Boccioni had forged a similar *rapprochement* of nationalism and Sorelian violence as early as the autumn of 1910. Indeed, Boccioni is

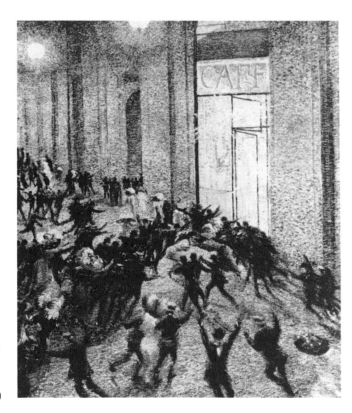

26. Umberto Boccioni, *Riot in the Gallery*, 1910

known to have read Sorel and Labriola, and Carrà—who participated in the Milanese general strike of 1904—was particularly enthusiastic about Sorel's "revision of historical materialism."[140] When Corradini organized a Congress of the Italian National Association in December 1912, Marinetti and Boccioni were participants.[141] In addition, Boccioni's earliest Futurist works are fictional depictions of riots in a divisionist style meant to enhance metaphorically the violence they portray (fig. 26). Marianne Martin has described Russolo's *Revolt* (1911) (fig. 27) and Carrà's *Funeral of the Anarchist Galli* (1910–1911) (plate 7) as depictions of "the multiple, regenerative force of the masses,"[142] but they could just as easily be described in terms of Marinetti's Sorelian program. Russolo's 1912 characterization of *The Revolt* as "the collision of two forces, that of the revolutionary element made up of enthusiasm and red lyricism against the force and inertia and reactionary resistance of tradition,"[143] metaphorically echoes *La Demolizione*'s syndicalist battle against "inertia and indolence," as well as the Sorelian myth of "heroic violence" Marinetti conjured up for Russolo and his fellow Futurists in his 1910 lecture on "The Necessity and Beauty of Violence."

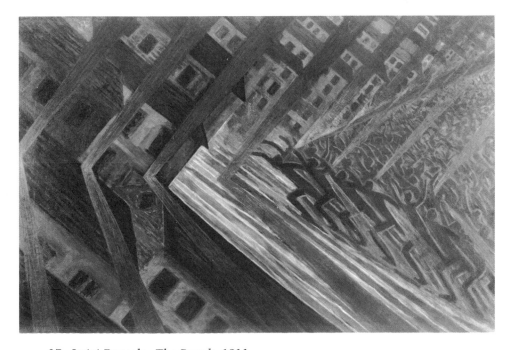

27. Luigi Russolo, *The Revolt*, 1911

This correlation of Sorelian myth and Bergsonian intuition is strongly alluded to in Boccioni and Carrà's February 1912 description of the radiating lines of force animating Carrà's *Funeral of the Anarchist Galli* (plate 7). Sorel in his *Reflections on Violence* had noted that images of strike action "have engendered in the proletariat the . . . most moving sentiments that they possess," adding that "the general strike groups them all in a coordinated picture, and by bringing them together, gives to each one of them its maximum of intensity; appealing to their painful memories of particular conflicts, it colors with intense life all the details of the composition presented to consciousness." "We thus obtain that intuition of socialism which language can not give us with perfect clearness," asserts Sorel, referring again to Bergson.[144] Indeed what Carrà has depicted is his memory of the "tragic epilogue" to the general strike of 1904; an anarchist funeral procession under assault by police mounted on horseback.[145] In the February 1912 catalogue for the Futurists' first Parisian exhibition, written mostly by Boccioni and Carrà, "the sheaves of lines corresponding to all the conflicting forces, following the general law of violence" in Carrà's work are labeled "force lines." Moreover, the irradiating expansion of these lines has a psychological effect on the viewer, so that he or she is "obliged to struggle himself with the personages in the picture."[146] Carrà's transcription of proletarian battle into abstract pictorial form, and the subsequent impact of these "force lines" on the viewing public, encapsulates the Futurist idea of "physical transcendentalism," which sees force lines as "the beginnings or prolongations of the rhythms that objects imprint on our sensibility." The "continuity" of these lines, whose emotive impact "must envelop and sweep along the viewer" is "measured by our intuition." In short, the Futurists employ intuition both to capture the emotive force of political violence and to forcibly oblige the spectator "to be at the center of the painting," to relive the intensity of the battle.[147] In her study of fascism in France, Alice Kaplan has noted that Sorel's description of the general strike "is called a tableau," adding that "any number of canvases by Severini or Boccioni would have made brilliant illustrations for an Italian edition of Sorel's book."[148] Perhaps we should take a cue from the Futurists themselves, and add Carrà's *Funeral of the Anarchist Galli* to the list.

All of which is to say that Futurists, in contrast to Colomer's Artistocrats, utilized Bergsonism to propagate an organicist and aestheticized theory of collective, rather than individualist, revolt. Thus when the Futurist painters referred to Bergsonian intuition in their later writings, they invariably quoted the philosopher in sup-

port of an *intersubjective* experience that Colomer openly rejected. The same year that *Action d'art* began publication, Carrà published an essay in the March 1913 edition of *Lacerba*, in which he proclaimed: "We Futurists seek to identify with the core of things through the power of intuition, so that one's Ego will merge with their uniqueness in a complex whole."[149] The intuitional merger of one's ego with some object external to it was also at the heart of Boccioni's theory of absolute and relative motion, which he derived from Bergson's discussion of intuition's intersubjective capacities in "The Introduction to Metaphysics."[150] And it is that theory which Severini explicated in his July 1913 *Action d'art* essay on Boccioni's sculpture, published in tandem with the sculptor's exhibition at the Boëtie Gallery. Since "all matter is transformed and ennobled in the expression of the ensemble discovered by our creative intuition," Severini tells us that Boccioni conceives of form "in its internal vitality, in its dynamic becoming," and thus sculpts "the construction of the action of bodies."[151] In the Boëtie catalogue Boccioni related "the construction of the action of bodies" to their "absolute movement" which in turn engendered his sensation of "pure plastic rhythm."[152] Thus the relation of "pure plastic rhythm" to "dynamic becoming" expounded by Severini and Boccioni echoes Colomer's pronouncements on durée's rhythmic properties. However the rhythm intuited by Boccioni is not that of his own ego alone, it also encompasses the internal vitality of another being or object, the molecular dynamism of which is part of a cosmic élan vital. And Severini shared these suppositions, asserting, in a Manifesto of 1913, that the "spiralling shapes and beautiful contrasts of yellow and blue" in a painting like his *Sea = Dancer* (plate 8) were "intuitively felt one evening while *living the movements of a girl dancing*."[153] In another text of 1913, Severini adds that "it is by his intuition" that he "is penetrating into the life, the soul, the activity of things," before relating the pictorial imagery resulting from this intuition to a passage from Bergson: " 'To perceive', says Bergson, 'is after all, nothing more than to remember.' "[154] In his Manifesto Severini traces the genealogy of that process, clearly operative in his association of the ballerina with ocean waves, back to his *Travel Memories* of 1911 (fig. 5), "a painting of memory that brought together into a single plastic whole things perceived in Tuscany, in the Alps, in Paris, etc."[155] Severini's *Sea = Dancer*, painted in tandem with his first exposure to the *Action d'art* group, simply updated a principle initially applied to representational content alone to include the "qualitative radiations"[156] of complementary colors and forms among those "plastic analogies" intuitive experience in-

voked in his mind. Severini's celebration of an intuitive merger with a given subject set his Bergsonism apart from the intuitive Egoism of Colomer. Similarly his neo-Impressionist technique, as a metaphor for intersubjectivity, evoked a psychological experience decidedly different from the utopian vision of harmony Signac associated with the divisionist method. The metaphorical import of Signac's divisionism encompassed the whole of society, while Severini hoped only to signify an intersubjective experience through his intuitive interpretation of the technique.

Perhaps then Severini's favorable evaluation of the Artistocrats' political program has more to do with his estrangement from the Sorelian political agenda of Boccioni and Marinetti than with any strict adherence to Colomer's Bergsonian aesthetics. Severini, unlike Russolo, Carrà, and Boccioni, never painted images of mass violence, choosing instead to focus on night club dancers. And when, in 1910, he drew on the passage in "The Introduction to Metaphysics" that had inspired Sorel's description of the general strike, he did so to depict memories of travel welling up from his own individual durée. Fully aware of the philosophical sources behind the politics and painting of his Futurist peers, Severini nevertheless rejected their Sorelian vision for a more benevolent version of the dynamism of modern life.

Thus while Severini did not fully accept the Egoism of Colomer's Artistocrats, he did praise the individualist dimension of their politics; a sure sign of his distance from a political side of Futurism he never fully embraced until the conflagration of World War I. To appease a public that may have regarded his status as a noncombatant with suspicion, Severini exhibited in 1916 a group of paintings dedicated to the "Plastic Art of War," executed in what Kenneth Silver terms a "High Futurist style" meant to "assault the viewer's senses, as well as his sense of humanistic values."[157] Severini's images of canon in action, or the deadly force of an armored train (fig. 28), glorify military technology and violence at the expense of a portrayal of the human lives lost in the canon's or train's wake.[158] And for the first time his art became engaged in a battle that his Futurist colleagues had launched in 1910; a battle not only against the past,[159] but in the name of a future, mythic war that had now become a reality.

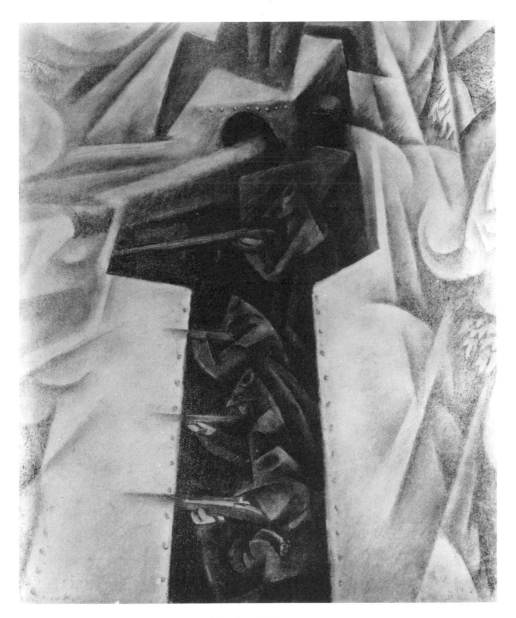

28. Gino Severini, *Armoured Train*, 1915

The Politics of Time and Modernity

MY OVERARCHING agenda in writing this book has been to historicize avant-garde conceptions of space and time by treating them as categories bound up with the philosophical and political landscape of pre–World War I Paris. In the case of the Cubist, Rhythmist, and Futurist movements, Bergson's qualitative definition of time was central to both their aesthetic and their social theories, which contested the quantitative or rational notions of space and time promoted by other cultural arbiters. On the purely formal plane the avant-garde couched this debate in a number of interrelated, theoretical oppositions. Empathetic intuition was set against an insensitive intellect, quality contrasted with quantity, and organic or musical order opposed to geometric order. The empathetic artist's ability to intuit the cadence of internal *durée* was contrasted with the analytical mind of the scientist, who relies on vision to focus on an object's external appearance in a detached manner. A painting, as the product of a creative intuition, was comparable to an organism whose growth is a durational event, composed of indivisible moments. Creative time cannot be divided or sped up as can the time involved in industrial processes of assemblage. The Cubists (despite the geometricity of their style) and the Rhythmists sided with the intuitive portion of this equation and condemned rival art movements for emulating the scientific or intellectual approach. For example, both groups disparage the Impressionists for being too reliant upon the retina and thus prone to analyze rather than empathize with their subject matter. They also reject Albertian perspective for treating space quantitatively and thereby draining space of those qualitative and durational aspects discernable in the rhythmic ordering of their own canvases into organic wholes. Although the Futurists did not attack Impressionism, they too disparaged Euclidian perspectivalism, describing the "pure plastic rhythm" in their work as a musical analogue for durée.

The oppositions outlined above were played out in the political sphere, where these movements deployed their Bergsonian aesthetic to proclaim their political allegiances. The Puteaux Cubists and

their Symbolist allies attacked the Action française for its praise of the "clarity" and "rationality" of Cartesian thought: in their hands *la lumière de la raison* became a negative phrase standing for the hegemony of vision and intellect over empathy and intuition. By declaring this Cartesianism foreign to the French Celtic temperament, and aligning the Action française's notion of classicism to the Germano-Latin spirit emanating from Italy and Germany, the Puteaux Cubists declared Maurras's cultural program a foreign incursion. In addition, Pelletier's Celtic League, which had a profound impact on Gleizes, set cultural parameters for French culture by applying the League's notion of organic unity to a definition of national identity. In effect, the intuitive, rhythmic, and durational principles that made the Cubists' canvases organic wholes were now used to delineate the consciousness of a people and the geographical borders of a corporative federation. The French people, along with their Celtic confrères in the United Kingdom and northern Europe, were united by their racial background in opposition to the Germano-Latin races. The cultural and political systems best able to embody the spirit of this Celtic tribe were the corporative organizations of the Middle Ages. Thus Gleizes, as a response to Pelletier's program, traced the racial genealogy of French art back to the Gothic, and in images like *Chartres Cathedral* (fig. 24) he celebrated the architectural monuments created by the corporative and artisanal communities of that era.

Although the Rhythmists did not share Gleizes's Gothic vision, their literary allies followed his example in forging a theory of national temperament. By proclaiming the French people a mixture of the Celtic and the Latin, the intuitive and the intellectual, Murry and the French Fantaisistes sought to transcend the factionalism that separated Bergsonian Symbolists from Bergsonian royalists. Since each individual possessed a different mixture of intuitive or intellectual traits, Middleton Murry could proclaim the individualist aesthetic of the Rhythmists conducive to the Fantaisistes' cultural strategy of appeasement. Presumably the ethnic backgrounds of Fergusson, Rice, and Segonzac contained that Celtic-Latin mix to varying degrees—Fergusson, for one, later advocated an alliance between the Scottish and French peoples on the basis of their shared Celtic roots.[1]

The Italian Futurists were equally nationalistic, though their Bergsonian variation on this theme stemmed from a theory of class rather than racial type. The nationalism of Marinetti and Boccioni owed a great deal to the Bergsonian theories of Georges Sorel. Sorel's Italian followers hoped to incite the working classes to rise up in

revolt against a parliamentary system they condemned as founded upon the rational principles of the Enlightenment. Sorel praised the proletarian syndicates as an alternative political organization to republican government, and regarded intuitive consciousness as a nonrational esprit de corps to be instilled in this particular class. Appropriately his theory of revolution centered on a "myth" of the general strike, a myth composed of images able to unite the proletariat through their collective intuition of an uprising against the bourgeois Republic. But by 1910 Sorel's followers in Italy had transposed the apocalyptic battle between classes evoked in his *Reflections on Violence* into a battle between nations. The Sorel enthusiast Enrico Corradini had proposed a synthesis of syndicalism and nationalism by declaring Italy a proletarian nation, and evoked his own myth of international warfare as the nationalist equivalent to Sorel's myth of the general strike. Corradini's myth won the approval of the Futurists as well as of Sorel, with the result that Boccioni, Russolo, and Carrà depicted mythic scenes of mass violence in their paintings in an attempt to awaken the intuitive and revolutionary capacities of their hoped-for proletarian audience.

Significantly, the disparaging of rationalist modes of social organization shared by these avant-garde movements continues as a central preoccupation of the contemporary discourse on modernism and the Marxist dialogue on time. For example, Michel Foucault, Martin Jay, Jonathan Crary, and Donald Lowe have critiqued the Cartesian approach to time as an oppressive social construct.[2] Marxists such as Georg Lukács, Michael Shanks, Christopher Tilly, and E. P. Thompson have related Cartesianism to the negative effects of capitalism, and in the case of Lukács an organicist model of time has been proffered as a positive alternative.[3] Yet as my comparison of the Cartesianism of the Action française and the organicism of the Bergsonian avant-garde has shown, both these temporal systems potentially lead to reactionary rhetorics. Thus in capitalist Europe at the turn of the century a group of Bergson's followers critiqued Cartesian perspectivalism and capitalism's chronometry only to arrive at models of temporal organization rife with racist implications. Current cultural critics need to consider the continuing appeal of the organic model in this light. It is my intention, then, to historicize that dialogue further by considering the interrelation of organic and mechanical temporal models from a materialist perspective.

For instance, the Bergsonists' association of vision with Cartesian thought and Albertian grids finds its parallel in Martin Jay's Fou-

cauldian contention that "Cartesian perspectivalism" is one of several "scopic regimes of modernity" subjugating human consciousness to discipline's analytic gaze.[4] Moreover, as Jay points out, "the rationalization of sight as a pernicious reification of visual fluidity,"[5] and the quantitative treatment of the flow of time, have often been associated by Marxists with the rise of capitalism. Thus Lowe in his *History of Bourgeois Perception* declares the "perceptual field" of capitalist society to be "visual" and "quantitative,"[6] while the Marxist archeologists Shanks and Tilly[7] describe the quantitative analysis of time as historically grounded in its commodification in "capitalist production."[8] The key link here is the association of vision with the quantification of space and time. The association of quantification with capitalism is in turn part of a Marxist critique of that economic system as oppressive. Thus the historian E. P. Thompson[9] describes the historical conflict between quantitative time and other forms of temporal organization as "one of exploitation and resistance to exploitation,"[10] while Shanks and Tilly judge "capitalism's chronometry" to be a tool for the displacement of other forms of social organization.[11] For example, "capitalism's time becomes temporally imperialist" when Western archeologists and historians set non-Western cultures in chronological time frames.[12] In sum, these writers concur that Cartesian thought and its extension in the time measurement processes of industrial capitalism radically altered our experience of time for the worse.

What remains for us to consider is the relation that this Marxist critique of capitalism has to the intuitionist underpinnings of Bergsonism. Does the negative appraisal of Cartesianism and of the scientific rationalization of time shared by these groups extend to a consensus on the positive import of its "organicist" counterpart? The issue can be clarified by comparing the Marxist critique outlined above to Georg Lukács's alignment of temporal rationalization and the reification of proletarian consciousness in a text seminal to modern Marxism, his *History and Class Consciousness* (1922). Lucio Colletti, in a penetrating study of the Hegelian roots of Marxism, has related Lukács's analysis of the psychological consequences of temporal rationalization in the workplace to a contemporaneous debate over "the great German-philosophical antithesis between *Kultur* and *Zivilisation*, organicist-romantic culture and rationalist-enlightenment culture."[13] Transposed into the context of "the estrangement of man in technological-industrial society, in the mass society of industrial capitalism," Lukács's commentary drew upon the ideas of Bergson and Georg Simmel, a German sociol-

ogist steeped in Bergson's writings.[14] Simmel's *The Conflict of Modern Culture* (1918), which had a lasting impact on Lukács, is described by Colletti as saturated in Bergsonian terminology:

The critique of science and the related disdain for technical-practical action—the world of work and production—are here extended to the critique of modern civilization, whose conflicts are not explained in the light of particular socio-historical causes, but are the basis of an irrepressible antithesis between the organic totality of 'Life' and the purely 'external' principle of mechanical and causal connection. The conflict in modern civilisation consists, for Simmel, in the fact that the 'forms' engendered by 'Life' are solidified into the objective institutions separated from it. . . . Thus, whereas Life continually tends to resolve and dissolve within itself the forms in which it has momentarily objectified itself, these forms become solidified and rigidified into permanent entities which oppose and impede the process of re-establishing the original unity, i.e., the recomposition of the identity of the finite and infinite. . . . The forms originally engendered as forms and functions of Life, by solidifying themselves into objective institutions, tend to subordinate and constrain Life, their own origin, into alienated routine and mechanical repetitiveness. . . . In Simmel the need of the infinite to posit itself as finite is described as a "tragic fate," i.e., as a 'split' which opens a permanent crisis, putting in jeopardy the 'return' to Unity.[15]

Colletti's analysis demonstrates that Simmel sees mechanization under industrial capitalism as the product of a Bergsonian conception of "Life" rather than "particular historical causes." Simmel's theory of modern culture therefore transcends the temporal context of human history. Modern technological society is yet another episode in an ahistorical "tragedy," the fall from grace of a monistic "Life" force whose unity is forever belied by its historical manifestations. Simmel identifies "Life" with the organic, and modern culture with the mechanical—presumably a unity of culture with "Life" could be achieved if our culture were able to retain its "vital" or "organic" characteristics. And if one were to historicize this theory of "origins" it follows that the vital alternative to modern industrial society must be preindustrial, if not primordial. This, in fact, is just what Lukács proposes in his contrast between modern industrial forms of labor organization and the condition of "organic" temporal unity those forms usurped. Writing of a turn-of-the-century system of factory organization known as Taylorism, Lukács notes that the quantitative analysis of time that the system instituted drains temporality of

its qualitative, variable, flowing nature; it freezes into an exactly de-limited, quantifiable continuum. . . . In this environment where time is transformed into abstract, exactly measurable, physical space, an environment at once the cause and the effect of the scientifically fragmented and specialized production of the object of labour, the subjects of labour must likewise be rationally fragmented.[16]

The Taylorist system's "mathematical analysis of the work process" not only destroys the "organic, irrational, qualitatively determined unity of the product"[17] but reduces workers to "isolated abstract atoms whose work no longer brings them together directly or organically."[18] Thus modern industrialism "declare[s] war on the organic manufacture of whole products" in order to institute its rationalist labor practices.[19] By fragmenting production into repetitive tasks, assembly-line methods assure that "the finished product ceases to be the object of the work process."[20] The quantified time involved in such labor lacks "the organic necessity with which interrelated special operations are unified in the end product."[21] The "organic necessity" that temporal rationalization destroys is allied by Lukács to time's "qualitative, variable, flowing nature," the time Bergson and his followers associate with biological production and the production of works of art. Moreover this qualitative time, so central to the theories of the body politic outlined in this study, is held by Lukács to have shaped labor practices "that bound individuals to a community in the days when production was still 'organic.'"[22] Under capitalism "consumer articles no longer appear as the product of an organic process within a community (as for example in a village community)."[23] The organic societies of the pre-capitalist era are, by way of the organic metaphor, rooted in the temporal processes of nature. Thus "naturalized," they are more than human constructs, they are integrated into a time scale that transcends human history. This appearance of the infinite in the finite signals the transposition of history into myth, an "organic truth," states Frank Kermode, that "presupposes total and adequate explanations of things as they are and were."[24]

In the art and art theory of the Bergsonian avant-garde, qualitative time is likewise rooted in organic or mythic metaphors. In Carrà's *Funeral of the Anarchist Galli* (plate 7) a battle between anarchists and police becomes an epic sign of the regenerative power of the proletariat, thus signifying the mythic essence underlying the historical contingency of any general strike. Fergusson's *Rhythm* (plate 4) made a rather explicit correlation between the generative function of the female half of the human species and creative evolution

in nature; moreover both the Cubists and Fauvists claimed that their artistic creativity was part and parcel of the élan vital's organic structures. Their creativity was synonymous with the very rhythm of life, or in the case of Gleizes with the organic life force of the Celtic race. Appropriately in his *Harvest Threshing* of 1912 (fig. 23) or *Fishing Boats* of 1913 (fig. 29), Gleizes painted images of labor allied to the rhythm of the seasons or tides rather than the Taylorist rhythm of the factory floor. The laborers portrayed were of a Celtic stock bound up with the creative evolution of the French race; their labor, attuned to nature's rhythms, is itself a product of the generative force of biological creation.

What is occurring in the criticism of the Bergsonian avant-garde is a merger of three distinct time frames: the cadence of human time, the rhythmic pattern of time in nature, and the variable temporal systems invented by particular cultures throughout their historical development. The Bergsonists claim that the rhythm of nature, in the guise of the élan vital, is synonymous with the creative duration of the artist's subjective experience and the creative élan of the nation. Thus the nation takes on the characteristics of the artist, it has a "body" and an intuitive consciousness. The preindustrial labor of the peasants portrayed in Gleizes's *Harvest Threshing* is therefore not only attuned to the cycles of nature through the rhythm of their labor, but that labor is part of nature's creativity, an expression of the rhythmic élan animating the Celtic people. In addition, even the rhythmic dissonance of modern industrial society captured in the pictorial structure of Gleizes's *The City and the River* (plate 6) is said to exemplify the creative élan nascent in the biological rhythm of the Celtic race. When the time of artistic creativity, peasant labor, or modern society is declared organic, the socially relative time of human culture becomes a naturalized absolute, with a time frame of cosmic proportions.

The difference between the thought of the Bergsonian avant-garde and present day critics of industrial time is that the latter declare society's preindustrial and industrial time to be the product of particular historical causes rather than an "organic truth." Although E. P. Thompson describes the rhythm of labor in peasant or seafaring cultures as tied to "natural rhythms" rather than those of the stopwatch, he still regards time as a social construct.[25] Gleizes's theories grounded the "harvest time" depicted in *Harvest Threshing* in the Celtic roots of French culture. Thompson, on the other hand, relates such labor to the historically relative "older collective rhythms" of "task oriented" time that had "the independent peasant or craftsman as referent."[26]

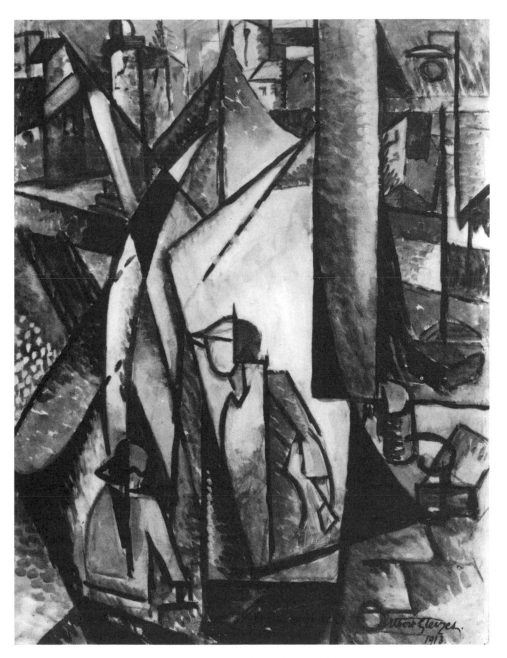

29. Albert Gleizes, *The Harbour (Fishing Boats)*, 1913

Thus in contrast to Lukács's or the Bergsonists' search for an organic alternative to industrial time, I would suggest that the concept of organic time itself needs to be relativized as a historical construct. Thus far I have historicized organic time in an ideological sense in terms of a debate between the Action française and the avant-garde entailing new geopolitical configurations. If this debate is considered from the standpoint of materialist analyses of industrial processes, the political consequences of Bergsonism can be further developed. The geographer David Harvey, for instance, has analyzed theories of time and space in terms of their relation to modern industrialism.[27] Not surprisingly, this leads him back to the issue of the pervasive rationalization of time in the twentieth century and the subsequent breakdown of older cultural patterns as the capitalist system of time became universalized. According to Harvey the eighteenth-century clocks and bells "that called the workers to labour and merchants to the market" separated the peasantry "from the 'natural' rhythms of agrarian life, and divorced from religious significations, merchants and masters created a new 'chronological net' in which daily life was caught."[28] By the twentieth century this "chronological net" had expanded to encompass the whole globe, and the spatial and temporal bases for the creation of a worldwide capitalist order were set. Space and time were now socially constructed as quantifiable commodities to be bought and sold. As social structures they were wholly absorbed under the homogenizing powers of money and commodity exchange.[29]

Since time and space had a quantifiable value, each parcel of land was like any other, and each measured hour interchangeable with the next. In effect the infiltration of capitalist rationalization to every corner of the globe created an awareness of the internationalism implicit in capitalist processes of standardization. Thus, in the 1920s, modernists like Le Corbusier saw industrialization and Taylorist techniques as a means of liberating human society from the parochialism of local culture.[30] But as Harvey notes, the shared conception of time and space promoted by capitalism precipitated a reaction on the part of modernists who wished to maintain a sense of local difference. For them, the standardization of human life under capitalism created "a heightened sense of what makes a place special."[31] Since the standardization of time and space "implied a loss of identity with place" or "any sense of historical continuity," architects like Louis Sullivan in Chicago "searched for new and local vernacular structures that could satisfy the new functional needs but also celebrate the distinctive qualities of the place they occupied."[32] The quantification of time in turn precipitated a revival of

preindustrial forms of labor, exemplified by the "craft tradition pushed by Morris in Britain" and "the craft work movement of Vienna."[33] By the 1930s even Le Corbusier had abandoned the internationalism of his Taylorist vision and advocated corporatist theories in the syndicalist journals *Plans* (1931–1932) and *Préludes* (1933–1935).[34]

Where Harvey's argument is in need of revision is in his analysis of the significance of Bergsonism and its relation to the modernist movement. Bergson is mentioned only in passing, as a thinker who led the Futurists "to shape space in ways that would represent speed and motion,"[35] while Cubist simultaneity, exemplified by Delaunay's 1910 *Eiffel Tower* (fig. 7), is related by Harvey to that radio tower's "capacity to collapse space into the simultaneity of an instant in universal public time."[36] For Harvey, Delaunay's attempt "to represent time through the fragmentation of space . . . paralleled the practises on Ford's assembly line." Ford, states Harvey, "fragmented tasks and distributed them in space" in an attempt to maximize "the flow of production" and thus "accelerate (speed up) the turnover time of capitalist production."[37] Thus the Cubist fragmentation of space is related by Harvey to the accelerated time imposed by capitalist rationalization, the very "public time" that the Bergsonian Cubists, Fauvists, and Futurists so vehemently rejected.

That rebuttal pervades the Rhythmists' and Cubists' theory of art, for both movements condemned the quantification of time by capitalists for its harmful effects on an individual's creative capacities. For instance, members of both movements eulogized Rabelais's utopian vision of an artistic commune called the Abbey of Thélème because he planned to banish clocks from the commune premises. In Rabelais's commune, artists were to be untethered from the social regulation of homogenized time, so that they could act in response to their subjective temporal rhythms.[38] The Abbaye de Créteil commune and the Rhythmists evoked Rabelais in their vision of a society composed of intuitive artists, freed from the utilitarian concerns of industrial capitalism.[39] That Gleizes did not abandon such utopianism is clear from his later attempt to detach technology and proletarian labor from capitalist rationalization by subsuming machine rhythms within the organicist ideology of Celtic nationalism. In 1913 Gleizes and his Cubist colleagues were living in the industrial suburbs of Courbevoie and Puteaux, districts dominated by a socialist proletariat agitated by attempts to introduce Taylorism in the Parisian factories after 1906. By 1913 there had been repeated anti-Taylorist strike actions in the banlieue, and syndicalist leaders such as Alphonse Merrheim and Emile Pouget

warned that Taylorism would reduce the workers' craft skill and
force them into a mechanical and uncreative form of labor. This pro-
test culminated, in 1913, in a major strike at the Renault factory in
Puteaux, which put an end to the forced introduction of Taylorist
techniques in French factories.[40] That the Puteaux group was cogni-
zant of such protest is made clear by the publication of an article
decrying Taylorism in *Les Cahiers d'aujourd'hui*, a journal founded
by Gleizes's Abbaye associate Charles Vildrac.[41] What Harvey fails
to realize is that the aesthetic of the Cubist movement, and Berg-
sonism as a whole, was part of the widespread reaction against the
temporal hegemony of industrial capitalism.

That reaction extended to the political sphere as well. "By en-
hancing links between place and social identity," states Harvey,
"this facet of modernism was bound, to some degree, to entail the
aestheticization of local, regional or national politics."[42] The uni-
versality implied by capitalism's normative sense of time was coun-
tered by a conception of time that identified "the 'ethical state' as
the end point of teleological history."[43] This conversion of teleologi-
cal history into spatial form was synonymous with the "place-
bound sense of geopolitics and destiny" promoted by fascism. The
Sorelian celebration of violence as an end in itself in turn was a key
ideological platform in Mussolini's mythic vision of a regenerated
Italy. "Intensely nationalistic," the fascist cause "emphasized the
power of myth (of blood and soil, of race and fatherland, of destiny
and place)."[44]

Since the regionalist politics of fascism are a reaction to capitalist
rationalization, fascists promoted an organic definition of the na-
tion-state. Even before World War I, future fascists like the Sorelian
Georges Valois contrasted their "organic" theories with the ration-
alist principles reportedly underpinning the parliamentary system.
Eugene Weber, the eminent historian of the French radical right,
notes that the followers of Sorel and Mussolini condemned Parlia-
mentarians as "the rationalistic heirs of the Enlightenment."[45] The
Fascist movement countered "rationalistic and utilitarian" par-
limentarianism with "organic doctrines of society" as "a call for
unity above and beyond parties."[46] Valois, Mussolini, and others al-
lied their "organic doctrines" to the "mythical component" of Fas-
cism, embodied in theories of "manifest destiny, national revival
and revivalism, chosen people complex and so on."[47] "The nation"
was "the new slogan that met their needs"; furthermore, "in the
eyes of nationalists, the nation too is a living organism; and if it is
ill it cannot be patched up as one might an engine; it has to be magi-
cally healed and revived by an appeal to its roots, not just of existing

society, but of life itself."[48] Thus while reactionaries like Sorel or Valois did not believe in "logical, discursive thought," they "did believe in energy, in force, in unthinking passions" evoked in the name of the mythic "purification and revival of a class, a nation, or a 'race' that had a task to perform . . . or a destiny to fulfill."[49]

For the Futurists, that destiny took the form of a regenerative war between proletarian and bourgeois nations, between intuitive and rational societies. For the Puteaux Cubists, the purification and revival of the nation called for a return to its Celtic roots in the face of Cartesian and Germano-Latin cultural incursions. For the Rhythmists, it was Celtic and Latin roots that made up the French cultural mix, to the exclusion of other racial configurations. But for all these movements, Bergsonism, with its attendant antirationalism and biological collectivism, was at the nodal point of their reactionary politics.

Moreover, as Alice Kaplan points out, the fascist "valorization of the organic" entailed "the transference of polar opposites—the abstract, the figurative—to actually specified groups of human beings." Thus in the organic ideology of Aryanism, "the threat of dispersal is reduced to a Jewish threat, because of historic Jewish mobility." Having noted the pervasive association, among organicist ideologues, of the Jew with the "rootlessness" of international capitalism, Kaplan adds that this organic/inorganic opposition "has many variants." One variant, I would suggest, was the Bergsonists' association of "non-organic" and "abstract" categories with particular racial groups. Barzun's association of Greco-Latin peoples with "cold reason," or Pelletier's separation of the Germano-Latin races from the "intuitive" Celts, are exemplary instances of the racial "transference" fundamental to the valorization of the organic.[50]

This biological model gained rhetorical power after World War I, as fascism was on the rise, where it played an important role in the dialectic between Taylorist and organicist social and temporal orders. In the process, an underlying tension arose as various proponents of fascism sought to subsume capitalism within the organicism of corporative, regionalist, and racial forms of social organization. In both France and Germany, Fascists developed corporative theories in an attempt to establish "organic" and thus "natural" relations between employers and employees. In Germany, the *Bureau of Beauty of Labor* eulogized corporatism as a means of returning to the supposed "class harmony" and "organic" unity of medieval society, even while it promoted Taylorism in the work place. In Nazi propaganda, the rationalization of labor was "organicized" as an aesthetic metaphor for the unified discipline of workers within the cor-

porative structure. In France, the fascist Georges Valois, in temporary alliance with the industrialists Ernest Mercier and Eugène Mathon, developed a similar model by attempting to conjoin the corporatism of Proudhon with the technocratic theories of Saint-Simon. Again class conflict was to be replaced by a corporative structure in which employees and employers would have shares in industrial enterprises free of state intervention and guided by the paternal employer alone. Having replaced the state with an "organic" structure, such corporations would strengthen France through rational economic organization. In 1926, Mercier and Mathon founded the *Redressement français*, a movement that advocated Taylorist rationalization as a means of bolstering French industry against international conglomerates like Standard Oil. Thus Taylorist methods of standardization were to be delimited within the "organic" structure of the corporative state in order to protect French society against the homogenizing forces of international capitalism.

The tension implicit in this structure is plainly manifest in the writings of the architect and painter Le Corbusier, a figure who participated in the *Redressement* experiment. The evolution of Le Corbusier's aesthetic, from an adherence to Taylorist utopianism in the *L'Esprit nouveau* (1920–1925) era to a promotion of the organicist theories of regional syndicalism in the 1930s, is exemplary of the continuity uniting this aspect of prewar and postwar avant-garde politics.[51] Le Corbusier's equivocation over the relative merits of a rational or organic *retour à l'ordre* had its precedent in the avant-garde debate over Bergsonism before the cataclysm of the First World War.

In the case of Le Corbusier, the preferred order of the 1920s was rationalist, Taylorist, and capitalist. Mary McLeod, who has studied Le Corbusier's Taylorist and syndicalist phases, notes that Le Corbusier regarded Taylorism as a means of social renewal and the basis for an aesthetic premised on "mechanical repetition and standardization." Appropriately in books like *Vers une architecture* (1923), he called for "the abandonment of handcraft production" in favour of Taylorist "standardization" and "mass production."[52] As one with a Saint-Simonian history, Le Corbusier saw social justice "as the product of technical rationalization, not of material equality"—his revolution did not call for the overthrow of the capitalist system, but merely for its Taylorist rationalization, the economic benefits of which were to ensure social stability.[53] Le Corbusier saw Taylorist standardization as a basis for the creation of aesthetic norms: thus *L'Esprit nouveau* was a major proponent of an international architectural style "at a time," says McLeod, "when many publications

were calling for a resurgence of regional styles."[54] The order Le Corbusier opposed to regionalism was the Taylorist order promoted by the industrialist Ernest Mercier through the organization Redressement Français. McLeod has given us the following summary of the geopolitical consequences of Le Corbusier's *L'Esprit nouveau* program:

> Le Corbusier's future, like that of the earlier Saint Simonians, was one of order on a series of ever grander scales; rationalization would spread in ever wider spheres resulting eventually in the attainment of universal harmony. International cooperation and reduced trade restrictions were essential components of this projection. Just as traditional class structures had little relation to appropriate managerial hierarchies in scientific management, so too national boundaries had only marginal connection to issues of industrial efficiency and a network of rationally unified enterprises. A standardization of architectural elements, Le Corbusier stated [in *Urbanisme* (1925)], would not only result in greater formal unity, but also lead to "universal collaboration" and "universal methods."[55]

When Le Corbusier considered his Purist aesthetic of the early 1920s from an economic perspective, the machine-made anonymity[56] of the objects portrayed in his Purist paintings (fig. 30) became a metaphor for the international rationalization of space and time precipitated by Taylorism. Concurrently he could claim that aesthetic to be nationalist, since the Taylorization of industry was an integral part of a war effort that had "mobilized invention, . . . imagination and cold reason," the supposed Greco-Roman elements of the esprit français. Le Corbusier's ambivalence over the ideological import of Taylorism was shared by fellow members of the Redressement Français, who saw Taylorist rationalization as a means of strengthening French industry against foreign competition. Paradoxically the Taylorist system of universal organization was employed to bolster the very national boundaries it was designed to transcend.[57] These two orientations, nationalist and internationalist, had an uneasy coexistence during a period when wartime zenophobia was still rampant. In effect, Le Corbusier was torn between a desire for "universal harmony" and the corporatist nationalism of the *Redressement* project, signaled by his organicist claim to integrate machine-made objects into the "viable organ" of his canvases. For instance, when the Swiss Le Corbusier suggested, in *Urbanisme*, that Paris be rebuilt with foreign capital as a means of assuring peace, he was accused by Camille Mauclair of being the "Lenin of concrete."[58] However, as McLeod notes, the optimism pervading

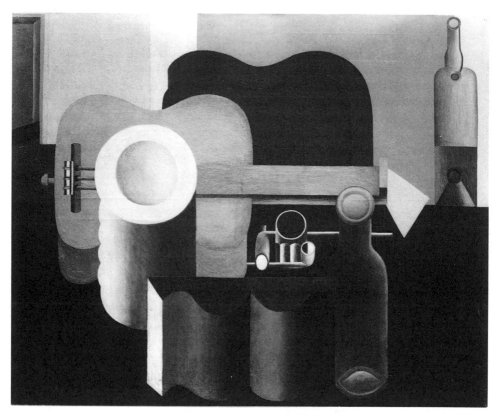

30. Le Corbusier (Charles-Edouard Jeanneret), *Still-Life*, 1920

L'Esprit nouveau was premised on Le Corbusier's faith that his promotion of Taylorism would win him the support of French industry. When that support failed to materialize, and the effect of the 1929 stock market crash on France revealed the weaknesses of international capitalism, Le Corbusier gave up his dream of a Taylorist utopia and the rationalized aesthetic that went with it.[59]

He found a substitute for Taylorism in the Sorelian and fascist principles of regional syndicalism. By the early 1930s, the mantle of Sorelian syndicalism had passed from Sorel to Hubert Lagardelle, who propagated a revised form of corporatism in the journals *L'Ordre nouveau*, *Plans*, *Prélude*, and *L'Homme réel* before becoming the Vichy Secretary of State for Labor. According to Sternhell, *Plans* was dominated by Lagardelle who allied his syndicalism "with anti-liberalism and anti-Marxism."[60] Le Corbusier's role as editor and writer for the last three journals[61] indicates that La-

gardelle's *ordre nouveau* had thoroughly supplanted the internationist *esprit nouveau* in his mind by the 1930s. What that *ordre nouveau* consisted of is admirably summarized by McLeod:

> Lagardelle, now the political spokesman of *Plans* and *Prélude*, argued that any revolutionary group could be effective only if it extended beyond the boundaries of the working class. As syndicalism transcended political parties, it must also transcend class; the crisis of democracy affected the whole nation. . . . In contrast to *l'homme économique* of the Marxists or *l'homme abstrait* of the democrats, the journals proposed *l'homme réel*. Man was an intuitive, emotional, "biological" being. *Esprit* was as important as *besoin*; art as material equality. Nietzsche and Sorel with their declarations of moral heroism were the oft-quoted heroes. Syndicalism, or regional syndicalism as it was sometimes called, was now in essence an organic movement; political and economic change were to emerge spontaneously, growing from cell to region. The new society . . . was to reflect natural hierarchies whether productive, geographic or racial. These "natural" frontiers would, it was hoped, insure world peace. To define objectives more specifically was unnecessary; the goal, after all, was simply the attainment of that which was natural and organic to man.[62]

The geopolitical lessons Le Corbusier drew from these ideological principles culminated in his collaboration with the Vichy regime: they also bear a striking resemblance to the geopolitics of the pre-1914 avant-garde. Lagardelle, in *Plans*, had defined the "abstract man" as an individual divested "of his sensitive qualities"; he was the overly rational "theoretical man" of "individualist democracy."[63] Lagardelle's "real man" preferred "the group" to such individualism, and the collective unit of the nation was to be organically rather than rationally defined.[64] Of the categories deemed "organic," Le Corbusier found the racial element most appealing, which led him to develop a grand scheme for the geographical division of Europe along racial lines. In Le Corbusier's plan, Europe was to be divided into three racial groupings: the Mediterranean for the "Latin Federation," Central Europe for the "Germanic" peoples, and finally a "Slavic U.S.S.R." Algiers was to be one of four capitals of the Latin configuration, along with Paris, Barcelona, and Rome.[65] Fifteen years earlier the Puteaux Cubists had proposed a Celtic Federation as an organic unit militantly opposed to a Germano-Latin configuration. Over the intervening years the geopolitical configurations changed but their bases in a Bergsonian, organic, and racial order remained constant.

In Le Corbusier's Algiers project (1931–1942), the rationalist prin-

ciples of Taylorism were systematically replaced by spatial meta-
phors for biological evolution. The city was now termed a "shell" in
order to signal its capacity for "organic growth."[66] Le Corbusier
adopted another temporal metaphor from nature as an architectural
motif: "the law of the meander," which had its inspiration in the
"organic life" of river systems.[67] McLeod reports that Le Corbusier
thought "the river's winding course" analogous "to the process of
human creativity"—an association comparable to the Bergsonian
correlation of human creativity and creative evolution. Thus in con-
trast to the "earlier vertical towers of the Ville Contemporaine," his
Algerian buildings were to reflect the temporal flow and growth of
natural forces. The rhetoric of "geometric order" and "rationality"
of his Taylorist aesthetic was jettisoned in favor of the organic order
of regional syndicalism.[68] With it went Le Corbusier's call of 1924
for architects to "abandon regional expression in favor of an interna-
tional idiom,"[69] for the Algierian project was meant to celebrate the
fusion of European and Muslim cultures in the Latin Federation.
Taylorist standardization was replaced by an emphasis on regional
difference as a metaphor for racial difference.

Le Corbusier's evolution from Taylorism to syndicalism was not
an isolated phenomenon but part of a paradigm that had first
emerged among the Bergsonian avant-garde before 1914. Over the
intervening years the Bergsonism of the Cubists, Fauvists and Fu-
turists analyzed in this study was incorporated into the fascism of
Sorel's admirers, Mussolini, Lagardelle, and Georges Valois. The
particular fascist configuration that brought Marinetti's Futurists
into the fold, and led Le Corbusier to collaborate on Lagardelle's
journal *Plans*, had a precedent in the organicist, syndicalist, and cor-
poratist ideologies that permeated the Bergsonism of an earlier gen-
eration. Thus the organic syndicalism of Le Corbusier echoed the
organicist politics and collectivist aspirations of the Fauvists, Cub-
ists, and Futurists because the ideological rhetoric of Bergsonism
found new relevance within the parameters of Lagardelle's reaction-
ary program. Only the political consequences were more grave.

NOTES TO INTRODUCTION

1. Maurice-Verne. Unless otherwise indicated, all translations are my own.

2. Having declared that he knew nothing of the Cubists and Futurists, Bergson stated that he ignored art that was the product of "a school," adding, "En principe, on ne peut exposer une théorie avant de faire une oeuvre d'art; on ne peut tenter de la faire en se basant sur telle ou telle théorie." Cited in Villanova, 3.

3. Bergson, "The Introduction to Metaphysics" (1903), 213.

4. "La Vie parisienne" 50 (1912), 509, cited in Grogin, 123.

5. Charles Péguy, Oeuvres en prose, 1898–1908 (Paris, 1959), 483, quoted in Bistus, 115.

6. For the most complete list of Bergson's publications, as well as publications on Bergson, see Gunter.

7. Grogin, ix.

8. Picard and Tautain, (10 February 1914), 544–60; (25 February 1914), 744–60; (10 March 1914), 111–28; (25 March 1914), 307–28; (10 April 1914), 513–28. Grogin has dealt with these issues in the section of his book titled "Controversies."

9. Romeo Arbour's Henri Bergson et les lettres françaises (Paris, 1955) remains the most substantial study of Bergson's impact upon French literature before 1914. A penetrating study of Bergson's influence on Charles Péguy, Paul Valéry, and Marcel Proust is A. E. Pilkington's Bergson and His Influence: A Reassessment (Cambridge, 1976). Shiv K. Kumar, Bergson and the Stream of Consciousness Novel (New York, 1963), in turn analyzes the writings of Dorothy Richardson, Virginia Woolf, and James Joyce. More recent studies analyzing Bergson's literary influence in Britain and the United States are Paul Douglass, Bergson, Eliot and American Literature (Lexington, 1986); Tom Quirk, Bergson and American Culture: the Worlds of Willa Cather and Wallace Stevens (Chapel Hill, 1990); and Sanford Schwarz, The Matrix of Modernism: Pound, Eliot and Early 20th-Century Thought (Princeton, 1985). For Bergson's influence in the sphere of French politics, see H. Stuart Hughes, Consciousness and Society (New York, 1958); Irving L. Horowitz, Radicalism and the Revolt against Reason: The Social Theories of Georges Sorel (New York, 1961); Ray Nichols, Treason, Tradition and the Intellectual: Julien Benda and Political Discourse (Lawrence, Kansas, 1978); and Grogin. For a book-length study of Bergson's own political evolution, with special emphasis on his diplomatic activities during the First World War, see Philippe Soulez, Bergson politique (Paris, 1990).

10. Grogin, 107–96.

11. Connections between Bergson and modernism before 1914 have been made with reference to Matisse, Kupka, Delaunay, Léger, Le Fauconnier, Gleizes, Metzinger, Duchamp, and Boccioni. See in particular the sections devoted to Bergson and

Matisse in Jack Flam, *Matisse: The Man and his Art* (London, 1986); on Kupka and Delaunay in Virginia Spate, *Orphism* (Oxford, 1979); on Delaunay and Futurism in Sherry Buckberrough, *The Discovery of Simultaneity* (Ann Arbor, 1982); on Léger and Le Fauconnier in Christopher Green, *Léger and the Avant-Garde* (New Haven, 1976); and on Gleizes and Metzinger in Mark Roskill, *The Interpretation of Cubism* (Philadelphia, 1985). In addition there are numerous articles devoted to Bergsonism and the individual artists mentioned above. See Ivor Davies, "Western European Art Forms Influenced by Nietzsche and Bergson Before 1914, particularly Italian Futurism and French Orphism," *Art International* 19.3 (March 1975), 49–55; Ivor Davies, "New Reflections of *The Large Glass*: The Most Logical Sources for Duchamp's Irrational Work," *Art History* 2/1 (1979), 85–94; George Beck, "Movement and Reality: Bergson and Cubism," *The Structurist* 15/16 (1975–1976), 109–16; Mark Antliff, "Bergson and Cubism: A Reassessment," *Art Journal* 47 (Winter 1988), 341–49; Timothy Mitchell, "Bergson, Le Bon and Hermetic Cubism," *Journal of Aesthetics and Art Criticism* 34 (Winter 1977), 175–84; David Cottington, "Henri Le Fauconnier's 'L'Abondance', and its Literary Background," *Apollo* (February 1977), 129–30; and Brian Petrie, "Boccioni and Bergson," *The Burlington Magazine* 116 (March 1974), 140–47.

12. See Daniel Robbins, "The Formation and Maturity of Albert Gleizes" (Ph.D. Diss., New York University, 1975); David Cottington, "Cubism and the Politics of Culture" (Ph.D. Diss., Courtauld Institute, University of London, 1985); Nancy J. Troy, *Modernism and the Decorative Arts in France: Art Nouveau to Le Corbusier* (New Haven, 1991); and Patricia Leighten, *Re-Ordering the Universe: Picasso and Anarchism, 1897–1914* (Princeton, 1989). Study of the relation of Cubism to cultural politics was largely initiated by Kenneth E. Silver in his study of art and politics during and after the First World War. See Kenneth E. Silver, "Esprit de Corps: The Great War and French Art, 1914–1925," Ph.D. Diss., Yale University, 1981.

13. For historical treatments of avant-guerre France focusing on the confluence of left and right, see Michael Curtis, *Three Against the Third Republic: Sorel, Barrès, and Maurras* (Princeton, 1959); Zeev Sternhell, *La Droite révolutionnaire, 1885–1914: Les Origines françaises du fascisme* (Paris, 1978); Eugen Weber, "France," in *The European Right: A Historical Profile*, ed. Hans Rogger and Eugen Weber (Berkeley, 1965) 71–127; and Paul Mazgaj, *The Action Française and Revolutionary Syndicalism* (Chapel Hill, 1979).

14. On the republican nationalism of Massis (pseudonym Agathon) and Raymond Poincaré, see Eugen Weber, *The Nationalist Revival in France, 1905–1914* (Berkeley, 1959).

15. See Eugen Weber, "Introduction," in Rogger and Weber, 1–28.

16. See Mazgaj; and Weber, *Action Française: Royalism and Reaction in Twentieth-Century France*, 1962, 3–88.

17. Mazgaj, 87–95 and 155–65.

18. Weber 1962, 79–82.

19. Mazgaj, 96–99.

20. Weber 1962, 52–53. Weber reports that Pujo was responsible for coordinating relations between the Action française and the Camelots, as well as for "ultimate discipline."

21. Mazgaj, 170–71.

22. Charles Maurras, "Revue de la presse," *Action française* (7 February 1909), quoted in Mazgaj, 95.

23. Mazgaj, 133–34.

24. For Pataud's anti-Semitic statement, see E. P., "Pataud et Rothschild," *Action Française* (6 March 1911), quoted in Mazgaj, 157; for a discussion of Hervé's negative reaction to the rally and reappraisal of his relations with the royalists, see ibid., 155–56 and 162–65.

25. Un Sans-Patrie (Gustave Hervé), "Ni antisémite ni antifranc-maçon," *Guerre sociale* (5–11 April 1911); "Une Lettre de Pataud," *Guerre sociale* (12–18 April 1911), quoted in Mazgaj, 162–63; on the Socialists' condemnation of Pataud, and Hervé's role in organizing the Jeunes Gardes, see ibid., 162–65.

26. See Weber 1959, 136–37; Mazgaj, 201–2.

27. The Action française's confrontation with the royalist conservative wing had begun with the publication, in the March 20, 1910, edition of Arthur Meyer's *Le Gaulois*, of the Duc d'Orléans's disapproval of a public assault on Premier Aristide Briand by Camelot du Roi Lucien Lacour. Weber notes that Meyer, along with the steering committee of the Duc's political bureau, had set out to discredit the Action française in the eyes of the Pretender. In response the Action française not only launched a successful campaign to win royalist subscribers from the conservative *Gaulois* and *Correspondance nationale* but, in June 1911, Maurras succeeded in ousting conservatives such as the Comte Henry de Larègle from the Political Bureau. This act was confirmed by royal writ, for the Duc had abandoned his conservative allies when he saw that the Action française could widen his support. See Weber 1965, 56–61.

28. Maurras, "La Violence," *Action Française* (12 August 1908), quoted in Mazgaj, 60.

29. Of the eight core staffers of the *Cahiers*, Georges Valois, Henri Lagrange, and Gilbert Maire were royalists from *Revue critique*, while René Marans and André Pascalon were both members of the Action française. The three nonroyalists were Berth, Albert Vincent, and Marius Riquier.

30. Weber 1965, 80–82, notes that Maurras's Catholic supporters were especially troubled by the *Revue critique*'s eulogies to the anti-Catholic Stendhal. Maurras's attempt to placate his Catholic supporters alienated Clouard and Maire, with the result that they severed relations with the Action française in February 1914.

31. Ibid., 82.

32. Grogin, 88; Sternhell 1986, 90–118. Historians have rightly criticized Sternhell for labeling the antidemocratic irrationalist currents in French culture before 1914 fascist *avant la lettre*, with the result that the term "fascist" is applied to movements unrelated to the postwar phenomenon. For a good overview of the reception of Sternhell's work among historians, see Antonio Costa Pinto, "Fascist Ideology Revisited: Zeev Sternhell and His Critics," *European History Quarterly* 16 (1986), 465–83; and Robert Wohl, "French Fascism, Both Right and Left: Reflections on the Sternhell Controversy," *Journal of Modern History* (March 1991), 91–98.

33. Grogin, 88. For Bergson's own evaluation of his political views, see Gilbert Maire, *Bergson, mon maître* (Paris, 1935); and Isaak Benrubi, *Souvenirs sur Henri Bergson* (Neuchatel, 1942). For an evaluation of the politics of Bergson as opposed to Bergsonism, see Ellen Kennedy, "Bergson's Philosophy and French Political Doc-

trines: Sorel, Maurras, Péguy, and de Gaulle," *Government and Opposition* 15/1 (Winter 1980), 75–91; and Philippe Soulez, *Bergson politique* (Paris, 1990).

34. See Richard Terdiman, *Discourse/Counter-Discourse: The Theory and Practice of Symbolic Resistance in Nineteenth-Century France* (Ithaca, 1985), 25–81.

35. See chapters 1 and 2 for a full discussion of this distinction and its political import; for reference to the "light of organization" in *Du Cubisme*, see Gleizes and Metzinger 1912 (trans. 1964), 5.

36. Derrida 1981, 3–25. Jonathan Culler has related the valorization of one mimetic system over another to the romantic metaphors of the mirror and the lamp as they are elucidated by M. H. Abrams. In chapter 2 I analyze the Cubists' linkage of their attack on the mimetic pretensions of Impressionism to their ideological rebuttal of Cartesianism and show that Bergson placed artistic intuition in an ambivalent position as both reflective of nature's spiritual essence and the light of being itself. Bergsonism is therefore an extension of an earlier romantic discourse. See Jonathan Culler, "The Mirror Stage," in *High Romantic Argument: Essays for M. H. Abrams*, ed. Lawrence Lipking (Ithaca, 1981), 149–63.

37. For a discussion of this paradox in romantic theory see Culler, 153–54.

38. See chapter 3 for a discussion of this issue.

39. Tison-Braun, 139–58.

40. Shiff 1991, 129–80. For Bergson's anarcho-individualist followers, organic unity is constituted within the parameters of individual consciousness; for anarcho-syndicalists its boundaries extend to class consciousness; while for proponents of Bergsonian nationalism, such unity constitutes a racial group or a nation state. This ambiguity with regard to what lies within the organic frame of reference lends credence to the deconstructionist notion that organic unity is the product of framing, and that attempts on the part of estheticians to define what is essential to a work of art by what lies outside of it implies that the supplementary frame of reference is, in fact, essential to the unified whole. In short, the distinction between inside and outside breaks down, and the notion of an organic essence dissolves. Recently Paul Douglass and Richard Shusterman have noted that deconstruction may possess its own organicist assumptions, inasmuch as the argument that everything is a "product of its interrelations and differences from other things, that there are no independent terms with positive or intrinsic essences, rests at bottom on the idea that all these interrelated and differential terms are indeed inexorably and ineluctably interconnected" (Shusterman, 107–08). Shusterman traces the metaphysical genealogy of this idea of a differentially interconnected world to notions of cosmic unity preferred by Nietzsche and Hegel, while Douglass outlines a similar paradigm in the context of Bergson's cosmology. By extending the deconstructive critique of essences to encompass this cosmological frame of reference, one can ground Bergsonian metaphysics within the context of social relations, as Richard Terdiman has done through his critique of the universalist pretensions of natural or mythic signs. For a summary of Derrida's analysis of organicism as figured in the term "parergon," see Jacques Derrida, *The Truth in Painting*, trans. Geoff Bennington and Ian Mcleod, Chicago and London, 1986, 18–147; and Jonathan Culler, *On Deconstruction: Theory and Criticism after Structuralism*, Ithaca, 1982, 193–200. For an analysis of the organicist assumptions underlying this critique, see Paul Douglass, " 'Such as the Life is, such is the Form': Organicism among the Moderns," in *Approaches to Organic Form*, ed.

Frederick Burwick, Dortrecht, 1987, 253–73; and Richard Shusterman, "Organic Unity: Analysis and Deconstruction," in *Redrawing the Lines: Analytic Philosophy, Deconstruction and Literary Theory*, ed. Reedway Dasenbrock, Minneapolis, 1989, 93–115.

41. Sternhell distinguishes "the mystical, irrational, romantic and emotional side of fascism" from "a 'planist,' technocratic, one might almost say 'managerial' aspect," based on a neo-socialist revision of capitalism. Bergsonism in its Sorelian manifestation exemplified the "romantic" strain, while Henri de Man's doctrine of "planism" combines both themes. See Sternhell 1978, 410; Sternhell 1986, 6–7 and 187–212. Herf complicates Sternhell's categories by showing how the technocratic was subsumed within the ideological rhetoric of romantic fascism in the writings of figures such as Ernest Jünger and Martin Heidegger. In many respects the present study analyses a French version of what Herf has called the reactionary modernism entailed in the merger of technology with philosophical irrationalism in post-war Germany. See Jeffrey Herf, *Reactionary Modernism: Technology, Culture and Politics in Weimar and the Third Reich*, New York 1987, 1–17.

42. Terdiman, 61–62.

43. Herf, 16.

NOTES TO CHAPTER ONE

1. See Silver, "Esprit de Corps: The Great War and French Art, 1914–1925," Ph.D. diss., Yale University, 1981; Silver, 209; and Green 1987, 190.

2. Lubar, 314. See Metzinger (August 1911); Gleizes (September 1911), 161–72; for Allard's description of Cubism as embodying a future classicism, see Roger Allard, (November 1910), 442, cited in Lubar, 313.

3. Lubar, 316.

4. Xènius (Eugeni D'Ors), "De l'Estructura," *La Veu de Catalunya* (1 June 1911); cited in Lubar, 309.

5. Lubar, 315 and 321.

6. Thus d'Ors, in speaking of the Cubist aesthetic in "Del Cubisme a l'Estructuralisme" (*La Veu de Catalunya*, 1 February 1912, 6; cited in Lubar, 320), declared that "nothing could be further, in its effect, from [Bergson's] ideological position, from his anti-intellectualism, and from his cult of intuition and reality, than the art of these innovators, which is all abstraction, reason, and complete disdain for the flux and mere appearance of life. In reality, the Cubists are, at the core of their conceptions and methods, anti-Bergsonians." That d'Ors considered his rejection of Bergsonian intuition in the name of classicism to be "ideological" points to a key issue missing from Lubar's essay: the political import of anti-Bergsonism within the cultural politics of the Action française. For examples of attacks on both Bergson and Symbolism by prominent members of the Action française, see Lasserre 165–83; Bernard, "Discours," 200–13; and Maurras, 1.

7. Cornell, passim Robbins 1963–1964, considers the relations between the Symbolist movement and Puteaux Cubism. For an analysis of the Bergsonism of Gleizes and Metzinger and its relation to neo-Symbolist theories, see Antliff (1988). For

Gleizes' statement on Cubism and Mallarmé, see Albert Gleizes, "Les Débuts du Cubisme," in Jean Chevalier, *Albert Gleizes et le Cubisme*, Stuttgart, 1962, 53–68.

8. Grogin, 175–92. Also see Sternhell 1978, 364–72.

9. Grogin, 185–90. Grogin provides us with an important corrective to the scholarship of Sternhell, who treats the Action française as free of internal dissention with regard to Bergson, by equating the opinions of Maire and Clouard on Bergson with those of Lasserre and Maurras.

10. On Sorel, see Sternhell 1986, 77–89; and Sternhell 1978, 318–46. For a more nuanced approach to Sorel's Bergsonism, see Richard Vernon, *Commitment and Change: Georges Sorel and the Idea of Revolution* (Toronto, 1978), and Richard Vernon, *Citizenship and Order: Studies in French Political Thought* (Toronto, 1986), 146–68.

11. The literary historian M. H. Abrams has noted the origins of this mechanical-organic opposition in the writings of Samuel Coleridge; Raymond Williams in turn charts the usage of this paradigm in the writings of Carlyle and Ruskin. See Abrams, 156–225; Raymond Williams, 137–61.

12. *L'Art libre*'s René Vachia outlined Lasserre's anti-Bergsonism in the December 1910 issue of that journal, while *Montjoie!*'s Jean Muller took note of Maire's attempt to "blanket himself" in "Maurrasian orthodoxy . . . by reducing, with access, intuition to intellect [thereby] sacrificing the vital order to the geometrical order." See René Vachia, 489–91; and Jean Muller, (14 March 1913), 8.

13. Grogin, 175–92.

14. Lasserre cited in Hulme, 40; cited in Grogin, 185.

15. Lasserre, 165–83.

16. Ibid., 166.

17. Ibid., 167.

18. Bacconnier, cited in Sternhell 1986, 63.

19. Sternhell 1986, 61–65.

20. Lasserre, 182. On Maurras's approval of Bacconnier's corporatism, and disapproval of the Sorelianism of the *Revue critique* group on that basis, see Mazgaj, 56–60.

21. Lasserre, 168.

22. Ibid., 169.

23. Ibid., 171.

24. Ibid.

25. Ibid., 172.

26. Ibid.

27. Ibid., 173–74.

28. Ibid., 174.

29. Rocafort, 1; Maurras, 1, cited in Grogin, 186–87.

30. Lasserre, 174.

31. Ibid., 178.

32. Ibid., 178–79.

33. Ibid.

34. Ibid., 179.

35. Ibid., 179–80.

36. Ibid., 180.

37. Lanson was one of the chief protagonists in instigating the 1902 Reforms in secondary education in France, which called for the replacement of classical studies, including Latin, with a modernized curriculum. In the period between 1905 and 1914 various groups used the Reforms to galvanize public opposition to the Third Republic. There is then a complex political subtext permeating references to "Latin" culture during the prewar period. For the most thorough analysis of this debate, see Claire-Françoise Bompaire-Evesque, *Un Débat sur l'université au temps de la Troisième République: la lutte contre la Nouvelle Sorbonne.* Paris, 1988.

38. Lasserre, 182–83.

39. Bernard (May 1910), 200–13. On Bernard's attacks on the symbolist movement following his conversion to the Action française in 1908, see Décaudin, 318–24.

40. Bernard (1910), 200 and 213.

41. Visan, (1909), 60–63, and (1910), 66–69.

42. Clouard, (1909), 113.

43. Bernard, (1911), 62.

44. Bernard (1910), 206.

45. Ibid., 208.

46. Ibid., 200–201.

47. Ibid., 210.

48. Ibid., 207.

49. Ibid., 208–13.

50. Visan (June 1910), 125–40.

51. Ibid., 127.

52. Ibid., 127–28.

53. Ibid., 128.

54. Ibid., 132.

55. Ibid., 133.

56. Ibid.

57. Ibid., 135.

58. Ibid., 131–32 and 139.

59. In his article Visan discusses this issue in the context of the public's response to works of art, ibid., 139. For an overview of Bergson's concept of vital order see Paul Douglass, "The Gold Coin: Bergsonian Intuition and Modernist Aesthetics," *Thought* (June 1983), 234–50.

60. See Billiet, "Conclusion," (Summer 1911), 618–22; and Vachia, 489–91.

61. Billiet, "Littérature," (Summer 1911), 621–22.

62. Ibid., 621.

63. A notice on the impending publication of Joseph Billiet's *Introduction à la vie solitaire*, with a frontispiece by Gleizes, appeared in the February 1910 issue of *L'Art libre.* Billiet's endorsement of Allard's theories is in his "Au Salon D'Automne de Lyon," *L'Art libre* (December 1910–January 1911), 479–81. That text is analyzed below.

64. See notes 60 and 61 for references.

65. Billiet (March 1911), 546.

66. Ibid.

67. Billiet's contrast of the classicism of the Action française with the Bergsonian classicism he advocates bears a close resemblance to Shiff's distinction between aca-

demic classicism and the 'classical primitivism' of modernism, a distinction based on the privileging of indexical signs on the part of modernists as a way of establishing criteria of genius. Shiff relates this conception to the supposed classical primitivism of Poussin and Cézanne in Chapters 12 and 13 of his superb study *Cézanne and the End of Impressionism: A Study of the Theory, Technique, and Critical Examination of Modern Art* (Chicago 1984) 162–84. For Shiff's meditations on this theme, see his "Mastercopy," *Iris* (Paris) 1/2 (September 1983), 113–27; "Representation, Copying and the Technique of Originality," *New Literary History* 15/2 (Winter 1984), 331–63; "The Original, the Imitation, the Copy and the Spontaneous Classic," *Yale French Studies* 66 (1984), 27–54; and most recently, "Phototropism (Figuring the Proper)," *Studies in the History of Art* 20 (1989), 161–79. Roger Benjamin has recently drawn on Shiff's work in an analysis of the modern copy in French art between 1890 and 1916. See Benjamin (June 1989), 176–201.

68. Billiet (Summer 1911), 620.

69. Ibid.

70. Ibid.

71. Ibid., 619.

72. Ibid.

73. Billiet (1910–1911), 479–81.

74. Allard, (November 1910), 441–43.

75. Allard was among the first to perceive a common orientation uniting the works of Gleizes, Metzinger, and Le Fauconnier hung at the 1910 Autumn Salon. Along with Apollinaire and Salmon, he was instrumental in encouraging the Salon Cubists to show as a group at the 1911 Salon des Indépendants. For a summation of Allard's activities over this period, see Golding, 5–9; and Cottington 1985, 355–69.

76. The appended note reads as follows: "L'abondance des matières nous oblige à renvoyer au prochain numéro le compte rendu du Salon d'Automne de Lyon." Billiet in Allard (1910), 443.

77. Vachia, 489.

78. Billiet (1910–1911), 479.

79. Ibid.

80. Ibid.

81. Ibid.

82. Ibid., 479–80.

83. Ibid., 481.

84. Ibid.

85. Ibid., 480.

86. Combet-Descombes is referred to in a footnote as an artist whose work is conducive to the aesthetic principles Billiet expounds, ibid., 481. At the time Combet-Descombes was painting tortured landscapes with titles such as *Paysages: l'heure troublée* (1911). See Dominique Brachlianoff, *Pierre Combet-Descombes, 1885–1966*, ex. cat. Musée des Beaux-Arts, Lyons, 20 June–15 September 1985.

87. Billiet (1910–1911), 481.

88. Ibid., 480.

89. Vachia, 490.

90. Billiet (1910–1911), 480.

91. Ibid., 481.

92. Ibid., 479.

93. Ibid.

94. Allard (1910), 443.

95. Ibid.

96. Ibid.

97. Ibid., 442.

98. Billiet (Summer 1911), 619.

99. Golding, 17, cites this passage as a justification for a painter's right "to move around an object and combine various views of it into a single image"; Fry, 63, does the same, noting that Allard "adds a suggestion that the viewer can reconstitute the fragmented elements in the painting and thus arrive at a full comprehension of the original object."

100. Allard (1910), 442 and 443.

101. Metzinger (October–November 1910), 649–52; and Metzinger (18 August 1911), 5.

102. Cottington has pointed to the relevant texts in this regard. In "L'Art et ses représentants," *La Revue indépendante*, 4 (September 1911), 164, Gleizes spoke of a need to "return to Greco-Roman art, and its cultural legacy as it is found in the work of David, Ingres, and Delacroix." Le Fauconnier, in his reply to J. C. Holl's "Une Enquête sur l'orientation de la peinture" in the May 1911 issue of *Revue des temps présent*, 466, praised Poussin's *Rape of the Sabines*. For an analysis of the relation of such comments to Allard's aesthetic views, see Cottington 1985, 210–18. Metzinger in "Notes sur la peinture," 649, referred to the Cubists' return to "Greek rhythm", while he eulogized Gleizes's art as embodying the "Latin" spirit in "Cubisme et la tradition," 5.

103. Allard (June 1911), 57–64; and (August 1911), 127–40.

104. Cottington, 1985, 355–69.

105. Ibid., 368–69.

106. Ibid., 365.

107. Ibid., 321.

108. Cottington, 365, notes that Allard's association of the concept with form in Poussin's *Bergers d'Arcadie* "enabled him to encompass the idea of life and movement even in works which had 'an absolute immobility.'"

109. For Cottington's discussion of Mithouard's theories, and their relation to the aesthetic theories of Denis, Gide, and Rivière, see ibid., 47–51 and Cottington (December 1984), 744–50.

110. Cottington is careful to separate the Action française's restrictive notion of classicism from that put forth by Mithouard and his followers. The latter group, represented by such figures as Gide and Maurice Denis, were prepared to subsume every manifestation of French culture under the rubric of the "French tradition", including Cubism in some instances. Allard made use of this idea; however, he was still prepared to disparage Denis, and through him the Nabis-oriented aesthetic that journals like *L'Occident* upheld. By exalting the art of the seventeenth century and Greco-Roman art, Allard attempted to fuse Maurras's more restricted classical canon with the Bergsonian conception of historical continuity that I have related to the criticism

of Visan and Billiet and that Cottington relates to Mithouard and his circle. I might add that the two groups are by no means exclusive, for Visan was the connecting link between them. On Allard's relation to Mithouard's circle, see Cottington 1985, 44–60 and 355–65.

NOTES TO CHAPTER TWO

1. Blanche, 244–45.
2. Ibid., 244. Blanche does not give exact dates for these sittings, but he dates his commission to the time of Bergson's London lectures of 1911.
3. Salmon (1912).
4. "Qui rencontre ces messieurs [Metzinger, Gleizes, Le Fauconnier, and Léger] aux soirées de *Vers et Prose* semble tout désigné pour les présenter à l'illustre métaphysicien." Salmon (1911).
5. See Gleizes 1957, 23–25.
6. For references discussing Bergson's impact on Cubism in France before World War I, see Introduction, n.11.
7. Romains, "Intuitions," 175. In a short review of George Perin's *La Lisière blonde*, Romains states that Perin's notion of the soul closely resembles Bergson's ideas concerning psychological duration, thus dating Romains's familiarity with Bergson to 1906 or earlier. See Romains, "Poésie," 463–64. Marie-Louise Bidal's *Les Ecrivains de L'Abbaye* (Paris, 1939), contains a section on Bergson's influence upon Romains and others associated with the Abbaye de Créteil.
8. Green 1976, 25, n.49.
9. Gray, 87.
10. Allard (November 1910), 442; Metzinger (16 August 1911). Selections from both articles are translated in Fry, 62 and 66–67.
11. Gleizes and Metzinger, *Du Cubisme*, Paris, 1912, 15 (trans. in *Modern Artists on Art*, ed. Robert L. Herbert, New York, 1964, 1–18; Herbert's translation is used throughout this book).
12. Gleizes 1957, 24 (trans. in Robbins 1985, 20).
13. See, for instance, Gamwell, 103 and 106.
14. Cottington 1977, 129–30, points to the writings of Visan as possibly influencing Le Fauconnier in his usage of generative imagery in his painting *L'Abondance*.
15. For a discussion of Visan, see Cornell, 73–76.
16. Robbins (1963–1964), 115, n.36.
17. For an example of such praise, see Mandin, 210–13. Alexandre Mercereau singles out Visan's book for special mention in his *Littérature et les idées nouvelles* (Paris, 1912), 34–35.
18. Gleizes and Metzinger 1912 (trans. 1964), 6. All uses of the male universal in this book reflect the language of quoted sources and are not my own.
19. Ibid.
20. Ibid.
21. Ibid., 8 and 12.
22. Henderson, 82–89.

23. Gleizes and Metzinger 1912 (trans. 1964), 4.

24. Ibid., 12.

25. Ibid., 7.

26. Ibid.

27. Ibid., 7 and 13.

28. Bergson, *Time and Free Will*, 1889, 107–11 and 194–96.

29. Ibid., 47–49 and 237.

30. Ibid., 102–4.

31. Ibid., 6–11 and 128–39.

32. Ibid., 132–34.

33. Bergson, *Creative Evolution*, 1907, 176–77.

34. Bergson 1889, 119–21; Bergson, 1907, ix–xv.

35. Bergson 1889, 136.

36. Ibid., 133.

37. Bergson 1889, 153.

38. Ibid., 165–66.

39. Bergson 1907, 6–7.

40. Ibid., 342–43.

41. Ibid., 7.

42. Bergson 1889, 135.

43. Ibid., 128.

44. Ibid., 18.

45. Gleizes and Metzinger 1912 (trans. 1964), 4.

46. For a discussion of Bergson's conception of space, see Gurvitch, 21–24.

47. Gray, 4.

48. Bergson 1889, 96 and 197.

49. Bergson 1907, 211–13.

50. Gleizes and Metzinger, 1912 (trans. 1964), 11, 14.

51. Ibid., 8.

52. Ibid.

53. Bergson 1889, 16–17.

54. Bergson, "The Introduction to Metaphysics," 1903, 213.

55. Bergson 1889, 132.

56. Ibid., 15.

57. Ibid.

58. See Visan, (December 1906–February 1907), 92, and (April–June 1910), 137.

59. Bergson 1903, 195. Cottington 1977, 129–30, cites Visan's reference (April–June 1910) to this passage and concludes that the figure of the woman in Le Fauconnier's *L'Abondance*, combined with her generative symbolism, may represent a Bergsonian combination of images. In addition he suggests that the painting's rhythmic structure could allude to a Bergsonian interpretation of the rhythmic properties of *vers libre*. However in "Das Kunstwerk," 3–4, Le Fauconnier relates the formal composition of his paintings to concepts of "numerical value" derived from theories of the fourth dimension, which indicates his lack of awareness of Bergson's critique of mathematical terminology in *Time and Free Will*. I would argue that Le Fauconnier excluded such mathematical references from his later writing because he had devel-

oped a more sophisticated understanding of Bergson, and recognized the schism separating Bergsonian intuition from such terminology. For an analysis of the relation of "Das Kunstwerk" to *L'Abondance*, see Ann H. Murray (December 1981), 125–33.

60. Ibid.

61. On the same page Bergson writes that the meaning grasped by way of a conglomerate of images "is less a thing thought than a movement of thought, less a movement than a direction." See Bergson 1903, 143.

62. Bergson, "The Life and Work of Félix Ravaisson," 1904, 261–300.

63. Ibid., 273.

64. Ibid.

65. Bergson 1889, 13.

66. Visan (April–June 1910), 131 and 137.

67. Visan (1906–1907), 92: "accumule les images disparate, tourne et retourne une impression primitive, un jeu savant d'analogies combinées, malgré un apparent discord, en vue d'enserrer cette impression dans son entière complexité."

68. Gleizes and Metzinger 1912 (trans. 1964), 12.

69. Ibid., 5.

70. Ibid., 9.

71. Ibid., 8.

72. Ibid., 9.

73. Bergson, 1903, 208–220.

74. Gleizes and Metzinger 1912 (trans. 1964), 17.

75. Ibid.

76. Ibid., 16–17.

77. See Sutton, 450–51; Severini 1965, 83–97. Severini also visited Albert Gleizes's studio in 1911. See Cassou, 19–20.

78. Martin, 98–99.

79. See Robbins 1985, 19–20.

80. Gleizes 1957, 26.

81. Ibid., 26.

82. Ibid., 25.

83. Robbins 1985, 20.

84. Visan 1906–1907, 90ff.

85. Romains, "La Poésie immédiate," *Vers et prose* (October–December 1909), 90–95. The essay was given as a public lecture at the 1909 Salon d'Automne.

86. Ibid., 92.

87. Ibid.

88. Ibid., 92–93.

89. Henri Matisse, "Notes of a Painter," trans. in Flam, 37.

90. Allard 1910, in Fry, 62; Billiet (1910–1911), 479–81.

91. Gleizes and Metzinger 1912 (trans. 1964), 3.

92. Ibid., 5.

93. Bergson, "Laughter," 1900, 162.

94. Ibid., 157–60.

95. Ibid., 161.

96. Bergson, "The Perception of Change," 1912, 159.

97. Ibid., 159–60.

98. Ibid.

99. Ibid., 159.

100. Arcos, 402–6.

101. Ibid., 402.

102. Ibid.

103. Bergson, 1900, 161.

104. Ibid.

105. Arcos, 403–4.

106. Ibid., 403.

107. Ibid., 406.

108. Gleizes and Metzinger 1912 (trans. 1964), 18.

109. Ibid.

110. Metzinger (October–November, 1910), 649–52.

111. Romains (August 10, 1910), 619.

112. Metzinger (October–November 1910), 651. The English translation is that of Daniel Robbins, who has recently drawn attention to Metzinger's discussion of Delaunay and Le Fauconnier in the 1910 *Pan* article. See Robbins 1985, 10.

113. Delaunay attended Alexander Mercereau's soirées as of 1910, and may have become acquainted with Unanimism there, before he met Romains in January 1912. Although Metzinger relates Delaunay's *Tower* image to the Unanimists' method of intersubjective perception, Delaunay's artistic process was similar to Severini's mode of intuitive self-expression. Delaunay apparently painted the image from memory during the summer of 1910. Thus the *Tower* is a composite of memory images whose fragmentary arrangement and disjunctive scale evoke their durational origin in Delaunay's consciousness. See Buckberrough, 54, 59, and 91. On Unanimism and Cubism, see Judy Sund, "Fernand Léger and Unanimism," *Oxford Art Journal* 7/1 (1984), 49–56.

114. Romains (1906), 175.

115. Nash, 436–47.

116. Nash is quite right to point out the Nietzschean component of *Du Cubisme;* indeed his Nietzschean reading of *Du Cubisme* can be easily supplemented by references to Nietzsche made by Gleizes and Metzinger in 1911. Gleizes in "L'Art et ses représentants: Jean Metzinger" (*La Revue indépendante*, 4, September 1911, 161–72) ends this article on Metzinger with quotes from Nietzsche's *Zarathustra*, to the effect that the artist is one "qui s'invente sa propre vertu, ceci est verité," adding that "le créateur" is despised by the public for destroying "vielles valeurs." Metzinger refers to Mercereau's evocations of Bergson and Nietzsche in a December 1911 article on Mercereau's writings. See Metzinger (October–December 1911), 122–29. The Rhythmists, whom I discuss in chapter 3, also correlated Nietzschean will-to-power with a Bergsonian notion of creative will. For Apollinaire's assessment, in 1910, of Metzinger's *Nude*, see Guillaume Apollinaire, "Salon d'Automne," *Poésie* (Autumn 1910), trans. in Breunig, 113–14, cited in Nash, 442. See Leighten, 44–47 and 53–63 on Apollinaire and Picasso; and Nash, 440–43.

117. Bergson 1912, 159.

118. Ibid., 160.

119. Bergson 1907, 259. This passage concerns the manner in which we overcome the focus of "retrospective vision" on the "ready-made" to grasp the "being-made" by means of intuition.

120. Bergson 1900, 159.

121. Bergson 1903, 174 and 176.

122. Bergson 1900, 131.

123. Ibid., 161.

124. Writing on artistic perception, Bergson asks: "what is the object of art? Could reality come into direct contact with the senses and consciousness, could we enter into immediate communion with things and ourselves . . . we should all be artists, for then our soul would vibrate in perfect accord with nature. . . . But this is asking too much of nature. Even for such of us as she has made artists, it is by accident, and on one side only, that she has lifted the veil [of utilitarian perception]. In one direction only has she forgotten to rivet the perception to need. And since each direction corresponds to what we call *sense*—through one of his senses, and through that sense alone—is the artist usually wedded to art. Hence, originally, the diversity of the arts." Ibid., 157–58 and 160–61.

NOTES TO CHAPTER THREE

1. Fry, 12.

2. Golding, xiv–xv.

3. Oppler, 331–35.

4. Golding, 150.

5. Ibid., 149.

6. Alvin Martin and Judi Freeman, "The Distant Cousins in Normandy: Braque, Dufy and Friesz," in *The Fauve Landscape*, ed. Judi Freeman (New York, 1990), 235. John Elderfield notes that although "the late Cézannist phase of Fauvism—the geometricism and primitivism of 1907—formed an important source" for the Puteaux Cubists, Fauvism was superseded at the Salons after 1908 by Cubism, and Fauvism's post–1908 legacy was to be found among "non-Parisian artists" such as the German Expressionists. See Elderfield, 141–47.

7. Golding, 16; Flam 1986, 21. Flam, 348, notes that by the time of *Du Cubisme*'s publication in 1912, "it was apparent that although Matisse was still highly regarded, he no longer held the center of attention," adding that "Matisse's empirically based works seemed to belong to a world apart" from "movements such as cubism, orphism, futurism." At the same time he relates Matisse's Cézanne-oriented desire to "penetrate apparent reality in order to arrive at an image of the deeper Reality" to the Bergsonian notion of duration. Flam regards duration as "the underlying and guiding metaphor of most of Matisse's painting after around 1905," which led Matisse to highlight "the process of painting" in his work. As proof of Bergson's influence, Flam points to Matisse's rejection of the Impressionist emphasis on momentary appearances in "The Notes of a Painter" (1908), in favour of an art that captures a subject's "truer, more essential character," adding that, in 1909, Matisse came in contact with Samuel Prichard, a Bergson enthusiast who may have influenced Matisse after 1910 (21, 243, 373–75 and 348).

Flam, in his otherwise excellent analysis, does not ground the Bergsonian suppositions found in Matisse's "Notes" in the Bergsonian art criticism of the period, and Roger Benjamin, who has explored that interrelation, concludes that the "Bergsonism" of Matisse's "Notes" probably owes more to the writings of Rodin or Signac than to Bergson himself. Thus, although Matisse was exposed to Bergsonian rhetoric through his Symbolist contacts, it seems unlikely that he actually read Bergson before his contact with Prichard in 1909. In addition, Flam considers the Bergsonism of Matisse and Prichard in isolation, as if other avant-garde artists did not share that interest. By way of contrast, historians of Cubism have proven that the debate over Bergson had entered Cubist-related criticism as early as 1910, and this chapter shows that connections between a Fauvist aesthetic and Bergsonism were forged by the Rhythmists in response to contacts with the Bergsonists at the Closerie des Lilas, rather than through exposure to Matisse. That fact is underscored by the absence, in *Rhythm*, of any articles on the 'Bergsonism' of Matisse, or critical evaluation of his exhibitions of the period. Though worthy of consideration, the Bergsonism of Matisse is a subject which lies outside the concerns of this study. On the "Notes of a Painter," see Benjamin 1987, 188–90.

8. Sykes, 12.

9. See for instance Francis Carco, "Aix en Provence" and "Les Huit danseuses," *Rhythm* (Summer 1911), 20–21; Carco, "Lettre de France," *Rhythm* (July 1912), 65–69; Carco, "Lettre de France," *Rhythm* (November 1912), 270–75; Tristan Derème, "Lettre de France, I, Les poèmes," *Rhythm* (June 1912), 32–33; and Derème, " Lettre de France, II, Esquisse de la poésie française actuelle," *Rhythm* (August 1912), 113–19.

10. Ortner in Rosaldo and Lamphere, 67–87.

11. Ibid., 75–77. Marcia Pointon has recently developed Ortner's insights in an analysis of "the relations between the viewing positions of spectators as gendered subjects and the viewing subjects as constructed in images." See Pointon, 11–34.

12. For discussions of the relation of sport to the nationalist discourse in avant-guerre France, see Weber 1959, 107–18; and Nye, 310–29. David Cottington, citing Weber, has suggested that Cubist images of sport, such as Gleizes's *Football Players* (1912–1913) and Delaunay's *Cardiff Team* (1913), are pictorial manifestations of this nationalist revival. See Cottington 1985, 30–41 and 430–37.

13. See Mathews, 21–31.

14. Robert Wohl, 5–41, has discussed the dichotomy developed by Massis, Psichari, and other representatives of the "generation of 1914," between the virility and combativeness of their peers and the pessimistic ennui of their Symbolist predecessors, the "generation of 1885." Nye in turn has related this discourse to contemporaneous calls for a regeneration of the French race through sport and other forms of public hygiene.

15. Morris 1974, 45–47.

16. See Sykes; and Cumming, in Scottish Arts Council, 11. The catalogue also contains a comprehensive bibliography of related literature.

17. Ibid., 8–9; and McGregor, in ibid., 15.

18. Ibid., 16–17.

19. See J. M. Murry 1935, 86–96 and Lea, 14–20.

20. Murry 1935, 135 and 145.

21. Lea, 21–22.

22. The poem dedicated to Murry is Tristan Derème's "L'auberge dans la ville," *Ile sonnante* (October 1912), 194–95. In the same journal Roger Frène describes *Rhythm* as a "publication anglaise-française," and notes the contributions of Carco and Derème to the *Rhythm* project. See Roger Frène, "Les Revues," *Ile sonnante* (June 1912), 125. For a summation of Derème's involvement in *Rhythm*, see Pondrom 146–67.

23. Fergusson, 7.

24. See Fergusson's autobiographical notes quoted in Morris 1974, 63.

25. Griselda Pollock, in an essay titled "Modernity and the Spaces of Femininity," has outlined this paradigm with reference to art of the nineteenth century. See Pollock, 50–90.

26. Referring to Anne Estelle Rice, Fergusson later recalled his impropriety in "taking a perfectly respectable girl artist to this café—the café was not concerned about respectability—L'Avenue was where you took respectable girls, but my girl friend survived it." Quoted in Morris 1974, 63.

27. Carol Duncan has outlined this paradigm with reference to the German Expressionists and Fauvists such as Van Dongen, Manguin, and Matisse. See Duncan in Broude and Garrard, 293–313.

28. Fergusson, quoted in Morris 1974, 63.

29. Ibid.

30. Jackson, 108. Jackson's comments are also cited in Cumming, 6.

31. Morris 1969, 28.

32. Fergusson, 7.

33. Ibid.

34. Murry (Summer 1911), 11.

35. Fergusson, 7; Cumming, 7–8.

36. Rutter 203–7.

37. Ibid., 207.

38. Ibid., 204 and 207.

39. Ibid., 207.

40. Ibid.

41. Carter (9 November 1911), 36.

42. Murry (Summer 1911), 12.

43. Ibid., 11. Carter also speaks of "intensity of vision" in the same context. See Carter (25 May 1911), 82.

44. See ibid., 9; and Carter, (9 November 1911), 36.

45. Murry (Summer 1911), 9, described "the immediate vision of the artist" as "pure intuition."

46. Rutter, 204.

47. Ibid., 207.

48. Marcel, 142–51.

49. Murry (Summer 1911), 12.

50. Carter (25 May 1911), 82.

51. Murry (Summer 1911), 12.

52. Carter (25 May 1911), 82.

53. Cumming, 9.

54. See Kolakowski, 103–5.

55. Bergson 1900, 159.

56. Bergson 1907, 370.

57. Ibid., 369.

58. Carter (10 August 1911), 345.

59. Lee, 51–60.

60. See ibid., 52–53.

61. Carter (10 August 1911), 345.

62. Fergusson recalls this episode in a note dated March 1959, Glasgow. The note is among his papers presently on loan to the library of Glasgow University from the J. D. Fergusson Art Foundation.

63. Raymond Drey (October 1962), 623.

64. Morris 1974, 103.

65. Murry 1935, 156.

66. See Drummond, 18–23. Although Drummond concludes that the dancers in *Les Eus* show "a real echo of Isadora Duncan and Eurythmics," he does not analyze that relationship beyond noting "the sense of free movement in the massive heavy-thighed dancers."

67. Carter, (10 August 1911), 346.

68. Sadler makes his comment in the context of Kandinsky's work, drawing a direct comparison between Dalcroze's ideas and Kandinsky's view that "musical sound acts directly on the soul and finds an echo there because, though to varying extents, music is innate to man." See Wassily Kandinsky, 27 and 50.

69. Morris 1974, 66.

70. Carter, (10 August 1911), 346.

71. Ibid., 346.

72. Carter, *The New Spirit in Art and Drama* (London, 1912), 221.

73. Green 1976, 32–33.

74. Cottington 1977, 129–30.

75. André Salmon, "Le Salon des Indépendants" *Paris-Journal* (18 March 1910) and "Courrier des ateliers" (17 September 1911); trans. in Distel, 23 and 39.

76. Gleizes (1911–1912), 44–45, 48–49.

77. Huntly Carter (9 November 1911), 36; and Crossthwaite, 32–34.

78. Dunoyer de Segonzac, "John Duncan Fergusson," in Arts Council of Great Britain, n.p.: "Quand je l'ai connu à Paris il y a plus de 50 ans, il dirigeait une très intéressante Revue 'Rhythm' à laquelle j'ai moi-même collaboré."

79. There is ample evidence that Fergusson's interest in the Ballets Russes and theater in general was encouraged by his contact with Segonzac: in his March 1911 reply to a survey on art and the theater conducted by Huntly Carter, Fergusson sent Carter "a book of sketches by de Segonzac" as evidence of the effect rhythmic design in theater was having on the avant-garde; Cumming, 10, notes that Fergusson's sketchbooks of 1912 contain drawings of "costumes from Poiret's *Fête du Bacchus*, for which Segonzac designed the decor"; Morris 1974, 66, recalled Fergusson's regular meetings with "de Segonzac, Friesz, Vlaminck and Digremont, who designed for the theater" at the Café du Dôme in 1913, and *Rhythm* magazine contained an article on

the Ballets Russes written by Anne Estelle Rice as well as her illustrations of *Schéhérazade, Salomé, La Spectre de la Rose* and *Le Dieu Bleu*, in addition to an illustration of Isadora by Jessica Dismorr and Petrushka by George Banks.

80. Gleizes (1911–1912), 48–49.

81. Crossthwaite 32–34.

82. Carter, *The New Spirit*, 1912, 220–21.

83. Bergson quoted in J. Bertaut, "Réponse à une enquête sur la jeunesse," *Le Gaulois* (15 June 1912); reproduced in Bergson 1972, 969–70.

84. Agathon, "Les Jeunes gens d'aujourd'hui: I. Ceux qui viennent," *L'Opinion* (13 April 1912), 451; "Les Jeunes gens d'aujourd'hui: II. La Foi patriotique," *L'Opinion* (20 April 1912), 483.

85. Bowditch, in Earle, 32–43.

86. Cottington 1985, 537; Guillaume Apollinaire, "The Salon des Indépendants on the Quai d'Orsay," *L'Intransigeant* (2 April 1913); Guillaume Apollinaire, "Through the Salon des Indépendants," *Montjoie!* (18 March 1913), 4, cited in Breunig, 281–93. Speaking of Gleizes's work in the latter salon review, Apollinaire notes that "élan constitue le sujet de la toile de Gleizes." Breunig, in his translation, substitutes "movement" for "élan."

87. Ortner, 75.

88. See Eugen Weber, "Gymnastics and Sports in Fin-de-Siècle France: Opium of the Classes?," *American Historical Review* (February 1971), 70–79. See Charles Maurras, "A propos de Bergson," *Action Française* (February 11, 1914), 1; Julien Benda, *Le Bergsonisme*, Paris, 1912, 71–90, cited in Grogin, 181; Julien Benda, *Une Philosophie pathétique*, Paris, 1913, 19 and 55; Etienne Rey, "M. Bergson et les Parisiennes," *L'Opinion* (March 25, 1911), 364; René Benjamin, "La Farce de l'Université: La Prise de Berg-hop-son," *Fantasio* 182 (1914), 482, cited in Bistus, 115–16; and René Vincent, "La Leçon de philosophie dans les fleurs," drawing in *La Vie heureuse* (March 5, 1914).

89. See Huntly Carter, *The New Spirit*, 216–21.

90. For an analysis of Bergson's views on this issue, see Gurvitch, 20–25; and Deleuze, 73–89.

91. Henri Bergson, *Matter and Memory*, 1896, 268.

92. Bergson 1889, 104.

93. Bergson 1896, 275.

94. Bergson 1900, 87.

95. Jules Romains, (October–December 1909), 92.

96. Gleizes and Metzinger 1912 (trans. 1964), 5.

97. See for instance, Carter, *The New Spirit*, 346.

98. Gleizes and Metzinger 1912 (trans. 1964), 5.

99. Carter (25 May 1911), 82.

100. Bergson 1907, 11–12.

101. Bergson 1900, 159.

102. Bergson 1907, 11–13.

103. Ibid., 128.

104. Gleizes and Metzinger 1912 (trans. 1964), 7.

105. Carter (9 November 1911), 36.

106. Gleizes and Metzinger 1912 (trans. 1964), 5.

107. Henri Bergson, "The Problem of the Personality," Gifford Lectures, University of Edinburgh, 1914, in 1972, 1071.

108. Bergson 1907, 13.

109. Ibid., 23.

110. Ibid., 6.

111. Ibid., 43.

112. Ibid., 51.

113. Ibid., 190.

114. Ibid., 180.

115. Ibid., 259.

116. Anon., "M. Henri Bergson et l'esprit de la nation," *Gil Blas* (11 July 1912).

117. Bergson, "Life and Matter at War," (October 1914–July 1915), 466.

118. Ibid.

119. Ibid.

NOTES TO CHAPTER FOUR

1. Albert Gleizes, "Cubisme et la tradition," *Montjoie!*, 1 (10 February 1913), 4; and *Montjoie!* 2 (25 February 1913), 2–3; reprinted in Gleizes, *Tradition et cubisme: vers une conscience plastique* (Paris, 1927), 15–23. All quotations will be from the reprinted essay.

2. Weber 1959. See Green 1987; Silver; *On Classic Ground: Picasso, Léger, de Chirico and the New Classicism 1910–1930* (ex. cat., Tate Gallery, London, 1990); Lubar; and Cottington 1985.

3. See Robbins (1963–1964), 111–17. Gleizes later noted, in "The Abbey of Créteil, A Communistic Experiment," *The Modern School* (October 1918), 300–15, that the Abbaye failed largely due to the anarcho-individualist orientation of its members, a complaint which helps explain his subsequent shift to the collectivist theory of the Celtic League.

4. Gleizes 1927, 15–23.

5. See Florian-Parmentier, 1914, 311–58. Florian-Parmentier outlines the movement's program and its membership.

6. Charles Callet (August 1912), 138–40.

7. Charles Callet (June 1912), 217–21.

8. Olivier-Hourcade, (February 1912), 58–61.

9. Olivier-Hourcade (May 1912), 148–55.

10. Florence, 184–91.

11. Charles Callet (November 1912), 56–58.

12. Reboul's theories, summarized in his *L'Impérialisme française: sous le chêne celtique* (Paris, 1913), revolved around an attack on the influx of "Latin" culture into France, and the misconception that France's cultural heritage was "Latin", rather than "Celtic." Reboul, 280–81, cites Pelletier's *Revue des nations* and Barzun's *Poème et drame* as among the principal journals advocating Celtism.

13. See Mercereau, (1 February 1913), 16–20; Fort, 25; and Florian, 48–51.

14. See Raymond Duchamp-Villon, "L'Architecture et le fer," *Poème et drame*, (January–March, 1914), 22–29; trans. in William C. Agee and George Heard Hamil-

ton, *Raymond Duchamp-Villon, 1876–1918*, New York, 1967, 114–118. That same year Duchamp-Villon made an architectural maquette that combined the geometricized features of his *Maison Cubiste* (1912) with a Gothic style derived from English country house designs. Both the maquette and the *Maison Cubiste* are reproduced in ibid., figs. 40, 56. Nancy Troy, in a fascinating study of Cubism's relation to the decorative arts, has linked Jacques Villon's and Duchamp-Villon's production before 1913 to the politicized aesthetic of André Mare and his allies Marie Laurencin and Roger de la Fresnaye. Troy reports that the nationalist aesthetic of the latter group was premised on craft traditions of "the post-revolutionary Directoire, Empire, and Restoration periods," the Napoleonic and Monarchical eras Pelletier and Gleizes set out to condemn. However Duchamp-Villon's newfound interest, in 1913, in the architectural merits of the Gothic style may indicate a shift in his political allegiances. On Duchamp-Villon's relations with Mare, see Troy, 4–5, 96–98.

15. Visan (July 1913), 215–19.

16. Jacques Reboul (29 May 1913), 5.

17. Henri-Martin Barzun, (September–October 1913), 3–4.

18. Charles Callet, "Reverie sur un centenaire," and Auguste Callet, "Etudes et méditations linguistiques," *Poème et drame* 1 (November 1912), 56–64.

19. Charles Callet (November 1912), 57.

20. Gleizes and Metzinger, "Du Cubisme," (November 1912), 65–69.

21. Lanson, 70–73.

22. For references to the attacks on Lanson by the Action française, and Visan's defense of Lanson, see chapter 1.

23. Barzun, (November 1912), 74–83.

24. Le Fauconnier, *Kunstkring* 1912, in Terpstra, 327–30.

25. Ibid., 327.

26. Ibid., 328.

27. Ibid.

28. Ibid.

29. Ibid., 329.

30. Ibid.

31. For a full discussion of the painting, see Murray, "Henri Le Fauconnier's 'Village en montagne,'" *Bulletin of the Rhode Island School of Design* (January 1973), 21–39.

32. Ibid. It should be noted that Le Fauconnier himself had used such mathematical terminology in his earlier essay, "Das Kunstwerk," published in December, 1910. As I state in chapter 2, n. 59, his rebuttal of these mathematical metaphors in the 1912 essay signals the general development, over the course of 1911, of a more informed understanding of Bergson on the part of the Puteaux Cubists. On Le Fauconnier's earlier theory, see Murray 1981.

33. Le Fauconnier 1912, 329.

34. Ibid.

35. Ibid., 330.

36. See Sadler (Summer 1911), 14–18; and Carter, (7 March 1912), 443.

37. David Cottington has noted that Emile Bernard endorsed the Action française program, as it was interpreted by Jean-Marc Bernard in *Les Gûepes*. See Cottington 1985, 44–46. For a discussion of Bernard's emphasis on logic in his definition of clas-

sicism, see Richard Shiff, *Cézanne and the End of Impressionism* (Chicago, 1984), 125–32.

38. Gustave Lanson, 70.

39. Ibid., 71.

40. Ibid., 72.

41. Ibid., 73.

42. Barzun 1912, 74.

43. Ibid., 75.

44. Ibid., 76.

45. Ibid., 77.

46. Ibid.

47. Ibid.

48. Ibid.

49. Ibid.

50. Ibid., 77.

51. Ibid., 77–78.

52. Ibid., 78.

53. Ibid.

54. Ibid., 78–80.

55. Ibid., 80.

56. Ibid., 79–80.

57. For a recent discussion, see Eugen Weber 1991, 21–39. Also see Stanley Mellon, *The Political Uses of History* (New York, 1957).

58. Ibid., 22.

59. Ibid., 24–29.

60. As Michael Fried and Francis Haskell have shown, the revived interest in the art of the eighteenth century was intertwined with a resurgent republicanism following the revolution of 1848, and a deliberate repudiation of the cultural politics of Louis-Philippe. See Michael Fried, "Manet's Sources: Aspects of his Art, 1859–1865," *Art Forum* (March 1969), 28–79; Francis Haskell, *Rediscoveries in Art: Some aspects of taste, fashion, and collecting in England and France* (Ithaca, New York 1980), 112–17.

61. Jules Antoine Castagnary, "Salon de 1866," *Salons*, 2 vols., 1892, 1, 231–32; cited in Fried, 49.

62. Bouchot, quoted in Charles Rosen and Henri Zerner, *Romanticism and Realism: The Mythology of Nineteenth-Century Art* (New York, 1984), 190.

63. Weber 1991, 38.

64. For a discussion of the Action française's debt to Fustel de Coulanges, and Jules Méry's attack on Maurras and Moréas, see Weber 36–38.

65. Pelletier, (15 April 1911), 1–2.

66. Ibid., 2.

67. Ibid., 1.

68. Ibid.

69. Ibid.

70. Mandy, 11.

71. Pelletier, (1 February 1913), 8–15.

72. Ibid., 9.

73. Ibid., 11. John Hutton has noted that the comparison of the socialist *maisons du peuple* to ancient cathedrals was a common metaphor within the syndicalist and socialist movements in France at the turn of the century. The medieval cathedral, like the union hall, was viewed as a cultural center for the common people. See John Hutton, "A Blow of the Pick: Science, Anarchism, and the Neo-Impressionist Movement," Ph.D. diss., Northwestern University, 1987, 342.

74. Ibid.

75. Ibid., 12.

76. Ibid., 11.

77. Ibid., 12.

78. Ibid., 13.

79. Ibid.

80. Ibid., 14. Bergson, quoted in J. Bertaut in "Réponse à une enquête sur la jeunesse," *Le Gaulois* (15 June 1912); repr. in Bergson 1972, 969–70.

81. Pelletier, 14.

82. Ibid.

83. Ibid., 13.

84. Pierre Florian, 48–51.

85. Ibid., 49.

86. For a fuller discussion see Antliff 1991, 182–90.

87. Jean Muller (25 February 1913), 8.

88. See Maire, (January–March 1913), 430–44; and Clouard (14 March 1913), 3–4. For a detailed analysis of both articles see Antliff 1991, 182–90.

89. Muller, (14 March 1913), 8.

90. Picard and Tautain (25 March 1914), 323.

91. Gillouin 1913, 1–8.

92. Ibid., 1–2.

93. Ibid., 5–6.

94. Gillouin, in Picard and Tautain (25 March 1914), 324.

95. Bergson 1903, 213.

96. Maire in Picard and Tautain (25 March 1914), 317.

97. Guillouin (April–June 1914), 18–19.

98. Ibid., 18.

99. Ibid.

100. See Gleizes, "L'Art et ses représentants: Jean Metzinger," *Revue indépendante* 4 (September 1911), 161–72; "Les Beaux-Arts: A Propos du Salon d'Automne," *Les Bandeaux d'or* 4/13 (1911–1912), 42–51; Gleizes in André Tudesq, "Une querelle autour de quelques toiles," *Paris-Midi* (4 October 1912); Albert Gleizes in Henriquez-Philippe, "Le Cubisme devant les artistes," *Les Annales politiques et littéraires* (1 December 1912), 475.

101. Gleizes (1911), 171.

102. Ibid., 163–164.

103. Gleizes (1911–1912), 47.

104. Ibid., 45 and 46.

105. Gleizes in Tudesq.

106. Gleizes 1927, 15–23.

107. Ibid., 16.

108. Gleizes in Henriquez-Philippe, 475.
109. Ibid., 475.
110. Gleizes 1927, 22.
111. Gleizes in Henriquez-Philippe, 475.
112. Ibid.
113. Ibid.
114. Gleizes 1927, 16.
115. Ibid., 17.
116. Ibid., 18.
117. Ibid., 18–20.
118. Ibid., 16.
119. Ibid., 20.
120. Ibid.
121. Ibid., 19.
122. Ibid., 20–21.
123. Ibid., 23.
124. Ibid.
125. Gleizes in Henriquez-Philippe, 475.
126. Ibid.
127. Ibid.
128. Reboul, (29 May 1913), 5.
129. Robbins 1975, 104.
130. Ibid., 106.
131. Ibid., 103–6; Cottington 1985, 462–63.
132. Cottington 1985, 462–63.
133. The seminal role of Bergsonism in this regard also serves as an important corrective to David Cottington's interpretation of Gleizes's political views. Writing of Gleizes's "Cubisme et la Tradition," Cottington notes that Gleizes's "unprecedently narrow and nationalistic" reading of the "French pictorial tradition" was pervasive throughout the journal *Montjoie!*, which advocated a nationalism "of an extreme right-wing kind, compounded of anti-democratic, racist, and traditionalist attitudes." On this basis he maintains that Gleizes's nationalism was "affirmed again in the third issue, by Henri Clouard who argued in an essay entitled 'La Discipline française' (14 March 1913) that writers had a duty to be traditionalists." Having equated the royalist Clouard's idea of tradition with that of Gleizes, Cottington then cites Reboul's "La Revolution de l'oeuvre d'art et la logique de nôtre attitude présente" as lending support to Clouard's position. Although Cottington is surely correct to describe Gleizes's politics as racist, Gleizes and Clouard were not right-wing racists of the same "traditionalist" stripe. As we have seen, the classical and traditionalist doctrine advocated by Reboul, Gleizes, Gillouin, and Muller in *Montjoie!* was part of a campaign to counter the criticism of royalists like Clouard and Maire. Similarly, because of his unfamiliarity with the Celtic League's "Celtic" alternative to the Action francaise's "Latin" ideology, Cottington in an otherwise nuanced discussion, misses the import of Gleizes's treatment of the French pictorial tradition in terms of race and class. Thus Cottington describes Gleizes's combination of an attack on the aristocracy's importation of Italian mannerism with racial nationalism as an "anomaly." In fact, Gleizes's synthesis of syndicalist and nationalist themes on the

basis of 'Celtism' constitutes a paradigmatic example of how Bergsonism was transformed into racial nationalism before World War I. See Cottington, 462–63, 510–11, 538.

134. Murry (June 1913), 134–38.

135. Ibid., 135.

136. Ibid., 136.

137. Ibid., 136.

138. Calais, 56–59. Calais's article is a review of Florian-Parmentier's pro-Celtic preface to his volume, titled *Toutes les lyres* (Paris, 1911).

139. Ibid., 58.

140. Ibid., 59.

141. "Et le style individuel est la proportion selon laquelle ces deux *éléments* rentrent dans sa composition." Ibid., 58.

NOTES TO CHAPTER FIVE

1. Maire (Paris, 1935), 217.

2. For an account of the so-called Lampué episode and its aftermath, see Leighten, 98–101. Gleizes, in his memoirs, recounted his knowledge of Marcel Sembat's defense of the Cubists in the Chamber. See Albert Gleizes, "Les Débuts du Cubisme," in Jacques Chevalier, *Albert Gleizes*, Stuttgart, 1962, 55.

3. The members of the Action d'art collective were: Atl, Banville D'Hostel, André Colomer, Paul Dermée, René Dessambre, Manuel Devaldès, Tewfik Fahmy, Gérard de Lacaze-Duthiers, and Paul Maubel. For a succinct history of the group and the Action d'art movement, see Ernest Florian-Parmentier, *La Littérature et l'époque: histoire de la littérature française de 1885 à nos jours* (Paris, 1914), 223–29.

4. The title, "De Bergson à Bonnot," was replaced with "De Bergson au Banditisme" from the April 15th edition onward.

5. André Colomer, "Les Revues et les journaux, 3: Littérature et Poésie," *Action d'art* 6 (10 May 1913), 4.

6. See Colomer (25 July 1913a), 4.

7. Patricia Leighten has convincingly documented the anarchist strain in Apollinaire's thought, most notably in its Nietzschean, individualist orientation. In addition, it is clear from Leighten's discussion that Jarry and Picasso shared a decidedly "illegalist" posture, exemplified by their frequent use of firearms. See Leighten, 53–69.

8. Atl, in his review of the spring 1913 Salon des Indépendants, pointedly criticized both the Cubist and Futurist movements for not following his own path in the creation of an art form based on decorative harmony. Thus, in speaking of *Du Cubisme*, he reductively summarizes that text as advocating the doctrine, "La Géométrie est une science." In the same article, Atl disparages the Futurist movement for deriving its cinematographic techniques from American comic strips, stating that its most significant contribution was "la représentation des sensations engendrées par l'activité extérieure de la vie contemporaine." See Atl, (15 March 1913), 1–2 and (1 April 1913), 3.

9. Guillaume Apollinaire, "The Atl Exhibition . . . May 1–5, 1914, at the Joubert and Richebourg Gallery," in Breunig, 371–72.

10. Colomer (15 August 1913), 3.

11. Atl (1 April 1913), 3.

12. Severini (10 June 1913) in Dorfles and Siena, 165; and Severini, (25 July, 1913), 2.

13. Severini 1946, rpt. 1965, 93–95.

14. Colomer, "Le Mouvement visionnaire," *La Foire aux chimères* 1 (February 1908), quoted in Florian-Parmentier, 226–27.

15. Gérard Lacaze-Duthiers first explicated the artistocratic doctrine in *L'Idéal humain de l'art* (Paris, 1906). See Florian-Parmentier, 223–24.

16. For a list of these journals and their primary contributers, see Roméo Arbour, *Les Revues littéraires: Ephémères paraissant à Paris entre 1900 et 1914* (Paris, 1956), 25–26, 56 and 67.

17. Florian-Parmentier, 227–28.

18. Gérard de Lacaze-Duthiers, *Vers l'Artistocratie* (Paris, 1913), 3–4. This volume was among the few actually published under the auspices of the *Action d'art* collective.

19. Ibid., 6–7.

20. In an article in *Action d'art*'s first edition, announcing the future publication of the "De Bergson à Bonnot" series, Colomer related the genealogy of the "individualisme anarchiste" movement to "ce courageux petit journal: *L'Anarchie.*" Colomer, (15 February 1913), 2–3.

21. For a summary of the history of *L'Anarchie* and its protagonists, see Parry, 21–32.

22. See, for instance, Colomer's praise of Lorulot's writing for the journal *Idée libre* in Colomer (25 August 1913b), 4.

23. Parry, 25, outlines *L'Anarchie*'s position in this regard.

24. Colomer (25 September 1913), 1.

25. See Joll 1966, 117–48.

26. Stirner, 79–83; Parry, 17–18; and Proudhon, *Qu'est-ce que la Propriété?* (Paris, 1840).

27. Joll 1966, 153–58; and Peter Kropotkin, *Mutual Aid* (London, 1902).

28. Stirner, 82–83.

29. Grave objected to the *L'Anarchie* group not only on these grounds, but also because, in his opinion, the illegalists rejected Kropotkin's theories of mutual aid in their advocation of violence. For a detailed discussion of Grave's adversarial relation to Libertad's and Serge's circle, see Jean Grave, *Le Mouvement libertaire sous la 3e République* (Paris, 1930), and Louis Patsouras, "Jean Grave, French Intellectual and Anarchist, 1854–1939" (Ph.D. Diss., Ohio State University, 1966), 89–95. Thanks go to Patricia Leighten for bringing Grave's evaluation of the illegalists to my attention.

30. Parry provides us with the most detailed history of the group available in English. Also see Benjamin F. Martin, *Crime and Criminal Justice Under the Third Republic* (London, 1990), 275–317.

31. On the "Trial of the Thirty," see Joan U. Halperin, *Félix Fénéon: Aesthete and Anarchist in Fin-de-Siècle Paris* (New Haven), 1988, 279–95.

32. For instance Bonnot apparently took out a subscription to *L'Anarchie* following his first involvement with the illegalist milieu in 1908. See Parry, 66.

33. Serge discusses his friendship with Callemin and Carouy in *Memoirs of a Revolutionary* (1951, trans. P. Sedgwick, London 1984), 35–42. For Serge's taking over the editorship of *L'Anarchie*, see Parry, 56.

34. Parry, 90–91, quotes at length from Serge's 4 January 1912 article.

35. Ibid, 152–59. Serge survived World War I by virtue of serving a prison sentence from 1913–1918.

36. Ibid., 166–67.

37. Ibid., 171. The reference to anarcho-communism is an evocation of the theories of Jean Grave, a principal organizer of the Fédération who was nevertheless wary of those at the Congress who urged collaboration between anarcho-communists and syndicalists. Apparently he feared the centralizing tendencies inherent in syndicalist organization. See Patsouras, 95.

38. Colomer (25 August 1913b), 4.

39. Serge, 22–23 and 32–34.

40. Patsouras, 92. For an overview of Le Dantec's biological theories, see Peter J. Bowler, *The Eclipse of Darwinism* (London, 1983), 113–15.

41. Serge, 19; Parry, 55.

42. Le Dantec, 36–39 and 40–45.

43. Lorulot, 260–61.

44. Colomer (1 April 1913), 4.

45. Colomer (10 October 1913), 4. The editor of *Individualiste scientiste*, Jean-Louis Delvy, is cited by Colomer as one who had supported his Bergsonian position in May 1913, only to repudiate it the following August.

46. Colomer (15 February 1913), 2–3.

47. Ibid., 3.

48. Ibid.

49. Colomer, (10 May 1913a), 2–3.

50. Colomer, (25 August 1913a), 2.

51. Colomer, (1 March 1913), 1.

52. Colomer (10 May 1913a), 2.

53. Bergson, *Matter and Memory* 1896, 21; and Colomer (10 May 1913a), 2.

54. Colomer (10 May 1913a), 2.

55. Ibid., 2.

56. Severini 1946, 94.

57. Lacaze-Duthiers, 6.

58. Stirner, 40–41.

59. Ibid., 49.

60. Indeed, Nietzsche's emphasis on the individual creating herself is indebted to Stirner's egoistic doctrine. For a theoretical study of the interrelationship of their ideas, see John Carroll, *Break-Out from the Crystal Palace. The Anarcho-Psychological Critique: Stirner, Nietzsche, Dostoevesky* (London, 1974), 87–100.

61. A comparison of Nietzschean will and Bergsonian intuition is made in Colomer (1 March 1913), 2.

62. Colomer (10 May 1913a), 2.

63. Colomer (15 April 1913), 2.

64. Colomer (15 February 1913), 2.

65. Colomer (25 August 1913b), 2.

66. Colomer (1 March 1913), 1–2. The article of April 1913 studies "L'Art, l'anarchie & l'ame chrétienne." See Colomer (15 April 1913), 1–2. The full title of Agathon's volume is *Les Jeunes Gens d'aujourd'hui. Le goût de l'action. La foi patriotique. Une renaissance catholique. Le réalisme politique* (Paris, 1913).

67. For a thorough analysis of the cultural significance of Agathon's *Les Jeunes Gens d'aujourd'hui*, see Wohl, 5–41.

68. Agathon, *L'Esprit de la Nouvelle Sorbonne. La crise de la culture classique. La crise du français* (Paris, 1911).

69. Wohl, 6.

70. Grogin, 120.

71. The Action française's unsavory criticism focused primarily on Durkheim's Jewish ethnicity rather than his scientific leanings. See Grogin, 119.

72. Visan expressed these pro-Agathon views in the 2 May 1911 issue of *Revue du temps présent*, 441–45.

73. Wohl, 8.

74. This passage, cited from Agathon's *Les Jeunes Gens d'aujourd'hui*, is also quoted in Maritain, 157.

75. Agathon, *Les Jeunes Gens d'aujourd'hui* quoted in Maritain, 160.

76. Agathon, *Les Jeunes Gens d'aujourd'hui*, quoted in Maritain, 159.

77. Whereas Maire turned away from Maurras to side with Bergson in 1913–1914, Massis headed in the opposite direction, becoming less sympathetic to Bergson by 1913. On Massis, see Bompaire-Evesque, 229–31. On Maire's rejection of Maurras in favor of Bergson, see Grogin, 190.

78. Colomer (1 March 1913), 1.

79. Ibid., 2.

80. Ibid., 1.

81. Ibid., 2.

82. Ibid., 1.

83. Bergson, in *Le Gaulois*, praised Agathon's text as proof of "une sorte de renaissance française," evident in "une vraie création de la volonté" among French youth. This "volonté créatrice" produced "une magnifique unité nationale," reflected in the "esprit d'invention" pervading modern France, and the "virilité" of French youth, exemplified by their love of sport. Bergson's extension of the terms "creative will" and "spirit of invention" to describe the French nation, are exemplary of the manner in which he transformed his doctrine into a theory of the body politic. See Bergson, quoted by J. Bertaut in "Réponse à une enquête sur la jeunesse," *Le Gaulois* (15 June 1912). Bergson's reply was also reproduced in Agathon 1913, 284–86. For a discussion of Bergson's evolving religious views, see Grogin, 69–98 and 139–68.

84. See Grogin, 139–69.

85. Les Compagnons de l'Action d'art, 1.

86. Colomer (10 May 1913a), 2.

87. Colomer (25 July 1913b), 3.

88. Colomer (10 May 1913a), 3.

89. Colomer (25 July 1913a), 3.

90. Les Compagnons de l'Action d'art, 1.

91. Having concluded that Bergsonian intuition is limited to discernment of the self, Colomer, in his article on Agathon's *Les Jeunes Gens d'aujourd'hui,* states that "L'intuitionisme Bergsonien semblait donc rejoindre . . . l'individualisme de Stirner. L'intuition serait la soeur de l'Unique." Colomer (1 March 1913), 2.

92. Colomer (25 July 1913b), 3.

93. Colomer (15 April 1913), 1.

94. Colomer (25 July 1913b), 3.

95. Ibid., 3.

96. Colomer (10 May 1913a), 2.

97. Colomer (25 August 1913a), 2.

98. Bergson 1896, 275. Also see my discussion in chapter 3.

99. Colomer (25 August 1913a), 2.

100. See Chapter 3 for a discussion of this aspect of Bergson's theory.

101. Severini 1946, 94.

102. Colomer (10 May 1913a), 2–3.

103. Colomer (25 September 1913), 1.

104. Sonn, 148–53; and Roslak, 96–114.

105. Sonn, 27, notes that *Action d'art* "acclaimed [the Bonnot Gang] in an article titled 'De Bergson à Bonnot: Aux Sources de l'héroïsme individualiste,' which linked Bergson's intuitionist philosophy to the anarchist sense of the self," but he does not explore the relationship that theory had to avant-guerre modernism.

106. Colomer (1 March 1913), 2.

107. Patsouras, 93–94.

108. Lista, in his seminal text on Marinetti's syndicalism, notes Severini's comparison of Marinetti's Futurism with the *Action d'art* program, acknowledging that their call for the "regeneration of man" by way of a "heroic individualism" inspired by anarchy prefigured some aspects of the Futurist doctrine. However he does not relate his findings on the Sorelian origins of Futurism to the Bergsonian theories of the *Action d'art* group. Joll mentions in passing Severini's comparison, adding that the *Action d'art*'s "mixture of anarchist and Nietzchean ideas" may have anticipated Marinetti's Nietzcheanism. Serge Fauchereau, in his preface to Severini's writings, limits his discussion of Severini's contacts with the *Action d'art* circle to the artist's disagreements with Atl over the latter's evaluation of Futurism in *Action d'art.* See Giovanni Lista, "Marinetti et les anarcho-syndicalites," *Présence de Marinetti,* ed. Jean-Claude Marcadé (Lausanne, 1982), 69; Joll 1960, 135–36; and Gino Severini, *Écrits sur l'art,* preface Serge Fauchereau (Paris, 1987), 15.

109. Lista 1982, 74–83; and Sternhell, Sznajder, and Asheri, 313–17. Sternhell is responsible for the Introduction, Chapters 1, 2, and the Epilogue; Sznadjer wrote Chapters 3 and 4; and Sznadjer and Asheri collaborated on Chapter 5.

110. See Sternhell 1983, 66–89, for a discussion of Sorel's "anti-materialist critique of Marxism."

111. Ibid., 78.

112. H. Lagardelle, ed., *Syndicalisme et socialisme* (Paris, 1908), 4–5; cited in Sternhell 1983, 82.

113. R. Michels, "Controverse socialiste," *Le Mouvement socialiste* 184 (March 1907), 280–81; cited in Sternhell 1983, 83.

114. See Sorel, 86–92; Mazgaj, 116–22; and Roth, 50–57.

115. Vernon 1978, 51–52.

116. Ibid., 55.

117. For a discussion of the issue of an intuitive "direction" of thought, see Chapter 2.

118. Sorel, 127.

119. For a discussion of this section of Bergson's *Introduction to Metaphysics*, and its impact on the Cubists and Futurists, see Chapter 2.

120. For a discussion of *L'Indépendance* and its synthesis of Sorelian and royalist ideas, see Sternhell 1989, 116–25 and Sternhell 1978, 348–400. Sternhell, in forging the links between Sorelians and the Action française, relies mainly on the writings of the syndicalist Edouard Berth, Georges Valois, and Gilbert Maire. The latter two were royalists whose sympathy for Bergson's and Sorel's anti-Cartesianism stands in stark contrast to Maurras, who condemned Bergson on this score. For a discussion of Sorel's anti-Cartesianism, see Sternhell 1989, 99–108; for Sternhell's reliance on royalists favorable to Bergson in his analysis of the relation of syndicalism and the Action française, see Sternhell 1983, 55–65. For an analysis of Maurras's antagonism towards the model of permanent class conflict proposed by Valois and his associates, see Mazgaj, 56–60.

121. Sznajder, in Sternhell 1989, 180–83.

122. Arturo Labriola, "I due nazionalismi," *La Lupa* (16 October 1910), 1, quoted by Sznajdar in Sternhell 1989, 221.

123. Sznajder in Sternhell 1989, 219. Jean Variot later recalled a November 1908 conversation with Sorel in which Sorel stated that "adversity, for nations, is often a source of energy," and praised the Action française for developing an image of France as a beleaguered nation in need of moral regeneration. In July 1909 Sorel wrote an article for *Divenire sociale* in which he praised Maurras's movement on similar grounds. See Jean Variot, *Propos de Georges Sorel* (Paris 1935), 25; cited in Mazgaj, 117 and 120.

124. Sznajder in Sternhell 1989, 220.

125. E. Corradini, "Nazionalismo e sindicalismo," *La Lupa* (16 October 1910), 2, cited by Sznajder in Sternhell 1989, 220. For Corradini's references to Sorel in a 1909 speech delivered in Trieste, see E. Corradini, "Syndicalismo, nazionalismo, imperialismo," in Enrico Corradini, *Discorsi politici (1902–1923)*, Firenze, 1923, 53–69.

126. Sznajder in Sternhell 1989, 186–87.

127. Lista 1982, 74.

128. Cited in ibid., 75.

129. Octavio Dinale, quoted from *La Demolizione* in ibid.

130. Marinetti (16 March 1910).

131. Lista 1982, 76.

132. F.T. Marinetti, "Primo Manifesto Politico Futurista per le Elezioni Generali 1909," and Marinetti, "Discorso al Triestini" (March 1909) in Luigi Scrivo, ed., *Sintesi del Futurismo: storia e documenti* (Rome, 1968), 4–5. The translations are those of Rosa T. Clough in *Futurism* (1961, rpt. Westport, CT, 1969), 17.

133. Lista 1982, 78; and Clough, 27.

134. Lista 1982, 78.

135. Quoted in ibid., 79. Unfortunately Lista gives us no date or author for the *Il Secolo* article.

136. Quoted in Clough, 27.

137. Lista 1982, 82. This article, written by the radical anarchist Maria Rygier in *La Donna Libertia*, is quoted by Lista with no date or page number.

138. Ibid.

139. Quoted from *Il Secolo*, in ibid., 80.

140. Lista, "Preface," 1975, 7; Severini 1946, 18; Carlo Carrà, *La Mia Vita* (Milan, 1945), 109–110.

141. Lista 1975, 10.

142. M. Martin, 88.

143. "Exhibition of the Works of the Italian Futurist Painters" (March 1912), London, Sackville Gallery, No. 12; cited in M. Martin, 118.

144. Sorel, 127–28.

145. M. Martin, 88; Carrà, *La mia vita*, Milan, 1945, 73–74.

146. The passage which, in my opinion, alludes to Carrà's work runs as follows: "If we paint the phases of a riot, the crowd bustling with uplifted fists and the noisy onslaughts of cavalry are translated upon the canvas in sheaves of lines corresponding with all the conflicting forces, following the general law of violence of the picture." Umberto Boccioni et al., "The Exhibitors to the Public," ex. cat., *Galerie Bernheim-Jeune*, Paris (5 February 1912), Eng. trans. "Exhibition of Works by the Italian Futurist Painters," ex. cat. *Sackville Gallery*, London (March 1912); rpt. in Umbro Apollonio, ed., *Futurist Manifestos*, New York, 1973, 48. Carrà later noted that the Futurists' stated desire to place the spectator in the center of their works was a platform initiated by him and emulated in his depiction of Galli's funeral. See Carrà 1945, 74.

147. Ibid., 48.

148. Kaplan, 63.

149. C. Carrà, "Piani plastici come espansione sferica dello spazio," *Lacerba* 1 (15 March 1913), trans. in Ester Coen, "The Violent Urge Towards Modernity: Futurism and the International Avant-garde," in Braun, 54.

150. For a discussion of Boccioni's association of absolute motion with an intuition of the internal dynamism of an object as opposed to a relative or intellectual cognition of it, see Petrie, 140–47; and Golding 1985, 10.

151. Severini (25 July 1913), 2.

152. Umberto Boccioni, "Preface, First Exhibition of Futurist Sculpture," ex. cat. *Galerie La Boëtie*, June 20–July 16, 1913, trans. Robert L. Herbert, *Modern Artists on Art*, (Englewood Cliffs, New Jersey, 1964), 47–48.

153. Severini (September–October 1913), trans. J. C. Higgit in Apollonio, 121.

154. Severini (April 1913).

155. Severini (September–October 1913), 121.

156. Ibid.

157. Silver, 75, provides us with an lucid analysis of Severini's evolving aesthetic during the First World War and after.

158. Ibid., 78.

159. Silver, ibid., relates Severini's Futurist war paintings to the prewar Futurist attack on "the past: inherited civilization, tradition, and everything homey, rustic, academic, or pre-technological."

NOTES TO EPILOGUE

1. For Fergusson's relation of Celtism to the Rhythmist aesthetic and "the Auld Alliance" between Scotland and France, see Morris 1974, 53, 103 and 187.

2. See Michel Foucault, *Discipline and Punish: The Birth of the Prison*, trans. Alan Sheridan (New York, 1979); Martin Jay, "Scopic Regimes of Modernity," in *Vision and Visuality*, ed. Hal Foster (Seattle, 1988), 3–23; Jay, "In the Empire of the Gaze: Foucault and the Denigration of Vision in Twentieth-Century French Thought," in *Foucault: A Critical Reader*, ed. David C. Hoy (New York, 1986), 175–204; Jonathan Crary, *Techniques of the Observer: On Vision and Modernity in the Nineteenth Century* (London, 1990); Donald M. Lowe, *History of Bourgeois Perception* (Chicago, 1982). In his article titled "In the Empire of the Gaze," Jay traces the genealogy of the denigration of vision in French thought back to Bergson; Crary in *Techniques of the Observer* grounds modernist conceptions of vision in a perceptual revolution that occurred in the early part of the nineteenth century.

3. Georg Lukács, *History and Class Consciousness* (1922, trans. Rodney Livingstone 1971, rpt. Cambridge, Mass., 1990); Michael Shanks and Charles Tilly, "Abstract and Substantial Time," *Archeological Review from Cambridge* 6/1 (1987), 32–41; E. P. Thompson, "Time, Work-Discipline, and Industrial Capitalism," *Past and Present* 38 (December 1967), 56–97.

4. Jay 1988, 3–23. The relation of vision and Cartesianism to Foucault's idea of discipline is explored in Jay 1986, 175–204.

5. Jay 1988, 20.

6. Lowe, 26; quoted in Jay 1988, 3.

7. Shanks and Tilly, 32–41. For an expanded version of this essay, see their *Social Theory and Archeology* (Oxford, 1987), 124–36.

8. Shanks and Tilly, "Abstract and Substantial Time," 32.

9. Thompson, 56–97.

10. Ibid., 94–95.

11. Shanks and Tilly, 32–33.

12. Ibid., 33. A profound analysis of this issue from a Marxist and phenomenological perspective is Johannes Fabian's *Time and the Other: How Anthropology Makes its Object* (New York, 1983).

13. Lucio Colletti, *Marxism and Hegel*, trans. L. Garner (London, 1979), 168. Chapter 10 of Colletti's book, titled "From Bergson to Lukács," deals with the relation of Bergson's and Lukács's ideas to the Hegelian critique of the intellect. For an analysis of Bergson's impact on Lukács, see Soulez, 340–41. On Lukács's later attempt to distance himself from such organicist doctrines, which he associated with the romantic tradition in fascism, see Paul Breines, 473–90.

14. Colletti, 168–72.

15. Ibid., 169–70.

16. Lukács, 90.

17. Ibid., 88.

18. Ibid., 90.

19. Ibid., 88.

20. Ibid.

21. Ibid., 89.

22. Ibid., 90.

23. Ibid., 91.

24. Frank Kermode, *The Sense of an Ending: Studies in the Theory of Fiction* (Oxford, 1967), 38–39. The "organic truth" referred to is that of the myth of the "German race." For a semiological analysis of the depoliticizing function of myth, see Roland Barthes, *Mythologies*, trans. Annette Lavers, New York, 1972, 142–59.

25. Thompson, 59.

26. Ibid., 61.

27. David Harvey, *The Condition of Post-Modernity: An Enquiry into the Origins of Social Change* (Cambridge, Mass., 1989). Harvey in Part 3 of his book deals with the effect of the rise of capitalism on European conceptions of time and space from the eighteenth to the early twentieth century. See ibid., 201–83.

28. Ibid., 228.

29. Ibid., 238–39.

30. Harvey in the sections of his book on Le Corbusier does not discuss the architect's interest in Taylorism, though he does relate Le Corbusier's interest in corporatism to his alliance with the reactionary politics of Vichy France. See Harvey, 21–23, 30–31, 34–36, 68–71, 115–16, 127–28, 271 and 282. For a cogent analysis of Le Corbusier's Taylorism, see Mary McLeod, "'Architecture or Revolution': Taylorism, Technocracy and Social Change," *Art Journal* 43/2 (Summer 1983), 132–47.

31. Harvey, 271.

32. Ibid., 272.

33. Ibid., 272.

34. For an excellent analysis of Le Corbusier's "corporatist" period, see Mary McLeod, "Le Corbusier and Algiers," *Oppositions*, 19/20 (Winter/Spring 1980), 53–85.

35. Harvey, 206.

36. Ibid., 266.

37. Ibid.

38. On Rabelais's theory of time, see Ricardo J. Quinones, *The Renaissance Discovery of Time* (Cambridge, 1972), 187–203.

39. The poet Charles Vildrac first envisioned the Abbaye as a commune modeled after Rabelais's prototype, and nailed a placard with a poem by Rabelais on the door of the Abbaye de Créteil. The published "L'Appel de 1906" announcing the commune project to would-be participants, described it as a "Thélème" for artists and poets who wished to escape capitalist "utilitarianism." The first issue of *Rhythm* (Summer 1911), 1–3 contained an article by Frederick Goodyear espousing similar concerns under the title "The New Thelema." See Christian Sénéchal, *L'Abbaye de Créteil* (Paris, 1930), 27, 141.

40. Lenard R. Berlanstein, *The Working People of Paris, 1871–1914* (Baltimore, 1984), 23, 47–48 and 157–63, has discussed the demography and socialist politics of Puteaux. On the strike actions and debate over Taylorism, with special attention to the situation at the Puteaux and Boulogne Renault factories, see Gary Cross, "Redefining Workers' Control: Rationalization, Labor Time, and Union Politics in France, 1900–1928," in *Work, Community, and Power: The Experience of Labor in Europe and America, 1900–1925*, ed. James E. Cronin and Carmen Sirianni (Philadel-

phia, 1983), 143–72; and Judith A. Merkle, *Management and Ideology: The Legacy of the International Scientific Management Movement* (Berkeley, 1980), 148–56.

41. Wallon, 159–63.

42. Harvey, 273.

43. Ibid.

44. Ibid., 209. For an analysis of the fascistic regionalism of the Vichy regime, see Christian Faure, *Le Projet Culturel de Vichy*, Lyon, 1989.

45. Weber 1965, 18.

46. Ibid., 4, 9, and 17.

47. Ibid., 4.

48. Ibid., 25.

49. Ibid., 22–23.

50. See Alice Y. Kaplan, *Reproductions of Banality: Fascism, Literature, and French Intellectual Life* (Minneapolis, 1986), 30–32. For a study that sets Kaplan's theoretical constructs in the context of French history before 1914, see chapter 4 of Zeev Sternhell's *La droite révolutionnaire: Les origines françaises du fascisme, 1885–1914* (Paris, 1978).

51. On Le Corbusier's *Esprit nouveau* period see McLeod 1983, 132–47; and Silver, 373–89. For an analysis of his regional syndicalist affiliations in the 1930s, see McLeod 1980, 53–85. On the Nazi response to Taylorism, see Anson G. Rabinbach, "The Aesthetics of Production in the Third Reich," in *International Fascism: New Thoughts and New Approaches*, ed. George L. Mosse, London, 1979, 189–222; on Valois, Mathon, and Mercier, see Sternhell, 1986, 90–97.

52. McLeod 1983, 136.

53. Ibid., 136–37.

54. Ibid., 137.

55. Ibid.

56. Silver, 383 and 386, in an excellent discussion of Le Corbusier's Purist paintings notes that machine-made rationalization represented through the style and content of his still lifes was wedded with a conception of the painting as a Darwinian, "organic" metaphor for "French wartime and postwar collectivity." Le Corbusier's conflation of the *esprit de corps* of the French nation with organicism could well signal the persistence of the prewar Bergsonian rhetoric into the postwar era; in any case, such rhetoric makes plain that the Purist theory of Le Corbusier was multivalent.

57. Ibid., 374–75; Sternhell 1986, 92–95.

58. Camille Mauclair, "L'Architecture va-t-elle mourir? La crise du 'panbrétonnisme intégral'" (Paris, 1933), 38; quoted in McLeod 1983, 138. For Le Corbusier's description of his painting as a "viable organ" composed of "purified, related, and architectural elements," see Amédée Ozenfant and Charles-Edouard Jeanneret, "Le Purisme," *L'Esprit Nouveau* 4 (January 1921), 67; cited in Silver, 383. I would conjecture that, given Le Corbusier's connections with advocates of corporatism, the organic form of his canvases could be a metaphor for that system, and thus an emulation of Mercier's and Mathon's integration of Taylorist rationalism within the geopolitical parameters of a national corporative entity.

59. McLeod 1983, 143–44. McLeod notes that Le Corbusier abandoned the Tay-

lorist "American model of productivity" without repudiating his social utopianism altogether. This led him to embrace the equally utopian ideals of Lagardelle's regional syndicalism in the 1930s.

60. Sternhell 1986, 202–3.

61. McLeod 1980, 56.

62. Ibid., 56–57. Lagardelle's Bergsonian and Sorelian opposition between "l'homme abstrait" and "l'homme réel" was first broached in articles written for *Mouvement socialiste* in 1908 and 1909. For a recent evaluation of Lagardelle's political evolution, see Jeremy Jennings, "Syndicalism and the French Revolution," *Journal of Contemporary History* (January 1991), 85–92.

63. Hubert Lagardelle, "Au-delà de la démocratie: De l'homme abstrait à l'homme réel," *Plans* (January 1931), 24–25; quoted in Sternhell 1986, 203.

64. Sternhell 1986, 203.

65. McLeod 1980, 57. McLeod's discussion is based upon an essay by Le Corbusier titled "Un Plan d'Organisation Européen," *Prélude* 6 (June–July 1933), 1.

66. Le Corbusier, *The Radiant City* (New York, 1967), 168 and 170; quoted in McLeod 1980, 59.

67. Le Corbusier, *Précisions* (Paris, 1960), quoted in McLeod 1980, 63.

68. McLeod 1980, 63 and 65.

69. Le Corbusier, *L'Art décoratif d'aujourd'hui* (Paris, 1924), 37; quoted in McLeod 1980, 65.

Abrams, M. H. *The Mirror and the Lamp: Romantic Theory and the Critical Tradition*. London, 1971.

Agathon. *L'Esprit de la Nouvelle Sorbonne. La crise de la culture classique. La crise du français*. Paris, 1911.

——. *Les Jeunes Gens d'aujourd'hui. Le goût de l'action. La foi patriotique. Une renaissance catholique. Le réalisme politique*. Paris, 1913.

Allard, Roger. "Au Salon d'Automne de Paris." *L'Art libre* (Lyons, November 1910), 441–43. Trans. Edward F. Fry, *Cubism*. London, 1966, 62.

——. "Les Beaux-Arts." *La Revue indépendante* (August 1911), 127–40.

——. "Sur quelques peintres." *Les Marches du Sud-Ouest* (June 1911), 57–64.

Anon. "M. Henri Bergson et l'esprit de la nation." *Gil Blas* (11 July 1912).

Antliff, Mark. "Bergson and Cubism: A Reassessment." *Art Journal* 47:4 (Winter 1988), 341–49.

——. "The Relevance of Bergson: Creative Intuition, Fauvism and Cubism." Ph.D. Diss., Yale University, 1991.

Apollonio, Umbro, ed. *Futurist Manifestos*. New York, 1973.

Arbour, Roméo. *Henri Bergson et les lettres françaises*. Paris, 1955.

——. *Les Revues littéraires: Ephémères paraissant à Paris entre 1900 et 1914*. Paris, 1956.

Arcos, René. "La Perception originale et la peinture." *Les Bandeaux d'or* (July–August 1912), 402–6.

Arts Council of Great Britain. *J. D. Fergusson, Memorial Exhibition of Paintings and Sculpture*. Intro. Andrew McLaren Young. Edinburgh, 1961.

Atl. "Le Salon des indépendants." *Action d'art* 3 (15 March 1913), 1–2 and 4 (1 April 1913), 3.

Bacconnier, F. "Conclusion de l'ABC du royalisme social." *L'Accord social* (20 June 1909).

Banks, George. "Letter to the Editor." *The New Age* (14 December 1911), 165–66.

Barzun, Henri-Martin. "D'un art poétique moderne." *Poème et drame* (November 1912), 74–83.

——. "Trois poèmes simultanés." *Poème et drame* (September–October 1913), 3–4.

Beck, George. "Movement and Reality: Bergson and Cubism." *The Structurist* 15/16 (1975–1976), 109–16.

Benjamin, Roger. *Matisse's "Notes of a Painter": Criticism, Theory, and Context, 1891–1908*. Ann Arbor, 1987.

——. "Recovering Authors: The Modern Copy, Copy Exhibitions and Matisse." *Art History* 7/2 (June 1989), 176–201.

Benrubi, Isaak. *Souvenirs sur Henri Bergson*. Neuchâtel, 1942.

Bergson, Henri. *Creative Evolution*, 1907. Authorized trans. Arthur Mitchell. New York, 1911. Rpt. 1938.

————. "The Introduction to Metaphysics," 1903. In Henri Bergson, *The Creative Mind*. Trans. Mabelle L. Andison. New York, 1946, 187–237.

————. "Laughter," 1900. Trans. in Wylie Sypher, ed., *Comedy*. Baltimore, 1956. 61–190.

————. "Life and Matter at War." *The Hibbert Journal* (October 1914–July 1915), 465–75.

————. "The Life and Work of Félix Ravaisson," 1904. In Henri Bergson, *The Creative Mind*. Trans. Mabelle L. Andison. New York, 1946, 261–300.

————. *Matter and Memory*, 1896. Authorized trans. N. M. Paul and W. S. Palmer. London, 1911. Rpt. New York, 1970.

————. *Mélanges*. Paris, 1972.

————. "The Perception of Change," 1912. In Henri Bergson, *The Creative Mind*. Trans. Mabelle L. Andison. New York, 1946, 153–86.

————. "The Problem of the Personality." Gifford Lectures, University of Edinburgh, 1914. In *Mélanges* Paris, 1972, 1051–71.

————. *Time and Free Will*, 1889. Authorized trans. F. L. Pogson. New York, 1910. Rpt. 1960.

Berlanstein, Lenard R. *The Working People of Paris, 1871–1914*. Baltimore, 1984.

Bernard, Jean-Marc. "Discours sur le symbolisme." *Les Guêpes* (May 1910), 200–13.

————. "Notes." *Les Guêpes* (December 1911), 62.

Bertaut, J. "Réponse à une enquête sur la jeunesse." *Le Gaulois* (15 June 1912).

Bidal, Marie-Louise. *Les Ecrivains de l'Abbaye*. Paris, 1939.

Billiet, Joseph. "Au Salon d'automne de Lyon." *L'Art libre* (December 1910–January 1911), 479–81.

————. "Conclusion" and "Littérature." *L'Art libre* (Summer 1911), 618–22.

————. "Les Renaissances." *L'Art libre* (March 1911), 546–48.

Binyon, Lawrence. "The Return of Poetry." *Rhythm* (Spring 1912), 1–2.

Bistus, Marguerite. "Bergsonism in the Belle Epoque." Ph.D. diss., Brown University, 1989.

Blanche, Jacques Emile. *Portraits of a Lifetime*. New York, 1938.

Boccioni, Umberto, and others. "The Exhibitors to the Public." Ex. cat., Galerie Bernheim-Jeune. Paris (5 February 1912). Eng. trans. "Exhibition of Works by the Italian Futurist Painters." Ex. cat. Sackville Gallery. London (March 1912); Reprinted in *Futurist Manifestos*, ed. Umbro Apollonio. New York, 1973, 48.

————. "Preface, First Exhibition of Futurist Sculpture." Ex. cat. Galerie La Boëtie. June 20–July 16, 1913. Trans. Robert L. Herbert, ed. *Modern Artists on Art*. Englewood Cliffs, New Jersey, 1964, 47–48.

Bompaire-Evesque, Claire-Françoise. *Un Débat sur l'université au temps de la Troisième République: la lutte contre la Nouvelle Sorbonne*. Paris, 1988.

Bowditch, John. "The Concept of élan vital: A Rationalization of Weakness." In *Modern France: Problem of the Third and Fourth Republics*, ed. E. M. Earle. Princeton, 1951, 32–43.

Braun, E., ed. *Italian Art in the Twentieth Century*. Munich, 1989.

Breines, Paul. "Marxism, Romanticism, and the Case of Georg Lukács." *Studies in Romanticism* 16 (1977), 473–90.

Breunig, Leroy C. *Apollinaire on Art: Essays and Reviews, 1902–1918*. New York, 1972.

Broude, Norma, and Mary D. Garrard, eds. *Feminism and Art History: Questioning the Litany*. New York, 1982.

Buckberrough, Sherry A. *The Discovery of Simultaneity*. Ann Arbor, 1982.

Calais, Charles. "Littérature." *Le Cahier des poètes* (November 1912), 56–59.

Callet, Auguste. "Études et méditations linguistiques." *Poème et drame* (November 1912), 58–64.

Callet, Charles. "Renaissance celtique." *Ile sonnante* (August 1912), 138–40.

———. "Rêverie sur un centenaire: Auguste Callet, 1812–1883." *Poème et drame* (November 1912), 56–58.

———. "Les Patois." *La Revue de France et des pays français*, (June 1912), 217–21.

Carco, Francis. "Aix en Provence" and "Les huit danseuses." *Rhythm* (Summer 1911), 20–21.

———. "Lettre de France." *Rhythm* (July 1912), 65–69.

———. "Lettre de France." *Rhythm* (November 1912), 269–76.

Carroll, John. *Break-Out from the Crystal Palace. The Anarcho-Psychological critique: Stirner, Nietzsche, Dostoevesky*. London, 1974.

Carter, Huntly. "Art and Drama." *The New Age* (9 November 1911), 36.

———. "Art and Drama." *The New Age* (23 November 1911), 84.

———. "Art and Drama in Paris." *The New Age* (7 March 1912), 443.

———. "The Blue Bird and Bergson in Paris." *The New Age* (11 May 1911), 43–45.

———. "The Independents and the New Intuition in Paris." *The New Age* (25 May 1911), 82–83.

———. "Letters From Abroad." *The New Age* (10 August 1911), 345–46.

———. "Letters From Abroad." *The New Age* (7 December 1911), 142.

———. *The New Spirit in Art and Drama*. London, 1912.

———. "The Plato-Picasso Idea." *The New Age* (23 November 1911), 88.

Cassou, Jean, ed. *Albert Gleizes*. Lyons, 1954.

Clouard, Henri. "La Discipline française." *Montjoie!* (14 March 1913), 3–4.

———. "La Littérature." *Les Guêpes* (April 1909), 113.

Clough, Rosa T. *Futurism*, 1961. Repr. Westport, Connecticut, 1969.

Coen, Ester. "The Violent Urge Towards Modernity: Futurism and the International Avant-garde." In *Italian Art in the 20th Century*, ed. E. Braun. Munich, 1989.

Colletti, Lucio. *Marxism and Hegel*. Trans. L. Garner. London, 1979.

Colomer, André. "Anarchiste d'Action d'art." *Action d'art* 1 (15 February 1913), 2–3.

———. "A notre Librarie." *Action d'art* 9 (25 July 1913a), 4.

———. "De Bergson à Bonnot: Aux Sources de l'héroïsme individualiste 1. Bergson et les 'Jeunes Gens d'aujourd'hui.'" *Action d'art* 2 (1 March 1913), 1.

———. "De Bergson au Banditisme: Aux Sources de l'héroïsme individualiste 2: L'Art, l'anarchie & l'âme chrétienne." *Action d'art* 5 (15 April 1913), 2.

———. "De Bergson au Banditisme. Aux sources de l'héroïsme individualiste: *Illusions sociale et désillusion scientiste*." *Action d'art* 11 (25 August 1913a), 2.

———. "De Bergson au Banditisme. La Science & l'intuition: Leurs rôles dans l'individualisme." *Action d'art* 6 (10 May 1913a), 2–3.

———. "De Bergson au Banditisme: Aux sources de l'héroïsme individualiste 7: Soyons des hommes nouveaux." *Action d'art* 13 (25 September 1913), 1.

———. "Girouette!" *Action d'art* 14 (10 October 1913), 4.

———. "Le Mouvement visionnaire." *La Foire aux chimères* 1 (February 1908).

———. "Notre Mouvement: La soirée de 'l'Action d'art.'" *Action d'art* 10 (15 August 1913a), 3.

———. "Les Poètes réfractaires 2: Vivre son rêve." *Action d'art* 9 (25 July 1913b), 3.

———. "Les revues et les journaux." *Action d'art* 4 (1 April 1913), 4.

———. "Les revues et les journaux." *Action d'art* 11 (25 August 1913b), 4.

———. "Les revues et les journaux 3: Littérature et poésie," *Action d'art* 6 (10 May 1913b), 4.

Compagnons de l'Action d'art, Les. "Déclaration." *Action d'art* 1 (15 February 1913), 1.

Cornell, Kenneth. *The Post-Symbolist Period: French Poetic Currents, 1900–1920.* New Haven, 1958.

Cottington, David. "Cubism and the Politics of Culture." Ph.D. Diss., Courtauld Institute, University of London, 1985.

———. "Cubism, Law, and Order: The Criticism of Jacques Rivière." *The Burlington Magazine* 126 (December 1984), 744–50.

———. "Henri Le Fauconnier's 'L'Abondance', and Its Literary Background." *Apollo* (February, 1977), 129–30.

Craig, Gordon. "In Defense of *The Mask* and Mr. Huntly Carter." *The Manchester Playgoer* (November 1913), 130–34.

Crary, Jonathan. *Techniques of the Observer: On Vision and Modernity in the Nineteenth Century.* London, 1990.

Cross, Gary. "Redefining Workers' Control: Rationalization, Labor Time, and Union Politics in France, 1900–1928." In *Work, Community, and Power: The Experience of Labor in Europe and America, 1900–1925,* ed. James E. Cronin and Carmen Sirianni. Philadelphia, 1983, 143–72.

Crossthwaite, Arthur. "A Railway Vision." *Rhythm* (Winter 1911) 32–34.

Crowther, Paul. "Cubism, Kant and Ideology," *Word and Image,* 3/2 (April–June 1987), 195–201.

Culler, Jonathan. "The Mirror Stage." In *High Romantic Argument: Essays for M. H. Abrams,* ed. Lawrence Lipking. Ithaca, 1981, 149–63.

Cumming, Elizabeth. "Colour, Rhythm, and Dance: The Paintings of J. D. Fergusson and His Circle." In *Colour, Rhythm and Dance: The Paintings of J. D. Fergusson and his Circle in Paris.* Ex. cat., Scottish Arts Council. Edinburgh, 1985.

Curtis, M. *Three Against the Third Republic: Sorel, Barrès, and Maurras.* Princeton, 1959.

Davies, Ivor. "Western European Art Forms Influenced by Nietzsche and Bergson Before 1914, Particularly Italian Futurism and French Orphism," *Art International,* 19/3 (March 1975), 49–55.

Décaudin, Michel. *La Crise des valeurs symbolistes: vingt ans de poésie française, 1895–1914.* Toulouse, 1960.

Deleuze, Gilles. *Bergsonism.* Trans. H. Tomlinson and B. Habberjam. New York, 1988.

Derème, Tristan. "Lettre de France, I, Les poèmes." *Rhythm* (June 1912), 32–33.

———. "Lettre de France, II, Esquisse de la poésie française actuelle." *Rhythm* (August 1912), 113–19.

Derrida, Jacques. "Economimesis." *Diacritics* 11/2 (1981), 3–25.

———. *Of Grammatology.* Trans. G. Spivak. Baltimore and London, 1976.

———. *The Truth in Painting.* Trans. G. Bennington and I. Mcleod. London, 1986.

Distel, Anne. *Dunoyer de Segonzac.* Trans. A. Sachs. New York, 1980.

Dorfles, Gillo, and Pier Luigi Siena, *Gino Severini.* Ex. cat., Bolzano, 15 December 1987–31 June 1988. Milan 1987.

Drey, Raymond. "The Autumn Salon." *Rhythm* (December 1912), 327–31.

———. "The Cubists at Grafton." *Rhythm* (February 1913), 419–23.

———. "Post-Impressionism." *Rhythm* (January 1913), 369.

———. "Some Memories of John Duncan Fergusson." *Apollo,* 76/8 (October 1962), 622–24.

Drummond, John. "A Creative Crossroads: The Revival of Dance in Fergusson's Paris." In *Colour, Rhythm and Dance: The Paintings of J. D. Fergusson and his Cricle in Paris,* ex. cat., Scottish Arts Council. Edinburgh, 1985.

Duncan, Carol. "Virility and Domination in Early Twentieth-Century Vanguard Painting" In *Feminism and Art History: Questioning the Litany,* ed. Norma Broude and Mary D. Garrard. New York, 1982, 293–313.

Earle, E. M., ed. *Modern France: Problems of the Third and Fourth Republics.* Princeton, 1951.

Elderfield, John. *The "Wild Beasts": Fauvism and Its Affinities.* Ex. cat., Museum of Modern Art. New York, 1976.

Fabian, Johannes. *Time and the Other: How Anthropology Makes its Object.* New York, 1983.

Fergusson, J. D. "The Autumn Salon." *The Art News* (21 October 1909), 7.

Flam, Jack. *Matisse: The Man and his Art, 1869–1918.* London, 1986.

———. *Matisse on Art.* New York, 1973. Rpt. 1978.

Florence, Jean. "Le Mouvement littéraire: Le lyrisme contemporain," *La Revue de France et des pays français,* (May 1912), 184–91.

Florian, Pierre. "Mouvement philosophique: Bergsonisme." *Revue des nations* (February 1913), 48–51.

Florian-Parmentier, Ernest. *La Littérature et l'époque: Histoire de la littérature française de 1885 à nos jours.* Paris, 1914.

———. *Toutes les lyres.* Paris, 1911.

Fort, Paul. "Poésie." *Revue des nations* (February 1913), 25.

Foucault, Michel. *Discipline and Punish: The Birth of the Prison.* Trans. Alan Sheridan. New York, 1979.

Freeman, Judi, ed. *The Fauve Landscape.* Ex. cat., Los Angeles County Museum of Art. New York, 1990.

Fry, Edward F., *Cubism.* London, 1966.

Gamwell, Lynn. *Cubist Criticism.* Ann Arbor, 1980.

Gillouin, René. *Essais de critique littéraire et philosophique.* Paris, 1913.

———. "Paul Claudel: poète catholique." *Montjoie!* (April–June 1914), 18–19.

Gleizes, Albert. "The Abbey of Créteil, A Communistic Experiment." *The Modern School* (October 1918), 300–15.

———. "L'Art et ses représentants: Jean Metzinger." *La Revue indépendante* (September 1911), 161–72.

————. "Les Beaux-arts: à propos du Salon d'automne." *Les Bandeaux d'or* (1911–1912), 42–51.

————. "Cubisme et la tradition." *Montjoie!* (10 February 1913), 4; (25 February 1913), 2–3.

————. *Souvenirs, Le Cubisme 1908–14, Cahiers Albert Gleizes I.* Lyons, 1957.

————. *Tradition et cubisme: vers une conscience plastique.* Paris, 1927.

Gleizes, Albert, and Jean Metzinger. "Du Cubisme." *Poème et drame* (November 1912), 65–69.

————. *Du Cubisme.* Paris, 1912. Trans. Robert L. Herbert. ed., *Modern Artists on Art.* New York, 1964, 1–18.

Golding, John. Boccioni: *Unique Forms of Continuity in Space.* London, 1985.

————. *Cubism: A History and an Analysis, 1907–1914.* London, 1959. Rev. ed. 1988.

Goodyear, Frederick. "The New Thelema." *Rhythm* (Summer 1911), 1–3.

Grave, Jean. *Le Mouvement libertaire sous la 3e République.* Paris, 1930.

Gray, Christopher. *Cubist Aesthetic Theories.* Baltimore, 1957.

Green, Christopher. *Cubism and its Enemies: Modern Movements and Reaction in French Art, 1916–1928.* New Haven, 1987.

————. *Léger and the Avant-Garde.* New Haven, 1976.

Grogin, R. C. *The Bergsonian Controversy in France, 1900–1914.* Calgary, 1988.

Gunter, P.A.Y., *Henri Bergson: A Bibliography.* Bowling Green, 1986.

Gurvitch, George. *The Spectrum of Social Time.* Dordrecht, 1964.

Halperin, Joan Ungersma. *Félix Fénéon: Aesthete and Anarchist in Fin-de-Siècle Paris.* New Haven, 1988.

Harvey, David. *The Condition of Post-Modernity: An Enquiry into the Origins of Social Change.* Cambridge, Mass., 1989. Rpt. 1990.

Henderson, Linda Dalrymple. *The Fourth Dimension and Non-Euclidean Geometry in Modern Art.* Princeton, 1983.

Henriquez-Philippe. "Le Cubisme devant les artistes." *Les Annales politiques et littéraires* (1 December 1912), 473–75.

Horowitz, Irving L. *Radicalism and the Revolt Against Reason: The Social Theories of Georges Sorel.* New York, 1961.

Hughes, H. Stuart. *Consciousness and Society: The Reconstruction of European Social Thought, 1890–1930.* New York, 1958.

Hulme, T. E. "Balfour, Bergson, and Politics." *The New Age* 10 (9 November 1911), 38–40.

Jackson, Holbrook. "John Duncan Fergusson and His Pictures." *Today* (1918), 108.

————. "A Plea for a Revolt in Attitude." *Rhythm* (Winter 1911), 6–10.

Jay, Martin. "In the Empire of the Gaze: Foucault and the Denigration of Vision in Twentieth-Century French Thought." In *Foucault: A Critical Reader*, ed. David C. Hoy. New York, 1986, 175–204.

————. "Scopic Regimes of Modernity." In *Vision and Visuality*, ed. Hal Foster. Seattle, 1988, 3–23.

Joll, James. *The Anarchists.* New York, 1966.

————. *Three Intellectuals in Politics.* New York, 1960.

Kandinsky, Wassily. *Concerning the Spiritual in Art*, 1912 Trans. M.T.H. Sadler. London, 1914. Rpt. New York, 1977.

Kaplan, Alice Yaeger. *Reproductions of Banality: Fascism, Litterature, and French Intellectual Life.* Minneapolis, 1986.

Kennedy, Ellen. "Bergson's Philosophy and French Political Doctrines: Sorel, Maurras, Péguy, and de Gaulle." *Government and Opposition* 15/1 (Winter 1980), 75–91.

Kermode, Frank. *The Sense of an Ending: Studies in the Theory of Fiction.* Oxford, 1967.

Kolakowski, Leszek. *Bergson.* Oxford, 1985.

Kropotkin, Peter. *Mutual Aid.* London, 1902.

Lacaze-Duthiers, Gérard de. *Vers l'artistocratie.* Paris, 1913.

Lanson, Gustave. "Préface à l'anthologie des poètes nouveaux." *Poème et drame* 1 (November 1912), 70–73.

Lasserre, Pierre. "La Philosophie de M. Bergson." *L'Action française* (March 1911), 165–83.

Lea, F. A. *The Life of John Middleton Murry.* London, 1957.

Le Dantec, Félix. *L'Egoisme, base de toute société.* Paris, 1912.

Lee, Jane. "L'Enchanteur pourrissant." *Revue de l'art* 82 (1988), 51–60.

Le Fauconnier, Henri. "Das Kunstwerk." *Neue Künstlervereinigung.* Ex. cat., Turnus. Munich, 1910–1911, 3–4.

———. "Le Sensibilité moderne et le tableau," in *Moderne Kunstkring. Catalogue des ouvrages de peinture, sculpture, dessin, gravure, exposés au Musée Munissipal Suasso à Amsterdam du 6 octobre au 7 novembre 1912.* Amsterdam, 1912. Reprinted in Aleida B. Terpstra, *Moderne Kunst in Nederland, 1900–1914.* Utrecht, 1958, 327–330.

Leighten, Patricia. *Re-Ordering the Universe: Picasso and Anarchism, 1897–1914.* Princeton, 1989.

Lista, Giovanni. "Marinetti et les anarcho-syndicalites." In *Présence de Marinetti,* ed. Jean-Claude Marcadé. Lausanne, 1982.

———. "Preface," in U. Boccioni, *Dynamisme Plastique: peinture et sculpture futuristes.* Lausanne, 1975.

Lorulot, André. *Les Théories anarchistes.* Paris, 1913.

Lowe, Donald M. *History of Bourgeois Perception.* Chicago, 1982.

Lubar, Robert S. "Cubism, Classicism, and Ideology: The Exposició d'Art Cubista in Barcelona and French Cubist Criticism." In *On Classic Ground: Picasso, Léger, de Chirico and the New Classicism, 1910–1930.* Ex. cat., Tate Gallery. London, 1990, 309–323.

Lukács, Georg. *History and Class Consciousness,* 1922. Trans. Rodney Livingstone, 1971. Rpt. Cambridge, Mass., 1990.

Ludovici, A. M. "Art: Mr. Bergson's Views." *The New Age* (3 October 1911), 547–48.

Maire, Gilbert. *Bergson, mon maître.* Paris, 1935.

———. "Systèmes philosophiques d'écoles littéraires: L'Utilisation du Contresens." *Revue critiques des idées et des livres* (January–March 1913), 430–44.

Mandin, Louis. "Tancrède de Visan." *Vers et prose* (May–June 1911), 210–13.

Mandy, André. "Chroniques des lettres et des arts." *L'Etendard celtique* (15 April 1911), 11.

Marcel, Gabriel. "Bergsonism and Music." In *Reflections on Art,* ed. Susanne K. Langer. Baltimore, 1958, 142–51.

Marinetti, F. T. "Our Common Enemies." *Le Demolizione* (16 March 1910).

———. "Primo Manifesto Politico Futurista per le Elezioni Generali 1909" and "Discorso al Triestini" (March 1909) in *Sintesi del Futurismo: storia e documenti*, ed. Luigi Scrivo. Rome, 1968, 4–5.

Maritain, Raïssa. *Adventures in Grace*. New York, 1945.

Martin, Alvin, and Judi Freeman. "The Distant Cousins in Normandy: Braque, Dufy and Friesz." In *The Fauve Landscape*, ed. Judi Freeman. New York, 1990.

Martin, Benjamin F. *Crime and Criminal Justice Under the Third Republic*. London, 1990.

Martin, Marianne. *Futurist Art and Theory*. Oxford, 1968.

Mathews, Patricia. "Passionate Discontent: The Creative Process and Gender Difference in the French Symbolist Period." *Allen Memorial Art Museum Bulletin.* (Summer 1988), 21–31.

Matisse, Henri. "Notes of a Painter," 1908. Trans. Jack Flam, *Matisse on Art*. New York, 1973. Rpt. 1978.

Maurice-Verne. "Un jour de pluie chez M. Bergson." *L'Intransigeant* (26 November 1911).

Maurras, Charles. "A propos de Bergson." *L'Action française* (11 February 1914), 1.

McCully, Marilyn. *A Picasso Anthology: Documents, Criticism, Reminiscences.* London, 1981.

Mazgaj, Paul. *The Action Française and Revolutionary Syndicalism*. Chapel Hill, 1979.

McGregor, Sheila. "J. D. Fergusson and the Periodical *Rhythm*." In *Colour, Rhythm and Dance: The Paintings of J. D. Fergusson and his Circle in Paris*. Ex. cat., Scottish Arts Council. Edinburgh, 1985.

McLeod, Mary. "'Architecture or Revolution': Taylorism, Technocracy and Social Change." *Art Journal* 43/2 (Summer 1983), 132–47.

———. "Le Corbusier and Algiers." *Oppositions*, 19/20 (Winter/Spring 1980), 53–85.

Mercereau, Alexandre. *Littérature et les idées nouvelles*. Paris, 1912.

———. "Paroles devant la fiancée." *Revue des nations* (February 1913), 16–20.

Merkle, Judith A. *Management and Ideology: The Legacy of the International Scientific Management Movement*. Berkeley, 1980.

Metzinger, Jean. "Alexandre Mercereau." *Vers et prose* 27 (October–December 1911), 122–29.

———. "Cubism et tradition." *Paris-Journal* (16 August 1911). Trans. Edward F. Fry, *Cubism*. London, 1966, 66–67.

———. "Notes sur la peinture." *Pan* (October–November 1910), 649–52.

Mitchell, Timothy. "Bergson, Le Bon, and Hermetic Cubism." *Journal of Aesthetics and Art Criticism* 34 (Winter 1977), 175–84.

Morris, Margaret. *The Art of J. D. Fergusson*. Glasgow, 1974.

———. *My Life in Movement*. London, 1969.

Muller, Jean. "Mouvement des idées." *Montjoie!* (25 February 1913), 8.

———. "Mouvement des idées," *Montjoie!* (March 14, 1913), 8.

Murray, Ann H. "Henri Le Fauconnier's 'Das Kunstwerk': An Early Statement of Cubist Aesthetic Theory and Its Understanding in Germany." *Arts Magazine* (December 1981), 125–33.

———. "Henri Le Fauconnier's 'Village en montagne.'" *Bulletin of the Rhode Island School of Design* (January 1973), 21–39.

Murry, John Middleton. "The Aesthetic of Benedetto Croce." *Rhythm* (Autumn 1912), 11–13.

———. "Art and Philosophy." *Rhythm* (Summer 1911), 9–12.

———. "The Art of Pablo Picasso." *The New Age* (30 November 1911), 115.

———. "Bergson and the Coal Strike." *T. P.'s Weekly* (22 March 1912), 357.

———. "Bergsonism in Paris." *The New Age* (4 June 1911), 115.

———. *Between Two Worlds*. London, 1935.

———. "French Books: A Classical Revival." *The Blue Review* (June 1913), 134–38.

———. "The Importance of Hegel to Modern Thought." *The New Age* (28 December 1911), 204–5.

———. "Mr. Middleton Murry Replies to his Critics." *T. P.'s Weekly*. (3 May 1912), 570.

———. "Preface." *Painting and Sculpture by J. D. Fergusson*. Ex. cat., The Connell Gallery. London, May 1918.

Nash, John M. "The Nature of Cubism: A Study of Conflicting Explanations." *Art History* 3/4 (December 1980), 436–47.

Nichols, Ray. *Treason, Tradition and the Intellectual: Julien Benda and Political Discourse*. Lawrence, Kansas, 1978.

Nye, Robert A. *Crime, Madness, and Politics in Modern France*. Princeton, 1984.

Olivier-Hourcade. "Revues des Revues." *La Revue de France et des pays français* (February 1912), 58–61.

———. "La Sagesse des druides," *La Revue de France et des pays français*, (May 1912), 148–55.

Oppler, Ellen C. *Fauvism Reexamined*. New York, 1976.

Ortner, Sherry. "Is Female to Male as Nature Is to Culture?" In *Women, Culture, and Society*, ed. Michelle Zimbalist Rosaldo and Louise Lamphere. Stanford 1974, 67–87.

Parry, Richard. *The Bonnot Gang*. London, 1987.

Patsouras, Louis. "Jean Grave, French Intellectual and Anarchist, 1854–1939." Ph.D. diss., Ohio State University, 1966.

Pelletier, Robert. "Ce que nous voulons." *L'Etendard celtique* (15 April 1911), 1–2.

———. "La Ligue celtique française: Sa doctrine, son but." *Revue des nations* (February 1913), 8–15.

Petrie, Brian. "Boccioni and Bergson." *The Burlington Magazine*, 116 (March 1974), 140–47.

Picard, Gaston, and Gustave-Louis Tautain. "Une enquête sur M. Henri Bergson," *La Grande revue* (10 February 1914), 544–60; (25 February 1914), 744–60; (10 March 1914), 111–28; (25 March 1914), 307–28; (10 April 1914), 513–28.

Pilkington, A. E. *Bergson and his Influence: A Reassessment*. Cambridge, 1976.

Pointon, Marcia. *Naked Authority: The Body in Western Painting, 1830–1908*. Cambridge, 1990.

Pollock, Griselda. *Vision and Difference: Femininity, Feminism and the Histories of Art*. New York, 1988.

Pondrom, Cyrena. *The Road from Paris: French Influence on English Poetry, 1900–1920*. Cambridge, 1974.

Proudhon, Pierre-Joseph. *Qu'est-ce que la propriété?* Paris, 1840.

Quinones, Ricardo J. *The Renaissance Discovery of Time*. Cambridge, 1972.

Reboul, Jacques. *L'Impérialisme française: sous le chêne celtique.* Paris, 1913.

------. "La Révolution de l'oeuvre d'art et la logique de nôtre attitude présente." *Montjoie!* (29 May 1913), 5.

Robbins, Daniel. "The Formation and Maturity of Albert Gleizes." Ph.D. diss., New York University, 1975.

------. "From Symbolism to Cubism: The Abbaye de Créteil." *Art Journal* 23 (Winter 1963–1964), 111–16.

------. "Jean Metzinger at the Center of Cubism." *Jean Metzinger in Retrospect.* Ex. cat., The University of Iowa Museum of Art. Iowa City, 1985.

------. "Le Fauconnier and Cubism." In *Cubism.* Ex. cat., James Goodman Gallery. New York, 1989, 6–9.

Rocafort, Jacques. "La Jeunesse d'aujourd'hui." *L'Univers* (15 February 1913), 1.

Rogger, Hans, and Eugen Weber, eds. *The European Right: A Historical Profile.* Berkeley, 1965.

Romains, Jules. "Intuitions." *La Phalange* (July–December 1906), 175.

------. "Poésie." *La Phalange* (July–December 1906), 463–64.

------. "La Poésie immédiate." *Vers et prose* (October–December 1909), 90–95.

------. "Sur quelques rapports de la philosophie et de l'époque." *La Grande revue* (10 August 1910), 619.

Rosaldo, Michelle Zimbalist, and Louise Lamphere, eds. *Women, Culture, and Society.* Stanford 1974.

Roskill, Mark. *The Interpretation of Cubism.* Philadelphia, Toronto, and London, 1985.

Roslak, Robyn S. "Organicism and the Construction of a Utopian Geography: The Role of the Landscape in Anarcho-Communism and Neo-Impressionism." *Utopian Studies* 1/2 (1990), 96–114.

Roth, Jack. *The Cult of Violence: Sorel and the Sorelians.* Berkeley, 1980.

Rutter, Frank. "The Portrait Paintings of John Duncan Fergusson." *The Studio* (December 1911), 203–7.

Sadler, Michael. "Fauvism and a Fauve." *Rhythm* (Summer 1911), 14–18.

Salmon, André. "Bergson et les cubistes." *Paris-Journal* (29 November 1911).

------. "La Section d'Or." *Gil Blas* (22 June 1912).

Scottish Arts Council. *Colour, Rhythm & Dance: The Paintings & Drawings of J. D. Fergusson and his Circle.* Ex. cat. Edinburgh, 1985.

Sénéchal, Christian. *L'Abbaye de Créteil.* Paris, 1930.

Serge, Victor. *Memoirs of a Revolutionary,* 1951. Trans. P. Sedgwick. London, 1984.

Severini, Gino. *Ecrits sur l'art.* Paris, 1987.

------. "Le futurisme pictural." *Action d'art* (10 June 1913).

------. "The Futurist Painter Severini Exhibits His Latest Works," Malborough Gallery. London, April 1913.

------. "The Plastic Analogies of Dynamism," September-October 1913. Trans. in U. Apollonio, *Futurist Manifestos* New York, 1973, 121.

------. "La sculpture futuriste de Boccioni." *Action d'art* 9 (25 July 1913), 2.

------. *La Vita di pittore.* Milan, 1946. Repr. 1965.

Shanks, Michael, and Christopher Tilly. "Abstract and Substantial Time." *Archeological Review from Cambridge* 6/1 (1987), 32–41.

------. *Social Theory and Archeology.* Oxford, 1987.

Shiff, Richard. *Cézanne and the End of Impressionism*. Chicago, 1984.

―――. "Cézanne's Physicality: The Politics of Touch." In *The Language of Art History*, ed. Salim Kemal and Ivan Gaskell. Cambridge, 1991, 129–180.

―――. "Mastercopy," *Iris* 1/2 (September 1983), 113–27.

―――. "The Original, the Imitation, the Copy and the Spontaneous Classic." *Yale French Studies* 66 (1984), 27–54.

―――. "Phototropism (Figuring the Proper)." *Studies in the History of Art* 20, (1989), 161–79.

―――. "Representation, Copying and the Technique of Originality." *New Literary History* 15/2 (Winter 1984), 331–63.

Silver, Kenneth E. *Esprit de Corps: The Art of the Parisian Avant-Garde and the First World War, 1914–1925*. Princeton, 1989.

Sonn, Richard. *Anarchism & Cultural Politics in Fin-de-Siècle France*. London, 1989.

Sorel, Georges. *Réflexions sur la violence*. Paris, 1908. Trans. T. E. Hulme and Jack Roth. *Reflections on Violence*. New York, 1950. Rpt. Collier Books, New York, 1961.

Soulez, Philippe. *Bergson politique*. Paris, 1990.

Spate, Virginia. *Orphism*. Oxford, 1979.

Sternhell, Zeev. *La Droite révolutionnaire: 1885–1914. Les Origines françaises du fascisme*. Paris, 1978.

―――. *Ni Droite, ni Gauche. L'idéologie fasciste en France*. Paris, 1983. Trans. David Maisel. Berkeley, 1986.

―――. With Mario Sznajder, and Maia Asheri. *Naissance de l'idéologie fasciste*. Paris, 1989.

Stirner, Max. *Max Stirner: The Ego and his Own*. Ed. John Carroll, trans. S. Byington. New York, 1971 (orig. pub. 1845).

Sutton, Denys. "The Singularity of Gino Severini." *Apollo* (May 1973), 448–61.

Sykes, Diane. *J. D. Fergusson, 1905–1915*. Ex. cat., Scottish Arts Council. Edinburgh, 1982.

Tate Gallery. *On Classic Ground: Picasso, Léger, de Chirico and the New Classicism 1910–1930*. Ex. cat. London, 1990.

Terdiman, Richard. *Discourse/Counter-Discourse: The Theory and Practice of Symbolic Resistance in Nineteenth-Century France*. Ithaca, 1985.

Terpstra, Aleida B. *Moderne Kunst in Nederland, 1900–1914*. Utrecht, 1958.

Thompson, E.P. "Time, Work-Discipline, and Industrial Capitalism," *Past and Present* 38 (December 1967), 56–97.

Tison-Braun, Micheline. *L'Introuvable origine: Le Problème de la personalité au seuil du XXe siècle*. Geneva, 1981.

Troy, Nancy. *Modernism and the Decorative Arts in France: Art Nouveau to Le Corbusier*. New Haven, 1991.

Tudesq, André. "Une querelle autour de quelques toiles." *Paris-Midi* (4 October 1912), 1.

Vachia, René. "Les Revues." *L'Art libre* (December 1910–January 1911), 489–91.

Vernon, Richard. *Citizenship and Order: Studies in French Political Thought*. Toronto, 1986.

―――. *Commitment and Change: Georges Sorel and the Idea of Revolution*. Toronto, 1978.

Villanova. "Celui qui ignore les cubistes." *L'Eclair* (29 June 1913), 3.

Visan, Tancrède de. "Notes sur la Closerie des Lilas." *Le Cahier des poètes* (July 1913), 215–19.

———. "La Philosophie de M. Bergson et le lyrisme contemporain." *Vers et prose* (April–June 1910), 125–40.

———. "Sur l'oeuvre de Maurice Maeterlinck." *Vers et prose* (December 1906–February 1907), 82–93.

———. "Tristesse du modernisme." *Les Guêpes* (March 1909), 60–63 and (February, 1910), 66–69.

Wallon, Henri. "Nouvelle méthode d'esclavage." *Les Cahiers d'aujourd'hui* (June 1913), 159–63.

Weber, Eugen. *Action Française: Royalism and Reaction in Twentieth-Century France*. Stanford, 1962.

———. "France." In *The European Right: A Historical Profile*, ed. Hans Rogger and Eugen Weber. Berkeley, 1965, 71–127.

———. *My France: Politics, Culture, Myth*. London, 1991.

———. *The Nationalist Revival in France, 1905–1914*. Berkeley, 1959.

Williams, Raymond. *Culture and Society, 1780–1950*. New York, 1963.

Wohl, Robert. *The Generation of 1914*. Cambridge, 1979.

DATE DUE			
JA 14 '02			

GAYLORD PRINTED IN U.S.A.